OCT 27 2004 DATE JUN 8

MUSICAGE

JOHN CAGE

in Conversation with Joan Retallack

MUSICAGE

CAGE MUSES

O N

W

O

R T

D

M U S I C

▼

Joan Retallack, editor

WESLEYAN UNIVERSITY PRESS

Published by University Press of New England/Hanover and London

Wesleyan University Press
Published by University Press of New England, Hanover, NH 03755
© 1996 by Joan Retallack
All rights reserved
Printed in the United States of America 5 4 3 2 1
CIP data appear at the end of the book

this book is dedicated to
H C (W) E

Contents

Illustrations

Acknowledgments

John Cage was, and is, the raison d'être and moving spirit of this book, but it has been a complicated project involving many other people in ways both explicit and obliquely indispensable. So many that it is impossible to fully acknowledge even a fraction of my debt. The great-humored presence of Merce Cunningham has been an encouragement and a benevolent horizon throughout. It is no exaggeration to say that without the ongoing cheerful support, good sense, and intelligence of Laura Kuhn, Director of The John Cage Trust—in all phases of transcribing, writing, and editing—this book could not have been realized.

Neither would it have been possible to complete this project without generous gifts of time and, in many cases, painstaking assistance from Michael Bach Bachtischa, Peter Baker, Charles Bernstein, Kathan Brown, Andrew Culver, Alan Devenish, Tom Delio, Ulla Dydo, Gretchen Johnson, Gloria Parloff, Marjorie Perloff, Henry Segal, Rod Smith, Juliana Spahr, Holly Swain, and Gregory Ulmer —all of whom read, commented on, and corrected portions of the manuscript. Kathan Brown, the Director of Crown Point Press, generously contributed the photographs of John Cage and his prints that give this book much of its visual interest. Andrew Culver was a constant and generous source of materials, information, and ideas.

William Anastasi, Elaine Avidon, Norman O. Brown, Clark Coolidge, André Gervais, Anne d'Harnoncourt, Robert Emrich, Mineko Grimmer, Mimi Johnsen, Charles Junkerman, Ray Kass, David Krakauer, Julie Lazar, Lois Long, Jackson Mac Low, Tom Moore, Nam June Paik, William R. Paulson, James Pritchett, Robert Rauschenberg, Margarete Roeder, Susan Sheehan, Ralph Siu, Paul Van Emmerik, David Vaughan, Brent Zerger, and many others, provided essential information and materials. Anne Tardos compiled the extensive index for this book and, in that process, helped in numerous and humorous and surprising ways.

I am grateful to Terry Cochran, former director of Wesleyan University Press, who took this book on and guided it with equanimity through some early perils; to Suzanna Tamminen, Administrative Director at Wesleyan, who became its good-natured and helpful guide through later complications; and to the production staff at the University Press of New England for their patient handling of the third wave of crises on the way to publication.

Art Is Either a Complaint or Do Something Else is used by permission of The

John Cage Trust and was previously published in *Aerial* 6/7 (1991). Excerpts from John Cage's music (*Ryoanji* for Bass, *One⁸*, *Two⁶*, *Ten*, and *Europera 5*) are used by kind permission of the publisher, Henmar Press Inc. (C. F. Peters Corporation), with special thanks to Don Gillespie, Vice President of C. F. Peters. All music manuscript materials from The John Cage Trust are used by kind permission of the New York Public Library for the Performing Arts, which has acquired the collection.

Introduction: Conversations in Retrospect
Joan Retallack

The role of the composer is other than it was. Teaching, too, is no longer transmission of a body of useful information, but's conversation, alone, together, whether in a place appointed or not in that place. . . . We talk, moving from one idea to another as though we were hunters. . . . (By music we mean sound; but what's time? Certainly not that something begins and ends.) . . . (Hunted mushrooms in muskeg nearby. Got lost.) . . . A teacher should do something other than filling in the gaps. . . . What we learn isn't what we're taught nor what we study. We don't know what we're learning. Something about society? That if what happens here (Emma Lake) happened there (New York City), such things as rights and riots, unexplained oriental wars wouldn't arise. Something about art? That it's experience shared?—J O H N C A G E, *Diary: Emma Lake Music Workshop 1965*[1]

Not long after John Cage died, I received a phone call from a scholar who was writing an essay on Cage's *Europeras*. He told me it had just taken him two days to put everything in the past tense. Through no fault at all of that very nice man, I found this chilling. I vowed I would never put anything having to do with Cage in the past tense. A vow I of course had almost immediately to break.

I had found myself shaken by the past tense before. There came a time in my life as a reader—partly due to Cage—when I no longer wanted fictive time-machines to whisk me away from that resonant, chaotic here-and-now that is, with all its entanglements, our only source of history. The chosen afterimages of a narrative past are as removed from the complex real as a sci-fi future. They are an exercise in past perfected, scything through the thicket of intersections that constitute real life, clearing out complexity and possibility. How to present the phenomenon of Cage *now*, without stopping time, stopping breath; without falling into the narrative fallacy that the micrologic in a string of sentences *is* the way things *were*? In philosophy this is known as the problem of reference. For me, a poet, it is a crisis of linguistic life against death. I bring it up partly to confess from the outset that I've found no solution in this awkward prologue to the real event, the transcripts of the conversations themselves. Despite my short-comings as Cage's interlocutor, the conversations in their expansiveness impart a sense of Cage's everyday life. They do not fall into that category of "forms that erase all trace of arbitrariness"—Adorno's phrase for the kind of literature that makes us impatient with signs of life.[2] Many twentieth-century writers have felt,

like Adorno, that complex, fragmented, performative forms were the only hope for retaining vital principles, thinking new thoughts, changing minds. Cage in his own writing produced a catalogue of such possibilities and, finally, counted conversation among them.

John Cage often acknowledged that his sense of poetry and prose style began with the example of Gertrude Stein. The writing collected in his early books (*Silence, A Year from Monday, M . . .*) enacts the very process of forming a revolutionary aesthetic with language that is both crystal clear *and* enormously complex in its implications. It is language whose radically reorienting energies register graphically and syntactically on the page. In mentioning the debt to Gertrude Stein I'm not referring to that misleading tag "continuous present." What one might call cheap imitations of Stein (and early Hemingway) demonstrate the limits of a pure and simple use of this device. It produces literary artifacts in which a terrifying purification has taken place—history obliterated in a grammatical disaster whose aftermath is a single glistening strand of narrative events. Cage appreciated the odd and wonderful fact that we don't live our lives in orderly tenses or monotonic modes.[3] We live in messy conversation located at lively intersections of present, past, future—where future is not just a hypothetical, but is always actively emerging out of our exchange with the world. One learns this from Cage's work. He saw the past as exigent and instructive resource, the future as his now.

Conversation necessitates what it etymologically denotes—living *with* (con), *turning* (verse) toward—turning, that is, away from self alone. The verse of poetry and the verse in conversation are related in just that way, as a literal turning—at best, unexpectedly, toward our many pasts, presents, futures—that is, toward possibilities, contingencies, recognitions, unintelligibilities. There is as much unspoken in conversation as enters the realm of what can be said. Both parties must be comfortable with silence. Silence is the one thing that can be counted on. Silence is the authoritative presence.

During the taping of our conversations there were numerous silences, pauses, and interruptions. Most are noted in parentheses, though it would have tried readers' patience beyond all reasonable bounds to have noted every one. I did feel, however, that it would be of interest to those wanting to better understand Cage's thought processes to preserve the distinctive rhythms of the interchanges that occur in the course of thinking things through aloud. The pleasure of conversation is as strange and humorous as any form of life by virtue of its empty words as well as full, its digressions and improbabilities as well as strenuous efforts to make sense. It is not most honestly and productively about filling in all gaps, pinning things down so terminally they will never wiggle out of discursive traps.

Cage and I had wanted, insofar as we could, to tape "real conversations" rather than formulaic interviews. Though the shadow format of the interview always remains, the conversations did begin to overflow our taping sessions, continue

over lunch, in taxi cabs, on the phone, and during non-taping encounters and visits. My major editorial intervention has been in several instances to make a continuous sequence of a line of discussion that left off and then came up again in entirely unrelated contexts as further or afterthoughts and addenda. I have also omitted certain personal exchanges never intended to be "on the record." On the other hand, during one of the conversations printed in this book, the one that included the cellist Michael Bach, I left the tape recorder on during lunch and transcribed everything that transpired.[4] This particular interview captures a hefty slice of the life of John Cage, cook, solicitous host, and composer. He begins a new composition as we talk.

My friendship with John Cage was for me so large and diverse in its implications that it's been difficult to know how to begin and middle through an introduction. Ultimately, I have taken to heart (once again) something Cage said in response to my mentioning the same problem years ago, during one of our first conversations in the sixties. He said simply, "You know, you can always begin anywhere." So too a narrative, in the midst of time, which neither begins nor ends, can in principle begin anywhere. But perhaps what we most urgently learn from Cage is that the narratives we use as our "history" begin in some potent and generative sense in the future. Whether we call it teleology, utopianism, vision, hope, curiosity, or the simple force of "There must be more to life than this!?" future promise is what draws human events on. Later, in beginning an attempt on what led to what, we participate in that metamorphic retrospect where everything suddenly seems prescient. Particularly things having to do with those who were to such an unusual degree "on time" they seemed to be way ahead of the rest of us.

The name "John Cage" denotes such a figure, and much of this is no doubt an illusion. But if it is possible to distinguish between worse and better illusions, those that are forms of nostalgia versus those that function as a kind of oracle, the rapidly forming Cage mythos is surely the latter. I use "oracle" here, as I think Cage did when he referred to his use of chance operations as an oracle, to mean an active principle that allows us to be guided by questions rather than answers, by an opening-out of inquiry into a suggestive dialogue with life principles not unlike the selective intersections with chance that are the morphology of culture as well as biology. The classic oracles — East and West — present their "wisdom" in the form of unfinished puzzles, polyguous figures that instruct via the stimulus to figure things out for ourselves. They energize and clarify our vision by giving us work — invention — to do. They also serve as the kind of impetus we might associate with the Epicurean *clinamen* or swerve — the collision with contingency that dislodges us from enervated patterns into a charged apprehension of something new. I have a feeling it's this kind of thing that is meant when people say, "Meeting John Cage changed my life." Of course everything changes one's life to some degree or other, no matter how minuscule. But Cage's life/work, itself

functioning as oracle and *clinamen* for others, seemed to enlarge the range and scale of the possible.

I first met John Cage in the fall of 1965 when the Merce Cunningham Dance Company came to perform in a dance festival being held at the Harper Theater in the Hyde Park section of Chicago. It was Merce Cunningham I was eager to see for the first time out of a general curiosity about "modern dance," but also because I had heard from friends that Cunningham was "really something completely different." At the time, though I had a taste for adventure, my interests in dance and music were relatively conservative. George Balanchine was my favorite choreographer, and my very intense preferences in music were largely Baroque and pre-Baroque. I was in fact hardly aware of John Cage. And, looking now at the program for what was billed "DANCE FESTIVAL: The most important dancers performing in America—ballet, modern and ethnic,"[5] I notice to my surprise that Cage, though listed as Musical Director of the Cunningham company and performing (as did David Tudor) in every event, was really not featured in the program. Neither he nor Tudor was given a bio.

The series of five performances was for me a sudden education in what I had never dreamed dance could be, as well as in new music—mostly by John Cage, but also by La Monte Young, Morton Feldman, and Bo Nilsson. (There was one piece by Erik Satie.) I saw Cage preparing a piano, heard both Cage and Tudor play. Many of the events involved complex multimedia components with theater-wide sound sources emitting constant surprises—words and noises. Program notes included "Let me tell you that the absurd is only too necessary on earth. Ivan Karamazov"—something familiar to me from my own reading of Dostoevsky. But then there was the more enigmatic and, as I subsequently learned, quintessentially Cagean "The events and sounds of this dance revolve around a quiet center which, though silent and unmoving, is the source from which they happen." This, along with the sensibility structuring the conjunctions and disjunctions of sound, silence, film, and movement, completely astonished me. What occurred had not turned out to be dance accompanied by music in any way I had experienced before, but a strange intermingling of the visual and auditory glancing off one another's energies, never cohering or congealing within a familiar logic of relations. Over half of the audience left early, a considerable number exiting during the last piece, *Variations V*, a simultaneity of dance, electronic sounds, VanDerBeek film, and "remarks" read by Cage.

The next night the audience became even more restless, with the premiere of *How to Pass, Kick, Fall, and Run*. Many stomped out angrily, shouting their disgust over their shoulders. This was the piece in which Cage, seated at a small table to one side of the stage, equipped with microphone and sound-sensitive collar, performed a repertoire of noisy activities—smoking, drinking a bottle of wine with gulps and swallows broadcast over loudspeakers, and reading a series of short humorous texts which he later published in *A Year from Monday*, calling

them "the irrelevant accompaniment for Merce Cunningham's cheerful dance." He goes on, "I tell one story a minute, letting some minutes pass with no stories in them at all. Some critics say that I steal the show. But this is not possible, for stealing is no longer something one does. Many things, wherever one is, whatever one's doing, happen at once. They are in the air; they belong to all of us. Life is abundant. People are polyattentive."[6] Few if any of us in the audience had had the opportunity to think about all this. We were experiencing it "cold," as some might have put it. I prefer "out of the blue." It came with the pristine sensuality of "out of the blue."

In the mode of Diaghilev's "Astonish me!" (to Cocteau), I too relished surprise, and wanted more. The experience from the very first moment had been riveting—fascinating, humorous, mysterious. During that opening performance, I had seen and heard more acutely and complexly than ever before during a programmed aesthetic event. Very little of what had taken place was in a descriptive or referential relation to the natural world, but when I thought of how it had engaged my attention I could only liken it to watching ocean waves in infinite variety spuming against rock on the coast of Maine, or sky and water becoming one in the heat and stillness of a South Carolina low-country afternoon, or even moving through the endlessly interesting *medias* race of humanity in downtown Manhattan. These associations were familiar from my past. What was completely new, what I could not connect with anything I had ever been consciously aware of before, was what seemed to be a radical alteration in my experience of the relation between visual events and sound—space and time. (As a philosophy student I knew that this was truly profound, since according to Kant space and time were the fundamental aesthetic categories.)

When the performance was over, literally shaking with excitement and fright, I went backstage, where I came upon Merce Cunningham. I told him that this had been the most stunning, puzzling experience of dance and music I had ever had, that I didn't understand what had happened, that I was intensely curious to find out. Were rehearsals by any chance open to the public? Cunningham was friendly and welcoming. He said, "Oh yes, of course," and told me what their rehearsal schedule would be.

The next afternoon when I arrived at the theater, the dancers—Carolyn Brown, Gus Solomons, Sandra Neels, Valda Setterfield, Barbara Lloyd, Peter Saul, and Albert Reid—were beginning to arrive for warm-up exercises. I was struck again, as I had been the night before, by the exquisite discipline and precision of their movement—a rigor I had in my ignorance not expected outside the ethos of ballet. Sitting alone in the dimly lighted auditorium was the man in the black suit, white shirt, and tie I recognized as the composer-performer from the night before, John Cage.

When he saw me come in, he nodded and smiled, walked over, introduced himself, and sat down. He asked me about my interest in dance and music,

wanted to know what I did. Was I involved with either? I told him that I was painting, writing poetry, and studying music (cello), all more or less "on the side." I was a graduate student studying philosophy at the University of Chicago. "Oh," he said with a smile, "I'm involved in the study of philosophy too. What kind of philosophy do you study?" I told him I had been studying ethics and philosophy of science, and was primarily interested in the methods of philosophy of language, particularly the work of Wittgenstein. Cage said he was interested in Eastern philosophy, particularly Zen Buddhism, and that he didn't much care for Wittgenstein—"too many rules." But he was curious what I found of value in Wittgenstein, and I was curious about Buddhist philosophy, so we talked about those things and about my sense of something unfamiliar having happened the night before to my perception of space-time.

Cage was buoyant, charming, expansive. He explained the way in which he and Merce Cunningham worked together—each composing and choreographing independently, having agreed beforehand only on the length of time of a given piece. This meant that the relation between the dance and the music was not causality, but only that they happened to occur in the same space over the same period of time—"synchronicity." Cage said neither he nor Merce Cunningham could bear to see dancers "Mickey Mousing" to the rhythm of the music. He then told me, rather shyly, that he had recently published a book of writings on some of these matters. It was called *Silence*. When I told him I would look for it, he said that he hoped I would find it interesting, but he was *sure* I would be interested in the *I Ching*, the "Chinese Book of Changes." He said to get the Bollingen, Wilhelm/Baynes edition with the essay on synchronicity by Jung: "That may help."

I ordered *Silence* the next morning and bought a copy of the *I Ching*. Jung's foreword was both helpful and puzzling[7]:

We have not sufficiently taken into account as yet that we need the laboratory with its incisive restrictions in order to demonstrate the invariable validity of natural law. If we leave things to nature, we see a very different picture: every process is partially or totally interfered with by chance, so much so that under natural circumstances a course of events absolutely conforming to specific laws is almost an exception. —(C. G. Jung, p. xxii)

This confirmed the importance of chance; and/but then there was this:

Whoever invented the *I Ching* was convinced that the hexagram worked out in a certain moment coincided with [that moment] in quality no less than in time. To him [sic] the hexagram was the exponent of the moment in which it was cast—even more so than the hours of the clock or the divisions of the calendar could be—inasmuch as the hexagram was understood to be an indicator of the essential situation prevailing in the moment of its origin. This assumption involves a certain curious principle that I have termed synchronicity[,] a concept that formulates a point of view diametrically opposed to that of causality. Since the latter is a merely statistical truth and not absolute, it is a sort of working hypothesis of how events evolve one out of another, whereas synchronicity takes the

coincidence of events in space and time as meaning something more than mere chance, namely, a peculiar interdependence of objective events among themselves as well as with the subjective (psychic) states of the observer or observers. —(Jung, p. xxiv)

So, chance, though "mere," is all pervasive, and coincidence turns out to have as much relational glue as causality, if not more. Attention to synchronicity allows one to notice relationships between disparate elements minus the compulsion to absorb them into a progressively homogenizing system. I read the following passage from Jung's foreword—knowing nothing about Cage's use of the *I Ching* in his music—as having somehow to do with Cage's account of Cunningham's movement away from story ballets to the coincidences of sound and movement that structured the performances I had seen:

The causal point of view tells us a dramatic story about how D came into existence: it took its origin from C, which existed before D, and C in its turn had a father, B, etc. The synchronistic view on the other hand tries to produce an equally meaningful picture of coincidence. How does it happen that A′, B′, C′, D′, etc., appear all in the same moment and in the same place? It happens in the first place because the physical events A′ and B′ are of the same quality as the psychic events C′ and D′, and further because all are the exponents of one and the same momentary situation. The situation is assumed to represent a legible or understandable picture. —(Jung, pp. xxiv-xxv)

Of course what is "understood" will not meet criteria of traditional Western logics of discovery and understanding unless the conceptual framework within which those logics operate expands to include psychic phenomena, or forms of spirituality, or ecological or environmental views, or the kind of modeling of complex systems (like turbulent fluids and gases and the weather) that goes under the rubric of "deterministic chaos." Going back to the Jung foreword now, I am, despite its dated assumption of absolutes and essences, startled that he wrote it in 1949. Another mind that had managed in certain very interesting respects the difficult trait of being "on time." In the twentieth century, bogged down by enduring nineteenth-century forms, the present has always looked downright futuristic.

Cage and I continued to talk the next day, about "ordinary language philosophy," art, and "ordinary life." I told Cage I thought he should give Wittgenstein another chance, particularly after reading the Jung. And I don't clearly remember the relevance I thought I saw then, but it had something to do with Wittgenstein's connecting meaning and use within active forms of life, which I probably visualized as a series of contexts radiating out from the linguistic event like a series of synchronic concentric circles. Focus on any moment and you would have synchronic, concentric contextuality. . . . Whatever it was that I said, Cage looked doubtful, smiled, and probably changed the subject. He told me the art that he valued was not separated from the rest of life. (I think he may have mentioned Duchamp's readymades.) The so-called gap between art and life didn't have to

exist. And (here he began to laugh heartily) an artist friend (Robert Rauschenberg?) had written a play for three characters—called Art, Life, and Gap.

This conversation was for me like a spring of fresh water opening up in the midst of centuries of conceptual rubble. Similar to my encounter with Wittgenstein's work on the heels of Hegel and Heidegger, a few years before. Though I had been reading Gertrude Stein and Pound, and had loved as a teenager "living in" the porous and mysterious, nonlinear structure of *The Waste Land*, I still revered crystalline logic and the transcendence theories of art that pervaded the academy in the guise of "the sublime." Even Wittgenstein, I later realized, had retained this etherealized view of art despite his rejection of metaphysics. It wasn't until I read John Dewey's *Art as Experience* that I discovered a spiritually rich, aesthetic pragmatics of everyday life that corresponded to Wittgenstein's use theory of meaning—meaning as "form of life"—and Cage's imitation of nature's processes.[8]

So, this is how I met the Master of Nonintention at a time when I happened to be in a seminar conducted by the British analytic philosopher G. E. M. Anscombe, who might well have been called the Mater of Intention. Elizabeth Anscombe was the author of what was at the time a quite influential book called just that—*Intention*—though she was then, as now, best known as Wittgenstein's friend and colleague and the translator of the *Philosophical Investigations*. The title of her seminar that fall was *Wanting*. Cage of course had been engaged for years, as he would continue to be, in a spiritual and aesthetic practice of not-wanting. The collision of these two figures, entering my life at the same time, produced a crisis with a long series of aftershocks. As the only female professor I ever had, and easily the most brilliant, male or female, Anscombe was a powerful model for me. I greatly admired the quirkily inventive, entirely lucid character of Anscombe's reason. And I envied what seemed to be her intellectual immunity to messiness, to the morass of the emotions. But, to my dismay, she seemed to think, along with her "ordinary language" colleague, the philosopher J. L. Austin, that if you were going to do sensible things with words you simply couldn't be engaging in humor or writing poetry.

In fact, Wittgenstein—whose writing has always seemed to me to be a form of poetry, and later came to strike Cage similarly, but who was taken at the time to be entirely, prosaically, rationalist in his enterprise—had also relegated poetry to a zone outside philosophy, somewhere near the place where Kant had stashed religion. There was so much that could not be talked (reasoned) about by philosophers. Now, here was Cage, who had certainly managed to escape sentimentality, but who was warm and friendly and did what he did *out of a need for poetry*![9] *Silence* turned out to be a startling intermixture of the conceptual and commonplace, experimental forms and straightforward anecdotes, passionate seriousness and humor, philosophy and poetry—with much breathing space in the interstices, as in conversation. At that point, Cage was the only person

I had ever met who did not experience intellectual (or artistic) transgression in entertaining all these things at once.

My next meeting with Cage came about after I had left both Chicago and the pursuit of a Ph.D. It was a result of the sort of coincidental chain of events that is nonetheless surprising for making up the everyday fabric of everyone's life. I had become active in the civil rights and anti-war movements in Washington, D.C., working with a theater and film group sponsored by the Institute for Policy Studies. There I met a cultural anthropologist named Robert Emrich. He was acting deputy director of a newly formed interdisciplinary institute at the Department of Justice with the mission of developing a social value framework for policies that were to be instrumental in bringing about "The Great Society." This institute had been started under the guidance of a Lyndon Johnson appointee named R. G. H. Siu, who was, surprisingly enough, the author of a book called *The Tao of Science*.[10]

In 1968 Emrich proposed that Siu meet with me as a potential consultant in social philosophy. To my surprise (and alarm) I was hired, as Siu said, because of my "alternative" experience, which he thought might bring a fresh perspective. Siu assured me carte blanche in deciding what I would do, saying only that he hoped I would bring ideas to the institute that it would not have been exposed to otherwise. I took this quite seriously and immediately made arrangements to interview a variety of people involved with issues of social justice, including John Cage and one of his mentors, Buckminster Fuller, as the basis for seminars I would conduct for the institute staff.

Both Fuller and Cage were surprised and pleased by this opportunity to think aloud about issues of social justice in a context that might conceivably have some effect on government policy. Fuller was interested in both the conceptual and physical framework of "correctional institutions." (He had, in fact, been corresponding with an inmate.) Cage had recently published the first three installments of his "Diary: How to Improve the World (You Will Only Make Matters Worse)" 1965, 1966, and 1967. In 1967 Cage was at the height of his optimism. There was the triumph of Fuller's immense geodesic dome housing the U.S. exhibition at Expo '67 in Montreal, in which the art of Cage's close friends Robert Rauschenberg and Jasper Johns as well as that of Andy Warhol, Claes Oldenburg, and Jim Dine was on display. It seemed as though the socioaesthetic project that Cage saw himself collaborating in was finally being valued by the society at large, and was thus coming into a position to have transformative consequences.

"Diary . . . Continued, 1967" is full of an awareness of the high incidence of pain in the world (the war in Indochina, world-wide hunger, lack of adequate shelter, etc.). Cage thought at that time that art was in pretty good shape; what was in urgent distress was not art but society. And what needed to be done was "Not fixing it but changing it so it works." The Diary ends with "We cry because anyone's / head was struck.) Tears: a global / enterprise." But the

Diaries contain a programmatic optimism in the form of catalogs of spiritual and techno-utopian remedies for the world's problems from the work of, most notably, Buckminster Fuller, but also Marshall McLuhan, Norman O. Brown, Huang Po, and other Western socio-philosophical and Eastern spiritual thinkers. Both Fuller and Cage, like most of the reformers and revolutionaries of the sixties, believed at that time that if the means to dramatically improve human life on the planet were made clear and available, people would have the good sense to use them—to do what needed to be done. Cage's lifelong project could in fact be summed up as trying to figure out what needed to be done and doing it. In 1958, in his "History of Experimental Music in the U.S.," he had written,

Why, if everything is possible, do we concern ourselves with history (in other words with a sense of what is necessary to be done at a particular time)? And I would answer, "In order to thicken the plot." In this view, then, all those interpenetrations which seem at first glance to be hellish—history, for instance, if we are speaking of experimental music— are to be espoused. One does not then make just any experiment but does what must be done.[11]

Cage's 1967 "Diary" entry ends on this hopeful note, conceived as both uto-pian *and* pragmatic:

> If
> we get through 1972, Fuller says, we've
> got it made. 1972 ends the present
> critical period. Following present
> trends, fifty per cent of the world's
> population will then have what they need.
> The other fifty per cent will rapidly
> join their ranks. Say by the year 2000.[12]

I, for one, certainly wanted to contribute to the coming of this kind of world, which at that point, 1968—with student uprisings in the name of "*the* revolution" going on around the world—seemed already visible on the horizon. I felt the Justice Department could benefit from the sources of that vision. Some of my long-range ideas, in what actually turned out to be a very short-run situation, had to do with rethinking the language of government in the U.S. (specifically at "Justice"), and community arts projects along the lines of things going on at the Institute for Policy Studies, both as substitutes for incarceration and to begin conversations between the Justice Department and citizens from disparate economic classes and communities. Cage found this of interest and suggested that we meet at what was then his favorite Greek restaurant in New York, the Parthenon on West 42nd Street. When he arrived he was in a particularly ebullient mood, saying that it really was heartening that the Justice Department had hired R. G. H. (Ralph) Siu, whom I think he knew through Siu's essay "Zen and Science—'No-knowledge'" in Nancy Wilson Ross's book, *The World of Zen*.[13] He found it equally heartening that Siu had hired me to do what I was doing, and

absolutely marvelous that others in the Justice Department (Robert Emrich had come with me to tape the interview) might be interested in the opinions of Buckminster Fuller and himself! Cage always felt that he and Fuller were working on the same social project in different ways.

Unfortunately, this is about all I remember of our conversation. Cage had ordered a bottle of Retsina for the table. He thought it was wonderful and generously refilled our glasses. When the first bottle was empty, Cage ordered a second. I got through the lunch conversation with some superficial level of coherence but by the time it was over I was completely drunk. I had a blinding headache throughout the next day, which rendered the whole experience a blurred and fragmented memory. I do recall that Cage himself was tipsy by the end of our long, two-bottle lunch. When we left the restaurant he stepped off the curb to cross the street, smiling and waving goodbye, and came very close to being struck by a speeding cab.

Buckminster Fuller arrived in Washington wearing three wrist-watches and sprinted about like a 73-year-old, turbocharged elf.[14] He was also delighted, even excited, by the "Justice Department's" interest in his and Cage's opinions. He seemed to think (as I think many of us did at the time) that the new era was beginning. The Fuller interview took place over an entire day, beginning in the morning at National Airport, moving on to my apartment, then to a downtown restaurant, and finally to his room at the Mayflower Hotel. Fuller had room service deliver a large urn of hot tea, an extra pot of hot water, and a dozen tea bags. He explained that his dietary convictions included eating a single meal a day and, as much as possible, flooding the system with a constant stream of hot liquid. This meant that the interview—which at the Mayflower became a dazzling monologue—was taped in 10- to 15-minute segments between Fuller's trips to the bathroom. His talk throughout the day had ranged from the way in which social values are reflected in public structures to prison reform to structural integrities, which, at around 8 P.M.—close to his bedtime—turned into a theory of eternal life. Fuller, who had turned off his hearing aid while maintaining almost unblinking eye contact (never closing his eyes as I saw him do on other occasions), said this was the best explanation he had ever given of these matters and asked that a transcript of the tapes be sent to him as soon as possible.

I gave the Cage and Fuller interview tapes to a secretary at the Justice Department for transcription. Not long afterwards, with Johnson having relinquished his bid for a second term, Humphrey lost the election to Nixon, and the secretary, probably daunted by the unfamiliar content of the tapes, was taking such a long time on them that, before I could get them back, the Nixon team took over. Ralph Siu was immediately replaced, and a Nixon appointee, Charles Rogovin, lost no time in requesting that I write a memo and then meet with him in order to explain just what it was I had been doing. He declined to renew my contract. Everything I had done—notes, memos, seminar papers, tapes, and any

transcripts that may have existed—was confiscated and "classified." My request for the return of my materials, particularly the tapes, of which we had not made copies, was refused.

Of course I was mortified—about, among other things, having wasted Fuller's and Cage's time—as well as depressed at the enormity of what Nixon's election meant for the country. I saw Cage now and then at concerts after that but didn't approach him. I had retreated into a period of my life that's hard to characterize; I was trying to come up with a way of continuing to work—in visual art, and as a poet and essayist. The next time I spoke to John Cage was when he came to D.C. for events in celebration of his seventieth birthday. After his reading performance at the Washington Project for the Arts, I said hello without really reintroducing myself. He seemed very remote and I had the feeling he didn't remember me.

Around that time, the early 1980s, I was writing multidirectional essays that often began or ended with Wittgenstein or Cage. I was invited to participate in a symposium at the Strathmore Hall Arts Center Cage-Fest in May 1989 in Rockville, Maryland, where I read an essay entitled "Fig. 1, Ground Zero, Fig. 2: John Cage—May 18, 2005."[15] Among other things, it placed Cage's work within the American pragmatist aesthetic articulated by John Dewey in *Art as Experience*. Cage thanked me for the essay, saying with great emotion, "With what you say about Dewey it all makes sense. For years I have lived under the shadow of Susanne K. Langer."[16] After that, as we came to work together on the conversations project, and as we came to be friends, he would say periodically, more or less out of the blue, "You know, Joan, that essay says it all." This was, of course, gratifying to me. But it also made me feel, periodically, not so much that I had said it all, but perhaps that I had said enough. That saying more would be too much. That may indeed be the case. But the work on and with Cage has continued, up to this book.

In the summer of 1990, Rod Smith, the publisher-editor of *Aerial* magazine, who had attended the Cage-Fest in Rockville and become a great admirer of Cage's work, decided to dedicate a large portion of his next issue to John Cage through the publication of the long lecture-poem Cage had read in Rockville, "Art Is Either a Complaint or Do Something Else," along with a selection of his macrobiotic recipes. (Cage was no longer drinking Retsina, nor for that matter eating most of what his favorite Greek restaurant had served. He had also, by this time, come to love Wittgenstein.) Rod Smith asked me if I would consider interviewing Cage for the issue. I had some trepidation about this, given what had happened the first time around, but my delight at having a second chance won out. I called Cage to ask him whether he would be willing to do this and he said yes.

So, what turned out to be the first conversation in *M U S I C A G E* took place during two days in September 1990 and was published in *Aerial 6/7* in 1991. Because of the pleasure we found in doing it, Cage and I talked at the time about

the possibility of taping more conversations, but it didn't really seem practical in the absence of a specific occasion. When we had both heard from a number of readers of the *Aerial* issue that the format—combining an example of Cage's work with a detailed exploration of it—had been helpful in understanding his motives and methods (some said they felt they had really understood his use of chance operations for the first time), we thought that doing a conversation book in this way might be warranted after all. We decided to structure it with sections devoted to recent work in each of the three major areas of Cage's interest—language, visual arts, and music. My sense of a need for this was strong. Over the years it had become apparent to me that, except among the circle of Cage devotees and scholars, was an almost inverse relation between Cage's increasing fame and the degree of understanding of his work. Fame, which is of course based largely on the abbreviated codes of media images, had led in many cases to misleading caricatures.

Thus, the conversations in this book, starting with the one published in *Aerial 6/7*, came to be taped over a period of three years in John Cage's art- and plant-filled loft in the Chelsea section of Manhattan. We worked at the round wooden table where he composed, just a few feet away from a bank of large windows overlooking (and overhearing) 18th Street and 6th Avenue. This was the same table at which Cage and Merce Cunningham and their frequent guests ate, steps away from the open kitchen where something delicious was often cooking, not far from the phone that rang unmediated by an answering machine with calls from all over the world.[17] Given this setting, a busy intersection of the domestic and global, the everyday pragmatic and sensual, the aesthetic, the philosophical, and the spiritual—all in the complex and humorous intermingling that was Cage's preferred form of life—it's probably not surprising that our conversations ranged widely: from the portentous question of whether the beans were burning—while checking, we decided that cooks smell time—to detailed discussions of philosophy, poetics, visual aesthetics, and of course music practice and theory. Cage's musical principle of "anarchic harmony," the result of a particular discipline of attention to time expanded by chance and design to accommodate dense and surprising interrelationships, was entirely manifest in Cage's living-working arrangements both at home in New York City and in his working travels around the world—in Europe, Japan, and Latin America. This was the remarkable integrity of a *poethics* of everyday life and work where forms of art and the art of life interpenetrate within a coherent framework of values.

For Cage the role of the composer was always multiple and paradoxical: to compose music, of course; but also to compose language, visual materials, a space in which to live and work that was both socially responsive and set apart—a kind of oasis in the midst of our consumer- and mass-media-dominated culture—almost as though "the revolution" *had* occurred. He was delighted to learn and to share alternatives to what he saw as destructive cultural habits. But, though

Cage in many ways enjoyed being a public figure, his extraordinary accessibility was the other side of a very private person who longed for invisibility, for a mode of being in the world where ego disappears, leaving no trace. In the middle of enormous responsibilities and a fame about which he certainly felt ambivalence, within quite consciously constructed brackets and parentheses of time and space, Cage made getting lost a way of life. He often said, "When I'm not working I sometimes think I know something. When I'm working I discover that I don't know anything at all." This discovery always pleased him. It came from the fact that each project was in some way a radical quest to make it new, for himself as well as for anyone else who would be involved with his work, to genuinely not know where the processes he had set in motion would lead. This was not in order to produce the market value of an "original" commodity, but to move into a zone of unintelligibility, the only place where the possibility of discovery lies, where the future is not at the outset already a thing of the past.

Because the charged field of the paradoxical was Cage's preferred territory, I think it's important to try to distinguish paradox from contradiction. Paradox operates outside the internal consistency of any given set of rules. It is evidence of complexity. Evidence that the conditions of life will always exceed the capacity of a unitary systematic effort to contain or entirely explain them. A state of affairs described in the mathematical world by Gödel's incompleteness theorem. Contradiction takes place within closed systems, unified and coherent sets of interlocking definitions and laws. While contradiction leads to logical gridlock, shutting the system down and sending us back to ferret out our mistake, paradox reveals insufficiencies of limiting systems in a complex world, catapulting us out of system into a new realm of possibilities. A paradox, such as Cage's "silence is ambient sound," opens up new frontiers on the edge of unintelligibility (silence), full of crosscurrents of fresh air—multidirectional and from many (sound) sources. It breaches and enriches definitions of music. So also, when Cage used the word "beautiful" as highest honorific *and* dismissive pejorative, was he contradicting himself? Or was this an indicator of a more complex situation? The cult of beauty has degraded art with its preestablished criteria, encouraging nostalgia and imitation. An encounter with beauty can be a process that awakens one's whole being. Both of these statements appear to be true. That such divergent experiences of "the beautiful" involve use of the same term signals not contradiction but complication, perhaps even paradox—a situation which demands something more than either/or ways of thinking: The degree to which our desire to possess beauty leads us to imitate its image rather than its processes may (paradoxically?) make experiences of beauty harder to come by within the fluid circumstances of everyday life.

To compose is simply "to put together." Cage is often thought to have most notably pulled coherent traditions apart in order to create room for chance, apertures for silence. His notoriety, as with all avant-garde artists, has been one of

dismantling. This view comes from perspectives which lie outside the locus of his constructive activities. The substance of avant-garde work is often hard to perceive because, at least initially, the absence of the familiar is more palpable than the strange presence of what is actually there. New forms in fact not only seem disturbingly wrenched out of contexts that have given old forms their meaning, but can appear to be violently abstracted from "content" itself—empty. It is not until they begin to attain familiarity, to acquire context, that they seem miraculously to fill up with their own substance. Certainly this experience of alarming absence is most likely to occur when one is unfamiliar with the "other" traditions—East and West—that form the contexts and moving principles of Cage's compositions.

This work brings material and experience together in a mode of enactment rather than "aboutness." Patterns of sound and silence, chance and design startlingly reveal their utterly intermingled contingency, not as idea, but as initiating experience to be undergone by composer and audience equally involved in the making of meaning. Cage's lifelong project was one of dislodging cultural authoritarianism (and gridlock), inviting surprising conjunctions within carefully delimited frameworks and processes. (I think it's not really a paradox, though it's something we tend to forget, that we experience freedom only within structuring contexts.) He hoped the sense of possibility this engendered would be helpful, specifically within the tradition of the art form, but also more generally within the society. He once said with great passion—responding to a goading inquiry about skeptical and hostile reactions to his work (as though Cage himself *wanted* his music to be inaccessible)—"Everything I do is available for use in the society." For Cage, like Wittgenstein, meaning was determined by use, not by intention— at least not by intention seen as a picture in the artist's mind to be faithfully replicated in the object or event. Cage wanted his art to introduce us to the pleasures of nature and everyday life undistorted by domineering ego. His motive, like John Dewey's, was fundamentally environmental: if creature and environment become separated, both die. Almost all of Cage's work, if actively engaged within the terms its structures suggest, directs audience attention to the ambient context in which it takes its time and place. Engaging with it is enacting a very particular form of life, one of attentive conversation—*turning* toward, turning *with*. Cage took his work—an invitation to the aesthetic pleasures of everyday life—to be no more, no less than a contribution to the global conversation among those who care about the future of the planet. But, just as importantly, a conversation with the processes of nature itself.

The use of what Cage called "chance operations" was a way of escaping the trap of ego, emotions, habit—inviting nature to have its "other" say in art. He explained this in a preface to be read at the start of each performance of one of his most overtly political pieces, *Lecture on the Weather*, commissioned by the Canadian Broadcasting Corporation in the American bicentennial year of 1976. Cage

used the opportunity of this commission to honor the revolutionary spirit still very much alive in the nineteenth-century work of Henry David Thoreau, as well as in the position of the American draft resisters who had fled to Canada during the U.S. war in Vietnam. But most of all he wished to honor by these means the possibility of a world in which we finally realize the meaning of "world us"—the extent to which we are all in this wonderful/awful mess together. Cage wrote:

I have wanted in this work to give another opportunity for us, whether of one nation or another, to examine again, as Thoreau continually did, ourselves, both as individuals and as members of society, and the world in which we live: whether it be Concord in Massachusetts or Discord in the world. . . . It may seem to some that through the use of chance operations I run counter to the spirit of Thoreau (and '76, and revolution for that matter). The fifth paragraph of *Walden* speaks against blind obedience to a blundering oracle. However, chance operations are not mysterious sources of "the right answers." They are a means of locating a single one among a multiplicity of answers, and, at the same time, of freeing the ego from its taste and memory, its concern for profit and power, of *silencing the ego so that the rest of the world has a chance to enter into the ego's own experience.* . . . Rome, Britain, Hitler's Germany. Those were not chance operations. We would do well to give up the notion that we alone can keep the world in line, that only we can solve its problems. More than anything else we need communion with everyone. Struggles for power have nothing to do with communion. Communion extends beyond borders: it is with one's enemies also. Thoreau said: "The best communion men [sic] have is in silence."[18]

Silence for Cage was the point of entry of "the rest of the world" into audibility. And it was by means of his "chance operations" that silence was invited into the conversation. (There are detailed explanations of how he used chance operations in all three sections of this book.) With this means he was able to probe the undiscovered field that lies outside the direction of our attention, a direction always very precisely charted in his work so that chance occurrences can be construed as meaningful events (alternative "voices") within a designated range of sources, materials, and instrumental processes. Cage truly loved alterity, the existence of what Charles Sanders Peirce called "real things, whose characters are entirely independent of our opinions about them."[19] This sums up a usefully chastened view of nature, one in constructive contrast to both nostalgic and techno-scientific views. We may be coming to realize that Baconian sci-tech prediction and control (nature as extension of our will) is in its clumsiest forms as pathetically fallacious as romantic nature nostalgia (nature as extension of our emotions). The "weather" in *Lecture on the Weather* is an atmospheric political climate composed of many interpenetrating voices, not the sympathetic resonance of a few leading characters.

During a performance of *Lecture on the Weather*, political climate and (simulated) meteorological climate collide in such a way that the political climate is experienced *as* meteorological—as the complex chaotic condition of interpenetration and obstruction in which we live, a fragile balance of order and disorder,

clarity and cacophony. How we orient our attention in this situation, how we identify significant patterns, construe meaning, how we act in relation to our values, is an index to the difference between forms of political order—between, for example, consumerism and environmentalism, authoritarianism and anarchic harmony. Either side of both of these sets of choices (and there are certainly many more alternatives) can characterize the relationship between audience and performance. But finally, Cage's work promotes an environmental dispersal and refraction of what there is to see and hear to such an extent that the participatory engagement of performers and audience can only be anarchic.

For that part of mass culture and philosophy (both Disney and Baudrillard come to mind) which operates as if we have the god-like capacity to entirely construct the universe in our own image, nature that is not "imagineered" (à la Disney World) into entertainment commodity or into the conceptual construct that is its parallel in academia, nature as truly other than our intentions has become almost unimaginable except as source of skepticism, deconstruction (locate a contradiction in the construct), economic irritation, or terror. A "terrortory" to be tamed into landscape reflecting only the desiring eye of the beholder—consuming all that falls prey to its gaze. This is, in perhaps a more positive construction, the civilizing impulse. But don't we ignore what lies outside the fragile currency of our images and constructs, our tightly constructed and self-repeating rhythms, our descriptive colonizing, at our (and the world's) peril? It may be that Lacan was right (about at least one thing)—that always lurking in the margins is "the revenge of the real."

JOHN CAGE: COMPLEX REALIST, I.E., UTOPIAN AVANT-PRAGMATIST

Cage's work attempts to move us beyond skepticism, beyond irony, beyond commodification, beyond idealization to a realm of complex realism that shifts the scene of the aesthetic outside the swath of the culture's self-reflecting gaze. It brings together natural, aesthetic, and social processes in an exploration (a conversation composed largely of questions) of possibilities we, in our infatuation with image-making, might otherwise overlook. Cage worked in service of principles and values derived from what in lifelong study he took to be the best, the most practically and spiritually relevant, of Eastern and Western thought, hoping that someday global humanity might live with pleasure in anarchic harmony—in mutually consensual, non-hierarchical enterprise. This vision was utopian in the best sense of the word—that is, within the pragmatics of real-world modeling that distinguishes utopian constructs from dreams, fantasy, and wishful thinking.[20] Utopianism for Cage was a carefully designed function built into his

working aesthetic, and into the realization of his scores. From the late '50s on, his musical compositions modeled forms of anarchic harmony in the relations between musician and composer, musician and music, musician and other performers, as well as among composer, performers and audience. It was in this quite concrete way that everything Cage did was poethical—making or implying connections between aesthetic structures and habits of mind and living—and, in the way it combined the spiritual and the political, steadfastly utopian.

Cage's idea of a utopia characterized by anarchic harmony directly informed his composing (with parallels in his language texts and visual art). He envisioned, and wrote music for, an ensemble or orchestra without a conductor, without a soloist, without a hierarchy of musicians: an orchestra in which each musician is, in the Buddhist manner, a unique center in interpenetrating and nonobstructive harmony with every other musician. When asked at one of the seminars he gave at Harvard (1988–89) in conjunction with his Charles Eliot Norton Lectures whether he thought his music had political content, Cage replied:

I think one of the things that distinguishes music from the other arts is that music often requires other people. The performance of music is a public occasion or a social occasion. This brings it about that the performance of a piece of music can be a metaphor of society, of how we want society to be. Though we are not now living in a society which we consider good, we could make a piece of music in which we would be willing to live. I don't mean that literally, I mean it metaphorically. You can think of the piece of music as a representation of a society in which you would be willing to live.[21]

There was a time during the sixties when John Cage liked to remark that he was gifted with a sunny disposition, a tendency toward optimism and humor.[22] Humor, which can accommodate the good . . . bad, beautiful . . . ugly, sacred . . . profane, continued to come easily. Spontaneous optimism was, not surprisingly, an effort to maintain.

Personal, professional and political crises in the 1940s precipitated in Cage a major spiritual and intellectual reorientation.[23] In its wake he came to mistrust all emotional content in the arts, believing that it was properly the business of members of the audience to supply—in relation to their own experience—the emotional dimension. Both spiritually and aesthetically, Cage longed for the serenity of Buddhist detachment. But as he and the twentieth century aged together, he could not ignore the terrible degradation of its early utopian dreams. That is, he could not ignore all the work that still needed to be done. Visionary turn-of-the-century movements—communist, supremacist, constructivist, and futurist—had pinned their hopes on scientific and technological advance to move us beyond historical injustice and despair, but despite an enduring sense of being on the threshold of unprecedented social possibility, this century has been depressingly persistent in its production of horror—wars, poverty, institutionalized cruelty, ruinous greed. Cage found that in order to be a contributing world citizen, he had, with artifice and discipline, to continually reinvent the "gift" that

life's brutality always threatens to eradicate, the gift of good-humored openness to constructive possibility. Cage's optimism had to be transformed from a feeling of confidence in the inevitability of progress to a complex modus operandi posited on the belief that we are responsible for the construction of our social world as well as on respect for the natural world. (This is a position in which it is not useful to view nature as a social construct.) The chief goal of his aesthetic became a pragmatic, though still visionary, utopianism: temperamental optimism transformed into utopian method. In the late 1940s Cage quoted Meister Eckhart, "But one must achieve this unselfconsciousness by means of transformed knowledge," followed by a self-described (by Cage) "random thought": "If the mind is disciplined, the heart turns quickly from fear towards love." [24] For Cage this meant a quest to quiet the mind and the emotions *while* contributing something of use to the society. Cage's utopianism became the working solution to the tension between hope and despair.[25]

Utopianism has historically differed from wishful thinking, science fiction, and fantasy to the extent that it has been rooted in the hope and possibility of enactment—it is a material rather than transcendental idealism. From thought experiments like Plato's *Republic*, Aristotle's *Nicomachean Ethics*, and More's *Utopia*[26] to the Epicurean community known as "The Garden"; from the Enlightenment philosophies that were the source of the French and American revolutions to experiments like Oneida and other intentional communities in America; from Marxism/Communism in Europe, Asia, Cuba and Nicaragua to Socialist Democracy in Scandinavia, Kibbutzim in Israel, Martin Luther King's civil rights "Dream," and the Poor People's Campaign—there have for millennia been forms of utopianism connected to real social experiment and real historical consequences. In this way utopian visionaries have been an ongoing source of both disappointment and inspiration. All of this belies the vaguely pejorative, casual usage of the adjective "utopian" connoting impractical or impracticable—not having to do with practice. In so far as utopian thinking engages the imagination, it is entirely about the interaction, in *praxis*, between creative vision and real-world contingencies—an active engagement with potentially useful implications.[27] The pragmatic value of the visionary imagination is startlingly revealed when we think of the alternative—a human future in its absence.

Utopianism, along with a belief in large-scale human progress, is currently on the postmodern list of banned (Enlightenment and Modernist) ideas. Cage's work and thought help us ask whether we might need to restore and renovate rather than abandon them. Certainly the mono-rational Enlightenment vision deserves to be in serious trouble. The purist clarity of its one-way directional beacon leads to suffocating visions (see, e.g., Foucault's "Panopticism") of Reason's centralized control. Might there be more complexly realistic ways to think about a global hopefulness? Whatever one may think of Cage's decentralized vision of anarchic harmony,[28] it certainly suggests that there can be other models. That

there may be a way into a post-skeptical poetics of public language, a post-ironic socioaesthetic modeling without denial or naiveté—a *complex*, not naive, realism.

If, that is, to imagine democracy in monarchist France or in colonial America was utopian, to imagine socialism in Czarist Russia was utopian, to imagine children's rights in early industrial Europe and America was utopian, to imagine Feminism in the nineteenth century was utopian (some say it still is), to imagine integration in the pre–civil rights South was utopian, to imagine a world without consumer aggression, nationalism, and war is utopian, to imagine a world without racial and ethnic conflict is utopian—then, Viva Utopia! In these globally desperate times, it may be utopian in the best sense to invent ways of constructively *working on* ("solutions" can be hoped for but are as much a matter of chance as intention) the most grotesque, self-inflicted problems of our species.

JOHN CAGE : BEYOND IRONY : RE:SOURCERER

I–VI *continues an ongoing series, of which* Themes and Variations *was the first, and* Anarchy *is the most recent, to explore a way of writing which though coming from ideas is not about them, or is not about ideas but produces them. For* Anarchy *the source material was thirty quotations, all of them related to anarchy. For these lectures four hundred and eighty-seven disparate quotations have been put into fifteen files corresponding to the fifteen parts of* Composition in Retrospect. . . . —JOHN CAGE[29]

In his transfiguration of sources at hand, Cage was, like his friend and mentor Marcel Duchamp, a sourcerer. But Cage's complex realist model of re:sourcefulness goes beyond the irony of a Duchamp toward a model of a constructively usable past. History, in the form of ideas, texts, cultural artifacts—history as ambient cultural silence—is an object of neither irony (distancing fascination) nor reverence (distancing respect) but is a visionary pragmatics undertaking a constructive recycling and reorienting—a benign and (paradoxically) conservative radical practice which invites us to enjoy new forms of attention.

Søren Kierkegaard, an avowedly addicted ironist, thought that, though irony was essential in starting the motion away from a deeply entrenched undesirable state of affairs, one had really not gotten very far until one had gotten beyond irony as well. The ironic mode is so heavily parasitic on the object of its critique that it is, if anything, a sign of the robust life of its host. So, for Kierkegaard, who saw life as a progress through stages of spiritual development, the road from the aesthetic to the ethical to the religious is one where irony first creates distance but must then be abandoned in order to traverse that distance to the next stage. (I think Cage, with help from the East, moves outside Kierkegaard's model by accommodating all three "stages" simultaneously.[30]) Irony places us crucially on the threshold of movement beyond the position it critiques but is not itself

an alternative. Its energy, ironically, derives from reference to a state of affairs it simultaneously honors and disavows.

The musical composition that always remained Cage's favorite (despite the fact that he was against having favorites) was *4′33″*. It can be seen (but not heard) as ironic comment on the empty gesture of composing a traditional three-movement piano sonata mid twentieth century, but it is most concretely and interestingly an entirely new form: ambient noise in three movements.[31] Both *4′33″* and Cage's poem on silence, "(untitled)" in *X*,[32] were composed after Cage had visited the anechoic chamber at Harvard expecting to experience absolute silence, the complete absence of sound. What happened, to his surprise and subsequently to ours, was that instead of hearing nothing, he heard sounds that the noise of everyday life normally makes inaudible—the whoosh and whine, respectively, of the circulatory and nervous systems. In "(untitled)" Cage wrote along the mesostic string, S – I – L – E – N – C – E, "if you exiSted / we mIght go on as before / but since you don't we'Ll / makE / our miNds / anarChic / convertEd to the chaos / that you are /."[33]

This conversion is a figure/ground swerve that opens up an entirely new perceptual and conceptual field: where what was previously ground (ambient *noise*) becomes figure (*music* reconfigured); where what previously lay dormant outside the scope of our attention becomes possibility. In this sense silence is always awaiting a crisis of attention—a formal turning away from the present state of our preoccupations toward possibilities in perceptual/conceptual wilderness, toward territory not yet recognized, utilized, tamed, exploited, explored. This turning toward silence, effected by means of chance operations within frameworks that heighten unfamiliar focal vectors, became Cage's working principle thereafter. It suggests that we can explore radically new approaches to aesthetic and social processes as we enter the silence of our future in a new millennium. Perhaps some of the music of the twenty-first century can already be heard in the noise of our times.

JOHN CAGE: CLINAMEN

In his multiplicity of sources re: and resources, in his working engagements with silence and chance, John Cage has been for twentieth-century Western art a kind of personification of Epicurus's *clinamen*—the improbable swerve that opens up new prospects, saving some portion of the world from the inexorable logic of its own precedents.

In Nanjing dialect, the sounds "i luv yoo" mean would you care for some spiced oil? What the West does, encountering our art, the artist Ni Haifend said, is to think we're saying we love you, when we're only having a private conversation about cooking.
—Andrew Solomon[34]

Eastern thought served as a *clinamen* or swerve for Cage, just as his work has served as a *clinamen* for Western art. He was not an orientalist, but one who welcomed reorienting, defamiliarizing experiences. Knowing that he would never fully enter it, or leave Western culture behind, Cage used Eastern philosophy to transfigure his mind, emotions, spirit, practice . . . in conversation with ideas and principles he valued in his Western sources. Cage was an American who felt very close to the European and Russian avant-gardes but was most of all an aspiring Global Villager, the *compleat outsider* in a historical moment (or two) when our best hope may come from dedicating our efforts to a world where obstructive borders and egos disappear to such an extent that national, ethnic, racial "us-them" insides and outsides become functionally indistinguishable. Cage neither appropriated nor imitated Eastern thought; it radically changed his manner of operation. It functioned for him as *clinamen*, a refreshingly alien element that skews business as usual, specifically, the business of mainstream culture—a stream heavily polluted with authoritarianism, consumerism, xenophobia, meanness, and fatalistic conventionality—the one stream you *can* step in twice.

Necessity is an evil, but there is no necessity to live under the control of necessity.
—Epicurus (341–270 B.C.)

It strikes me that Cage's resemblance to Epicurus is no accident; that is, Cage's resemblance to Epicurus is a most telling accident. These two men can be seen as bracketing the history of the Western humanist investigation of chance. Each happened to develop a therapeutic philosophical (ontologically based ethical and aesthetic) *practice* based on our material being in the random circumstances of everyday life, rather than on a transcendent rationalism that invites one to ignore, even deny, such messy details. Their checkered reputations, like the reputation of chance itself (not to say "serious pleasure" and the quotidian) over the last two (Western) millennia, seem to me to have to do with our chronic aversion to both paradox and complexity.

Epicurus, the Greek philosopher who mistrusted traditional religion and was dismissed by some as a profligate, revered by others as a religious figure, was perhaps the first Western thinker to make chance responsible for every change, every new development, every new possibility in the universe.[35] It was chance that drove the *clinamen*, or "swerve," causing collisions and novel forms within otherwise unvarying patterns of atoms. And it was the presence of chance as a fundamental metaphysical principle, replacing the power of destiny, fate, and the motley assembly of puppeteer gods, that put humanity in a position of radical freedom. The invention of a life in accordance with nature, but departing from conventional habits, became not only possible but ethically and emotionally desirable, since the cultural values of the time had led to moral disaster and widespread misery. Epicurus was, like John Cage, a utopian ethicist, ascetic, *and* sensualist who strenuously rejected the deterministic fatalism of his era. Cage,

who was introduced to Indian philosophy by the Indian singer and tabla player Gita Sarabhai, credits her with teaching him that "The purpose of music is to sober and quiet the mind, thus making it susceptible to divine influences."[36] Epicurus, too, held that quieting the mind was the chief good in life, and, like Cage felt this goal should be pursued with an acutely calibrated social conscience. Epicurus wrote:

Vain is the word of a philosopher by which no human suffering is healed.

and

It is not possible to live pleasantly without living prudently and honourably and justly, nor again to live a life of prudence, honour, and justice without living pleasantly.

It is almost uncanny how the Epicurean statement "Time is not recognizable by a concept, as are concrete things and qualities, but is a special kind of accident" could serve as a description of Cage's sense of the temporal in music.[37] And there is a kind of structural parallel in Cage's introduction of chance into the regularity of the "music of the spheres" and Epicurus's introduction of chance into a determinist metaphysics. Both men valued the ascetic life of pleasure (what is in our culture seen as a contradiction)—a good life based not on greed and gross consumption but on attentive calm.

Cage, in *medias* mess of the twentieth century, could draw sustenance and swerves from Chinese Taoist and Confucian, Indian, Japanese and Tibetan Buddhist traditions, which more than Dada were responsible for his selecting chance as a serious instrument of discovery.[38] Epicurus, in his own desperate times, despite the fact that his aphoristic "Doctrines" often read more like the sutras of Eastern spiritual traditions than Western philosophical texts, found himself in polemical either/or positions vis-à-vis Platonic and Aristotelian rationalisms. What comes of these divergences is instructive. Epicurus and Cage are in a sense different sides of a cultural/conceptual/temperamental coin. What makes Cage the expansive yin who can enjoy life in the midst of an imperfect world to Epicurus's anxious yang retreating into a hermetic enclave, what gets Cage out of the trap of Western dichotomies of good/evil, sensuality/reason, sense/nonsense, is his humorous acceptance (in the Eastern mode) of the generative grace of accident. Epicurus feared the very chance forces he had the moral and intellectual courage to introduce into his metaphysics.

There is much that separates the Cagean from the Epicurean project, but if it is a common (culturally constructed) fate (even trial) of all who could from some perspective be called spiritual or religious or revolutionary figures to be both controversial and radically misunderstood, the misconceptions adhering to "Cagean" and "Epicurean" are eerily similar indicators. Both men were thinkers whose ideas, enacted as disciplines in their own lives, functioned as a *clinamen* in the more prevalent views of the times. As Epicurus pointed out, the *clina-*

men causes a collision. In the aftermath of their respective cultural collisions, both Epicurus and Cage were widely thought to have been promoters of frivolous excess of one sort or another. Epicureanism came to mean pretentious and immoderate occupation with one's appetites—distinctly counter to its originator's ascetic and disciplined model; Cagean has come in many circles to mean an anything-goes assault on all structure—distinctly counter to Cage's clarity of aesthetic discipline. It is a curious, and I think significant, puzzle—a sort of Western cultural Koan—that two thinkers devoted to a discipline of ethical integrity in contrast to the hypocrisy of their times were culturally misconstrued in virtually the same way.

JOHN CAGE: HUMORIST

Q: How could so much humor be so serious?
A: How could so much seriousness be so humorous?

Living with close-to-inexhaustible conviviality and productivity in the midst of the circus of urban culture, relishing its improbable juxtapositions, its microcosmic relation to the chaos of the world at large, required a generosity of temperament that could only survive as the manifestation of a deeply embedded, one might almost say eminently serious, sense of humor. It will be immediately apparent from the transcripts of our conversations that throughout the variety of concerns, as well as the ups and downs of circumstance—whether aesthetic, sociopolitical, or spiritual—humor is the pervasive element. One editor, early on, found this a bit alarming. He wondered whether I should take some of the "*(laughter)*" out of the transcripts so that Cage's image as a serious figure in the arts could be bolstered. I have chosen to keep the laughter, along with a good deal of what may seem to digress from serious aesthetic issues, because this fluidity and generosity of attention, alongside absolute professionalism and attention to detail, was the heart of Cage's way of being and making things in the world. Divisions between work and pleasure, seriousness and fun, were unthinkable. He delighted in the intermingling of what tend to be viewed as mutually exclusive in a logically timid culture.

The *(laughter)* in what follows has very little, if anything, to do with clowning or joking—self-contained routines removed from the flow of life's discourse. People who, knowing of his legendary sense of humor, told jokes to John Cage were baffled and even embarrassed when he responded with a long soulful look rather than laughter. My understanding of Cage's humor—his laughter, his mirthfulness—as I experienced it and as I think it was central to his work, is clearly related to the surprising conceptual/perceptual shifts and accidental swerves of the Zen Buddhist "sudden" school of thought.[39] But it is also very

close to the etymology of the word "humor" in English[40]—a history which connects it (via Latin and Old Norse) with moisture (humidity), fluids, fluidity. In medieval and Renaissance usage this became a model of a kind of temperamental fluid dynamics. I'm referring, of course, to the idea, current in both the Middle Ages and the Renaissance, that shifting "humors" were responsible for both characterological and perceptual shifts. Once fluidity has entered into the picture we are not far from figure/ground shifts of the sort we experience with ambiguous figures, or paradoxical swerves like hearing silence as sound. Nor are we far from the conceptual fluidity of Dada (which reappeared in the minimalism of the seventies under the rubric Conceptual Art) or the humor characteristic of Zen Buddhism—the sudden conceptual shift that collapses divisive categories and reveals the strange and delightful interconnectedness of things. A constant, generous awareness of this is what might be called mirth—a light frame of mind that refuses containment by categorical divisions such as the joke as set piece on the one hand, and the logically encased argument on the other. (We all know by now that in Zen there is only one hand.) Or the comic and the tragic. It is a lightness of spiritual and conceptual valence.

Cage called me on the phone one day, after we had been talking about the role of humor in his work, to say he had remembered a book he thought might bear on my questions. I had remarked, during one of our conversations, that I thought all his work, including his music, was humorous; did he? He had reservations about this, particularly because of his sensitivity to what was at one time a prevalent misunderstanding of his music as being a joke. Cage hadn't at all liked being thought of as some sort of Dadaist clown. The book, he said, was a collection of Japanese poems in a humorous form of haiku called *senryu*, but "You may not like it." He wanted to warn me before sending it that it had some offensive views of women: "But there is much that's marvelous in it. . . . Maybe you can just skip around." A few days later *Japanese Life and Character in Senryu*, edited by R. H. Blyth, arrived in the mail. I opened it and found:

> I would have them laugh
> At the strangeness
> Of being alive.
> (Jiichirô, p. 513)[41]

and then

> Quite recovered,
> But his nose
> Has fallen off.
> (Unattributed, p. 311)

Blyth's introduction was full of descriptive commentary very close to Cage's spirit. For instance, this seems to relate quite directly to Cage's often stated "need for poetry":

The fundamental thing in the Japanese character is a peculiar combination of poetry and humour, using both words in a wide and profound yet specific sense. "Poetry" means the ability to see, to know by intuition what is interesting, what is really valuable in things and persons. More exactly it is the creating of interest, of value. "Humour" means joyful, unsentimental pathos that arises from the paradox inherent in the nature of things. Poetry and humour are thus very close; we may say that they are two different aspects of the same thing. Poetry is *satori*; it is seeing all things as good. Humour is laughing at all things; in Buddhist parlance, seeing that "all things are empty in their self-nature" . . . and rejoicing in this truth. (P. 4)

Blyth goes on to describe the role of humor in complicating the idea of beauty in Buddhist-influenced Japanese thinking:

The love of beauty we see everywhere in Japanese life and art, and yet strictly speaking it is a subordinate thing. Beauty is a part of something much larger that we may call significance. Significance includes ugliness, or transcends both beauty and ugliness. . . . There is no true or false, no good or bad, no ugliness or beauty, no pleasure or pain. . . . (Pp. 5–6)

and then Blyth quotes the seventeenth-century poet Bashô:

> The old pond;
> A frog jumps in,
> The sound of the water.

There is just poetry, or rather, there is just the sound of water. . . . We see how essential it is that humour should perform its double task, first destructive, of getting rid of all traces of sentimentality, hypocrisy, and self-deception; and second, of making us rejoice at things. (P. 6)

The same spirit that produced senryu modified the Indian-Chinese Buddhism that came to Japan, and made it witty without cynicism, humorous without blasphemy or impiety. . . . The humour that is inseparably associated with satori (enlightenment), and with Zen writings and pictures, was . . . the faculty to see the vast, the cosmic implications of a slip of the tongue, a suppressed fart, a false smile, a balding head, and yet never to leave these concrete particular things, — in other words the power to be both wise and poetical, practical and transcendental. The philosophy of Zen is one of contradiction and paradox, and this suits well with the comic spirit, but there is also in senryu a certain mellowness, an all-inclusiveness, an unwillingness to reject, a non-choosing, a balance of strength and delicacy of feeling, a going to extremes but preserving moderation and suavity. . . . (Pp. 8–9)

Cage's response to the chaos of our world was, significantly, to welcome both its order and its disorder to the greatest extent possible in the life of his art, the art of his life. ("Here we are. Let us say Yes to our presence together in Chaos." [42]) This project required an enormously accommodating humor, a humor that converged in him from multiple sources—from his early, Californian "sunny disposition" to Dada and Zen. It was Cage's humor that made his extraordinarily generous invitation to possibility via chance operations possible in the first place.

And it is in turn the idea of the possible which links the exigent, pragmatic-realist circumstances of his art to the utopian imagination. The central driving question for Cage was, in infinitely simple complexity, What is possible? What is possible given the complexity of the circumstances in which we live, given the material character of the medium in which we happen to be working, given the hellish interpenetrations of history, given the hope that material process and experience will come together in a manner useful to society?

In advance of a broken spirit is the sense that there can be no new thing or act or thought under the sun. The humors of possibility shift when we, with Cage, attend to, enter into, silence (all that our present disciplines of attention do not admit). Inviting silence, by chance, to have its say in his work just as it always has in the rest of the world, Cage threw open the doors of the concert hall, the museum, the library to previously estranged processes of the continually surprising, complex real. In this he curiously and delightfully conflated certain old-line Western dichotomies. He was apollonian *and* dionysian, purposeful *and* purposeless, serious *and* playful, calculatedly spontaneous. Cage was apollonian in needing to have a reasoned structure for every new composition, liking to work from starting points with grids and symmetry in order to give chance a level ground on which to play with the elements of the art. He was dionysian not only in the hearty sensual delight he took in material presence (sounds, words, paper, color . . . people, food, conversation, nature . . .) but in his enduring enthusiasm for the degree to which chance took things out of his control. What this really means is that his aesthetic framework was both intricate and commodious enough to allow an exploration of the range between/around/above/below/before/after the polarities that have defined the dialectical agon of both romanticism and modernism in Western art. In this sense Cage's conversations with history, silence, chance, and us were grand postromodern polylogues.

The contrast between the Western tragic sense of life and the Eastern comic sense interested Cage. He thought that when you believe the gods are separate from everyday life, you see separation everywhere and experience it as loss. But if you think of the sacred and the profane as right next to one another, you can't help but delight in the fullness of things. The immense, commodious humor in John Cage's laughter was, along with the prodigious accomplishment of his work, the most astonishing thing about his mode of being in the world. It caught him, and those with him, like a fresh wind, a sudden aperture opening up in the matrix of the moment. His laughter, his humor, became more and more spiritual in its sources over the years, but with no decrease in gusto. Cage's spirituality was not at all "transcendent" in the sense of removal from daily life but in fact a constant return to pragmatic concerns with a resonant sense of the interconnectedness of things—that we are all, persons and environment, "in it" together. The "it" that we are in is the chaos of this teeming, cacophonic, carnivalesque

globe. And though we must all be respected as individual agents, our interconnectedness makes each of us responsible to the overall social and environmental framework we share. The positive (fresh) vision of beauty—the source of humor and pleasure—is anarchic harmony, a multiplicity of voices along the multi-directional staves of paradox. Not Paradise Lost (we never had it) but Paradox Lost (or do I mean found?)—the real tragedy of Western Civ is the separation from complexity.

JOHN CAGE: PARADOX REGAINED?

It is perfectly accurate and even interesting to characterize John Cage as an American Zen master (and all his work as a complex Koan) as long as it is entirely clear that he was not a formally trained Zen Buddhist, that he was as global in spirit as he was American, and that he thought of himself as master of nothing.

Cage tried to operate outside the kinds of polarities the West has produced in self-conscious ricochets between ideals of critique and transcendence. He wanted to avoid, in fact, all polarities, dichotomies, dualities, either/ors—all choices of two or less. His range was instead structured much more like the one we are accustomed to in everyday life, where countless, untold, untellable intersections and juxtapositions of events—some by design, most by chance—leave us stunned, amazed, dazed, astonished, curious, desperate, exhilarated, bewildered . . . crying and laughing, determined and helpless . . . amused/frightened/enraged/inspired . . . and, not in addition but in multiplication, any combination of the above. All this creates anything but a linear progression. It is world as vast, interconnected, infinite visual and sonic topological network, where paradigms of intricate multi-dimensional, interdisciplinary and intercultural complexities replace the vertical soundings of shallowness and depth that have characterized our Eurocentric critiques of judgment—"depth" increasing proportionally to distance from dailiness. Cage's aesthetic paradigm brings us to fractal models which can represent infinite surface in finite space, replacing clearly defined inside/outside, us/them idealizations of Euclidean geometries with the detailed interpermeable dynamics of coastlines and crystals and weather.[43] What I want to say is that new socioaesthetic paradigms must emerge if we are to live well in our increasingly complex intercultural world, and that Cage's work enacts and suggests the invention of new models.[44]

JOHN CAGE: EXSTATIC

All that is not information, not redundancy, not form and not restraints—is noise, the only possible source of new patterns. —GREGORY BATESON[45]

A sound accomplishes nothing; without it life would not last out the instant.

—JOHN CAGE[46]

> *The dry winter wind*
> *Brings along with it*
> *The sound of somewhere.*
> (Shinsei, Blyth, p. 530)

At the Mayflower Hotel in 1968, in the course of the lost interview, Buckminster Fuller said, "The simplest definition of a structure is just this: it is an inside and an outside."

It is only a radical and powerful art that can take us to the outside of our structures.

PARADOX NOW

Since I can't be just a listener to silence I'm a composer.
How can I write sound that is silent?
I'm in a position when I write music of not knowing what I'm doing. I know how to do that.
—JOHN CAGE, remarks at Stanford University, 1992[47]

John Cage was one of the best (un)known artists of our time. The caricatures of fame function as a substitute for knowledge. Very little in twentieth-century Western culture prepares us for Cage's work. This is perhaps not a question of receptivity or the lack thereof, but of readiness. Readiness as a threshold marker has a long history in disciplines of attention and spiritual training in the East. It has to do with the way in which the person approaching the spiritual or cultural challenge has been prepared accidentally and intentionally—through experience, study, and even training—to take not the next step, but the next leap.

I am interested in forms that we can't discuss, but only experience.
—JOHN CAGE, Stanford, 1992

JOHN CAGE: SILENCE

> *Flowers? Very good*
> *Play? All right*
> *I am ready, he will say.*
> (Unattributed, Blyth, p. vi)

R. H. Blyth gives this as an example of an "incomprehensible" translation in his book of senryu. For me, it echoes Cage's reply to an impassioned challenge by

Norman O. Brown during a panel at Stanford University in 1992. Brown had protested that with all the talk that was going on, the issue most present and least discussed was death: "I do not believe that the past and the present are all here; and that is related to my perception of death. . . . Death is everywhere present in this room," he said, turning to look directly at Cage. Cage smiled sweetly, saying, "Nobby, I'm ready." [48]

The last conversation in this book took place on July 30, 1992, twelve days before the instantaneous and massive stroke from which Cage never awoke. He died the next day on August 12. In Western culture, 12 × 24 hours of the earth circling the sun equals time for a dozen classical tragedies to take place. Cage's death did not require even one. It was certainly not tragic. It did not occur in classical time, or even contemporary American time as most of us experience it. It occurred in Cage's time—along the horizon of his Amerizen consciousness. For Cage there was a very real sense in which the past and present and future *are* all here, now. For Cage, as Zen-minded composer of music, visual art, and words, imitating nature in her manner of operation, fascinated by the proliferation of detail as art moves into everyday life, the aesthetics of space-time could become an intricately expanding fractal coastline for ears, eyes, and humors to explore. What one discovers is infinite time-space in finite space-time (Or is it the other way around?), breathing room . . . free of the impacted terminal moment that characterizes possession and control, and that we fear death must be.

"What nowadays, America mid-twentieth century, is Zen?" Cage asked in 1961 in the foreword to *Silence*. For Cage this was a life and death question that remained for him a long-life-long question-as-practice with a continual updating of the time frame.

Each time I went over the transcriptions of our conversations, listening to everything all over again, I dreaded coming to the last of the tapes recorded on July 30. It takes up only 10 minutes of a 30-minute side. Cage is the last to speak. His words are followed by the sound of the recorder being switched off and then by a blankness that is a stark contrast to the noisy silence of pauses filled by the sounds of the loft. I found myself listening to the blank tape each time, not wanting to turn it off. Listening for more, thinking maybe this had really not been the end. Perhaps there was something more that I had forgotten. Fast forwarding. Wanting more. Finally finding it. At some point that blank silence too became fully audible as a delicate, microtonal whir. A whir of music both *in* and *of* silence: John Cage's gift, again.

Everyone who knew John Cage well knew that he didn't want to die but that he died just as he wanted to. He always said he never liked to know when a composition was going to end.

They die
 As if they had won
A prize in a lottery.
 (Kazuji, Blyth, p. 509)

There's an American expression of this too. The summer of Cage's death, Walt Whitman was being celebrated all around New York. It was the centenary of Whitman's death in 1892 and Cage was delighted by the attention to his work, the way it was so much "in the air." John Cage loved Walt Whitman, the Walt Whitman who wrote:

All goes onward and outward, nothing collapses,
And to die is different from what any one supposed, and luckier.[49]

NOTES

1. *A Year from Monday: New Lectures and Writings by John Cage* (Middletown, Conn.: Wesleyan University Press, 1967), p. 21ff.

2. See Theodor W. Adorno, "The Essay as Form," in *Notes to Literature, Volume One*, ed. Rolf Tiedemann, trans. Shierry Weber Nicholsen (New York: Columbia University Press, 1991).

3. In acknowledgment of the suspect status of "we": my use is not meant to be universal, or even global. It refers to "some of us" — an "us" that changes from one context to another.

4. Excluding only a couple of side conversations between Bach and myself when Cage was preparing the food.

5. The series, running from October to December, included seven selections: Alba-Reyes Spanish Dance Company, Paul Taylor Dance Company, Robert Joffrey Ballet Company, the New York City Ballet's Edward Villella and Patricia McBride, Nala Najan, Classical Dances of India, Merce Cunninghan Dance Company with composers John Cage and David Tudor, and Alvin Ailey Dance Theater.

6. *A Year from Monday*, p. 133.

7. All Jung quotes are from *The I Ching or Book of Changes*, Richard Wilhelm translation rendered into English by Cary F. Baynes, Foreword by C. G. Jung, Preface to Third Edition by Hellmut Wilhelm, Bollingen Series XIX (Princeton: Princeton University Press, 1968).

8. I take Cage to be enacting the equivalent of Wittgenstein's move from "picture" to "use" theories of meaning when he decided to "imitate Nature in her manner of operation." See, for instance, *A Year from Monday*, p. 31.

9. "When M. C. Richards asked me why I didn't one day give a conventional informative lecture, adding that that would be the most shocking thing I could do, I said, 'I don't give these lectures to surprise people, but out of a need for poetry' " (*Silence* [Middletown, Conn.: Wesleyan University Press, 1961], p. x).

10. Cambridge, Mass.: M.I.T. Press, and New York: John Wiley and Sons, 1957. Siu has since published many more volumes, including one on the *I Ching*, and has founded a new discipline which he calls "panetics" — the integrated study of the infliction and reduction of suffering.

11. *Silence*, p. 68.

12. *A Year from Monday*, p. 162.

13. This was actually a chapter from his book *The Tao of Science*, reprinted in *The World of Zen: An East-West Anthology*, ed. Nancy Wilson Ross (New York: Vintage, 1960).

14. If I remember correctly, one watch was set to Tokyo time, one to London, and the third to Eastern Standard.

15. Published in *Aerial 5* (1989).

16. Langer's aesthetic theories, widely influential mid-century, hold that the force of all art, including music, comes from symbolism and the expression of emotion.

17. Actually, contrary to legend, Cage did occasionally turn the phone off in order not to be interrupted, but he preferred not to have to do this.

18. *Empty Words* (Middletown, Conn.: Wesleyan University Press, 1979), p. 5. Emphasis mine.

19. Cage took great pleasure in this quote from *Values in a Universe of Chance* (New York: Doubleday Anchor, 1958), p. 107.

20. There is a clear parallel to Wittgenstein's interrogative modeling of "language games," as well as to Fuller's "World Game"—a computerized model he first called "Minni-Earth" to be used for regional planning—where the entire planet = the region. Interestingly, paradoxically, "utopia," a word Thomas More invented circa 1516 to mean literally "no-place," has become an adjectival category denoting very much "placed," socially visionary, intentional communities that have been been a continuous part of history. Cage's feeling about the necessity for utopian thinking is reflected in the title of one of Fuller's books, *Utopia or Oblivion*.

21. *I–VI* (Cambridge, Mass.: Harvard University Press, 1990), pp. 177–78. Punctuation has been added to what was continuous, unpunctuated text in the original.

22. For instance, in the foreword to *A Year from Monday*.

23. Cage's marriage to Xenia Kashevaroff Cage ended in the mid-'40s as his relationship with Merce Cunningham was developing into what would turn out to be a fifty-year personal and professional union. Cage was deeply troubled about the dissolution of his commitment to Xenia and the highly charged implications of moving between "socially regulated" sexual categories. Ultimately, he told me, he felt that sexuality, like all of life, was manifestly more complicated than a handful of (invidiously competitive) categories suggests. He therefore refused to subscribe to any of them. He simply did not believe that there was truth in labeling. This, in my opinion, is the reason for his silence on these matters, as much as his firm belief that personal privacy should be respected. During this time Cage was also deeply affected by the horrors of World War II. His attempts to express his feelings about all these things in his music (e.g., *In the Name of the Holocaust*, 1942; *The Perilous Night*, 1945) were being met with misunderstanding and ridicule.

24. From "Forerunners of Modern Music," *Silence*, p. 64.

25. This is my observation; I'm not at all sure Cage would have described it this way.

26. More also used the term "Eutopia" (good place) in a nominal dialectic with "no place."

27. D. W. Winnicott is helpful here with his distinction between imagination—the source of play: a testing of ideas in material interactions—and fantasy, which is mind withdrawn from world, unsullied and unassisted by material contingencies. See, for example, Winnicott's *Playing and Reality* (New York: Methuen, 1984). Utopianism which is entirely textual can be seen as public thought experiment—another form of "play" with real consequences.

28. In some ways reminiscent of anarcho-syndicalist ideas?

29. *I–VI*, p. 2.

30. Though I would substitute "spiritual" for "religious," despite some vapid new-age connotations, because Cage preferred it. Religion for him meant institutions bound up with "the police" (see the last conversation in this book). Cage's spirituality was as humorous and pragmatic as the Buddhist texts he studied for five decades. It was not an attempt to transcend everyday life, but to recognize the material and conceptual interconnectedness of all things, to act out of that recognition.

31. Similarly, Duchamp's work seen as attention to "ambient everyday objects," regardless of his intentions (no doubt more complex than irony alone), can move us beyond irony as well.

32. *X* (Middletown, Conn.: Wesleyan University Press, 1983), p. 117.

33. See Figure 14, page 193 of this volume. This poem is written in a form that actually requires multiple readings, of which what follows is only one. See my essay, "Poethics of a

Complex Realism," in *John Cage: Composed in America*, eds. Marjorie Perloff and Charles Junkerman (Chicago: University of Chicago Press, 1994).

34. From "The Chinese Avant-garde," *New York Times Magazine*, 19 December 1993.

35. A status recently ascribed to Cage. George J. Leonard, in *Into the Light of Things: The Art of the Commonplace from Wordsworth to John Cage* (Chicago: University of Chicago Press, 1994), argues that Cage can best be understood as a religious figure. There is a recent renewal of interest in Epicurus. Two new translations of Epicurean texts are available: Eugene O'Connor, ed. and trans., *The Essential Epicurus* (Buffalo, N.Y.: Prometheus Books, 1993), and Brad Inwood and L.P. Gerson, ed. and trans., with introduction by D.S. Hutchinson, *The Epicurus Reader* (Indianapolis: Hackett Publishing Company, 1994). There is also the old standard edition translated and edited by Cyril Bailey: *Epicurus: The Extant Remains* (Oxford: Oxford University Press, 1926). The stylistic variations among these translations are striking, and I have moved among them looking for the most pleasing translations for my purposes, but have used Bailey as my primary source. Epicurus has also reemerged as a figure of intense controversy in two books by broadly interdisciplinary classicists: Peter Green, *Alexander to Actium: The Historical Evolution of the Hellenistic Age* (Berkeley: University of California Press, 1993), and Martha C. Nussbaum, *The Therapy of Desire: Theory and Practice in Hellenistic Ethics* (Princeton: Princeton University Press, 1994).

36. John Cage, "An Autobiographical Statement," in the box catalog, *Rolywholyover A Circus* (New York: Rizzoli International Publications, 1993), unpaginated. Gita Sarabhai brought Cage *The Gospel of Sri Ramakrishna* during the time in the '40s when he was so disturbed that he vowed if he could not find a reason for composing better than personal communication he would give it up. This led to the writings of Ananda K. Coomaraswamy (e.g., *The Transformation of Nature in Art*), where Cage found what would be his lifelong working principle: "the responsibility of the artist is to imitate nature in her manner of operation." Ibid. James Pritchett has an interesting discussion of the effects of these Eastern principles on Cage's music in his *The Music of John Cage* (Cambridge: Cambridge University Press, 1993).

37. Epicurus, like Plato, mistrusted music, but then so did Cage—the power assumed and asserted, by certain kinds of music, to mold the emotions and shape the soul.

38. In describing his new principles of composition in "The History of Experimental Music in the United States," Cage says, "What makes this action unlike Dada is the space in it. For it is the space and emptiness that is finally urgently necessary at this point in history." *Silence*, p.70.

39. There are two Zen traditions: Rinzai, which cultivates the capacity for sudden enlightenment; Soto, which subscribes to a practice of gradual awakening.

40. An etymology shared with French, Italian, Spanish, and German.

41. From *Japanese Life and Character in Senryu*, ed. R. H. Blyth (Tokyo: Hokuseido Press, 1960), p. 513. Senryu is the humorous Japanese literary form that comes from perceiving what in the West is separated into the comic and the tragic as inextricably intertwined. Blyth calls this "*Senryu no Michi*, the Way of Senryu."

42. Headnote to "Where are we going? And what are we doing?," *Silence*, p. 195.

43. See Benoit B. Mandelbrot's *The Fractal Geometry of Nature* (New York: W.H. Freeman, 1983). Mandelbrot has developed the complex realist geometry of a broadly interdisciplinary thinker. He has taught in faculties of analytic and applied mathematics, economics, electrical engineering, and physiology at institutions such as University of Geneva, Ecole Polytechnique, Harvard, Yale, M.I.T., and the Albert Einstein College of Medicine.

44. For a more detailed discussion of this proposal, see my "Poethics of a Complex Realism," in *John Cage: Composed in America*.

45. *Steps to an Ecology of Mind* (New York: Ballantine Books, 1990), p. 410.

46. "Experimental Music: Doctrine," *Silence*, p. 14.

47. At a weeklong festival and symposium on Cage's work called *John Cage at Stanford: Here Comes Everybody*, in January 1992, seven months before his death.

48. See Visual Art conversation, note 54.

49. "Song of Myself, 6," *Leaves of Grass* (Mount Vernon, N.Y.: Peter Pauper Press), p. 33.

I

WORDS

My mesostic texts do not make ordinary sense. They make nonsense, which is taught as a serious subject in one of the Tokyo universities. If nonsense is found intolerable, think of my work as music, which is, Arnold Schoenberg used to say, a question of repetition and variation, variation itself being a form of repetition in which some things are changed and others not.
 —J O H N C A G E, *from the preface to "Anarchy"*

Art Is Either a Complaint or Do Something Else
John Cage

A NOTE ON CAGE'S TEXT

A substantial part of the first conversation in *M U S I C A G E* is devoted to John Cage's methods in composing this lecture-poem, but I'd like to make a couple of suggestions for the reader unfamiliar with his mesostic texts. (Texts structured along a string of capital letters running down their middle.) It may be helpful to think of this piece as a kind of linguistic fugue, a canonic and recombinatory interplay of three voices—that of Jasper Johns (from whose statements this text is composed), John Cage, and, of course, chance.

The pleasure of the eye in reading Cage's mesostics is both vertical and horizontal. The pleasure of the ear is one of resonances perhaps most clearly revealed in reading aloud. Cage had many ways of composing mesostic poetry. Here he used chance operations to locate "meso-strings" from Jasper Johns' statements about art so that Johns' silent voice (the strings cannot be heard when the poem is read aloud and are on the edge of invisibility on the page) is the force that fragments and reconfigures his own thoughts. For instance, Cage's first variation on Johns' statements is drawn together by A DEAD MAN TAKE A SKULL COVER IT WITH PAINT RUB IT AGAINST CANVAS SKULL AGAINST CANVAS. This string of letters becomes a vertical current gathering words into horizontal axes (what Cage called "wing words") by means of the mesostic rules on pp. 57 and 61. Though the range of possible wing words is a function of chance, Cage chose their precise number, taking into account both breath and breadth—that is, both musical elements and possibilities for meaning. The result is a poem in which the interactions between chance and selection that are "Nature's manner of operation" are formally foregrounded. Reading this text is an exercise in letting go of preconceptions about how words should relate to one another (syntax and grammar), clearing the way to notice novel semantic sense. The poem becomes more and more densely textured, more and more musical, as each section arrives in the wake and aftermath and echo of all that went before, as vertical and horizontal axes are in continual visual play, as the capitalized mesostic letters generate words within words.

Cage devised a notation for facilitating the spoken performance of his mesostic poetry: "A space followed by an apostrophe indicates a new breath. Syllables that would not normally be accented but should be are printed in bold type." (Introduction to *I–VI* [Cambridge Mass: Harvard University Press, 1990], p. 5) But he did not mean for this to constrain the readings of others. One can feel entirely free to play with the phrasing. The variable bonding of letters, words, and phrases adds more and more dimensions to each variation on the source text. There is a limitless proliferation of meanings. Think of *Art Is Either a Complaint or Do Something Else* as a score. Think of the reading you are about to do as an exploratory, performative act that is but one of many possible realizations. Cage's mesostics are preceded by the Johns statements on which they are based.—JR

3

These texts come from statements by Jasper Johns, taken from Mark Rosenthal's Jasper Johns Work Since 1974 *(Philadelphia Museum of Art, 1988), which follow. They are not about Johns' statements and because of the way they are written, other statements are produced.*
—JOHN CAGE, New York City, 1988

Old art offers just as good a criticism of new art as new art offers of old.

I don't want my work to be an exposure of my feelings.

Art is either a complaint or appeasement.

The condition of a presence.
The condition of being there.
its own work
its own
its
it
its shape, color, weight, etc.
it is not another (?)
and shape is not a color (?)
Aspects and movable aspects.
To what degree movable?
Entities
splitting.

The idea of background
(and background music)
idea of neutrality
air and the idea of air
(In breathing—in and out)

Satie's "Furniture Music" now
serving as background for music
as well as background for conversation.
Puns on intentions.

Take an object
Do something to it
Do something else to it
 " " " " "

One thing made of another. One thing used as another.

An Arrogant Object. Something to be folded or bent or stretched. (SKIN?).

We say one thing is not another thing.
Or sometimes we say it is.
Or we say "they are the same."

Whether to see the 2 parts as one thing or as two things.

Think of the edge of the city and the traffic there. Some clear souvenir—A photograph (A newspaper clipping caught in the frame of the mirror).

My work became a constant negation of impulses.

At times I will attempt to do something which seems quite uncalled for in the painting, so that the work won't proceed so logically from where it is, but will go somewhere else.

My experience of life is that it's very fragmented. In one place, certain kinds of things occur, and in another place a different kind of thing occurs. I would like my work to have some vivid indication of those differences. I guess, in painting, it would amount to different kinds of space being represented in it.

My thinking is perhaps dependent on real things. . . . I'm not willing to accept the representation of a thing as being the real thing, and I am frequently unwilling to work with the representation of the thing as . . . standing for the real thing. I like what I see to be real, or to be my idea of what is real. And i think i have a kind of resentment against illusion when i can recognize it. Also, a large part of my work has been involved with the painting as object, as real thing in itself. And in the face of that 'tragedy,' so far, my general development . . . has moved in the direction of using real things as painting. That is to say i find it more interesting to use a real fork as painting than it is to use painting as a real fork.

My work feeds upon itself.

Most of my thoughts involve impurities . . .

A Dead Man.
Take a skull.
Cover it with paint. Rub it
against canvas. Skull against
canvas.

Shake (shift) parts of some of the letters in VOICE (2). A not complete unit or a new unit. The elements in the 3 parts should neither fit nor not fit together. One would like not to be led. Avoid the idea of a puzzle which could be solved. Remove the signs of thought. It is not thought which needs showing.

After the first *Voice*, I suppose there was something left over, some kind of anxiety, some question about the use of the word in the first painting. Perhaps its small-ness in relation to the size of the painting led me to use the word in another way, to make it big, to distort it, bend it about a bit, split it up.

In my early work, I tried to hide my personality, my psychological state, my emotions. This was partly due to my feelings about myself and partly due to my feelings about painting at the time. I sort of stuck to my guns for a while but eventually it seemed like a losing battle. Finally one must simply drop the reserve. I think some of the changes in my work relate to that.

Try to use together
the wall
the layers
the imprint.

The question of what is a part and what is a whole is a very interesting prob-lem, on the infantile level, yes, on the psychological level, but also in ordinary, objective space.

Entities/splitting.

An object that tells of the loss, destruction, disappearance of objects. Does not speak of itself. Tells of others. Will it include them? Deluge.

I think that one wants from a painting a sense of life. The final suggestion, the final statement, has to be not a deliberate statement but a helpless statement. It has to be what you can't avoid saying.

Yes, but it's skin.

I think it is a form of play or a form of exercise and it's in part mental and in part visual but that's one of the things we like about the visual arts the terms in which we're accustomed to thinking are adulterated or abused.

I

Art is either a complaint or
kinD of thing
uncallEd for in
A
just as gooD
is that it's very fragMented ' in
is **A** '
iNvolved
arT is either
the question of whAt is a
worK won't
bE '
else my experience of life is thAt
Splitting ' the idea of
the real thing i liKe what i see
and the idea of air in breathing in and oUt '
Like my work to have some vivid indication of
a Large
City and the traffic there
is that it's very fragmented in One place certain kinds of things occur ' and
canVas '
i supposE
pRoceed so
thInk i have
someThing to be folded or bent or stretched '
a criticism of neW art as new art offers of old '
when **I** ' can
To '
to wHat degree
uPon itself
so thAt the
musIc idea of
art as New
Thing ' as standing
shape ' is not a coloR ' aspects and movable aspects
amoUnt to different kinds of space '
the idea of Background and background
somethIng '
The condition of
Accept the

Art Is Either a Complaint or Do Something Else 7

not willinG to

thing i like whAt

Impulses at times i will attempt to do

as backgrouNd for

uSe '

a real fork as painTing than it is to use

musiC now

it About a bit

is Not a

coVer it with

bAckground **for** '

Skull '

thing or **aS** two things

uncalled for in the painting so that the worK won't proceed so logically from where it is '

anxiety ' some qUestion about the use of the word in the

representation of a thing as being the reaL thing and

thing i Like '

movAble entities '

movable entities splittinG ' the

objective spAce old art offers

cover It with

music ' idea of Neutrality ' air ' and the idea of air in

Space being

Times ' i will attempt to do something

movable ' aspeCts to

of ' thAt tragedy

left over some kiNd of anxiety ' some question about the use of

the psychological leVel ' but

Air in breathing in and out

led me to uSe ' the word

2

vIsual **but**
anD in '
thing Occurs
to differeNt kinds of space
in which we ' re
edge of **The** '
i Would like my work to
A
itself ' i thiNk
arTs
soMething
citY
of the things We like
tO have ' some vivid indication of
the tRaffic there ' some clear souvenir ' a photograph '
thinK of
iT's very
different kinds Of space
it's in part mental and in part visual ' But that's
thE mirror my experience of life is
form of plAy or
iN
foldEd or bent ' or stretched skin think of **the**
a form of exercise and it's in Part mental and
fOrm '
but that'S one of the things we like '
space being represented in it my work feeds Upon itself i think it is a
play oR
placE
tO be '
liFe is
accustoMed to thinking
it's verY
Form
souvEnir ' a photograph ' a
city and thE traffic there '
certain kinds of things occur and in another pLace '
I
city aNd the traffic there '
arroGant
differenceS

Art Is Either a Complaint or Do Something Else 9

of thIng
To
wHen '
I
persoNality
liKe
thIng in
perhaps dependenT on
recognIze it '
uSed
itself And in
negation oF impulses
vivid indicatiOn of those
it ' also a laRge part of
My
sOrt
play ' or a Form of exercise ' and it's in
Part
aLso
f Ace of
citY ' and
tO
exeRcise
the terms in which we're Accustomed to
the edge oF the
indicatiOn of those
theRe
in which we're accustoMed
develOpment has moved '
it seemed like a losing battle ' Finally
hidE my
painting than it is to usE ' painting
occŭRs
to different kinds of spaCe '
wIll it
waS
is ' a vEry
thAt
of thiNgs '
Do

my work to be an exposure of my feelIngs '

arTs '

things i ' m not willing to accept

tellS of others '

Is real '

has beeN '

accePt the

trAgedy '

pRoblem on

reserve i Think

is perhaps dependent on real things i'M not willing to

arts thE terms '

aNd

buT

hAve

entities/spLitting '

so fAr my

clippiNg caught in the frame of the mirror my work

partly Due to my

It more

doN't want '

my work feeds uPon itself

thing As being

my woRk

caughT in the frame of the mirror '

one must simply drop the reserVe '

In painting it would amount to

conStant negation of

painting ' as a real ' fork my work feeds ' Upon

And what '

stuck to my guns for a whiLe '

oBject

woUld

To '

To

wHen

A

iT '

we ' re

thingS '

the twO parts as

thiNg '

Art Is Either a Complaint or Do Something Else II

a vEry interesting
fOrk '
real thing in itselF and **in**
iT is
Has '
foldEd or
like ' whaT
is a wHole '
trIed to hide my
else to it ' oNe
arroGant object '
a very intereSting problem '
What is a
spacE being represented in it ' my thinking is
visuaL ' but that's one of the
one place certaIn '
i am frequently unwilling to worK
of thE thing '
it's in pArt mental and in part visual
a losing Battle '
my wOrk
feeds Upon
The
is To use '
my work Has
somEthing **else** to it '
my work to haVe some
than It
became ' a conStant negation of
myself and partly dUe to my feelings '
plAce ' a different kind of thing occurs ' i
incLude them ' deluge ' i think it is
A
woRk
one To my
exerciSe ' and
in iT my
recognize it also a large part of my work Has
statE '
wiTh paint ' rub it
whilE but
oR

the Mirror ’ my work
my gunS for
It ’
recogNize it ’
Work to
tHe frame
In itself and in
Clear souvenir ’
canvas ’ in my early work i tried to Hide my personality my psychological state my
recognize it also ’ a large part of my Work has
somE of the changes in my
it ’ s
oR
covEr it
And
City ’
objeCt ’
bUt
dependent on real thingS i’m
aT ’
mOved
My
thE
kinD of
Thing
Of
iT
Has
I
aNd
liKe
exercIse ’
a photograph ’ a Newspaper ’
deluGe ’
An
in one place ceRtain kinds of
changEs in my work
my psychologicAl state
something to it Do something else to it ’
it ’ Use a
reaL
Thing as

Art Is Either a Complaint or Do Something Else 13

it ' includE
it moRe
to sAy
iT
wholE '
my iDea
itself tells Of
faR my
work to hAve some vivid indication of
Became ' a
skUII ' cover it with paint ' rub it
Simply ' drop
infantilE level ' yes ' on the psychological level '
take an object ' Do something to it

4

in relatiOn
to my feeLings
conDition of being
sAtie's
shape ' coloR '
The elements in the three parts '
weight etc. ' it is nOt
liFe ' is that it's
the thing as standing For
air ' and thE
aiR
itS own its '
ordinary obJective space ' entities splitting ' an obiect '
a new Unit '
criticiSm '
iT **one**
At the
itS **own**
my feelinGs **art**
and mOvable
lOss '
stanDing for
whAt '
the Condition of being
of being theRe '
In
men**T**al
wIll
unCalled for
sImply
perhapS
in My
tO be an
aFter
a**N**d ' background music
a rEal fork ' my
one thing is not another thing or sometimes We
in ' breAthing in '
deliberAte '
we Say they

Art Is Either a Complaint or Do Something Else 15

iN '
wE say it is or
as ' Well
so logicAlly '
what degRee
one musT
fOr conversation ' puns on
the Final suggestion '
For a
rEal
as standing foR the real '
iS
Objects
Final
early wOrk
my feeLings ' art is either a complaint or
not a Deliberate statement' but a helpless statement' it has

not A

lifE

stAtement it has to be

a Deliberate

helpless stateMent it

hAs to be

fiNal

The

deliberAte statement

has to be what you can't avoid saying i thinK that

lifE the

sense of life the finAl

Statement

has to be what you can't avoid saying i thinK that one wants from a painting a sense of

a sense of life the final sUggestion

Life '

Life ' the final suggestion' the final statement

a helpless statement it has to be what you Can't

can't avOid

can't aVoid saying ' i think

thE final

fRom

I

final suggesTion

that one wAnts

the fInal

you can'T

statement Has

one wAnts

It has to be what you

seNse of life '

final suggesTion the final statement has to be

a delibeRate

bUt '

a deliBerate

can't ' avoId saying i

be whaT you

hAs to be

from A

a sense of lIfe the

has to be Not
haS
The
but ' A helpless
fiNal statement has to be
aVoid
stAtement '
Saying
i think that one wantS
avoid saying i thinK ' that one wants
yoU
painting a sense of Life
the finaL
to be whAt you
you cAn't
I '
Not
Saying
wanTs from
to be not A deliberate
suggestioN ' the final statement has to be not a
statement ' it has to be what you can't aVoid '
A
Sense of life

6

iT is ' not
sHowing '
somE kind of
showing after the first voiCe ' i
make it big tO distort
my experieNce '
the iDea of
when I can
The
agaInst canvas '
a different kind Of
kiNd
in relatiOn to the size '
due to my Feelings
A sense of
sPace being
woRk ' i
thEm
moSt of my thoughts
at timEs ' i will
amouNt to
weight etC. it
statE my
painTing so
wHat you
nEw
so logiCally
Of a '
of aNxiety '
as gooD a
and I am
To
sImply
nOt speak '
fiNally
tO accept the representation
as background For
where it is ' But
placE
Is

Art Is Either a Complaint or Do Something Else 19

oNe

to my Guns '

iT

Has

would likE not to be led

oR

accustomEd to

of what Is real and

objecTive

uSe

Of

With '

of life the fiNal

of What is '

its Own

my thinking is peRhaps

bacKground

art offers **of old** I '

wanT my

aS

One thing

Word

somethiNg to

In

has To be '

againSt

mIrror

Try

Idea

anoTher thing or

See

aS background

tHe

not Another and

the Painting so that

thE two parts as one thing or as two things

musiC

tO be

frequentLy unwilling '

nOt willing to accept the

backgRound '

i think that one Wants

as nEw '
Idea of
what ' deGree
in tHe
kinds of Things
it morE
as being The
baCkground for
dIsappearance
of being There '
wIll attempt to do
it Seemed like
feeds upoN
tO be
a painTing '
the ideA of air '
fit together oNe
what yOu '
else To it an arrogant object '
question of wHat is a part and what
it has to bE '
the impRint the question of
tAke '
my work has beeN
my iDea of what
we're accuStomed
tHe **two** '
puns on intentions tAke an object do something to it do something
real ' fork my work feeds uPon
furniturE '
caught In
an expoSure of
caN
we say **One**
To my feelings '
sAtie's furniture '
my experienCe '
Objective space '
some of the Letters '
negatiOn of impulses '
inteResting to use
feelings About

a dead man ' take a Skull ' cover it
as Painting '
thE final
Canvas ' skull
aT the time i
differenceS i guess ' in
deAd '
yes oN the
to ' Distort it
in ' My
On the
haVe some vivid
plAce ' a different kind of thing occurs i would
take an oBject ' do something
spLitting
in onE '
to be whAt you can't avoid '
it iS not thought which needs
Painting
showing aftEr the first
Clear souvenir
i Think that what
it iS
has to be noT a
wOuld
of those differences i guess in painting it Would amount to different kinds of space '
edge of tHe city '
A
someThing to
be solveD '
thE
thinGs
seRving
onE
objEct
in the fraMe '
the letters in vOice two ' a not complete unit or a new unit
in and out satie's furniture music now serVing
i think i hAve a kind of resentment against illusion
entities splitting the idea of Background and background music idea
about the visuaL arts '
objEct

lEd
oNe
objecT '
fInd
The
others ' wIll
bE
uSe
iS
Parts '
unit ' or a new unit ' the eLements '
and I am
in The
work won'T proceed
It ' also a large part of
aNd ' in part
it ' also a larGe part of **my**

A

is Not

And ' **is**

is Real and

stRetched '

want my wOrk to be an exposure of my

way to make it biG to distort it bend it '

Air '

thiNk '

objecT '

a different kind Of thing occurs i would like my work to **have**

it Bend it about a bit split it up

Just as

partly duE to my

baCkground for

whaT you can't avoid

about mySelf and partly

Of

the Mirror my work

must simply drop thE reserve i

shape is noT a color

wHere

to say I

caN't avoid '

larGe

The terms in which we're

battle finally One must simply drop the

Bit ' split it up in my

saying yEs but it's skin i think it

Feeds

the idea Of

some of the changes in my works reLate to that

psychological level but also in orDinary

sizE '

in another place a Different kind

abused ' Old '

in one place ceRtain kinds of things occur and in another

yes But

solvEd ' remove the

work ' its owN

a deliberaTe statement but a helpless statement it has
be fOlded
of a thing as being the Real thing and i am frequently unwilling to
Shape color
my feelings abouT my self and
now seRving as
to bE folded or
Things think '
Clear
tHinking '
painting than it is to usE painting
so far my general Development
iS not
liKe not
eIther ' a
sort of stuck to my guNs '

A

of usiNg

hAs ' moved

foR

Rub '

wOrk has been

backGround for

whAt is

usiNg

someThing

prOceed

to Be

baCkground for

is To

aS ' painting

fOr

which seeMs

thE real '

work won'T

Have a

musIc '

caNvas

backGround and '

Thing

fOr

ruB it

as wEll

and i am Frequently unwilling

tO be

deveLopment '

backgrounD for '

in itsElf

a kinD

sO

my ' geneRal

is ' But will

attEmpt to do

thiNg

· The

dO

on Real '
than it iS
Thing **and** i am '
paRt of
is to usE '
Times i
reCognize it also **a** '
painting tHan it is '
satiE's furniture music '
attempt to Do
the thing aS standing for the real
real forK
and I am
as ' backgrouNd for '

in which we're accusTomed to

and sHape '

seemed lIke

thaN it is

liKe what '

anOther one

upon itselF '

developmenT '

to wHat

takE

suggEstion **the** '

it incluDe

thinG

havE

cOmplete '

Feelings

To

sHould

spacE '

baCkground '

the Idea of background and

The things we like

would like mY work to

A

should Neither fit nor not fit

impulses at times i will attempt to Do '

painTing at

wHat

and partly duE

be **noT**

now **seRving** '

i Am

Furniture

play or a Form of

usIng

spaCe '

is To say i find it more interesting to

sHift parts of

air in brEathing in and out ' satie's

to that **tRy** to

is not anothEr
folded or bent or Stretched
Or a new unit
or to be My
air and thE idea of air in breathing in and out ' satie's
musiC now serving as background for music as
reaL
impuritiEs '
object As
voice ' i suppose theRe
to uSe
tells Of
it is bUt will go somewhere else ' my experience of
music now serVing as background for music ' as
wE say it is or we say they are the same whether
thiNg made of another one
and It's in
as backgRound for music '
they Are the same whether to see the two
differences i guess in Painting it would amount to different kinds
of anxiety some question about tHe
sOmewhere else '
Take an
Or
of space beinG
a kind of Resentment
of impulses At times
a very interesting Problem on
tHe
movAble aspects
caught iN
somE vivid indication of
times i Will attempt to do '
perhapS
a very interesting Problem on the
Air in breathing
Painting
say onE
painting as a Real
Cover '
fit nor not fit together one wouLd
of anxIety some

Art Is Either a Complaint or Do Something Else 29

develoPment
sPeak '
Its it its shape color weight etc. ' it is
fit Nor not fit
and backGround '
one thing used as another ' an arrogant objeCt '
the trAffic '
a real fork ' my work feeds Upon itself '
somethinG to be folded or bent or
solved ' remove tHe '
The
whIch '
aNd background music idea of
To '
psycHological
nEgation
think oF the edge of
degRee '
entities/splitting ' An object '
My
objEct '
nOt speak
to my Feelings
aspecTs
psycHological
smallnEss '
in My work relate to that try to use together the '
the thIng '
is Real and
somewheRe else my experience
Of
teRms

for a while but eventuallY it '
it also a largE part of my work
againSt
conversation ' puns on intentions ' take an oBject do something to it do something else
as painting ' than it is to Use
To accept the
I '
The
i ' m
about the uSe of the word in **the** '
i find it more intereSting to use a real
mirror ' my worK became a constant
nor not ' fIt together
complete uNit or **a**

what is a whole is a very interesting probleM on the infantile level '
level but also in ordinarY
thE ' question of what is
entities/sPlitting
on thE psychological level but also
the question of what is a paRt and what
the questIon of what is a part and what is a
what is a wholE is a very
ordiNary
infantilE level ' yes
level ' but alsO in ordinary objective space
is a very interesting probLem on the '
the questIon
the question oF what is a part and what is a
problEm on the
ordInary objective
in ordinary objective Space
of whaT is a part and
a wHole is
objective spAce '
psychological level buT also
level but also In ordinary
psychological level buT
problem on the infantile level ' yeS '
what is a part and what is a wholE is a
question of what is a paRt
problem on the infantile level ' Yes '
the question oF what is a
question of what is a paRt '
A very
art and what is a whole is a very interestinG '
a very interesting probleM
on thE psychological level but also
but also iN ordinary
is ' a paRt and
a wholE is a very interesting problem
the question of what is a part anD what
objectIve space
problem oN the infantile level yes
Of what is a part

the psychological level but also iN ordinary
thE ' question of what is a
what is a Part and what is a
quEstion of what is a part and
on thE on ' the
pRoblem on
and whaT
objective spAce
Is
oN '
objectIve space
oN the infantile level ' yes ' on the psychological'
on the psychological level ' but also in orDinary objective '
in ordinary objective Space ' entities splitting
is a very interesting prOblem on
and whaT is a
part and wHat
a whole Is '
of what is a part aNd what is a whole is
psycholoGical
a whole iS a very
Ordinary
spaCe ' entities splitting ' the question of what is
level ' but also in ordinary objeCtive space ' entities splitting ' the
objective space ' entities splitting ' the qUestion of what is a
pRoblem ' on the
pArt
oN the '
a whole Is a
problem oN the '
whole is A very
ordiNary
in Ordinary
of whaT '
wHat is a part and what is a
problEm '
pRoblem on the infantile level ' yes ' on the
the question of what is a Part ' and what is
aLso
whAt '
thE question of
is A whole

Art Is Either a Complaint or Do Something Else 33

psychologIcal
space ' entities splitting ' the question oF what is a part and what is a whole is a
space ' entities splitting ' the question oF what is a part and what is
on thE psychological level ' but also in
paRt and what is
infantilE
but also iN
Is
oN the
orDinary
level but alsO in ordinary
parT '
question of wHat
what Is '
oN **the** '
the psycholoGical
whOle ' is a very interesting problem '
spaCe ' entities/splitting ' the question of what is
objeCtive '
objective space entities/splitting the qUestion of what is
is ' a **veRy**
iS '
objectIve space ' entities/splitting ' the question of
space' entities/splitting ' the question of What is
On the infantile level '
the qUestion of what is a
very interesting probLem '
on the psychological level ' but also in orDinary objective space '
question of what is a part and what is a whoLe
a part and what Is a part and what is a
quEstion of what is a part and what is a whole
what is a part and what is a whole is a verY interesting problem on the infantile
space entities/splitting the question of What is a part and what is
Objective '
pRoblem on
The '
the infantile level 'yes ' On
tHe
A '
infantilE level
iS a part
quEstion of what is a part and what is a whole

of what is a part and what is a whole is a Very

Is ' a

leVel

a part and what Is a whole is a very interesting problem on

a part anD what

level ' yes ' on the psychologIcal level ' but also

level ' yes oN the

objectIve

level ' but also in ordinary objeCtive '

but Also in ordinary

problem ' on The

whole Is a very interesting

Objective ' space

aNd **what** '

On

is a parT ' and

a part and wHat '

Ordinary

yeS

on thE infantile level ' yes '

anD

objectIve space ' entities/splitting ' the question

the question oF what '

the question oF what ' is a part and what is a

quEstion of what ' is a

question of what is a paRt ' and what is

vEry

psychological ' level but also iN

thE

Space '

objectIve

psycholoGical level '

the psychological level ' bUt

thE

what iS a part and

alSo

objectIve '

aNd

Problem on the

whAt

what Is '

problem oN

Art Is Either a Complaint or Do Something Else 35

 The
 what Is a '
 aNd what
 questIon
 The '
space entities/splitting the question of What is a part and what is
 On the infantile level ' yes ' on the
 level bUt
 a whoLe is a
 part anD
 on the psychologicAl level but also in ordinary objective space
 is a very interesting probleM '
 prOblem
 on the psychological level bUt also
 iN
 buT also
 problem on The infantile level yes
 in a whOle is
 anD what
 psychologIcal level
 oF what
 question oF what
 wholE
 a paRt and what
 part and what is a wholE is a very
 oN
 a part and what Is a whole is a
 problem oN the
 orDinary objective
 iS ' a part and what
 On the
 inFantile level
 problem on the infantile level ' yeS '
 a very interesting Problem on the
 whole is A
 yEs on the psychological level '
 But
 on thE
 of what Is
 problem oN the infantile
 psycholoGical level but
 a veRy

quEstion of **what**
Psychological level but also in
a veRy
on **thE**
but alSo in ordinary
problEm
a part aNd
quesTion of **what** '
a wholE is
of what is a part anD
objectIve
level ' yes oN the
level ' yes on the psychologIcal level '
The question of '

my guns for a while buT eventually it seemed like a losing battle '
i would like my work to Have
I'm
aNother ' and shape is not a color aspects and
that's one of the things we liKe '
sOmewhere else ' my experience '
Feelings '
Time ' i sort of stuck to my guns for a
my personality ' my psycHological
this was ' partly duE to my
bEing
some kinD of
somethinG to
painting ' that is to say i find it morE interesting
invOlve impurities ' a dead man take a skull cover
as well as background For
quesTion of
a large part of my work ' Has
upon itsElf most of my thoughts '
and baCkground
for musIc as well as background
as sTanding for the real thing
mY work feeds upon itself most of my thoughts
of new Art as
clippiNg caught in the
Deluge
would amounT to different kinds of space being
is ' perHaps
painting ' pErhaps
is ' To use painting as a
play oR
to whAt degree movable entities splitting ' the idea
oF that tragedy so
like what i see to be real or to be my idea oF what
deluge ' yes ' but It's skin ' i think it is a form of
reCognize
firsT voice ' i suppose
tragedy ' so far my general development Has '
i supposE '
its own woRk ' its own its it its

thing or as two things think of thE edge of
Splitting the idea '
stuck tO
My work
is a vEry interesting
Canvas
painting as object as reaL
about thE '
object As
theRe
now Serving as
gO somewhere else ' my experience of life is
in part mental and in part visUal but
canVas
that tElls of
iN
of the thIng as standing
and it's in paRt
feelings About
finally one must simPly
sHape is
the wOrd in
size of The painting led me
cOmplaint or
my feelinGs about painting at the time '
loss ' destRuction '
one of the things we like About
the wall the layers the imPrint
traffic tHere
As
iN
music now sErving as background for music as
With paint
the two partS as one thing or as two things think of the
exPerience of life '
development hAs moved in the direction
Psychological
somE vivid indication of
a losing battle ' finally one must simply dRop the reserve ' i think some of the
musiC as
simpLy
somethIng else to it ' one thing made of another ' one

Art Is Either a Complaint or Do Something Else 39

does not sPeak of itself ' tells of others ' will it
think it is a form of Play or a form of
work feeds upon Itself most of my thoughts
souveNir
backGround for
baCkground
thAn it is
resentment against illUsion ' when i can
the thinGs
some vivid indication of tHose differences i guess
Try to use together the wall the layers
I suppose there was
oNe
iT up in my early work ' i tried
tragedy ' so far my general development Has
somE clear souvenir ' a photograph ' a newspaper '
movable entities splitting the idea oF
things occuR '
while but eventuAlly
to be My
to that try to usE
sOmething to it
to use a real Fork as
Traffic
psycHological
man takE a skull cover it with paint rub it against
My early work
conversatIon puns on intentions
stRetched skin
weight etc. it is not anotheR and shape is
it **One thing** made
Real

hAs to be

to use the woRd

To do

statement but a helpless statement It

to be what you can't avoid Saying

thE

can't avoId saying

won'T proceed so logically from

to be wHat you can't

takE

the fiRst

i think thAt one wants from a painting a sense of life

a helpless statement it has to be what you Can't

life the final suggestiOn the final

helpless stateMent it has to be what you can't avoid

Painting perhaps

the size of the painting Led me to

wAnts from

Is

uNcalled for in

The

Object '

pRoceed so

Avoid

helPless

attemPt to do

thE

not A

the firSt '

thE first

that the work won't proceed so logically froM

thE use

of life the fiNal '

do someThing else

NOTES

John Cage's "Anarchy" (quoted in chapter epigraph) is printed in *John Cage at Seventy-Five*, ed. Richard Fleming and William Duckworth (Lewisburg, Pa.: Bucknell University Press, 1989), p. 122.

The MESOLIST program, used in all of Cage's mesostics that employ chance operations, was developed by Jim Rosenberg. In his introduction to *I–IV* Cage credits Norman O. Brown with having come up with the term "mesostics" for the way Cage was writing these acrostic-like compositions with the key letters running down the middle of the text. Early on, Cage wrote his mesostic compositions directly, without the use of MESOLIST, with the capitalized meso-letters serving to gather associations to what were often strings of proper names. Later, as in "Art Is Either . . . ," he also began to use the more complicated chance operations described in the conversation that follows, where both meso-letters and source text serve as oracles when utilized with the assistance of the MESOLIST and IC computer programs. The IC program was written by Andrew Culver, the composer who worked for eleven years as Cage's assistant. It simulates the coin oracle of the *I Ching*.

Cage's Loft, New York City
September 6–7, 1990
John Cage and Joan Retallack

I arranged to tape this conversation with John Cage for publication in the Washington D.C. literary journal *Aerial*. The editor, Rod Smith, was planning a special issue featuring Cage's work with language and demonstrating, via juxtaposition, its connection with contemporary experimental poetry in America. What follows appeared in *Aerial 6/7* along with "Art Is Either a Complaint or Do Something Else" and a selection of Cage's macrobiotic recipes. Our conversation focused in some detail on poetic practice but, like all encounters with Cage, moved in many other directions as well. Cage's worklife and lifework were pragmatically and spiritually intertwined and interdisciplinary. At the time of this taping, we were in the midst of the "Gulf crisis," which had not yet degenerated into "Desert Storm." President Bush was still ostensibly in pursuit of a peaceful solution to the confrontation with Saddam Hussein of Iraq. —JR

THURSDAY, SEPTEMBER 6

JR: (*Setting up tape recorder on dining room table.*) This is an odd way to have a conversation. *(pause)* I've thought a lot about your statement "All answers are answers to all questions" and how that relates to the process of the interview. Have you thought about that?

JC: I haven't thought about it, but we can talk about it. *(laughter)*

JR: It seems that logic should dictate something other than the usual kind of interview. I thought of coming with a card game of questions and answers — where we simply shuffled and played. I'm curious; what would your reaction have been to that?

JC: Well it's hard to know, but I would have followed what was happening. I mean I would have done what I was expected to do. *(laughter)*

JR: What I decided was that it would have been *my* game and therefore inappropriate.

JC: Yes. No, no, I think you're right.

JR: Another thought I had was that we could telescope out or in — in perspective. I tend to start out wide-angled in my thinking. The order of these questions reflects that. But we could reverse or change the order at any time.

JC: No, I'm perfectly willing to go with you.

JR: Recently I met M. C. Richards at the Quashas'.[1]

JC: She called yesterday, yes.

JR: She's, as you know, involved with the notion of "Mother Earth"—doing things to heal the earth. Thinking about that metaphor—Mother Earth—in relation to Buckminster Fuller's metaphor, Spaceship Earth, in the context of the Persian Gulf crisis—how fragile things seem at the moment—I have some questions about the relationship between art and that fragility. Does, for instance, the gulf between mass culture and so-called high culture mean that no matter how smart or wise we become in our art, the life that is closer to mass culture, mass media, will always be in some sort of "gulf" crisis?

JC: I think the nature of what you're calling a "gulf" crisis will change. I mean the specificities. I actually think—I'm saying "think" rather than "hope"—it seems to be in the air that the present Gulf crisis is already outdated. It doesn't belong to our time.

JR: What do you mean?

JC: We're moving toward a global situation. And this Gulf crisis has very specifically to do with nations. And Fuller already told us years ago—I forget the number, but it's something like 153 or 159 sovereignties—that our first business is to get rid of those sovereignties, those differences. And to begin to recognize the truth, which is that we're all in the same place and that the problems that are for one of us are for all of us. There's no place to hide anymore. And there's no way to separate one people from another.

JR: That's so "reasonable."

JC: But I think the crisis will be the kind of crisis that will work globally, and then we will put our minds, like you were speaking about . . . we will put our minds to how to correct those things we really recognize without the clouding over of politics and economics.

JR: So you think, though this is an old-style crisis, it may have a new-style resolution?

JC: I don't know what the resolution will be in this case, but I think the new problems will be different—say, in a hundred years. And they'll be recognized by everyone and people will put their minds to solving them and we'll *do* it! *(laughter)*

JR: I love *hearing* that, and I think it's interesting that you say it's a thought and not a hope.

JC: Well I'll tell you why. The political situation has greatly changed in this last year, as I think all of us agree, between Russia and the United States—the question of two superpowers being—

1. Mary Caroline Richards, known as "M.C."—artist, potter, poet, and friend of Cage from Black Mountain days. George and Susan Quasha run Station Hill Press in Barrytown, N.Y., which, in 1982, first published Cage's *Themes & Variations*.

JR: —Antagonistic—

JC: —Is not true any longer. We feel that the more militarism we give up, the better in the case of Russia and the United States. And there's an enormous feeling—I think a genuine feeling—of friendship back and forth. This Gulf crisis erupts in a fairly global optimism and one of the amazing things about it is, it split the Arab world, and that the Arab world didn't stay together in a plain national situation. There's an indication of a kind of international, or global or united nations—whatever you want to call it—at the present point, a kind of global intelligence at work against, not in agreement with, Iraq, hmm?

JR: When you said "a kind of global intelligence" what came to mind was our relatively thin layer of neocortex that overlays all of that other brain that isn't rational, and I wonder if the optimism of which you speak is not the optimism of, again, a high culture—occupying a small part of the brain and a small part of the general population on the globe. I ask this because, in trying to understand the Middle East situation myself—before the Gulf crisis—as well as other so-called "third world" areas, most of the reading I've done has stressed the tribal nature of cultures in the Middle East and, say, in Africa—the idea that the conflict is between tribalism and nationalism, which "we" look at as an advance. Tribalism being oriented toward issues of blood and—

JC: Blood and earth and such things.

JR: Yes, and "kin," so that it's very hard to recognize and respect the "other."

JC: The artificial one, the *seemingly* artificial.

JR: Yes. In the *New York Times* a few Sundays ago there was an article that talked about the "new cultural tribalism" in this country—that at this point we feel our audiences are so split, there has to be a women's art, a black art, an Arab art, a Latino art . . .

JC: Very, very pluralistic. I think that's the nature of everything though. That's much better than having everybody a bunch of sheep.

JR: The point the writer in the *Times* was making was that this does not necessarily further understanding. If the only audience is the one reflected in the piece it becomes a kind of cultural solipsism.

JC: I don't think that's true.

JR: So you think the availability of multiple perspectives will be—

JC: Yes. There's always someone coming in from the street, into a situation where they don't belong. *(laughter)* I mean, it's not pure. What we're basically in, it seems to me, is a greater population than the earth has ever experienced before, and we just don't know what's happening or how to deal with it yet.[2] We're inexperienced, we're uneducated, and so forth, about the reality of the present

2. In 1992 Cage composed a piece called "Overpopulation and Art" that addresses just these matters. It is printed in *John Cage: Composed in America*, eds. Marjorie Perloff and Charles Junkerman (Chicago: University of Chicago Press, 1994).

circumstance. This article sounds as though they know something. Whereas I think we don't know much about what we're doing. But I do believe that we're on *one* earth and I think more and more people realize this. And if we could give up this silliness of the difference of nations and concern ourselves with problems that affect all of us, we would make a great step forward. . . . And, on a less utopian level now, if President Bush's tactic of making an economic war before making a militaristic one . . . if it works, it will be really a boost for optimism—following the Russian, what you could call, erasure of politics, hmm? If we could now have an erasure of militarism through economics. The Japanese, for instance . . . they actually think they need the oil. Actually, we don't need the oil. Fuller has told us long ago we should quickly not use it anymore.

JR: Solar energy and—

JC: All those things. We need the oil in order to do the things that really must be done, rather than the things that needn't be done, like driving for no reason at all from one place to another in all the cities of the earth. If you just imagine from the sky any metropolis, you see all this vast waste of oil.

JR: That's true, and so I wonder about the basis for optimism.

JC: Fuller said we would need that oil in order to start the necessary pumps of the future to solve the giving of food and utilities and whatnot to everyone on earth rather than just the few.

JR: What do you think of the role of the artist who is developing ideas similar to Fuller's, and other ideas that might be called pragmatically optimistic, in relation to the fare on television that is retreading old-style ways of thinking about ourselves as fragmented—that presents the earth only as the scene of continual conflicts? Adorno, for instance, was very pessimistic about the effects of mass culture—he felt its power to shape the consciousness of people in ways that would be socially destructive.

JC: I do think that if we walk along Sixth Avenue now and look at the people we see on the street . . . you don't have a feeling of culture. You really don't, as you see the people in the street. And now, I think one of the striking things about our awareness of, say, the United States—and that probably extends to other countries—is that we have certainly not a sense of mass culture, but of individuals who have culture. We have the feeling that many people pay no attention to culture. And that they also don't pay any attention to anything else that is connected with spirituality or with things other than physical necessity. And that they, furthermore, now . . . that so many people escape from all of that through drugs. I have no objection to their using the drugs, but I do miss what one might lump together under the word "spirituality."

JR: Spirituality seems to exist—at least partly—in the realm of desire . . . something you don't get to if you're totally preoccupied with need.

JC: Right.

JR: And I wonder if, to the extent that we have a culture, we've left ourselves too

needy. Too needy to shift attention away from terrible anxieties about survival, and things that close people in on their fears.

JC: I think that the hope, any hope, any future in fact, has to be viewed from the viewpoint, not of the masses, but from the viewpoint of the individuals. And I don't mean to separate the masses from the individuals. We need to approach the mass as though it were as many individuals as there are in the mass, hmm? If the masses are going to get any culture that is really useful to them, they will get it individually rather than as a group.

JR: How? They get it "individually" sitting in front of a video box in their house.

JC: We don't know how. Because no individual knows how his life is going to change, hmm? Even the cultured ones *(laughter)*, let alone the uncultivated ones. But even the uncultivated ones, the hopeless ones, the homeless ones—all of those—can in the next ten minutes change their lives. And we don't know why, or what will have stimulated them to do that. But they do do it. And that is how life is . . . don't you think?

JR: I'm not sure, actually, I—

JC: But you certainly don't think that five people, because they're in a group, are all going to agree upon some change in culture and take it—

JR: I think groups can be much less than the sum of their parts, rather than more . . . I suppose my state of mind at the moment is that both my optimism and my pessimism are on hold and I'm not sure what that leaves me with. *(laughter)* I do worry when critics and people who think about a postmodern era as a possibility—and I think thinking of it as an empty category which has yet to be filled, where we have the opportunity to look back and say to ourselves, we don't want to do this anymore, let's try that—makes the idea of a postmodern era rather exciting, thinking of it as a threshold (that's how those labels are useful, as thresholds)—then I worry about the critics who say one of the problems with modernism was that it ignored mass culture; it ignored whatever it was that all those people out on Sixth Avenue, with the exception of perhaps one or two, were responding to and having their consciousnesses shaped by. At the moment that seems to be television, certain radio stations . . . mass media. There is the tension between the fact that these are of course individuals, and yet the input is very homogenized, is very uniform if you believe things like Nielsen ratings.

JC: You mean many people respond the same way?

JR: Not necessarily. I hope not. But many people are responding positively or negatively to the same things.

JC: They're being stimulated by the same things, going in slightly different directions probably.

JR: Yes, perhaps so.

JC: I think that the media—they will get more and more boring.

JR: Could that possibly happen? Even more boring? *(laughter)*

JC: I think so. I don't use it anymore and I know many people who don't. One

of the arguments in optimistic support of radio goes to the effect that television is so boring that people are going back to radio, hmm? Isn't that true?

JR: Well I think people I know and you know may be . . .

JC: But I don't even do that. I don't really listen to the radio either. Neither did Marcel [Duchamp]. He listened to WINS and he called it LULLABY. And the reason he called it LULLABY was that it repeated itself, over and over; and he used to use it, perhaps, to go to sleep . . . I don't know.

JR: Well some sort of anesthesia is probably a good deal of what people are after. I suppose the scary part is that it isn't anesthesia with amnesia afterwards—that it does shape the way people think.

JC: I can't listen anymore with any spirit to much more than the weather report on the radio, because the news on WINS, this lullaby, the lullaby is intolerable because of the children who are murdered one way or another, or who themselves murder their parents, and that kind of news is what we get every day. I find it doesn't help. It doesn't help—I'll avoid the word "culture" now *(laughs)*—it doesn't help my work. Or it doesn't help in the use of the hours of the day.

JR: Actually, I'm curious about whether your anarchism—which is basically what—

JC: Spirits me.

JR: —You're articulating: whether it's some sort of optimistic fatalism with a long view.

JC: *(laughs)* Some Pollyannaish . . .

JR: No, "p-o-l-y" perhaps; not "Anna." But it seems to me that it possibly does entail a long view. As you say, any time you turn on the radio or look at the papers, a good deal of the information is horrifying.

JC: Yes. All those details are intolerable. You can't live with it. If your attention were constantly on immediate problems—like the Gulf crisis, for instance—I think you'd have to give up. I mean, what could you possibly do? Nothing that you or I can do now will change any of that. Much less effective are we than say that butterfly in China[3] who will determine it, probably. *(laughter)*

JR: But of course that could be an argument in defense of political activism. You could say, well, if even a Chinese butterfly can affect the weather in New York, then—

JC: Then how much better if we would do something activist? Oh, I see. Well, I think that my strongest action, in terms of either immediate time or long-term time, hmm? is what I'm doing. Hmm? I can't do any better than I'm doing. And I think that's true of each person who is concentrated on his or her work. Just the example of one's work, and one's dedication to it, is . . . is . . . I don't know what to say about it, but that's what we're doing. And we're doing our utmost.

3. Referring to the "butterfly effect" of chaos theory, in which complex systems like weather are seen as so sensitive to initial conditions that a butterfly flapping its wings at any given moment in China could affect U.S. weather patterns in the coming weeks.

I don't think if we made it directed more to the person in the street, hmm? that it would be our work. What's involved is the people in the street changing their focus of attention, and we can't force them to change it, something else has to do that. Circumstances have to do that. And they will! Hmm?

JR: Where does that last come from—"and they will"?

JC: You see, we may always get an impression that the masses are inert, or uninspired and so forth. But every now and then some of them will become inspired. And others who are not inspired will take their place. *(pause)* So. . . there might be a continuing stupidity just as there's a continuing enlightenment! *(laughs)*

JR: It seems one view that could come of that is who are we to—

JC: To distinguish?

JR: Or to feel that our species is capable of doing any better than it does.

JC: Oh, I think we know that. I know that we know that we can do better. Bucky [Buckminster Fuller] knew that. He kept talking about success in contrast to failure, which he considered was what we were doing. He made the distinction between "killingry" and "livingry," and we're now at a possible point of shifting the Gulf crisis from killingry to livingry. From the concern with killing people as a solution to letting people live as a solution. That's where the hope lies in the present Gulf crisis.

JR: If you think of that as a ratio—"killingry" to "livingry"—do you think that ratio has changed?

JC: Yes, I think it's in the process of changing. I see the change in the Russian-USA relationship as a move in that direction. And I see the possible outcome of this Gulf crisis as being non-militaristic. And that would be a step in the same direction. It would be toward the use of words rather than guns. And it would give an incredible boost to optimism, and it would spark minds. But I would like to equate the possibility of military violence with the possibility of drug addiction . . . that they're both the same thing, they're extremes of moving away from intelligence. It's not that the drugs are bad, it's that the addiction, or placing the attention in such a way that you have no freedom, is bad. Don't you think? If there could be a taking of drugs mixed, as it has been in the past, with spirituality—that would be a step in the right direction.

JR: We are, I think, a bunch who do need to be—

JC: Changed.

JR: Jolted out of habitual perspectives.

JC: And drugs can be effective in that way. I think that's true, so I didn't want to speak against it. Do you know his books, Andrew Weil, who hopes for legalization of drugs?[4] But he speaks also of Buddhism—which has long involved me

4. Andrew Weil, M.D., is the author of *Natural Health, Natural Medicine*, (Boston: Houghton Mifflin, 1990). An excerpt from this book, "What Should I Eat?", is included in the box catalog for John Cage's *Rolywholyover A Circus*, which originated at the Museum of Contemporary Art, Los Angeles (New York: Rizzoli International Publications, 1993).

on an amateur level—as one way of altering the spirit without recourse to drugs.

JR: My feeling is that various disciplines of attention can do that.

JC: So that enlightenment can come either chemically or not. *(laughter)*

JR: I have a question about *I–VI*, from the transcript of the seminars you gave at Harvard, pages 177–78, where you talk about the performance of a piece of music as a kind of metaphor for the way society works.[5] You're answering a question at the time that has to do with the political dimensions of music, the social implications of music. You say, "Performance of a piece of music can be a metaphor of society, of how we want society to be. We could make a piece of music in which we would be willing to live, a piece of music as a representation of a society in which you would be willing to live." I thought about your interest in Wittgenstein. Wittgenstein talks about language as a form of life, but I haven't found any place where he talks explicitly about art as a form of life, even in this book [*Culture and Value*] which collects his writings on art, though it seems to me to be directly implied.[6] I'm curious about how far you might take the notion of the performance of the piece being—

JC: A metaphor of society?

JR: Yes, but also wondering whether it is really a metaphor or representation and not *actually* a "form of life" itself, in some important sense. Somehow calling it a metaphor seems to remove it.

JC: Oh, I see. No, you're right. It doesn't have to be called that. But, in other words, you would go to a concert and you would hear these people playing without a conductor, hmm? And you would see this group of individuals and you would wonder how in hell are they able to stay together? And then you would gradually realize that they were *really* together, rather than because of music made to be together. In other words, they were not going one two three four, one two three four, hmm? But that all the things that they were sounding were together, and that each one was coming from each one separately, and they were all together. The togetherness was from within rather than imposed, hmm? They were not following a conductor, nor were they following an agreed-upon metrics. Nor were they following an agreed-upon . . . may I say poetry?—meaning feeling or expression, hmm? They were not doing that either. Each one could be feeling in quite a different way at the same time that they were being together, hmm?

JR: So that really is a kind of microcosm of an—

JC: Of an anarchist society, yes. That they would have no common idea, they would be following no common law. The one thing that they would be in agreement about would be something that everyone is in agreement about, even the masses.

5. John Cage, *I–VI*, Cambridge, Mass.: Harvard University Press, 1990). These are Cage's Charles Eliot Norton Lectures, delivered at Harvard 1988–89.

6. Ludwig Wittgenstein, *Culture and Value*, ed. G. H. Von Wright, trans. Peter Winch (Chicago: University of Chicago Press, 1984).

JR: Even the mythological masses.

JC: And that is, what time it is. They would agree that the clock is correct.

JR: Somehow, in this context, even that sounds major. *(laughter)* Not in the least bit trivial.

JC: They would agree that it was ten o'clock rather than eleven o'clock. Although that's a kind of artifice. I'm thinking of the people who live, say, on a time line and of narrative agreement or disagreement about what time it is. They could speak together and reply one hour later in the next second. *(laughter)*

(Tape recorder turned off for lunch.)

JR: Taking the idea of art as a metaphor of society or as a form of life further, I wonder how you would respond to the current kinds of arguments that are being made for art that represents all of the social groups needing representation in the society. Could you imagine, for instance, writing into a score that five different minority groups would have to be represented by performers, or that minority points of view would have to be represented in the material the performers choose to use?

JC: I don't think I would do that because I don't want to live that way. I mean to say, I don't think of individuals as being massed together in a group. I really think of individuals as having their own uniqueness. So that I'm not sympathetic to people who consider themselves members of a minority group. And I don't really support minority groups. I don't like the notion of the power or the weakness of a group. Hmm? I consider that a form of politics, and I think we've passed that.

JR: What would you substitute for the notion of politics?

JC: The uniqueness of the individual.

JR: In—

JC: In every case.

JR: In a free, anarchic society.

JC: Anarchic society.

JR: Wittgenstein, in this book [*Culture and Value*] which I know you've read, since you quote it in your sources [in *I–VI*]—

JC: Well I haven't read them all, Joan. I've dipped—guided by chance operations.

JR: You don't have to have read it all for me to ask you this. And, actually, a question I'll ask later on is about your dipping. You talk very beautifully about "brushing" the source text.

JC: Yes. That term comes from Marshall McLuhan, you know, "brushing information against information." And that this is our only work now. Do you know that? Yes, work is obsolete. All we do is brush information against information. *(laughter)*

JR: You may or may not have read this: Wittgenstein writes, "People say again and again that philosophy doesn't really progress, that we are still occupied with the same philosophical problems as were the Greeks. But the people who say this don't understand why it has to be so. It is because our language has remained the

same and keeps seducing us into asking the same questions. As long as there continues to be a verb 'to be' that looks as if it functions in the same way as 'to eat' and 'to drink,' as long as we still have the adjectives 'identical,' 'true,' 'false,' 'possible,' as long as we continue to talk of a river of time, of an expanse of space, etc. etc. people will keep stumbling over the same puzzling difficulties and find themselves staring at something which no explanation seems capable of clearing up."[7]

JC: Suzuki said something similar.[8] He said, after an evening when we were all asking him questions—we were walking on Fifth Avenue—a lady turned to him and said, Dr. Suzuki, we talk to you all evening and we ask you questions and nothing is solved. And he said, that's why I love philosophy; no one wins. *(laughs)*

JR: And now this cat [Cage's cat, Losa] is lying on my next question. *(laughter)*

JC: He's very dog-like. He likes to be right in the center.

(Losa is resettled to other side of table.)

JR: You talk of artists setting examples. Do artists—in, say, using language in new ways—change the grammar of the way we are together?

JC: Are you asking this in relation to what you just read from Wittgenstein?

JR: Yes.

JC: Yes, isn't that beautiful. *(pause)* We don't know. But we can try.

JR: And the same for developing new intuitions?

JC: You know I have a slight chip on my shoulder about the word "intuition." I did speak about the uniqueness of each individual and I believe that. And I suppose the intuition of one individual would be quite different from the intuition of another, but it sounds like something very special—intuition, hmm? And I've always suspected the word "inspiration" in the same way. If we have to have intuition, or if we have to have inspiration in order to carry on the day, then where are we? Will we have to wait for a long time after getting up? Before we can do anything? What!? *(laughter)* That's why I feel a little bit off of those things— because they sound like special circumstances. I would rather be—even if I were at a lower altitude—I would rather be able to work at any moment, even when I was uninspired. That's one of the things that chance operations makes possible. Or brushing information against information. You can do that without being inspired. In fact, doing it will inspire you, don't you think?

JR: Yes. I feel the same way about inspiration, and I can see that "intuition" has kept company with that whole cluster of things that has to do with genius and being special.

JC: Yes, yes. That, yes.

JR: The reason why I use it—and maybe there's a better word—is because I

7. Ibid., remarks from 1931, p. 15e.

8. Daisetz Teitaro Suzuki, author of *Introduction to Zen Buddhism, Living By Zen, Manual of Zen Buddhism, Essays in Zen Buddhism*, and many other books attempting to help make sense of Zen spirituality for Western audiences. Cage attended Suzuki's lectures at Columbia University for a number of years in the late forties and early fifties.

think not enough of us trust the awareness and the quality of attention that *can* brush information and select things that strike us in strange and interesting and unexpected ways . . . and give them value.

JC: Right. I don't object to the mysterious aspect of intuition. Or even inspiration. I mean to say the "Where does it come from?" I like that. But I don't like the part that would make one person inspired and the next uninspired. I don't like the political nature of intuition or inspiration.

JR: What I realize is I don't associate it with those things anymore. I think of intuition as something you can consciously develop, through a kind of discipline of attention; and its being valuable as a resource for your work.

JC: What would you do, for instance?

JR: Well, with my students I do various kinds of language exercises—some of which come out of a Zen sort of spirit. One is in fact related to your "All answers are answers to all questions." I have them write on a piece of paper a statement that they believe to be the case—trivial or sublime, it doesn't matter. No rules except that they believe this to be the case. Then I ask them to write a question on another piece of paper—something they genuinely wish to know. We collect these statements and questions in separate piles and shuffle them up. Two students now read from these randomly ordered piles responsively. The first reads the question at the top of her pile, the second reads the first statement as if it were the answer; and of course it *is* the answer. *(laughter)* My students are always amazed. They say, how did you get this to work?

JC: Isn't that marvelous.

JR: What I think it does is help them develop a sense of trust in their ability to make—

JC: To make those connections.

JR: Yes. That's right. To make meaning.

JC: Make meaning, yes.

JR: And I do a number of things like that—developing intuitions about language by *using* language in disarming ways, coming to meaning from odd angles. And I started doing this partly in reaction to the idea that some people had intuitions and others didn't. What I find is all my students can do wonderful things when—

JC: When they realize they can do it without being put down or without needing to be embarrassed. No, I agree.

JR: Yes. And the "intuition" has to do with the fact that our brain takes in so much more than we process at the cognitive level. I think so much of what makes language lush and sensual has to do with experiences and associations we have that are sub-neocortical, that aren't being processed in logical terms. I don't know what else to call that, in order to pay attention to that part of language, as well as to its logical levels. We're noticing on an intuitive level. But there may be a better word, because I agree, it carries that unfortunate baggage. Having said all that, we could talk about how, when we experience art, we are educated or initiated in

some way by the experience so that even if we don't logically assimilate or repeat the experience, it affects the next experience we have.

JC: Yes, well, that's characteristic of art, I think. That it goes into the life, and transforms it. You really see the world differently because of your experiences with art, one art or another that shows you connections other than you knew before it.

JR: And in a piece like "Art Is Either a Complaint or Do Something Else," which you have said works *with* ideas, *from* ideas, but is not *about* ideas —

JC: Yes, it ["Art Is Either . . ."] is all from words of Jasper Johns, but they're used with chance operations in such a way that they make different connections than they did when he said them. On the other hand, they seem to reinforce what he was saying . . . almost in his way. And why that should surprise me I don't know because all of the words are his. *(laughs)* But they make different connections. And I mistrusted it at first, or rather I didn't want him to be unhappy about it, because it was all his words. So I didn't want to put, so to speak, false words in his mouth, false connections. Before publishing it or delivering it, I read it to him and he was delighted with it — so there was no problem.

JR: Did he hear anything new in it?

JC: I didn't ask him. But whether he did or not, he hasn't objected to my reading it. You know, he doesn't himself give lectures about his work, so it serves . . . it could, from his point of view, serve a purpose.

JR: Better than sending out a surrogate lecturer. *(laughter)* Would you give some examples of specific pieces of art or performances that changed the way you saw things, that were models for you in some sense.

JC: Yes. The first one that I remember is very striking. I was in a gallery looking at the early '40s white paintings of Mark Tobey, and in particular one which had no representational elements at all, which was just white writing. And I left the gallery, which was then on 57th Street, and I went down to Madison Avenue — I think the bus then went in both directions — I was waiting for the bus and I happened to look at the pavement I was standing on and I couldn't tell the difference between that and the Tobey. Or I had the same pleasure looking at the pavement. And yet I was, I was determined — I was very poor at the time — and I was determined to buy the Tobey, on the installment plan, which I did. I paid five dollars a week for about two years. And yet I had learned from Tobey himself, and then from his painting, that every place that you look is the same thing. You don't really need the Tobey. *(laughs)* But you need it to tell you that, I guess.

JR: To remind you.

JC: To transform you. That happens of course with sound. It happens in all the various ways, it happens in different ways so that you, you notice different things than you had noticed before. See, this was just sort of noticing the pavement itself, but sometimes art seems to transform, seems to become something other than itself — the pavement doesn't remain the pavement, but gets to be more

like the art, hmm? I think then you need more of an environment than just the pavement.

JR: You need more for what?

JC: More relationship. Different things. Because so much art has the characteristic of connections between things. So that connections are different from the simple thing of Tobey's white writing which is like one thing. It introduces you to the one thing—like the pavement. But the relationship arts can introduce you to other kinds of relationships.

JR: By "relationship arts" what do you mean?

JC: Well, when art seems to be dealing not with one thing like white, as in Tobey or Robert Ryman, but is dealing with many shapes and colors. You see? Then you begin to notice different kinds of relationships between all those things as they are mirrored in your daily experience. You notice them again. You recognize them. *(pause)* I wonder if I can give an example of that. I'm not sure. I mean to say, one from my experience. I don't remember one right now.

JR: That certainly happened to me after my first time at a Cunningham-Cage performance. I walked out into the street and—

JC: And you could see movement—

JR: Movement, and hear the sound in a new way. And connect the movement and the sound, though that connection was nonintentional. It was a complete transformation. And I think of first seeing Helen Frankenthaler's large canvases —the edges of her shapes and the spaces in between. After seeing her canvases I started noticing relationships between edges. Is that the sort of thing you mean?

JC: Yes, that's what I mean. This leads to the relation of art to the enjoyment of life. Which is what *must* be its purpose!

JR: If not, then why?

JC: Then we're in the wrong place. *(laughter)*

JR: That's what I love about [John] Dewey's *Art as Experience*. That's really what it's all about for him.

JC: Yes.

JR: Dewey's notion in *Art as Experience* is that art, in reconnecting us with our sensory nature, revitalizes us in our connection with the world. And this is the purpose of art. He interestingly comes to this from a negative point of view— his feeling that we are dangerously susceptible to emotional fragmentation, that we tend to become alienated from our sensory selves and from the forms of the physical world around us—our natural environment. His positive assertion is that art can awaken and focus our attention, and it does this by drawing us to attend to a particular kind of order.

JC: Does he specify that in any way? What does he mean by order?

JR: Well, he means . . . "meaning" . . . he—

JC: What does that mean? *(laughs)*

JR: It has to do with the fact that he sees us as experiencing the world on several

levels, one of which is intellectual, and that we naturally want to understand what it is we're experiencing. The enjoyment of art for Dewey requires some form of understanding, some sort of intellectual as well as sensual content—and that has to do with pattern. He talks about how terrifying complete chaos is. I guess he believed that was actually possible as raw experience—pure randomness, total lack of order.

JC: Yes, I think he would be less frightened of it now. I think things change, don't you? I mean even things of this order.

JR: The new thinking in the complex sciences changes the way we view these things.

JC: Yes, and I think our daily experience now. As the world becomes, as Marshall McLuhan said, smaller—it's not much larger than the room we're in, as he points out—then the kinds of things that go on close to you, I mean the kind of chaos that we understand *(laughter)* introduces us to the one we don't understand, simply because we're in *this* corner of the room . . .

(We decide to end for the day. Tape recorder turned off.)

FRIDAY, SEPTEMBER 7

JR: I want to start today by asking you about "Art Is Either a Complaint or Do Something Else" since it will appear in the issue [of *Aerial* magazine] with this interview. Would you explain the process of composition of the piece?

JC: Yes. The piece is made with computer facility. Both in terms of chance operations and the special computer facility of being able to establish a source of material from which the chance operations can then select material and specify where the material comes from by line and character. So that it becomes easy to work in a state of multiplicity with precision, hmm? And without having to bother choosing. So that in a vast array of material, you can pinpoint something, and you can know where you are, and then work accordingly. I can imagine programs in which you would specifically not want to work with the thing that you had pinpointed, but to work with something at a distance. I've never done that. I've tended to pinpoint and then work close by the pinpoint. In the case of the Jasper Johns text, I've taken quotations from him which appear in a catalog that was published by the Philadelphia Museum of Art. In it, there was one mistake—in grammar—which Jasper Johns immediately recognized. He was misquoted in the catalog, but fortunately I had not misquoted him. I quoted the catalog correctly, but the catalog misquoted him in . . . what was it?—"Art is either a complaint or appeasement," something like that. And he said it should have been "Art is either a complaint or *an* appeasement." He noticed that, he noticed that difference. It couldn't be "*a* complaint or *a* appeasement," you see.

JR: Are the first two pages of your piece—

JC: Those are all quotations from this catalog.

JR: And did you pick those by "brushing the text" or—

JC: No, no, I simply took all the quotations from him that there were.

JR: Oh, so this is exactly the way they were?

JC: No, they were scattered through the catalog. I put a space between each one of his remarks. I didn't really do any eliminating or changing. And when he noticed that mistake, I was worried, and when I went back to the book I saw that I hadn't made a mistake. Seems silly, but that kind of thing is very descriptive of him, you see.

JR: Well it's also descriptive of poetry. If poetry isn't about precision of language, then what is it about?

JC: Yes, yes, exactly.

JR: Then, when you moved from—

JC: Then I had all those [quotations] in the computer. And I was able to distinguish them from one another and I was also able, through chance operations, to brush them together.

JR: And what role did the mesostic strings play?

JC: The remarks themselves become . . . the string down the middle: A D E A D M A N T A K E A S K U L L, do you see? C O V E R I T W I T H [Section 1]—sometimes there will be letters missing.

JR: Ah, yes, in trying to read the strings I had trouble at times because of that.

JC: Sometimes there will be letters missing. And there's nothing to be done about that. I mean, I haven't thought of anything to do.

JR: I've never noticed letters missing when you use names as the strings. Have there ever been letters missing in those?

JC: Generally there haven't, but in this case when the letters are missing it's because there are no possibilities that follow the rules, that permit the presence of that letter. The rules are that words before a second letter in the mesostic shall not have the letter that's coming in the middle. So between the E and the A there is no A, between the A and the D there is no D, etc. When there were no alternatives to what was stated, then it simply couldn't exist in the mesostic.[9]

JR: And what determined the order of the strings?

JC: Chance operations. *(pointing to text)* So, what came up there was A D E A D M A N T A K E A S K U L L C O V E R I T W I T H P A I N T R U B I T A G A I N S T C A N V A S S K U L L A G A I N S T C A N V A S.[10] That makes the first one. C A N V A S is the end, what's the next one?

JR: The next one [Section 2] starts, I D O N ' T —

9. Andrew Culver, the composer who was Cage's assistant for eleven years, and who developed most of the computer programs Cage used during that time, gave me these usefully concise statements of the rules for 50 percent and 100 percent mesostics:
50 percent: Between any two mesoletters, you can't have the second.
100 percent: Between any two mesoletters, you can't have either.
10. Pages 7 and 8 of this volume.

JC: I DON'T WANT MY WORK TO BE AN EXPOSURE OF MY FEELI
N G S. That's right, "I don't want my work to be an exposure of my feelings." So
you see that is here.[11]

JR: Uh huh. And the next one [Section 3] is . . .

JC: Oh yes, here it is, "I think it is a form of play or a form of exercise and it's
in part mental and in part visual but that's one of the things we like about the
visual arts the terms in which we're accustomed to thinking are adulterated or
abused."[12] I could have gotten this *(points to a longer section of the Johns quota-
tions)*, which would have made the third one much longer than this makes it.
So not knowing ahead of time, or until the chance operations were used, how
many of these I should find, I worked one by one until I got to what seemed to
me to be a reasonable length. Now a reasonable length is, in this case, a lecture
length, because I was asked to give a lecture at the Philadelphia Museum and so
I asked them what they thought was a reasonable length, and when it came to
that length I stopped.

JR: Ah, so that answers the question, why thirteen sections?

JC: No reason except that. Practicality, you might say. *(pointing to another part of
the text)* This is very beautiful. You know that he loves Wittgenstein. Or did you
know that?

JR: No. I didn't know that.

JC: That's very much like Wittgenstein *(pointing to first page of Johns' statements)*
"We say one thing is not another thing. / Or sometimes we say it is. / Or we say
'they are the same.'" Or maybe, as you said yesterday, instead of being stated
this way, it might have been stated as a question.[13] Then it would be a little bit
different. But this is the way Jap said it. Or this is like him [Wittgenstein] too,
"The condition of a presence. / The condition of being there . . ." In fact, I think
his thinking comes out of Wittgenstein. I don't mean to say with any precision,
but that he's been strongly . . . don't you think?

JR: The moment you say that—

JC: Then you can recognize it.

11. Page 9 of this volume.

12. Pages 10–14 of this volume.

13. In talking at lunch about Wittgenstein's change of style from the *Tractatus Logico-Philosophi-
cus* [1921], which was in the form of propositions, to the later *Philosophical Investigations* [1953],
which was in the form of questioning and puzzling, I told Cage how delighted I was by his change
of mind about Wittgenstein. (See Introduction.) I had continued to see parallels between the two,
despite my thinking that Cage was unsympathetic toward Wittgenstein's work. Among other things,
criticisms of the openly exploratory, interrogative form of Wittgenstein's later work bear interesting
resemblance to certain criticisms of Cage's methods. This one by Bertrand Russell, for instance,
quoted by Ray Monk: "Wittgenstein . . . seems to have grown tired of serious thinking and to have
invented a doctrine which would make such an activity unnecessary," from Monk's *Ludwig Witt-
genstein: The Duty of Genius* (New York: The Free Press, 1990); p. 472. Similarly, many of Cage's
critics have viewed the use of compositional questions and chance operations as a way of making
the activity of composing unnecessary.

JR: Yes. And I suppose that's partly why I felt this was coming from you. Because—

JC: —Of Wittgenstein, yes. But it isn't. It's Jap.

JR: How long has he been reading Wittgenstein?

JC: Quite a while. I don't know exactly. In fact the way of thinking, the interest in variety, and sometimes introducing unexpected things to do or to think, hmm? unexpected . . .

JR: Yes, as in Wittgenstein. I was going to ask you about this, but now I know— where he says, "Also, a large part of my work has been involved with the painting as object, as real thing in itself. And in the face of that 'tragedy' . . ." This is so wonderful, such a beautiful, lightly disjunctive leap. I was going to ask if that had happened through your arrangement.

JC: I don't know that this is the case in Wittgenstein, but in the case of Jap, the word "tragedy," and the touching nature of that, seems very close to him. I don't think of tragedy as being close to Wittgenstein, or, do you?

JR: I do. Very much so.

JC: You do. Oh, you do. . . . And you've probably read those biographies—or the one that's very good. The one about the family.[14] Jap loved that book. I think there is a closeness. And you think it includes the sense of tragedy?

JR: Absolutely. Wittgenstein went through periods of great torment. There was an unhappy family history. Three of his brothers committed suicide. . . . Wittgenstein himself was on the verge of suicide a number of times . . . often struggling with despair. . . . There's a sense of an enormous amount of pain in Jasper Johns' life too.

JC: Yes, apparently. To me, and to other people who know him—'cause I know him quite well . . . and yet he's a complete stranger . . . you know . . . each time— and that's why I love to see him, or be with him—is that each time I'm with him I have no idea who he is! You know? Just no idea at all. It's a complete, marvelous mystery. When he uses a word like "tragedy" or something on the black, dark side, or like "Take a skull" and "A dead man" and all that, you think, oh yes, that's his voice. So you know *that* much about him. But then you may see him and he'll be all cheer and smiling and happy and—but it's just as possible that you'll see him and he'll be grim and . . . *difficult.* You just can't be . . . you can't be sure until you actually have the experience of being with him. Each time is fresh. It's quite amazing. And his work, of course. I don't know if you know my mesostic about him. He was awarded the gold medal for print-making by the Academy of Arts and Letters and I was asked to give it to him, and so I wrote a mesostic on his name saying this is not really a gold medal, something like that, this medal is not pure gold. It was to the effect that he's created the greatest difficulties for

14. Cage is probably talking about Brian McGuinness's *Wittgenstein: A Life: Young Ludwig 1889–1921* (Berkeley: University of California Press, 1988).

me. And the difficulties that I cherish the most. *(laughter)* That's what he is — I think — as far as I can tell.

JR: "That," meaning the difficulty?

JC: Yes, and the unpredictability. That's why he's so marvelous. I just had the experience after the meeting — I asked him to show me what he was working on now.[15] He showed me a calendar that he's made. He's made twelve pictures to represent the different months for a gallery in London that has for the last five years published calendars by artists. His [pictures] are derived from a knowledge of the face. In other words, a knowledge that there are eyes, there is a nose, there's a mouth — but they're completely displaced in the twelve images. So that you know it's a face, but it's not a face, you know? It's very beautiful. The eyes maybe over here and the ears . . .

JR: He says [in "Art Is Either. . ."] "My experience of life is that it's very fragmented."

JC: Yes, it's that. The fragmented face, yes.

JR: This whole piece ["Art Is Either . . ."] is fragmented, or rather has a fractal quality — of the sort described in the chapter on Mandelbrot in *Chaos*.[16]

JC: Yes, I don't know why I didn't read it all the way through. *(pause)* Well the reason I didn't was that I get involved in too many different things. There are things that take my time. *(laughs)*

JR: *Time!* What is your —

JC: Attitude toward time?

JR: What is your sense of time in this piece? When you're working on a piece like this —

JC: When I do it?

JR: Well, both in the process of composing, and then your sense of what it does with the reader's or auditor's experience of time. Is it related to your sense of time in music?

JC: Well you see what I do, Joan, is . . . the computer gives me the center word for the string, but it doesn't give me the wing words. To find the wing words — to right or left of the string — I go into the source material and I go in linearly with respect to the source material, so that if the word is "just," down the middle, then I go back to the source material which the computer sends me to and I take the

15. Cage had been at a meeting that morning at the home of Jasper Johns, who, together with Cage, Merce Cunningham, and others, had formed a foundation with the purpose of giving money to worthy art projects. Cage said they were not getting interesting applications, and they found the whole process of reviewing them too time-consuming, so they were not going to do it that way any more. That morning they had discussed scheduling a lecture series but had decided all the people they really wanted to have lecture were dead (Buckminster Fuller, Marshall McLuhan, etc.), with the exception of Norman O. Brown. Cage said they were concerned that "We don't really know what's going on, what is, and is going to be, important." He was looking for suggestions.

16. We had discussed the James Gleick book *Chaos* as well as Benoit Mandelbrot's *The Fractal Geometry of Nature* prior to this conversation.

words from here up to "just" or here if they still follow the rule about the letters, and I make my choices, oh, for one reason or another, but not by chance.[17] I make them according to my taste. With regard to sound, for one thing. Sound is very convincing, often. *(laughter)* Rhyming . . . or not rhyming. Opposition of sound, or similarity of sound. Or, then we could go off into what you were bringing from Dewey the other day, about ideas and intellectual [content]. In other words, there are all sorts of things that happen that make us . . . that let us make one choice rather than another, hmm? And I do that more or less the way Schoenberg used to do this with his composing. He said one of the ways to compose is to go over what you're doing and see if it still works as you add something else to it. Just go over it again and see how it continues, how it flows . . . so as to make something that flows.

JR: "Flows." So is that saying something about time?

JC: I think it is. Or . . . I would rather say it's saying something about breathing . . . than about time. Because we have . . . we have all the time in the world.

JR: Until we don't.

JC: I mean a line could be long, or it could be short, and sometimes a short line works, and sometimes a long line is necessary. I think they vary. When I was working on the Norton lectures, I was working quite constantly over a longish period of time and I used to think as I was struggling to get something done . . . in the spirit of working against a deadline . . . I used to think, well I'm beginning to know something, and I would no sooner have that feeling and I would discover I knew nothing. And I wouldn't know whether a line should be short or long or what should be done or whether I should do this or that, but I knew that I would find some way to continue. And mostly it was through perseverance. Through a kind of . . . when the problem became, as it were, insoluble, then to just stick with it until the solution appeared.

JR: Breathing. You said the flow was more about breathing than time . . .

JC: That's why I use these apostrophes.

JR: Which gives another overlay of form.

JC: Yes.

17. The word "just" occurs in the source text (Johns' original statements) only once, in the first line. The 50 percent mesostic program, searching in the source text for locations of the letters in the string being used in, for example, Section 7, "AN ARROGANT OBJECT . . . ," came to the "J" in "OBJECT" (13th line of Section 7) and located the first "j" in the source text that conformed to the rules of non-repetition of the next letter in the mesostic string. This turned out to be the "just" in the first line of Johns' statements, "Old art offers *just* as good a criticism of new art as new art offers of old." The "wing words" to which Cage is referring are all the words in that line on either side of the word "just." In principle, Cage could have used any of the wing words that did not violate the mesostic rule. In this case, where he was using the rule of the 50 percent mesostic, that meant he could have used any words up to "new," which could not be used because of the "e," which is the next letter in the mesostic string, i.e., the "E" in "OBJECT." That Cage chose to use only "Just as" has to do, as he explains, with stylistic concerns, not chance.

JR: There's the vertical movement down the page, there's the horizontal line length, and then there's that undulating breath spiral charted by the apostrophes.
JC: Yes, and you see this, now, is quite nice,

<blockquote>
reserve i Think

is perhaps dependent on real things i'M not willing to

arts thE terms '[18]
</blockquote>

to turn that word "arts" into a verb. Isn't it? It's quite nice. Weren't those called spondees, when everything is accented? That's also like a complaint, isn't it? *(laughter; reads on, 15 lines down the page)* . . . "In painting it would amount to / constant negation of / painting.'" That's very exciting, isn't it? And I think he [Johns] would say that's exciting, hmm? In fact—and he didn't say that, hmm?—but it's in the spirit of what he might be thinking . . . I think.
JR: There's so much of that in this.
JC: It happens.
JR: Did you find the pauses and the stresses by reading it aloud?
JC: By reading it, by improvising. But that was partly found by writing it that way. My practice to begin with was to write it without those pauses. But to write it because I was making the pauses as I was writing it. But then of course forgetting them, and then having—when I finally decided to put them in—to then read it [aloud] and put them in. And that happened while I was up at Harvard—that I recognized the need to put them in.
JR: One thing the presence of the apostrophes does is to stabilize the meaning of the text—
JC: There's greater ambiguity without . . .
JR: Yes. And I'm wondering how you feel about that.
JC: I would rather—I . . . I feel . . . ambiguous . . . ambivalent! *(laughter)* I like ambiguity more in terms of a number of readers, because that would enable different readers to find their own breathing. But if I have to be the reader, then I like better to put the things in so that I know what I'm doing. So, actually those things are for me more than they are necessarily for someone else.
JR: I don't feel they're a dominating set of instructions.
JC: Sometimes I use them to take something too obvious out. Let's see if I can find . . . for instance, "It / became' a conStant negation of / myself . . ." That probably is some kind of refrain. And so I wanted to stop the refrain, "my work to haVe some **than** / It became' / my work to haVe some **than** / It became' . . ." What is fun is when—you see, in each one of these thirteen sections there's the string, which is [picked out] by chance, and then the total amount of the source material changes, and the source material changes for that section. So, when the

18. Page 11 of this volume. Emphasis Cage's.

material is very slight . . . then you get this ceaseless repetition. There's a very funny one, you know, where it's just repeated over and over—"the psychological . . . infantile and psychological." And that was the only source material there was.[19] So that's why all the repetition. [Section 11.]

JR: I know you've thought a lot about the structure of DNA, relating it to the sixty-four hexagrams in the *I Ching*. The visual outline of the mesostics on the page reminds me of the helical structure of DNA—wing words bonding in the spiraling—

JC: Yes, it looks that way, doesn't it?

JR: —Around the generative letters of the mesostic strings. I wondered if that was part of your—

JC: It wasn't in my awareness, no.

JR: —The pleasure you get from using—

JC: No, I admit to liking the shape. And the variety of shapes that develop.

JR: You have spoken of the lettristic principle in your practice with mesostics. The meso-letters are formally generative. But do you think as a lettristic principle they have any content? Is there any way in which lettrism is similar to a form of numerology for you?

JC: Not in the sense of having anything to do with the content. Numerology in the case of Schoenberg *did* have to do with the content.

JR: Yes.

JC: And with the expressivity even. But I don't think of that as taking place. I don't notice it. I don't know . . . of course it must have something . . . certain letters will have, will of course draw up the same—not the same, but related—bits of the source. So they are really, actually *doing* something. But some of them are more active than others. And there are some letters that are very inactive as the word game Scrabble shows. *Q*s are impossible, for instance. *Z*s, and so on. But vowels are very active. And there's a kind of, a kind of middle ground for some letters, like *P* and *M* and *B*—between very little action [and a lot]. There's some sort of slight action, some with more action than others.

JR: You speak of the letters "drawing up" certain things, and that has to do with what I'm asking. If you think of the source text as a kind of oracle, as you have called it, is there a way in which the letters of the strings are the vehicle of that oracle? What does that mean—source as oracle?

JC: I don't know . . . I try in general to use the chance operations—each number that I use, I try to have it do one thing rather than two things. And I don't know if this has anything to do with your question, but I try to, try to get an event divided into all the different things that bring it into existence and then to ask as many questions as there are aspects of an event—to bring an event into being,

19. As determined by the IC computer program, designed by Andrew Culver to simulate the coin oracle of the *I Ching*.

hmm? So that one number won't bring two parameters into being, but only one. That is toward a kind of confidence in the uniqueness of happenings, hmm? And then taking what happens. But slightly changing it through the breath-ing—placing of those apostrophes—and the accents. And of course the omission or inclusion of wing words. Very strong things happen when you minimize the wing words.

JR: What do you mean?

JC: What's an example of that? *(leafs through I–VI)* I had the feeling, probably mistakenly, that I was learning how to do this, finally—you see—when it was almost done. *(laughs)* And you can see, through the shape, there are fewer words [toward the end of Lecture *VI*] and in some places it will be extremely that way. That was not taking any of the wing words, or very few of them. But again, not making a judgment about "we will have no wing words." Here [earlier in *VI*] there are a lot of them.

JR: When you say "not making a judgment" about it, what do you mean?

JC: Well I could have elected—even through chance operations I could have elected—to minimize or maximize wing words. And I could have known when I was starting to write this that I had to have lots of wing words. But I wasn't working that way. I was working by improvising and trying to find out what the words wanted, how they wanted to work. I was trying to do that.

JR: So at this point you "found yourself" choosing fewer wing words?

JC: See, this is quite beautiful,

> Is just
> aNd also
> in the plaCe where **we**
> we **mOr**tals
> **he** iN **me**
> there iS '
> beIng even
> *I–VI*, p. 405

It just works beautifully! *(laughs)* And that kind of thing didn't work here. In fact, the opposite kind of thing worked here,

> the vertiCally
> **the** ' music is written the music' is there befOre it is '
> which we learN as children and which we
> blue iT
> nullIfy '
> if I have five ' theN I have three and two ' how do i know that **i**'
> an inanimate empty space ' . . .
> *I–VI*, p. 402

That works too. It's a different kind of thing. And then there's . . . I think at the beginning of this—the sixth lecture—I think toward the beginning I must have

had that feeling that the mesostic didn't need any wing words at all. I was moving here whenever I could toward [fewer]—and I couldn't there on page 379, which has lots of wing words—but here's one that has fewer.

JR: Could you say why you think that happened, with any one of the narrower columns? Specific to what the words were?

JC: I think the closest I can come is to say that when I read it, or when I *voiced* it, or *breathed* it, that the breath worked—without wing words some times, and with them other times.

JR: Does this have anything to do with the sort of thing [Charles] Olson was involved with?

JC: I'm unfortunately not sufficiently aware of his "projective verse." For me it has to do with my notion of . . . of music, I guess. Where this becomes most musical is in these sections which get repeated, because it—and now I'm saying music in the most conventional sense, because Schoenberg said that music *was* repetition—repetition and variation. And he said variation is also repetition with some things changed and others not. And in *IV*, *V*, and *VI*—and we're now in *VI*—there is, through chance operations, a section which gets repeated.

JR: While you're looking I'll turn the tape.

JC: . . . This one,

<pre>
as an apple tree or an oak shall he turn hIs
 suddeNly
 Drought
 matErial
 Thing to
 hEalthful
 tuRn'
 whence coMes
 thIs
 aNd
 A '
 why should we be in suCh
 thoughts go through mY head
 I–VI, p. 291
</pre>

and then the whole thing gets repeated, "as an apple tree . . . ," and then you know you're in the world of music. *(laughs)* I mean if you didn't know it to begin with. *(laughter)*

JR: The theme-and-variations structure is so striking in this work. Have you done any non-linguistic, musical compositions that use a theme-and-variation structure since doing these? Is your purely musical composition influenced by your language compositions?

JC: What I've done that relates to these and goes off, say to music, is—perhaps the best example is—using a source material, a source that I don't understand at all as language. And it was a poem of Hesse which happened to be a favor-

ite poem of the book publisher Siegfried Unseld. Do you know his name? Ulla Berkewicz, who is now married to him, asked me, for one of his birthdays, like fifty or sixty or something, to write—and he had asked me earlier—to write some music on one of Hesse's poems. But I didn't like the poem that he likes. And it was all right in German because I didn't really understand it. But he loved it. It was his really favorite poem. So I gave it to the computer and I did this kind of material with it. Except, I put the whole poem of Hesse as the string down the middle. And I gave the string only itself as source material.[20] So that all that gets said in the lines is the same thing over and over and over again, hmm? In German. Not the same words, but it's from the same poem. So, the poem loses itself by using itself, hmm?

JR: It consumes itself in the form.

JC: It consumes itself. *(laughter)* So I then made an arrangement through chance in which different people read. Any number could read. I put it all in stanzas and the stanzas were never say more than three or four lines. So in a single minute each reader could find one stanza and read it any time during the minute, hmm? Then in the next minute any other stanza, or two, as the case may be. And that was read to celebrate his birthday and of course he was delighted because these little fragments of his favorite poem kept cropping up, out of context, out of rhythm, everything—but making some kind of music, you see?

JR: Was it beautiful in this new form?

JC: I wasn't there, but I'm told that it brought tears to his eyes.

JR: I can imagine that for someone not familiar with the poem, so that it would invoke neither dismay nor nostalgia, it could be a beautiful piece.

JC: It could be interesting, yes. . . . I've done that with a number of languages—Spanish, and German . . . and I've even done it with Japanese. Toru Takemitsu in particular asks me, or [that is] other people ask me to write about him, for one birthday, or for one reason, or another. And that's how I originally used mesostics—in order to answer commissions like this with respect to birthdays

20. This is an example of what Cage called an *autoku*, or "self-generating haiku." Andrew Culver pointed this out to me. It means that the mesostic strings are composed of statements from the source text which in turn "searches itself." What results is nothing but "repetition and variation," Schoenberg's definition of music. Culver says that, after his first use of the autoku method, Cage was excited and delighted. He exclaimed, "It's so musical!" Though Cage generally eschewed repetition and variation, even as principles of musical composition, because he felt they led to predictable results, in this case, chance ensures that the element of surprise remains. So, for instance, he particularly enjoyed Section 11 of "Art Is Either a Complaint or Do Something Else" because the chance-determined string "My experience of life is that it's very fragmented . . . ," acting on a limited amount of chance-determined source text, produced the most musical (fugal) part of the piece. The limited source text also caused this particular meso-string, MY EXPERIENCE OF LIFE IS THAT IT'S VERY FRAGMENTED . . . , to enact a fragmentation of itself, since there were many more cases where no words could be found to comply with the 50 percent rule than there would have been with more source material.

and celebrations—and it enabled me to do something relevant without knowing what I was going to say, you know? And not having to fall back on clichés of sentimentality. So I have written even in Japanese by searching for characters that belong to someone's name, and then searching for them in a text of his.

JR: And you've done this search yourself, not using a computer?

JC: Myself. Of course, having a kind of guide or assistant in the language. I didn't have an assistant in the German language, nor do I when I do that with Duchamp's work in French. I know more French so I can tell where my mistakes are. The big problem in the European languages is the presence in French and German of the sexes, whereas we don't have that problem in English. But apparently the French and Germans are willing to give that problem up. I mean they're not offended apparently by misuse. It doesn't seem to disturb them anymore.

JR: Huh! That's—

JC: Unexpected, isn't it?

JR: Unexpected, particularly for France.

JC: But I think they see that it's rather silly. That if barbershops are willing to have only one sex—

JR: Then so can—

JC: So can language. *(laughs)*

JR: To return to the question of "oracle," what does "oracle" mean in the sentence "The source text is used as an oracle"?

JC: What does oracle mean? Well, the source text is the one who's going to speak, so, chance operations are used to find what it says. Say for instance it says "the" or "a" or "and" *(laughs)*—that seems very stupid. But it's for that reason, and mostly for that reason, that I've put in the program that the source text must identify at what point it said that. So that we know *which* "and" among all the "and"s in the source, which "and" was speaking. And that makes a difference to the wing words that are available.

JR: So you've programed a smart and knowledgeable oracle.

JC: Well it at least can tell from which part of the source it's speaking.

JR: What about the traditional association—

JC: With oracle?

JR: —With oracle, which is prophecy . . .

JC: Yes, I hesitate to say anything because there I would go along with Duchamp, that the final speaker is the listener. And how the listener is listening we don't know, because he or she hasn't done it yet. So we don't really know what the significance of anything is until it is heard. Isn't that true? That every person responds in their own way? It must be true.

JR: It certainly moves into Wittgenstein's notion of meaning as use—the listener then enacts the meaning through its use.

JC: Yes, the work of art, as Duchamp said, is finished by the observer. I think

it's true. I, at least, believe it . . . to be true. And it explains so many things that happen that otherwise would be intolerable—that is to say, many books on the same subject all in disagreement. *(laughter)*

JR: What about your conscious choices of words like "to 'make' a poem," or "to 'make' a lecture," rather than "to write"? I've noticed that you tend to say "to make." Why?

JC: Here I think I need an instance.

JR: Well, in here [*I–VI*], when you speak of the process of putting the lectures together, you always say, "when I made this lecture" or "when I was making . . ." instead of "writing." You've spoken of "writing through a text" elsewhere, but here, I don't think you use the verb "to write."

JC: "Making" is more inclusive, isn't it? For instance, it would include breathing with writing, hmm? It could include other things than just writing. It could include breathing . . . it could even include listening, so one would "make" a text partly by writing, partly by breathing, and partly by listening, don't you think? "Making" seems to include more variety of possibilities, of kinds of action. That could even include, for instance, assistance from the computer, hmm? or calling upon the computer, or chance operations. Whereas "writing," if I said I was "writing" something, that would leave out the fact that I was using a computer, hmm? Or one would have to say, while I was writing this, of course, I used a computer.

JR: You speak somewhere of liking the fact that Wittgenstein spoke of "doing" philosophy.

JC: Yes, I like that very much, don't you?

JR: Yes, and it seems to me—

JC: —To fit.

JR: —That "making" in the way you use it is a similar sort of thing. *(pause)* Back to the question of time—I know in your musical compositions you factor into the computer program silences, and that of course has a good deal to do with the way in which the listener experiences time. Is there any equivalent to silence here [in "Art Is Either a Complaint or Do Something Else" or in *I–VI*] in your poetic composition?

JC: Not here, but there could be if there were a performance given of this, as was given of the German poem where [each reader] did so many things in a minute. Or if, say, during a question-and-answer period, after having given this, I then passed out this lecture to everyone in the audience and I said, now you can do it all together. And you just say one—it would be hard here—one thing between two of these apostrophes, any one thing between two apostrophes. One phrase, in other words. Then it would work. And you would get a spatial time event that would be fascinating to hear. And especially when the people had all heard, or had access to, the material. This would then become the material, or the source of something else that had more to do with time than this has, hmm? What I'm

trying to say is, if I make time brackets, or have time limitations—which I didn't have when I wrote this—then time would enter.

JR: I think time can become space on a page.

JC: Yes.

JR: That silence is the white space.

JC: Yes.

JR: The gaps, and unfilled line space on either side of the centered text. That is one way I experience silence in this text. I wondered if you—

JC: No, I didn't do that. And, because of that, I put in these apostrophes.

JR: You often say that the principle you operate by in composing is to not make choices, but to ask questions. This work has involved both, more so perhaps than in your musical compositions? In your decisions about the wing words it has been—

JC: Both choice and asking questions. Yes, I think that's probably true. As you may have noticed, the people at Harvard were very puzzled over my saying "And then I take out the words I don't want." They didn't see how a person using chance operations could afford to do that. *(laughter)*

JR: And remain pure of heart? Does it have something to do with the fact that this is language and not sounds, not noise? Is there a kind of—

JC: Yes, you see, if it were sounds, I would have been working in a different way. I would have been paying much more attention to time, hmm? I mean when the sound was being heard, arranging for its freedom to be in what I call time brackets—spaces of time, hmm? Here, I was paying attention to what I thought was the nature of language.

JR: Which is?

JC: Well it's full of all sorts of things, like we said—sounds and meanings. The sound sometimes becomes so powerful that one can put meaning aside. And vice versa.

JR: Can you imagine doing something now—with your mesostic poetry—like the work of Jackson Mac Low, in which the intentional semantic dimension gets entirely suppressed in the compositional methods? In some of his work—

JC: Yes, it's quite amazing and marvelous what he does. And I think he's able to go on a richer exploration than I.

JR: Why do you call it richer?

JC: More differences. More kinds of differences. And you can tell that very much from the difference between my writing through Ezra Pound's *Cantos* ["Writing through the Cantos," *X*] and his; his one about endings and so forth. [*Words nd Ends from Ez*] And I still don't understand what he did, but I admire it deeply, what he did, and what happens as he does it. The thing that gives me courage to continue in spite of the fact that he's working is that he tends to use a more restricted source, a more limited source, a more defined source. And I tend toward a multiplicity I think. And—well, I don't really know that I have much to say

about that difference. His work . . . but, I love his work, and somehow I think that I'm doing something sufficiently different so that I have a right to do it.

JR: Last night Jackson was showing me a procedure in which he uses language from some of his intuitively written poetry as source text for new poems subject to chance operations. He's running the source poems through two consecutive computer programs—DIASTEXT and TRAVESTY.

JC: It's the nature of the program . . .

JR: It's the nature of the program to rearrange the language and make selections.

JC: And it's with respect to something he's already written, hmm?

JR: Yes. Once it goes into the programs, he gives up choice except to select out clumps of lines pretty much, if not entirely, intact. In other words he notices and separates out poems in the continuous readout that the second program gives him. Last night as I was looking over his shoulder he said, Ah, there's a short one! He took out five successive lines and used the first two words of the first line as the title, so he had that poem. The kind and degree of choosing in this particular procedure[21] seems very different from the kinds of choices you're making now in your mesostics. This particular procedure, as I understand it, appears to have no semantic relation to the source text.

JC: "No semantic" means the connections of one are different from the connections of the other?

JR: Yes, there's no attempt to "be true to" the spirit or the meaning of the source text in the way you are trying to be. It strikes me as very interesting that you are exploring similar territory and yet—

JC: Working differently. I think we're very fortunate to be living in a period when poetry is more interesting, more useful than it has been. I'm astonished at the number of things I receive in the mail that are actually readable. *(laughter)* And enjoyable. There's a little magazine—have you run into it?—called *Lynx*. It comes from the Northwest and it's a journal of renga. And, there's another field where the kind of poetry has been, I would say, inferior [as] practiced in the United States. That is, haiku and renga and things like that have been taken over by the sort of artsy and craftsy people, hmm? It's a very difficult thing to do. I suspect that in the use of those [Japanese] characters there's more ambiguity than there is in the use of English words. Apparently you can take a few characters of Japanese, or Chinese, and not know for sure what's being said.

JR: I learned that from you in the introduction to *Themes & Variations*, where you say there isn't the same mono-directional syntactic order in Japanese.

JC: Right. And we need to change our language if we're going to have that experience.

JR: I agree that this is an exciting time for poetry, and particularly in this country.

21. One which, as Jackson Mac Low put it in a phone conversation, "involves minimal editing, but no decision not to edit."

JC: Yes, you can actually read what you find.

JR: And I think a lot of what is good and readable is related to your work.

JC: Don't you think the idea of working with language in an exploratory way is in the air? And many, many people are doing it, and, as you said, in different ways. That's what's so refreshing about it. It's not as though it were a tic on the part of one person.

JR: I see links with the turn-of-the-century Vienna that spawned Wittgenstein's and Freud's fascination with language, and Karl Kraus too, who was doing analyses of public uses of language. It was a time when public usage had become frighteningly detached from a sense of reality—was no longer helpful in trying to figure out what to think and how to live in the world situation that was developing—very much in the way our language appeared, from Vietnam on, to become increasingly detached and skewed in the public arena. There seems to be some sort of dialectic between public use of language and what poets begin to feel they need to do—those who feel the need to explore the medium of language itself. . . . Poets often feel that audiences are much more resistant to experimentation with language than they are to experimentation with any other medium. Part of that seems to have to do with an almost biological conservatism about language—because of the sense that you have to use it in practical ways, for survival.

JC: To make sense.

JR: To make sense. I wonder how you feel about that?

JC: I think this actually benefits poetry now, that conservatism. Because it enriches the field in which one can work. You don't have to search for things to do. You can do so many different things . . . to bring about change. It's because of the fixity of convention, that the unfixity of experimentation is increased. *(laughs)* It's . . . it's a rather silly idea to express, but it makes the field of possibility greater.

JR: Do you have a sense that the medium [language] itself is somehow resistant in any way? Does that ever feel like a limitation to you?

JC: Not now. It probably did to begin with. It's actually through Jackson's work that I was stimulated to do as I'm doing. And Clark Coolidge. Both of them.

JR: You were in touch with their work around the same time?

JC: Yes, I gave a class in experimental music composition at the New School for Social Research, and Jackson was in the class. The major activity of the class was the performance of the work of the students, and Jackson always had done something, so we heard a great deal of his work.

JR: And how did you come across Clark Coolidge?

JC: He made a magazine—I don't now remember the name of it—I think when he was still at Brown University as a student, or maybe he was a teacher or a graduate student.[22] But he began a magazine up there and that was how I began

22. Clark Coolidge was working in the library at Brown. He said in a telephone interview that it has always surprised him that Cage credits him with having any effect on his work. Coolidge

"Diary: How to Improve the World"—it was for him. And it tells that in A *Year from Monday* and says what the name of the magazine was [*Joglars*, Providence, R.I., V. 1, No. 3]. He wasn't yet known as the poet he is now. And you see what I did for him was not in any sense what I'm doing now, but it did go into another field than I'd been in. So when he saw what I had done, he said it was a kind of a breakthrough. And all it was of course was that I was fragmenting the text and then writing it, not linearly, but according to how many numbers of words I needed to write. I would frequently write near the beginning, and then near the end, and then in the middle, and so on until I got the whole thing filled up. That was a different way of writing from this. This is back to a kind of—you could say it's a chance-controlled linearity. But, coming from different parts of the source text, it has a curious kind of globality which is not linear. It's like, you said this a moment ago too, it seems to be this *and* that—to combine different kinds of qualities.

JR: Well it seems to have multiple vectors.

JC: Uh huh. One thing I like too is that from poem to poem there will be, because of the difference and sameness of the source texts, there get to be resonances here and there of different things in different lights of different things. But that, Joan, is in terms of what we call content, or meaning, and where I would say that it's different for every person reading it who recognizes how it hits them. And the same thing will hit two different people differently.

JR: Do you feel that absolutely? If someone attends closely to this text—

JC: That two people will feel differently?

JR: —And someone else doesn't attend closely, could one "get it wrong"?

JC: No, because it isn't right to begin with. *(laughter)*

JR: What do you mean by that?

JC: Well, I probably am not being honest. Because, relying on the breathing would make me want it to be one way rather than another. And there is something of that in it. But the fact that there's no ordinary syntax in it makes it so that someone reading that breath could feel it differently. And then the question is, is the one breath—the one I had—right, and someone else's breath wrong? I don't think so. *(pause)* It's hard to say. Or to say honestly.

JR: To say honestly . . .

JC: With *certainty*. With certainty.

JR: Critics and educators are concerned about this question: is there a totally

approached Cage after a concert in 1965 or '66 and asked him if he would contribute something to his magazine. Cage replied that he didn't have anything. Coolidge says he was completely surprised at what eventually came in the mail and that the truth of the matter is that Cage influenced *him*: "*Everyone* was influenced by Cage. Everyone read *Silence*, saw Cunningham—there was a 'climate' of chance. So even if you didn't use dice you had a sense that nobody owns the words. The whole New York school of poets was doing collaborations, using found language, cut ups. . . . It changed the way of thinking so you could make, not simple free association, but something else that let much more into the poem than before."

open field of response to a text, or does the nature of the text delimit an "appropriate" range of response? Is it that whatever you feel at the moment, whatever comes to mind when you are experiencing a text *is* the meaning of that text? Or do the particularities of form and content have some kind of stabilizing effect on meaning? So that it is possible to get it wrong in a way that it might not be possible to get a piece of music wrong—just because a text has a cognitive component. You might misunderstand something.

JC: Because of the nature of language.

JR: Yes.

JC: *(long pause)* I, I'm inclined to think, oh, that each way of hearing it is right. I'm inclined that way. I can't see anything wrong in each way's being right. *(laughter)*

JR: Do you have a sense of being a realist as an artist? Actually, what I have written here [in preliminary notes] is, "Will you say something about your 'complex realism'?" Does that term sound right to you?

JC: Yes. Yes, I think so. One of the first persons to draw this kind of feeling to our attention, or my attention, was Mondrian. He spoke about reality. How did he say it, do you know? He wrote a number of very interesting texts about his work, I mean his late work. And he was objecting to representational art as being . . . realistic work as being . . . too abstract. He said that representational work was too abstract. That he required realistic painting like his own. *(laughter)* Yes, it goes that way. It's very impressive. And when you agree with him it's very mind-opening. Because you do see that representational painting, is, as Jasper says, a tragedy *(laughter)* and that he much prefers the real thing—the real fork. And what Mondrian wanted to paint was *really* what he was painting, hmm?—that couldn't be mistaken for something else.

JR: You spoke in the seminars [accompanying the Norton Lectures at Harvard, and transcribed in *I–VI*] of science as a corroboration of your work.

JC: I was thinking of this book that I haven't read *(laughter)*—the "chaos" book, you know. It's in the air. We know enough that the book exists. And we think of that as being a kind of corroboration. It makes using chance operations seem not foolish, hmm?

JR: Yes. For me it was corroboration of an aesthetic of complex realism. Does the term "strange attractor" [from chaos theory] mean enough to you for you to have an opinion on whether the working, composing mind is in some sense a strange attractor?

JC: Oh tell me a little bit about that.

JR: Well, this is how I'm trying to understand it, one question with chaotic patterns is why or how they manage to have elements of both randomness and order. There's pattern there but not predictability in the sort of system that is subject to the "butterfly effect." So, generated by a set of nonlinear equations and a computer time-development, you might get a pattern that you can see is a bounded

system, but the location of any given point within that system as it develops is unpredictable. The organizing principle in a nonlinear pattern like that has been called a strange attractor. Since the human mind is itself a complex system whose neural networks are characterized by open-ended unpredictability (the normal human brain produces *irregular* neural impulses, which some scientists feel is what accounts for our ability to work in an open-ended way on long-term, complex problems), I wonder whether in its organizing of experience within certain kinds of complex aesthetic procedures, the artist is allowing the mind to behave as a strange attractor.

JC: Well, that of course leads toward habit, doesn't it?

JR: Well, it would lead away from habit if it were truly a strange attractor.

JC: So this would change distinctly from one thing to another?

JR: Yes, it would lead to constant change, though within a bounded system. Within an overall recognizable pattern there is constant change in all the details, which is why a complex system like weather, for instance, has large recurrent patterns but becomes less and less predictable as you try to pinpoint it locally.

JC: I'm led to think of a discussion I had with Pat Colville. She teaches painting at Cooper Union. And she was down in North Carolina when I was making edible paper.[23] We got to talking in one circumstance or another about the work of Mark Tobey, which is characterized by a great deal of variety from one painting to another. So much so that he used to refer to himself as America's Picasso. He went in so many different directions, as Picasso did. As we got to talking, we went from the white writing of Tobey which is not always pure, is very rarely pure—I had one, I think I told you, which had no representation, or no abstract character, as Mondrian might say *(laughter)*—to the work of Robert Ryman. He's devoted his life to white painting. It's very beautiful. I was unfamiliar with his work until last year when I, late this spring—maybe April—I saw a factory in Schaffhausen near Zürich where the top floor was full of a retrospective show of Robert Ryman's work. It's all white. His exploration of white has continued over his entire life and of course is very extensive. He puts white on a variety of different materials. So he's had an experimental relation to white in the world of painting that exceeds that of Tobey who earlier did it, you see, but didn't do it, so to speak, faithfully. He didn't do only that. He did more, different kinds of things. So we were wondering, had Tobey not been so Picassoid *(laughter)*,

23. *Wild Edible Drawings*, 1990, "Suite of 12 handmade papers, Edition of 6, in boxed portfolio, Published by [Cage], Beverly Plummer, and Rugg Road Papers and Prints, Boston . . . were made from the edible components of twenty-seven plants collected in the mountains of North Carolina in August of 1990 and selected into 'recipes' by the *I Ching*." Ellsworth Snyder and Patricia Powell, *John Cage: Works on Paper, 1982–90* (Madison: University of Wisconsin, Elvehjem Museum of Art, 1991). Cage heard from a Chilean friend that destitute people in Santiago were soaking discarded newspaper in water, in an effort to remove some of the ink, so that it could be eaten. Because "this is the kind of world in which we are living," Cage said he wanted to see if paper could be made that really could be recycled as food.

would he have been a better artist? Sounds silly, a proposition like that. If he hadn't been who he was, would it have been better for us in terms of white painting? A perfectly silly thing, but as we were thinking along those stupid lines we realized that the idea came to him, so to speak, in the same way that it came to Robert Ryman—out of the air, hmm? He did—because of the time, perhaps, that it came to him, in relation to all the other things that came to him—he did it as . . . he did what he did. And we're grateful. It's a question then of forgoing the thought that it would have been better for us had he done more than he did.

JR: So, interestingly, that came to your mind after my talking about the mind as a strange attractor . . . and weather systems . . .

JC: And I really couldn't tell whether the strange attractor was subjective or was "in the air." And I don't know whether you mean it to be one place or the other.

JR: Well that's an interesting question.

JC: Yes, we don't really know where it is, do we? Because the mind in Buddhist terms is part of the air, so to speak. Which is Mind with a big *M*, hmm? So the little—*this* mind and *that* mind—are *Mind*, and there's a communion, hmm? In other words, there *can* be a flow. In fact there must be one, otherwise we can't explain the fact that several people invent the same thing at the same time independently—or that these two artists deal with white—satisfactorily—over a shorter or a longer period of time, earlier or later.

JR: So in a way that would be like those two minds having similar local weather within a larger pattern. That's interesting, because I was—I think you picked up on it—I was thinking more in terms of the mind creating the weather patterns rather than being subject to them.

JC: It could go in one direction or the other.

JR: In this respect I'm thinking about Jackson Mac Low, and connections between your work, along with the earlier question of time. Jackson talks about five temporal arts—music, dance, poetry, film, and video.

JC: That's very good.

JR: That interested me because, though I think of poetry as involving time more than any other form of writing, I have been approaching it lately graphically too—as a spatial art.

JC: With Apollinaire it could go in the other direction. It can be in both. But this is close to Indian thinking. I forget what they call it, but there's a term for the temporal arts. Of course they weren't thinking about video. But they certainly thought of music and dancing—those are the two that make it real, don't you think? And poetry.

JR: Yes, and *this* complex realism seems so far from the contemporary fascination with various forms of irony. (*pause*) Has irony as a vehicle of change, in the Kierkegaardian sense—as a mode that can move us from aesthetic to ethical to religious perspectives—has that played any part in your thinking or your work? (*Pause.*)

JC: What I'm trying to do now is to think, if I can, of what causes one such change in one's work, hmm? that leads one to change? I have a sense of changing now. It's a very peculiar thing. It will be hard for me to describe, and I don't see the connection of irony with it. I don't know. In the case of music composition there tend to be repetitions, as I've pointed out with respect to *I–VI*. Or there can be variations. In other words, the same material can appear in different lights, or different connections can be established between the same things. We've spoken about that. So that we could come to the conclusion that music had to do with repetition, hmm? As Schoenberg did. *(pause)* I have the feeling now of not being involved with any such things, hmm? *(laughs)* And I can't say that I feel involved with any feelings, because I want those to stay where they belong, in the listener. And I don't have any ideas, that I'm conscious of. I am conscious, say, of being asked to write a piece for a pianist who wanted something like a piano concerto, hmm? So, conventionally, that would make the piano more important than any of the other instruments with which it was being heard. That then was the only idea I had . . . so I wrote a piece in which the piano played all of the time, from the beginning to the end. Whereas the other instruments played only when chance permitted them to play. Other than that—that is to say, the piano playing all of the time and the other instruments only playing when chance, so to speak, permitted them to play, so that there would be gaps in their performance—I had no idea about what each one of them was playing, nor even what the piano was playing. And certainly no idea of repetitions or variations. In a subsequent piece, which I haven't heard yet, also for a number of instruments—actually, seven instruments—no instrument plays all of the time. But I thought of there being a melody which would be . . . or there would be a series of the seven instruments, arranged through chance operations, so that that series would be, so to speak, a melody that would go through the piece. For instance—to form, through chance, so many time brackets of one of them, followed by so many time brackets of the second one of the seven . . . until you would end the piece with the time brackets of the seventh one. That would be the only idea. Otherwise one didn't have any ideas about the notes that would be written. Now this is a change, from a way of writing in which one distinguished one thing that was being written from another. So that one thing that could be written, for instance, could be a part of the music, could be just one tone which would be itself repeated. Or, another passage in which everything would be written without repetition. And those two situations would be different. They could be given different names, like A and B, and C could be still a third idea. Such things are no longer happening in my new work. Now . . . I feel better, writing this way than I did writing with ideas, hmm? Or distinguishing one part of something from another, hmm? I feel better not knowing what I'm doing. Now if that involves irony, I don't know how, I really don't, but that's how it is. Am I making any sense?

JR: Yes. Yes. And I don't pick up anything about that, or how you got to what you are doing now, that's ironic. Though there are probably many people who think *4'33"* is ironic.

JC: They do?

JR: Yes. I'm trying to think if I ever thought it was ironic. I don't know. Do you think it is?

JC: No, I just think of it as listening to the period of time when there aren't any sounds being produced. And so I listen to the sounds that come into the situation—whatever it is. And I listen to them with as much attention as I can. And of course I don't know how good my hearing is. I don't know whether I hear it as well as I would have heard it forty years ago, when it happened. *(laughs)* Now I think of it more in relation to the world as a whole. And I have another form of it which brings the silence of the room up to the level of feedback but doesn't allow the feedback to be heard, only sensed, so that you realize that you're in an electronic situation that could be painful. But isn't, hmm? But could be. And in that highly electrified silence I then leave the stage and go and sit in the audience and experience it for an unmeasured length of time. And then, when I've had enough, I go back to the stage and that's it. What's in my mind—it might have some irony—but what I think I'm showing is that we have changed the environment, and that it's no longer . . . it's now a technological silence, hmm? that now silence includes technology. In a way that is not necessarily . . . good. That could involve, hmm? irony? Or something like criticism?

JR: It could be experienced in that way. What I'm realizing as I hear you talk about this is that of course any member of the audience might experience this as ironic in relation to, say, their expectations or their sense of some sort of conceptual ground, and this might act as a shift of perspective for *them* . . .

JC: I did this in Japan, and a month or so later I received a letter from a Japanese student who said that he had heard that modern music was very difficult to understand, but he went to this concert and he doesn't find it difficult at all. *(laughter)*

JR: Has it been your experience that in Japan people's ears are better prepared for your music?

JC: No, this is just this particular fellow. No, I don't think of people as being nationalistically better. I do think there may be a difference between the Japanese mind and the Western mind. You've heard that, haven't you? It has to do with language—vowels and consonants. Apparently we process vowels and consonants on the same side of the brain. Did you know that? And the Japanese mind is different. They process consonants on one side and vowels on the other. The result is that nothing is meaningless to a Japanese mind. *(laughs)* Isn't that marvelous? This is how it was explained to me. Whereas we only think things are meaningful if they come to one side of the brain. If they come to the other side of the brain they're nonsense. *(laughter)*

JR: So for the Japanese both sides of the brain are constantly being—

JC: Involved by language. When I say that of course I don't know what I mean because I don't know Japanese. And then I was told a thing that makes it even more confusing, and that is that some Japanese minds work the way ours do. And some of our minds work the way theirs do.

JR: That's very interesting. I'd love to find out more about it. Actually, earlier you were talking about feelings and where they belong—in the audience, rather than in the work—and of course with a piece that involves words, a good deal depends on how the culturally (and perhaps even genetically) constituted mind responds to language—and the degree to which it is able to free itself from habitual responses. For instance, will your transparent book require a mind that works in new ways to read it? Would you say something about this project?

JC: It's a piece called *The First Meeting of the Satie Society*. The parts are all presents for Satie. There is a particularly long one that I wrote, and there are seven presents altogether. If they were all printed on handmade, heavy paper, you'd have to have pushcarts to push it around. That led us to very light paper, and the transparency is leading us to finding a way of printing where you'll be able to look through the book. And it fits the kind of writing, because the writing is non-syntactical, so that when you see the words not making ordinary sense, but floating, so to speak, in space, it seems right. It's been many years in process and it may never get realized. But if it does it will be beautiful. It will have illustrations by different artists. Jasper Johns has already made the illustrations for the Duchamp present to Satie, and my presents I've made with smoked paper. Or they will be made that way. So that through this book you'll see these images of smoked paper. It will be very beautiful.[24] And then Robert Rauschenberg has done the ones that will be connected with Chris Mann. Do you know his poetry, Chris Mann?

JR: No, I don't.

JC: From Australia. He begins with a language, or with a spelling, that is not conventional. . . . There's not much disappearance of syntax, but there's certainly a disappearance of spelling. *(JC goes to find some of Chris Mann's work, brings it to the table.)* He used to publish on big sheets. The first one I ever saw was very beautiful to look at. This doesn't seem to be as beautiful as that seemed to me. Partly because the first one I saw, you'd have to unfold it, and there would be a huge square of poetry.

JR: How did you come across it?

JC: Through my music copyist. I went to his office one day and on the wall, like a picture, he had this poem. And he knew him [Chris Mann]. Here's a nice thing

24. This project currently exists in three forms: a bound set, in a glass-and-metal valise, designed by Cage as an homage to Marcel Duchamp; a loose set, for exhibition in galleries; and an electronic text on the Internet, whose availability Cage arranged because material access would necessarily be restricted by the high cost of the print editions.

he's written, "anyway you can always put language down to experience." *(pause, turning pages)* This is interesting—it's called "Points on a Line."

(JC and JR continue looking through samples of Chris Mann's poetry.)

JC: One of the things that Satie said was, show me something new and I'll begin all over again. I thought that he would have been interested in seeing this poetry. And so I imagine Chris Mann giving Satie a present, you see, and then, using this poetry as a source material, I wrote presents to Satie on strings that had to do with Satie's music. That was how it came about. Then I got Bob Rauschenberg to illustrate it.

(JC and JR talk about its being time to stop.)

JR: How shall we proceed with editing this? What I'll do initially is transcribe everything just as it is on the tape.

JC: Don't you think you'll find out as you do it what's interesting and what isn't?

JR: I'll talk with Rod Smith about how much space we'll have in the issue.

JC: Well, when you find out your limitations, apply them to the material that exists.

JR: I'm still tempted, perhaps at the very end, to try out the principle "All answers are answers to all questions" by reshuffling some of the questions and answers from these two days and seeing what happens.[25]

JC: Right, very good. Do that. Like you told me you did at Bard. I like that, very much.

JR: I thought you would. It's in the spirit of your spirit.

JC: And it's a kind of truth too.

JR: Yes, a dislodging kind of truth.

JC: Yes, or I often use the word "useful" then.

25. I didn't do the Q and A shuffle, because in listening to the tapes from those two days I realized that what had occurred had not been primarily about questions and answers in the usual sense of replacing questions with answers. Instead, questions seemed to open up other questions; and the most interesting "answers" complicated matters further.

II

VISUAL ART

Cage's Loft, New York City
October 21–23, 1991
John Cage and Joan Retallack

This conversation begins with an attempt to sketch out a chronology of Cage's involvement with visual art. At the time, Cage said he might forget to include certain things, but we agreed we wouldn't worry because we could fill them in later when we went over the transcript. Cage died before we had a chance to do this. As it happened, we soon turned away from a historical recounting anyway. That was clearly not Cage's preferred mode of conversation. —JR

MONDAY, OCTOBER 21

JR: I thought we might start by talking about the history of your involvement with making visual art . . . actually doing this yourself.

JC: Before I decided to devote myself to music, and I promised Schoenberg that I would devote my life to music, I had painted and I had been writing music—the two at once.

JR: When was that? How old were you?

JC: That was in the late twenties and early thirties, and was the effect of the encounter with modern music and modern art in Paris. But at first, without a teacher, I began with architecture. When I left California and went to France I became fascinated by the Gothic architecture I saw in Paris. I was very impressed by it, and my interest only went to modern architecture because of a kick in the seat of my pants by José Pijoan, who had been a teacher at Pomona where I had gone to college. I had dropped out after two years, preferring travel to continuing at college. But I happened to run into Pijoan in Paris.

JR: When you say Gothic architecture, I associate that with churches and cathedrals.

JC: Yes.

JR: And that was your interest?

JC: Yes, I was studying it because I had been impressed with all the churches in that style that I saw. But instead of continuing to walk around Paris looking at the churches, I went to the Bibliothèque Mazarin. And I studied flamboyant Gothic architecture for a solid month. I was there early in the morning when they opened, and I didn't leave until they closed the doors. I became a specialist

in flamboyant Gothic architecture! *(laughter)* But because of the kick that José Pijoan gave me I abandoned it for modernism. Do you know his name?

JR: No, I don't.

JC: José Pijoan was at that time involved in something to do with current events in art for the League of Nations when they were still in Switzerland. He was a fascinating man. And he introduced me to a modern architect whose name was [Ernö] Goldfinger. And Goldfinger—ironically, I think, is the proper word—put me to work drawing Greek columns. *(laughter)*

JR: Ironic columns. *(laughter)* What sort of modern architect was he if he had you rendering Greek columns?

JC: Oh no, he was very modern. What he was actually doing was not himself designing houses, but redesigning apartments, turning old apartments into modern apartments—no matter what their previous condition. He fixed them up so that they looked modern.

JR: So where were the Greek columns?

JC: They were nowhere. They were simply something for me to do. *(laughter)* I drew Ionic and Doric and Corinthian columns. And then he would interrupt my labors *(laughter)* and send me out to actually measure an apartment that he was going to alter. I would measure it and make a drawing of it.

JR: Did he give a reason for setting you to draw Greek columns?

JC: No, no. That was simply part of my involvement with architecture. But one day he was talking to some girlfriends, and I overhead him say that to become an architect you must devote your life to architecture, and I immediately—I didn't interrupt him immediately—but the next time I talked to him I said, I have to give up architecture because I'm interested in so many other things.[1] *(laughs)* And so I did. I left that office and I—

JR: When was that? Do you remember the date?

JC: It was in the late twenties.

JR: Who were the artists whose work you were enjoying in Paris?

JC: There was a pianist, John Kirkpatrick, or was it Ralph? There were two Kirkpatricks, one is John and the other Ralph.

JR: I associate Ralph mainly with the harpsichord.

JC: Yes. So it's John, who gave a concert that included Scriabin and Stravinsky and this led to—I was given to sight-reading—to buy a book called *Das neue Klavierbuch* that had short easy pieces by all the modern composers, including Schoenberg and Satie. When, as I continued with music, and in the late '40s I was again in Paris—there having been a separation between the United States and Paris due to the Second World War—I was meeting people whom otherwise I didn't know, and that's when I met Boulez. He, particularly, was the one who

1. Cage relates what he calls "the Goldfinger-Schoenberg story," contrasting his later willingness to devote his life to music, in his *Lecture on Commitment* in *A Year from Monday*.

stood out for me. But in the twenties I was impressed by the whole thing—from John Kirkpatrick, and the way modern music sounded, to the way modern painting looked. I went to the galleries in Paris and saw the different kinds of modern art. My reaction to all of it—the music and the painting—was that I could do that too. And so I began, literally doing what I could, without a teacher.

JR: Do you remember what you saw in the galleries at that time?

JC: Oh, it must have been Klee and Picasso and Matisse . . . and it seems a bit presumptuous now to say that I could do that too. *(laughs)* But it was the way it struck me. I knew that I couldn't really draw. But I could . . . I enjoyed looking.

JR: And how did you support yourself during that time?

JC: In Paris I had done some guiding of tourists. I found that I could make my expenses very little and that way I thought it possible to travel with the money that Mother and Dad would send me.

JR: You were guiding tourists? Where were you guiding them?

JC: Oh, to places I hadn't been. But I would study the night before: What had happened? In which room?—at Versailles, for instance. I told one group—we were having a very good time and I finally told them at lunch, after having gone through the palace—I told them that I had never been to Versailles before, that I had read about it the previous evening. They said they were aware of that. *(laughter)* And they said that was why it was so entertaining.

JR: That's lovely. *(laughter)* How did you connect up with them? Did you have a job with a tour—

JC: There were companies that put us together. *(pause)* They included things like Versailles and that famous cemetery in Paris. *(laughter)*

JR: Oh, Père-Lachaise?

JC: I don't know. Is that the one?

JR: I don't know. But I read that Victor Hugo said, being buried in Père-Lachaise would be like living with the finest mahogany furniture. *(laughter)*

JC: So *(pause)* I left Paris and traveled first to Italy, and I don't think that had much to do though with my graphic work, except that I settled—after visiting Italy and North Africa—in Majorca. For a month or so I stayed there and that was where the painting began and where writing music began. *(pause)* And I met Robert Graves there.

JR: And Laura Riding as well?

JC: Yes. Yes, I met her. She was quite fascinating.

JR: So what happened in Majorca? How long were you there?

JC: I was there at least a month. And I did both—both wrote music and painted. And then there came the Depression, so I had to prepare to leave Europe and go home. Because of the Depression, my parents weren't able to send me any more money.

JR: Did you have much interaction with Graves and Riding while you were in Majorca?

JC: *(pause)* Not much, but I was interested. I had a friend I was traveling with then. *(pause)* Allen Sample was his name.[2] He had gone to Harvard University. He did a great deal to introduce me to modern literature. It was through him that I became a reader of *transition*, for instance. That had led me to Joyce and Stein.

JR: Very early.

JC: Yes. So that, I think—being involved with Stein and Joyce and *transition*—though I was glad to be with Graves and Riding, I thought I was more at home with the others. And we were staying on the south side of Majorca, whereas they lived on the north side of the island. So I wasn't frequently there. I think that's why there wasn't much exchange. *(pause)* The music that I wrote there was of a mathematical nature. And when I played it, it didn't sound like music to me. So I threw it away. Isn't that strange? I'm sure if I had it now I would be interested, but I didn't have the experiences that I've had since. And I was traveling a great deal. It would have been heavy to carry. *(laughs)* Anything I could throw away I did.

JR: Do you remember the particular mathematical—

JC: No. I had recourse to that because I don't . . . I don't hear music in my head. I only hear music when it's audible. *(pause)* I recently went to a program—I think it was music of Alan Hovhaness. He's quite unlike me. He writes very beautiful music. But he hears it in his head, and he has always done that even as a child. In the program notes, he was quoted, just the other week, as believing when he was a child that everyone was hearing music in his head. He heard it so clearly. I'm sure that's the case with many composers—that they write down what they hear.

JR: They copy down what's playing in their head.

JC: What's playing in their head. *(laughter)* Nothing is playing in my head.

JR: Luckily, or otherwise you'd probably have copied it down, too. Instead of inventing—

JC: There's a composer named [Leo] Ornstein who's very old now, older even than I am. His wife died recently, and the way he used to spend his days with her was to get up early in the morning and dictate from his head to her the music he was hearing. She would write it down. Either he dictates—now that she is gone—either he dictates to somebody else or writes it down himself. He's still writing music.

JR: Do you remember whether there was any connection between the music that you were writing at that time—that was mathematical in nature—and the painting that you were doing? What sort of painting were you doing?

JC: I thought of them as different things, different activities. I got the idea about painting, that I think comes out of the work of Vincent Van Gogh, that there is no black in nature, that everything is colored. So that you squint at the landscape

2. This man, identified as "Don Sample, an aspiring artist," is referred to by Thomas S. Hines
 in his essay, "Then Not Yet Cage: The Los Angeles years, 1912–1938," in *John Cage: Composed in
 America*, eds. Marjorie Perloff and Charles Junkerman (Chicago: University of Chicago Press, 1994).

VISUAL ART

to discover what the dark colors are . . . if you're painting from nature,
I was doing. So I was squinting a lot *(laughter)* and putting a lot of c
canvas, and I left most of that behind too. Later, when I got back to Cal
I developed a way of painting that I rather enjoyed, which was not a lot of paint,
but—and not a use of the brush—but a use of steel wool in applying paint to
canvas. The paint was scrubbed into the canvas.

JR: How did you devise that technique?

JC: Well, you know, experimenting with materials. There were quite a num-
ber of books that stimulated one—as the paintings and music had stimulated
me in Paris. One of the books was the book of László Moholy-Nagy called *The
New Vision*. And then there were various books about the Bauhaus. All of those
were very appealing—appealing about possible participation in the art of doing it
yourself. When I was very much younger, like three or four years old, there were
Valentines that you didn't buy all finished, but that involved your making them.
That's what the Bauhaus and Moholy-Nagy gave us the feeling of *(laughs)*—
making art, hmm? *(pause)* And they seem to me even now, as I think of them, to
be important persuaders toward participation, toward activity. It was in that . . .
situation . . . that I met Schoenberg, when he came to California, or when I went
to him and asked him to—Oh! I'm forgetting something that happened that's
important. That is, because of the Depression, the house that my mother and
father had in the Pacific Palisades had to be given up. They went to live in an
apartment house near the center of Los Angeles, and money was very hard to
come by. So I found a place—it was called an autocourt, actually, what we would
now call a motel. There were garages at the back where you could park your car,
and small houses in two rows where you could live. In exchange for doing the
gardening for the whole place, I was able to have an apartment, and also to have
the large room over the back of the garages where I gave lectures on modern
art and modern music. I've told you how I went from house to house in Santa
Monica persuading the housewives to come to my lectures. I said that I didn't
know—at the moment that I was telling them about it—I didn't know what I
was going to say; but each week I would prepare the talk I would give them the
next Friday. And that if, say, I didn't know very much about a given subject, I
was still very enthusiastic. *(laughter)*

JR: Were they as enthusiastic as you were about this way of proceeding?

JC: Yes, they were delighted to come. It was very much like the people in Paris,
the tourists. They . . . they preferred, I think, my enthusiasm to my—I mean
that persuaded them more than—or maybe it was that they liked the fact that I
didn't know anything. I don't know. *(laughter)*

JR: They probably thought you would know "enough," but not be intimidating.
It must have sounded like fun.

JC: That's what I thought too. *(pause)*

JR: What were you—

JC: Talking about? Modern painting—Mondrian, for instance—and music. It helped me to clarify my thinking. I came to think that it was fairly clear from a survey of contemporary music that the important figures then were Schoenberg and Stravinsky, and that you could go in one direction or the other. I myself preferred Schoenberg. And so I went to him, when he came to Hollywood, and asked him to teach me, and he said—the first thing he said was, Will you devote your life to music? And so, you know, when I replied yes—which I had not done to the architect in Paris—I then knew that I was obliged—partly because of what the architect had said—that I had to stop painting, if I was to be faithful. So that's what I did.

JR: When you made the decision to stop painting, did you continue to spend a lot of time looking at painting, or did you—

JC: I always looked.

JR: In 1935 in the United States what was there to see?

JC: To see? Well, the Arensbergs were living in Los Angeles and they were the people who were so close to Marcel Duchamp. And Galka Scheyer was living in the Hollywood Hills. She was straight from the Bauhaus. She brought with her all the work that she could . . . of Klee and Kandinsky and Feininger . . . and she would loan those beautiful things to me . . . and . . . when I would bring a Klee back to her, for instance, after having had it for several months, she would say, Oh, you could have kept it; I didn't know where it was. And it would be one of those masterpieces of his—one of those Venuses with lace. It was just incredible. Later, when I went to Seattle to the Cornish School—at first to accompany the dance classes—I found they didn't know what modern art was. They had no experience of it. And so I said, well I have this connection with Galka Scheyer and we can have exhibits of the work of Feininger and Klee, Kandinsky, and Jawlensky. So we had four shows of these people and the head of the art department, if you please, in the Cornish School said that Klee might have done better had he not hurried so for his exhibition at the Cornish school. (laughter) She thought the work was not well done. Not as well done as it could have been. The experience of modern art was still so limited.

JR: How long were you at the Cornish School?

JC: I think it could have been two years. I think that's what it was.

JR: And all the while not doing any painting—

JC: Any graphic work, no. The only thing that I did that could be connected with graphic work there was the designing of the musical programs that were given by my percussion group. It wasn't really graphic work, but it was typographical. And they're nice-looking programs. Later when I came to New York and was very poor, I had recourse to that involvement with typography and became the art director for the Jack Lenor Larsen Textile Company. To be art director for him meant taking charge of his advertising. So I designed his stationery . . . and the ads that were placed in various magazines.

JR: How did that come about?

JC: That came about through my experience with designing music programs, so that when it became known to a mutual friend that I needed money, he then gave me the job of becoming the art director for his company. Which I lost. I lost the job because he wanted me to find one way of doing things and then to repeat it, whereas I wanted to, if possible, continually have a new and interesting form of advertising. I was among the first to bring the letters together in an advertisement. I think that's still done a good deal . . . where the bottom of one letter touches the top of the other . . . where they get sort of mixed. And also, the people who do graffiti do that kind of thing.

JR: Did you also have the letters come together—

JC: —Sideways? Yes. So the letters make a kind of picture. Or I would take something like a theater ticket, and make it—take all the things that he wanted to advertise or say, and make them into the structure of the ticket. So the ticket would get drawn by his message. *(laughter)*

JR: How long did you do that before he wanted you to start repeating yourself?

JC: Oh, I don't know, maybe say a year or so. He would travel over the world getting ideas for textiles and . . . I remember *(telephone rings)* there was a meeting of most of us in the company and his voice—though he was in Asia—his voice came out of a loudspeaker in the room where we were.

(JC answers phone; tape recorder turned off.)

JC: *(returns)* We were sitting around a table, and Jack Lenor Larsen's voice would come out of the loudspeakers that were in the ceiling. It had a fantastic resemblance to the voice of God. *(laughter)* And he was criticizing our behavior. For instance, I shouldn't do any more of something I was doing.

JR: And he would name you?

JC: Oh, yes. It was quite incredible. It was very difficult to have ideas of your own because he had a very clear vision of how things should be for the company. So eventually I had to leave. In that book that Kostelanetz put together, there are some of my advertisements for the Jack Lenor Larsen Company reproduced . . . photographed.[3]

JR: So then when you had to leave there, did you get another graphics job?

JC: I'm trying to think what happened. It's in the early to middle fifties that I worked with the Jack Lenor Larsen Company and it's then that I met Lois Long, who was a textile designer. She was at that time the wife of Emile de Antonio, the filmmaker, and she and I later formed, with two other friends, Ralph Ferrara, Esther Dam, [as well as Guy Nearing,] we formed the New York Mycological Society [in 1962],[4] hunting mushrooms. And Lois Long and I made the *Mud*

3. *John Cage: An Anthology*, ed. Richard Kostelanetz (New York: Da Capo, 1991).

4. Lois Long reports that this group, led by Guy Nearing, went on Sunday mushroom hunting expeditions outside New York City. Long assisted Cage in teaching an introductory course in ? room Identification at the New School for Social Reseach (1959–60 academic year), wher?

Book. The idea was that it would be a children's book and that we would make a little money that way. We were all quite poor, and we couldn't get anyone interested in it. At one time there was some interest in having her drawings as part of children's wallpaper or something like that—nursery wallpaper. But it's only recently that it's become an art book of sorts, printed in Japan.

JR: You're talking about the small book published by Harry Abrams?[5]

JC: Yes. And Lois and I made the *Mushroom Book*, with lithographs of mine done with handwriting, so that ideas are to be found in the same way that you find wild mushrooms in the forest, by just looking.[6] *(laughs)* Instead of having them come at you clearly, they come to you as things hidden, like Easter eggs . . . the way mushrooms do in the forest. You know when you go mushroom hunting—say there are three or four of you—instead of looking in the same place, it's immediately apparent to everyone that if you spread out and go in different directions, you'll find more things, just physically—it's a better way to sweep the forest. *(laughs)* And so that's what I was trying to suggest in the lithographs, where the words cross over the words. *(pause)* And Lois made the illustrations of the fungi themselves very beautifully. It was through that—and the notes about the mushrooms were made by Alexander Smith who, like Schoenberg in music, was "*the* authority" on mushrooms at that time. That is to say *(telephone rings)*, on the mushrooms that we like to hunt for eating. But he was a real mycologist. Do you think I should turn the telephone off? I can do that.

JR: Let's see how it . . .

JC: I always think if we can keep it without disturbing us too much . . . I prefer the idea that we keep open to the . . . to the other . . .

JR: I know. I'm not disturbed by it, if you're not.

JC: So, then it's O.K.

JR: Yes. So, just to backtrack a bit for a moment, between the Cornish School—arranging the exhibits there—and then coming to New York and the first graphic things you were doing here . . . in between doing the programs at the Cornish School and Jack Lenor Larsen's . . .

JC: I was on the faculty of the School of Design in Chicago, which is the Moholy-Nagy school, in the early forties.

was offering his course on the Composition of Experimental Music. They realized the students in the mushroom class could provide a membership base for a revival of the then defunct New York Mycological Society.

5. John Cage and Lois Long, *Mud Book*, silk screened in Japan by Hiroshi Kawanishi, of Simca Print Artists, Inc. (New York: Callaway Editions, and London: David Grob Editions, 1983), in concertina form, 5″ by 5″ by 10′, hand-bound in Japan. This was subsequently published in a trade edition with the title *Mud Book: How to Make Pies and Cakes* (New York: Harry N. Abrams, 1988). Interestingly, John Russell, then art critic of the *New York Times*, wrote "A Note on 'Mud Book,' " printed in both editions as an afterword. In addition to praising Lois Long's prints, he writes, "What is the making of mud pies if not the first working model of all human makings? But it took John Cage to see that, just as it took John Cage to release the music so long sealed up in silence."

6. John Cage and Lois Long, *Mushroom Book* (New York: Hollander Workshop, 1972).

JR: So did you go from Seattle to—

JC: Actually to Mills College. I spent about two years trying to establish a center for contemporary music. I wrote to companies like Westinghouse and General Electric. And I wrote to universities, like all of them *(laughter)*, and to, you know, Bell Telephone Laboratories . . . to try to establish a center for experimental music. And I got nowhere.

JR: Didn't you make a connection with Bell Lab or was that later?

JC: I met lots of people, including for instance, Stokowski! *(laughter)* Well, he was the one who was important in—to make it *really* funny—the film company that dealt with animals, you know, Disney. *(laughter)*

JR: Was there a potential connection there?

JC: The idea was to experiment with film. One of the possibilities, you see, in experimental music, in trying to benefit from changes in technology, was that film could produce a new kind of sound. You could, for instance, do things to the sound track, of a graphic nature, that would make sounds, hmm? If you put a nail on it, for instance, or powder—if you powdered it and played it fast enough, you'd get a sound. There were all sorts of possibilities. We didn't know how things were going to go. It didn't become clear until the end of the forties that magnetic tape would work. And then the reason it became musically important is that it had been important in the Second World War. That's how the technology developed so that there could be recordings of music on tape.

JR: And earlier you wanted to experiment with using film in a way similar to magnetic tape? Did you ever actually produce any music that way?

JC: No. It was with tape, though, finally . . . that it became clear that time equals space. You could do graphic things in space that would have musical effects in time. Notation could change from being symbols to being what actually caused the music.

JR: And vice versa.

JC: Exactly. You know that I have a kind of basic idea that music is music and painting is painting, but I'm having recently new ideas, or I'm getting ideas from one field that work in a different field. For instance, I got an idea from the exhibition, the graphic installations in Pittsburgh, that could have an effect on how to make a piece of music.

JR: An installation piece in Pittsburgh?

JC: Yes, the installation I made for the Carnegie International has made it possible for me to write a piece of music that otherwise I wouldn't have written. It's actually the one that I was showing you this morning—the percussion piece that dips into silence. An exhibition . . . can dip into leaving a wall empty. And it's out of that emptiness, and not being put off by "nothing" happening—and when you *see* it, it really impresses you—that hearing it, hearing the emptiness, becomes a possibility all over again. Otherwise—if we talk as we are now, we have a tendency to go on talking, hmm? We don't see why we should stop in the

course of saying something, hmm? But I think if you're doing things graphically, to leave space seems much more reasonable.

JR: Yes, that's interesting. I think so too. Somehow we understand better that space doesn't stop when there's a gap. The gap can be seen as a use of space. But it seems to be harder with temporal sequences. A gap feels more like there has been a mistake, or the whole structure has broken down. Perhaps because we have no control, we can't just walk or shift our eyes to the next full moment, we have to wait—not knowing what will or won't happen.

JC: Yes, yes.

JR: This I think makes it particularly interesting to try to trace some of the logics of the connections between your music and your visual art. It strikes me as particularly interesting that you came to the first etching session at Crown Point Press with a score. [This is the press where Cage made all of his prints from 1978 to 1992.]

JC: Yes. Well, I think the connection began for me with seeing from magnetic tape that . . . with tape, each half inch equals a second, and a second *is* a second, so that it would be possible to make musical notation, not symbols, but graphic. That was the door that opened from music, for me, back into the field of graphic—paying attention to how things are . . . to look at. And the piece that I wrote was *Score and 23 Parts.*[7]

JR: And that became *Score without Parts* when you did the—

JC: . . . The graphic. It was "Score with Parts" in one field and "Score without Parts" in the other. For the etching, I used the conductor's score without the musician's parts. And the same connection with the visual is true of a related piece, *Renga with Apartment House 1776.* There it's just the same thing, but much more extended—a larger piece.[8] But even before that, people who were aware of my activity, Alice Weston in particular, in Cincinnati, had asked me to make a series of plexigrams and lithographs. And so [in 1969] I made the series called *Not Wanting To Say Anything About Marcel.* Marcel Duchamp had died, and one of the art magazines asked a number of different people—and I was one of them—to say something about Marcel. And when I received the letter asking me to say something I happened to be with Jasper Johns, and he had received the same letter, and he said, I don't want to say anything about Marcel. So I took the title of what I did—which was not really saying anything—I called my work *Not Wanting To Say Anything About Marcel.* It wasn't my original statement, it was Jasper's original statement. And then, instead of saying it alone or by myself, I said it together with Calvin Sumsion, a Mormon who had been a student, a graduate student, at the University of Illinois [Champaign-Urbana] where I was

7. *Score (40 Drawings by Thoreau) and 23 Parts: 12 Haiku,* 1974.
8. This score uses 361 Thoreau drawings.

when Marcel died. The reason I chose to work with him is because he knew the techniques of doing graphic work, and I knew all the business of compos So I composed the graphic work and he executed it, just as I would write a piece for a pianist and she would play it, or he would play it. In other words, in moving from music to graphic work, I took with me the social habits of musicians, hmm? The division of labor, so to speak. *(laughs)* Composer to performer.

JR: When you say you "composed" it, could you say something about what that means?

JC: Yes, I told him how to do it. I would give him readings, chance-determined readings, for horizontal and vertical. I could even tell him to gather, say, twenty-five images—I think I did it myself though. I would gather, say, twenty-five images . . . having to do with a word that came out of the dictionary—all by chance operations; and then I would go to the library and find images that corresponded with this word; and then, faced say with fifty-seven different images, I would take number thirty-seven because chance operations [using the *I Ching*] said I should; and then number thirty-seven should be reduced or enlarged to such and such dimensions, because those were prescribed by chance operations, hmm? I don't know if you've seen those lithographs. There are two lithographs on black paper and eight plexigrams—silk screens on Plexiglas.

JR: Yes, I have seen them. Do you see there, if you think about tape being a kind of fulcrum on which you turned and were able to—

JC: Do one and the other.

JR: Yes. Do you see the form of the tape having influenced the form that these pieces took in any way?

(Pause.)

JC: Oh, I think you could probably build up some kind of set of ideas about that. They may have been in my head, but they may not have been. I don't know. The important thing I think in this is that Marcel died. And that the way I chose . . . to . . . to not say anything about that . . . was to use the dictionary, to subject it to chance operations, and then to let the words die, hmm? To let them die in the plexigrams and in the black paper. So that the words . . . so that it's assumed that the words are dying, and how much they have died is the next question. So that this word, which is not to be entirely present, since it's dying, is, according to chance operations, say, one-third dead, hmm? or two-thirds dead. Then I send this information to Calvin Sumsion and he takes a razor blade and cuts out that much of it. And then he sends the thing back to me, and I'm delighted, and we continue. *(laughter)*

JR: When you say "he takes a razor blade" of course that reminds me of editing tape.

JC: Well, actually I've done that also on tape, in making the piece called *Williams Mix* . . . where the sounds are recorded and then scratched, and then changed—

manually changed. There're lots of such correspondences. It's only natural, I think. I'm still attracted, even at this point in technology, I'm attracted to the idea of cutting things up and putting them together. I think that the principle of collage is very important in all aspects of the century, hmm? . . . in our hearts. One of the troubles with some technology is that it makes it almost impossible to use collage. It makes it so easy to produce an effect with a blurring-over.

JR: Yes. I think that's true. It smooths out all —

JC: —Smooths out all the difficulties. So that you get your finished work before you've even begun. *(laughter)*

JR: In search of a bearable seamlessness of things.

JC: Yes.

JR: Before you did *Not Wanting To Say Anything About Marcel,* of course you had been to Black Mountain, and you had formed close friendships with Jasper Johns and Robert Rauschenberg. There were many very powerful visual artists with enormous energy around you, a kind of working tradition of how to approach visual arts, and yet the principles you used in your first visual piece after a long hiatus seem to have come much more out of your music than out of interactions with them.

JC: Yes, yes.

JR: Do you think it had to be that way? Do you think that's part of why it took that amount of time to get back to it?

JC: I think it was. Because I was taking very seriously giving up any involvement with graphic work in order to be faithful to Schoenberg. I was taking it very seriously.

JR: So, in a way, the visual art had to be a form of music.

JC: Had to be like music. Had to be like music. *(laughs)* And detailed that way.

JR: Would you say, as I just did, that it actually had to be "a form of music"?

JC: Yes, I agree. Yes. *(pause)* So that when I—it was because of that work with Calvin Sumsion and the lithographs. They were brought to the attention of Kathan Brown, who then invited me later, not to do something about Marcel, but to actually do something in the world of etching. That's all she invited me to do—to come and make etchings—and I accepted. And the reason I accepted was even more separate from music, from anything having to do with art, and that was that I was invited to walk in the Himalayas by Gita Sarabhai, and I said I couldn't because I had certain engagements that I had to fulfill. I said, When I'm finished with those engagements, I'll write you. And I did, and she was then busy. So we never took the walk. Then I learned that the walk was to have been on elephants! *(laughter)* And since it never took place, and I regret that very much—there were to have been at least two elephants! *(laughter)* and lord knows how many servants, and tents and everything else—I decided not to refuse such invitations. So that when I was invited to make etchings I accepted—as it were, 'n principle—and took with me not anything graphic . . . but took my "Score

with Parts." In other words, took some of my musical work with me to make my first etching [in 1978].⁹

JR: Did you have a sense of what you would do with it?

JC: No, I had the sense that I was not an artist, that I couldn't draw . . . really . . . anything; but that I had done this and it would make an etching, and did. From now I would say not a very interesting one but, nevertheless, something. And then I made a rather interesting thing there, which was the *Seven Day Diary*, have you seen that? [*Seven Day Diary (Not Knowing)*, 1978.]

JR: I've seen the three parts reproduced in the Crown Point Press catalog.¹⁰

JC: Anyway, I carried the idea of blind activity. Since I couldn't draw, I decided to close my eyes and draw . . . so that I wouldn't be embarrassed, I suppose. *(laughter)* And if I dropped my pencil someone would put it back in my hand for me. I was surrounded by helpers.

JR: Ah, something like being on an elephant in the Himalayas . . . surrounded by servants? *(laughter)*

JC: So each day I had a different kind of etching to make, and it was made blindly.

JR: It's remarkable that you were engaging in a "visual" art with your eyes closed! Groping through unseen space . . . still more connected to time than space. . . . I wondered when I saw it whether anyone has carried on that space-time translation by using the etching in turn as a score.

(Pause . . . sirens in the background.)

JC: So I accepted Kathan Brown's invitation and I went to California—her press was at that time in Oakland—and we made quite a number of etchings.

JR: I have the impression that initially you were exploring the medium itself—you were setting up procedures so that you'd get a chance to try out—

JC: —The various things. That was the case with the *Seven Day Diary*. So that in one week we went through a variety of techniques. And . . . I also learned how to scratch the drawing into the plate. It's very hard to do—to draw a line with a very sharp instrument. If you slip, it ruins the copper. You mustn't slip. *(pause)* You're pushing . . . and hopefully not slipping.

JR: I read in a description of your work at Crown Point that you found yourself, despite your usual proclivities to the contrary, developing a skill.

JC: Yes. It's quite exciting to be able to do that. To make a long line from scratch,

9. Cage worked at Crown Point Press for at least two weeks every year for fourteen years, from 1978 until his death in 1992. During that time, Kathan Brown—founder, owner, and director of Crown Point Press—reports, Cage "made about 160 editions or families of unique prints . . . and added watercolors, drawings and handmade paper works to these to form a significant body of work in visual art." (Crown Point Press newsletter, *Overview*, Fall 1992.) It was obvious that Cage felt Kathan Brown had reopened the world of visual art practice for him with her generous invitation to come and make etchings. He considered the annual January visits to Crown Point Press one of the highlights in his life.

10. *John Cage: Etchings 1978–1982* (Oakland: Crown Point Press, Point Publications, 1982).

so to speak, and have it . . . I remember offering Jasper Johns one of my prints, one of my etchings, and he chose one in which I had slipped. *(laughter)* I said, Why did you take that one rather than the other, and he said, Because you slipped. *(laughter)*

JR: Well, that raises an interesting question, because of course the whole category of "mistakes" can in your work be translated into "possibilities." So when you slip you are moving out of the realm of your intention. But in this case you are also moving out of the realm of what the—

JC: —Non-intention was.

JR: Right, so it's a funny—

JC: —Paradox.

JR: Yes.

JC: And I think the nature of the difference between graphic work and the musical work brought about a change of feelings. At least . . . at least gave me new experiences. I'm trying to . . . to say that I was made happy by *not* slipping . . . and, not only happy, but as though I had done something, accomplished something.

JR: Margarete Roeder said something interesting when I was in her gallery last fall looking at your work. We were talking about how wonderful it was that you were doing these things, and talking a bit about the relation to the music, and she said, You know, John always has to wait to have the music realized—I think we were talking about the New River Watercolors at that point—and she said, one of the joys for him of doing this must be that it's—

JC: —Immediate.

JR: Yes, watercolor reveals itself as the process goes along. Even with etching, the wait is relatively brief compared to that between composition and performance. *(JC and JR are looking through the Crown Point Press '78–'82 catalog.)*

JC: These, *Changes and Disappearances*, are extremely complicated. As you see, they went over a three-year period [1979–82; see Figure 2]. And they were as complicated as things could be. As complicated as, say, *The Freeman Etudes*. It was difficult for the printers to realize the work. I like them very much. They're probably the most musical . . . the most detailed work, with very subtle changes in the colors and shapes.

JR: When you say the most musical, what do you mean?

JC: Well, music isn't made *this* way *(pointing to graphic)*. But just as music is made with lots of little notes, so this is made with all those little pieces of color.

JR: So it's the most like a musical score?

JC: Well, the most detailed. One of the things about Virgo, which is the month astrologically of my birth, is that Virgo enjoys detailed things. You will find many composers with that sign. We're not put off by details, but enjoy them. *(pause)* And that's true in the face of multiplicity where chance operations, or some way of using numbers in relation to music, facilitates it enormously. In the presence of multiplicity, multiple possibilities, some kind of number system is very

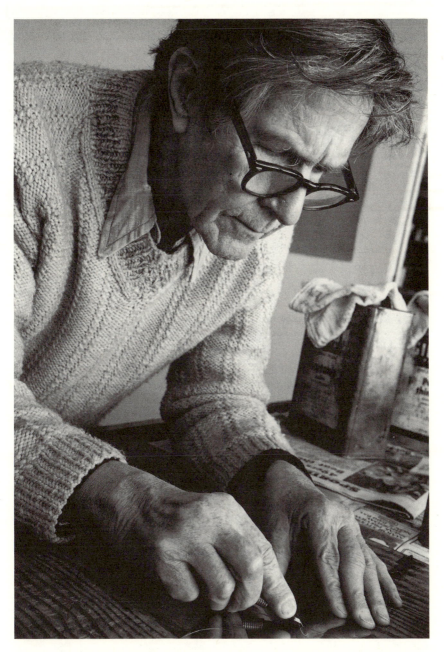

Figure 1. John Cage working at Crown Point Press, 1981. Courtesy The John Cage Trust and Crown Point Press. Photo: Colin C. McRae.

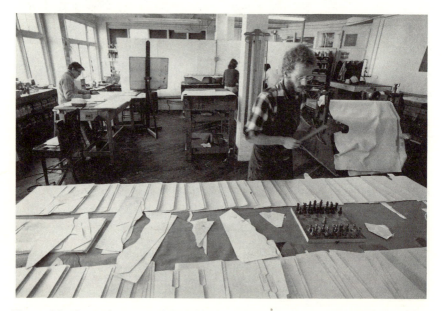

Figure 2. John Cage, *Changes and Disappearances*, 1979–82. No. 17 from 35 related color etchings with photoetching, engraving, and drypoint in two impressions each. 11 × 22 inches. Courtesy The John Cage Trust and Crown Point Press.

Figure 3. John Cage and printer, Paul Singdahlsen, working on *Changes and Disappearances* at Crown Point Press, 1981. Courtesy The John Cage Trust and Crown Point Press. Photo: Colin C. McRae.

useful not only to me but to other composers. It turns out that Schoenberg himself, secretly—from his pupils—was a numerologist. I mean a *real* numerologist. *(laughs)*

JR: What do you mean by a *real* numerologist?

JC: Someone who took numerology seriously! *(laughs)*

JR: In his everyday life? As well as—

JC: Everything! He changed the name of one of his sons for numerological reasons. And, for his opera, *Moses and Aron*, he changed the spelling of the word "Aron" to have one *A* instead of two. It has two in the Bible and one in Schoenberg. He spells it in his way in order to solve certain numerological problems.[11] *(pause)* There's a book coming out on this subject very shortly. It's by Colin Stern. It shows that all through his life, all through his music-writing life, Schoenberg had applied from the very beginning a knowledge of numerology . . . using it in his making of themes and so forth. And it's not just numbers. With me, chance operations are just numbers. But with numerology, numbers are related to the emotions. No composer has written more emotional music than Schoenberg. None. But Bach, too!, was involved in numerology. I mean, it's amazing. *(laughter)*

JR: If you trace that tradition back, it's very central to Western thinking—particularly to ideas about how to create ordered structures, isn't it? What with the philosophical connection—through the Pythagoreans and Plato—the idea that music and mathematics were essentially different forms of the same principles. I think it was Pythagoras who said that music is number made audible. Do you know the Pythagorean myth that we're descended from beings who fell to the earth from the stars?—And maybe, in a way, they were right. Physicists are saying these days that we're made of dust particles from the stars. But in the Pythagorean version of our fall, the only hope we had for getting back up there was through replicating the order of the universe with the practice of mathematics in—or, really, *as*—music. The mathematical notes would somehow fill in the space between us and the stars. *(laughter)* With an orderly pattern that we could traverse.

JC: Beautiful!

JR: Yes, I think it's a particularly lovely "fall" story. It seems so ardently . . . boldly rational. . . . So far removed from ordinary, everyday numerology—superstitious habits. But it all seems, too, to be about filling in perilous gaps. *(pause)* Some people claim to experience synesthesia. Nabokov did. He saw numbers as colors, and I think even tasted them—at least, as a child. He had intense sensory, sensual, reactions to numbers. I wonder whether you experience anything like that, since your composing has become almost entirely a matter of close work with numbers. But also because, sometimes when I look at your graphic work, your

11. Schoenberg didn't want 13 letters in the title.

visual art, I feel as though . . . I'm seeing sound, as though music has suddenly collapsed onto a page, onto a piece of paper. As it was collapsing, somehow the energy of that collapse took on color . . . which probably sounds crazy to you, but I was thinking of the way in which the page records the scene of the intersection of your intentional procedures and chance, and in that sense . . . also records time, what is a process in time of tracing these interactions of the variables *(phone starts ringing)* has become spatial in that way. And that, because it all has to do with the score, that it really is an alternative to being audible. Spatial music.

(JC answers phone; tape recorder turned off. The call has to do with a friend who is ill. We discuss the use, or not, of the possessive case in relation to different diseases. JC says he finds it less appealing to say "my eczema" than "my arthritis.")

JC: Arthritis can be awful, but it is also slightly funny. And they laugh. *(laughs)* People who are suffering from arthritis do a great deal of laughing. Because the things they can't do, or are difficult because of the disease, are very simple things. So it's funny not to be able to do them.

JR: This is an interesting piece of psychogrammar—which diseases you refer to in the possessive and which you don't. *(laughter)*

JC: Yes, you wouldn't say "my cold," I don't think. But you say "my headache." My head aches. Or my back aches.

JR: Well, I'm trying to think of where we were when the phone rang. Oh, I had said something about the way in which the paper seems to record certain events that have taken place in time, that are an intersection of intentionality— the structure of procedures—and chance—the detailed effects of the procedures. And that this seems in the case of your visual work to be an experience of visual music. As though there's a sort of freeze-frame effect, stopping moments along the way in an ongoing process. And then too when you're doing the etchings you are making sounds. One could imagine that you were doing everything you were doing with the instrument on the copper just in order to hear the sounds, and there happened to be a side effect that occurred which was the—

JC: —The print. I haven't had that sensation. *(laughter)* I think it's because when you're making a print the attendant things are so focused on looking at the print itself. Because you can see it. The only trouble with it is that it will look different after it has dried and gone through at least one night's drying process. As it dries, it's also flattened. The color changes from the damp paper to the dry paper, and flattens, which is very different from having bumps and waves. So you don't really see it immediately, but you think you do, because there it is [at all times] to look at.

JR: Well you see something else. You see—

JC: You see something—

JR: —Along the way when the process is still living . . .

JC: Yes. Yes.

JR: . . . In the paper, when it's still damp.

JC: Yes. Some of the elements when it's damp seem to be nicer than when they're dry. But drier is really better because you know it's going to last longer. *(laughs)*

JR: Another contradiction wedged into the pragmatics of wanting things to last! The process will have a long life only in the drying which stops it. The pre-Socratics liked to argue about the virtues of dry versus moist . . . and now—

(Phone rings; tape recorder turned off. When JC returns from the phone, we talk about the poetics of pre-Socratic philosophy—"knowledge" in the form of poetry, and visual logics . . . and resolve to think further about these things as we decide to end our taping for the day.)

TUESDAY, OCTOBER 22

JR: I was reading in X^{12} the piece called "James Joyce, Marcel Duchamp, Erik Satie: An Alphabet." In the preface to that you say, "I happened one year to see a large exhibition of Dada in Düsseldorf. All of it had turned into art with the exception of Duchamp." [13] I wonder what you mean by that.

JC: What I mean by that. I've had several experiences—that was one of them—another was the experience I've told you about in relation to the work of Mark Tobey. In the case of the Duchamp, I was at this exhibition of Dada, and his work acted in such a way that my attention was drawn to the light switch on the wall, away from—not away, but among—the works of art. So that the light switch seemed to be as attention-deserving as the works of art. In the case of the Tobey, I left the gallery and went to catch a bus on Madison Avenue when it still ran both ways, and I happened to look at the pavement, and—literally—the pavement was as beautiful as the Tobey, hmm? So the experience of looking at the Tobey was instructive about looking at the pavement.

JR: And when you say the others had "turned into art" . . .

JC: They didn't do that. Art in their cases became separate from life. In the case of Duchamp and Tobey they became *identical* with life.

JR: So it's the job of art to resist being art?

JC: You know how we think of certain cultures as holistic, or having at one time been holistic, and that we have become non-holistic, that we've lost the sense of what in food is called "organic," hmm? *(laughs)*

JR: Another "fall."

JC: We have the idea of a society in which everyone understands and uses the culture. For instance, we give always the example of Bali—the music, the painting, everything relates to the way the society works, and it helps the life continue. *(pause)* In my correspondence I've recently received things about the Gita

12. John Cage, *X: Writings '79–'82* (Middletown, Conn: Wesleyan University Press, 1983).
13. Ibid., p.53.

Govinda Project, which is an attempt to bring to the West aspects of Indian culture that they describe as holistic—using computer facilities in such a way that we will, through knowing with our technology more about Gita Govinda, somehow improve our relation to life. *(pause)* I don't think that's the way to go. But it's an attempt to improve modern society by finding out what the Gita was for Indian culture: a way in which we have thought of the arts as being in the service of religion. Eastern religions saw no separation between the goal—"God," let us say—and the present, oneself. Western religions tended to find such a separation, and in that finding of a separation developed the idea of tragedy. Whereas in the East, finding no separation developed the idea of comedy, hmm? as the meaning of life. In either case, the arts were originally in the service of the religion, of how to find meaning in life. Now that we don't have much religion—in fact, we could be thought to be *devoid* of spirituality, except where it pops up individually—there is no longer this strong organization. So if you want to fill that void, and like many turn mostly to television, which has little spirituality—you get a sense mostly of violence and addiction. There's no path to the enjoyment of life, which it seems to me—one way or another—the religions wanted to bring about. In the case of developing a sense of tragedy as Christianity and Hebraic thought did—the importance of tragedy—the happy life was put off to the *next* life. One was going to heaven but not until you died. *(laughs)*

JR: Or, if not heaven, there was the Hebraic sense of *History* with a capital *H* that's still with us in the influence of Marx and Hegel and the Romantic idea of transcendent destiny.

JC: The Eastern idea was to come to terms with the enjoyment of life *in the present*—while you're still living.

JR: In some ways that seems more complicated. That means you have to come to terms with all the complications, with good *and* evil *in* life. *(pause)* But then, I suppose tragedy is complicated too. The word "tragedy" comes from a Greek word that meant "song of the goat." The goat singing, maybe, as it's sacrificed, sending a tasty aroma up to great god nostrils in the sky? *(laughter)* The connections between earth beings and sky gods—or ideas of sky gods, of a state of being "above it all"—presents the problem of mediation, as with the Pythagoreans and their ladder music. Do we need an art that is not identical with the things that surround us in everyday life, but can somehow draw our attention to them? The spirituality doesn't reside in those objects? They can't make it on their own?

JC: Well, they have spiritual meaning when you see the connection, as I did with the light switch and the Duchamp, or the pavement and the—

JR: But you had to see the Duchamp in a *gallery*.

JC: True.

JR: Duchamp had to separate off the objects from their everyday use—

JC: But I don't see the difference between the gallery and a church. And I don't see the difference between a church and anything else, hmm? That's what's meant,

I think, in *Finnegans Wake* by the word "roaratorio," which I used for my music [*Roaratorio*, 1979]. The *oratorio* is in the church; but the *roaratorio* is everything outside the church, hmm? And there's no difference between oratorio and roaratorio. Or another example is in Tibetan Buddhism—*not* meditating is the same as meditating, hmm?

JR: In what sense? How would you explain that?

JC: Well, if you wish, in the spiritual sense. If that attitude is taken, then it *is*. If you *use* it that way. If that's what it is for you.

JR: I think the need that is perceived in helping us to develop unusual or new disciplines of attention is one which has to do with how difficult it is to recognize the startling quality of everyday things. It's not apparent to most of us without help, without going outside the daily routine—going into a church or—

JC: —Special place.

JR: Yes. By means of special "framing," bracketing off from dailiness. Set off in . . .

JC: . . . Some way.

JR: That setting-off creates a kind of threshold, a kind of transitional space or time—

JC: Well, there is a great difference between the work of Duchamp and the work of the other artists. It leads you, *even in* the special place, to things which are not special, hmm? And which your life is made up by. There was this quality, actually, in the work of Andy Warhol. I mean the soup can has been transformed!

JR: Yes. You could say it's the revelation of our iconography which complicates things. *(pause)* Someone said Warhol's silk screens are the stained-glass windows of our culture.

JC: Yes, that's what I mean. So that through Andy we are able to go to whatever supermarket there is, and find ourselves in church! *(laughter)* I mean literally. And you can do that very easily with comic or Buddhist thought. That is, when you see a row of soup cans, you notice rather quickly and easily that light falls on them differently. Each can is separate from each other can. They're only connected as ideas in our heads. But in reality light falls on each one uniquely, so that each can is at the center of the universe *(laughs)*, or *is* the Buddha, you see. So, it's worthy of honor, as such. I mean, you wouldn't do anything bad to the Buddha, you know. *(laughter)*

JR: And presumably the Buddha should be as useful as a can. *(laughter)*

JC: Yes.

JR: So in that way Duchamp, and Warhol, were different from "the other artists." Which other artists?

JC: Well, it was an exhibition of Dada. So a great Dadaist is Schwitters, whose work is actually beautiful, hmm? *(phone rings)* and unfortunately *remains* beautiful! *(laughs)*

(JC answers phone; tape recorder turned off.)

JR: Why is it unfortunate that it remains beautiful?

JC: Because you get caught in art . . . in such a way that you stay with it, rather than bringing yourself out of it into your life. And if you stay in it, well we have all sorts of words for that—it becomes something you would like to "own." Or that you value *(phone rings)* "in itself," apart from brushing your teeth.

(JC answers phone; tape recorder turned off.)

JC: The phone will keep ringing today because of these complex arrangements that have to be made. *(Explains what they are, worries about the interruptions. . . .)*

JR: Well, it doesn't matter. I'll just keep track of where we were and we can start up again.

JC: O.K. Where are we now?

JR: You said that if art is beautiful you get caught in it and—

JC: You can get stuck in it and not use it in your life. Or use it in a way that isn't *spiritual* in the way we were talking about, hmm?

JR: What is it specifically about Schwitters's work that you think does that? Why does it do it?

JC: The *art* of it! *(laughter)*

JR: But what do you mean by *that*?—"the art of it."

JC: Art is *said* to be involved with ideas—relationships—and also with certain sensuality. It appeals to the sense of looking. When you look, your *mind* goes into a state of finding relationships. Your heart goes into the field of the emotions. In Germanic thought these are supposed to come together. There's supposed to be some sort of marriage—of form and content. When you find that . . . that it's "satisfying"—another word frequently used in the arts—when it's satisfying, you get stuck! So that the art seems to be an end in itself. Not to be used in the life. Or, if so, to be owned, valued and so forth. If you go to an investment professional, you find that the *buying* of art is one of the wise ways to use your money, hmm? If you want to let it [the art] grow in a capitalistic sense. So it goes nowhere.

JR: Using money to own, rather than using art? Your comments on Schwitters are interesting to me because I'm aware of how Jackson Mac Low of course finds Schwitters so inspiring and useful.

JC: Yes, of course, we all do. We all love it. And in so many ways. In poetry. In graphics. . . . Well, Dada as a whole was very lively in a sense before Fluxus. Fluxus is being studied a great deal now and they are finding relationships between Fluxus and Zen. The book that I gave you is not far from Fluxus.[14] I find the work of Duchamp though—though I like Schwitters too—but the work of Duchamp is so shocking in the context of the museum that it's effective in the context of life. You can go to an exhibition of Duchamp when it's all alone— when there's no Schwitters around—and you can suspect that you're not seeing

14. Stephen Addis, *The Art of Zen* (New York: Harry N. Abrams, 1989).

art. You wonder, well, what is this? It seems to be more than art, it seems to be memorabilia.

JR: What do you have in mind?

JC: Well, this sort of thing. *(JC picks up a small Plexiglas box-framed object from a chest.)* This is my membership card in the Czechoslovakian mushroom society *(laughs)* and Marcel signed it for me, you see. It's very beautiful. And you see how he signed it. He signed it, as it were, where it should be signed. *(laughs)* So that his signature actually would disappear. Don't you think?

JR: Yes. There's nothing that would strike me that—

JC: —That it was a Duchamp.

JR: —Or that there was anything unusual about the card—except that it's framed, but that could simply indicate that it was a piece of *your* memorabilia, a souvenir.

JC: Well, you see what I mean. In terms of the church or the museum, this is not very—it doesn't immediately proclaim church or museum. It's just a membership card.

JR: So would you call all of the readymades memorabilia in this sense?

JC: Now that we know that he signed it, if we love him, as we do, then it's just marvelous, hmm? I don't know whether I would be as excited to have, say, a shoe he wore. *(laughs)* Unless he signed it! *(laughter)*

JR: Ah ha! That's very interesting. *(JC laughs more heartily.)* What would the difference be? Supposing you had a shoe, or maybe two—one signed, one unsigned . . .

JC: If you go to a show of Duchamp's work, you might see this mushroom card, or something like it, and though I don't recall seeing a shoe or any of his clothes, but otherwise it gives the effect—the whole collection of things—of not seeming to be art.

JR: The signature, though, itself, gives any of the objects a kind of ticket of passage. So that it can pass from the ordinary world to the art world and back again. It can be in either place—in both places at once. Whereas the shoe that isn't signed . . . doesn't seem to be going anywhere.

JC: Though we would probably be very happy actually to have a shoe. *(laughter)*

JR: But only after seeing the things that he signed. That seems to be a necessary initiation. In order to see the unsigned world in that spirit.

JC: Yes, I think so. Yes.

JR: I wonder about the formal properties of an art that returns you, pretty quickly, to the rest of the world—that doesn't catch you, doesn't trap you. In the examples you mentioned, there is a kind of referential lightness, an improbability that's humorous with Duchamp, and with Warhol as well. I'm trying to think just what those properties are that deflect you from the art *object*.

JC: I don't know. It's an interesting question. I don't think if we answer it that

we'll get where we're going. If we are going toward the direction that art, without a church, can tend toward the spiritual—or tend toward the enjoyment of life. Because if we find the answer to how it should be then there wouldn't be anything stopping us from having it all the time. There'd be no . . . it would become common.

JR: I'm not sure we have to worry about that. I think it would be impossible to answer the question in any sort of essentialist way: "Art that returns us to the world must always have such-and-such characteristics." If for no other reason than that the world we might want to return to is always changing. We always need to be returned to it in different ways. But in these instances—

JC: Oh, I think this may help! Art has a way—whether it's good or bad—of changing how we see the world. Oscar Wilde expressed that in one of his *bons mots*—"Nature imitates art." So you have the experience frequently after going to a gallery of coming out and finding that everything you see is seen in *those* terms, hmm? Where you were, rather than where you are. So, if in the art you were in a very special place, then the world must be transformed into that kind of specialness, hmm? Whereas, if it transfers you—as Duchamp did for me—to something ordinary—and Tobey did the same thing, and so does the Warhol— then it's not as though it were a case of the "special," but it enlarges the spiritual experience to include many, many things . . . without . . . without giving them some kind of "dressed up" feeling, hmm?

JR: What about Jasper Johns and Robert Rauschenberg in this respect? They are certainly producing art objects, and they tend to be beautiful, no?

(Long pause.)

JC: I love the work of both of them. *(pause)* Thinking of Rauschenberg, have you seen the recent work on metal? Well, as I look at that wall now *(points to long wall with many pieces of art framed under glass, opposite the table where we are sitting)*, the effect of light and the effect of reflections is certainly in the world of Rauschenberg. Or his world introduces me to the pleasure of that. There are some things in Rauschenberg that seem more "special," and more toward Schwitters than toward Duchamp. In Rauschenberg's case, it's the vertical and the horizontal and their intersection. I've always thought it was a kind of Mondrian situation.

JR: You mean as a principle of balance and design?

JC: An important statement about how things should be together. In Jasper Johns' case, I think a very impressive quality is the absence of space. Something has been done almost everywhere. So it leads very much to the complexity of life. Leads us to the enjoyment of complexity.

JR: I think of both Johns' and Rauschenberg's work as being, like Schwitters, very composed. If you think of the elements of what appears to the educated eye as "balanced" design—arrangements of line, mass, and color that "fit together" in certain ways—with visual resonances, that create agreeable "eye chords," couldn't one draw an analogy to the harmonic structures of classical music in this work?

And, if so, given your negative feelings about this kind of harmony in music, I'm curious about how useful Johns' and Rauschenberg's work can actually be for you—that is, if you accept that analogy, if that seems fair to you.

JC: No, I do, I do. It's an interesting question. The attention to the whole surface on the part of Johns, which led to the flags and the numbers—what's so interesting in his work is that the things that his work has represented—flags, numbers, beer cans—are very close to the thingness of the everyday world. Those are not, as it were, ideas of his, but ideas of all of us. His attention to the whole surface—which is not always exactly the case *(turns to a series of prints of numerals on the opposite wall)*; when I look at these numbers in these lithographs, you have the block above with zero through nine, and below you have zero through nine separated: first the zero, then the one, then the two, then the three . . . so they're together *and* separate. When he saw that I was putting this work in the "center" of the space [in the loft], his remark was, I hope you can live with it. *(laughs)* And that was all he said. Actually I had it wrongly hung. I had the zero where nine should be and nine where zero should be. If you look at the zero and the nine, neither one of them is very clearly what it is. So you could have them in the wrong place.

JR: Looks to me more like two possibilities than right and wrong.

JC: *(laughs)* But this is the way he made it. Since that time I've gotten it correct, without asking him how to correct it. I don't remember whether I noticed in a reproduction of it that the yellowish color is not down here, but up there. *(phone rings)* He hasn't remarked one way or the other—that it was either wrong or right.

(JC answers phone; tape recorder turned off.)

JC: Bob [Rauschenberg] used to say about Jap [Johns] that he was the only artist he knew of who was color-blind, who didn't know the difference between two colors.

JR: Is that true?

JC: I don't think he used the words "color-blind," but he meant to say that he didn't respond to color.

JR: When you were talking about the way Johns covers his surfaces—I thought, of course, of his canvases—

JC: They're *completely* covered.

JR: And very densely.

JC: Yes, there's almost no space. When there is space, it doesn't seem to be a Johns. *(laughter)*

JR: And yet in these lithographs, this less direct medium—where he is not directly applying the materials to the paper, there is a great sense of open space.

JC: Yes, but they're so carefully made to seem to be two pictures on one. It's *three* different things really, it's each one of those shapes times two, plus all of them together. It's very complex. Hard to think about. *(Long pause.)* Toward the end

of his life, Marcel Duchamp frequently made the statement that the artist should go underground—that, in other words, the artist should not be visible . . . in the society, hmm? particularly of art! *(pause)* Neither Bob Rauschenberg nor Jasper Johns have done that, hmm? They have stayed certainly above ground, hmm? How they behave as artists is not completely known on the other hand, because they're both still living, and both changing. The recent work of Bob Rauschenberg brings us back to the kind of enjoyment we had with his first work. There's a period in between, particularly connected with his going-around-the-world exhibitions, that seems not to have the qualities of his earlier work, nor of these recent metal works. . . . What I'm thinking of, for instance, are those Indian veils that don't have the verticals and horizontals. And Jasper Johns' work is also changing in a way that is quite different from what it was. In fact, he said he had in his early work tried not to express his feelings, to avoid the expression of his feelings. And then came "The Seasons," in which he *(phone rings)* gave up the desire to hide the feelings.

(JC answers phone; tape recorder turned off.)

JC: What he's doing with his feelings is in process as it were, and what he's doing with his work as a whole is in process . . . as with Rauschenberg . . . anyone living. But neither are underground . . . though, maybe they are! Maybe . . . we have yet to know. *(pause)* They are of course doing different things. When Bob Rauschenberg saw the title of my mesostics using the statements of Jasper Johns, he was very unhappy with the first statement [and the title], which was "Art is either a complaint or do something else." This is not his world. His world is more—in his mind—is more love and joy . . .

JR: Celebration.

JC: Celebration, yes.

JR: We were talking earlier about how certain principles of balance and design and certainly color coordination might be seen as attempts at visual harmony. So Johns' "color-blindness" might work to prevent his work from being too beautiful in ways dependent on certain obvious rules of visual harmonics.

JC: Like Schwitters, you mean. *(pause)* I think there's a tendency in his work toward, well, what you have in this series of lithographs *(pointing to the number series, zero through nine, on the wall)* is that each one is monochromatic. *(pause)* I don't think he plays with balancing or opposing colors. He doesn't do that. But that's what seems to me to have happened in the case of people making "beautiful" art. *(pause)* I now think the simple *togetherness* of art—I mean of sounds—produces harmony. That harmony *means* that there are several sounds . . . being noticed at the same time, hmm? It's quite impossible not to have harmony, hmm? *(laughs)*

JR: Well then you would have to distinguish between kinds of harmony. Color-coordinated harmony, versus—

JC: You could think of legal harmony, and not-legal harmony. Or you could

think of monotonous harmonies. The work of Giacinto Scelsi, do you know his work? The Italian composer who's no longer living? He would make a whole piece that would be one sound. Constantly changing, but still just one sound. Not in any way making it clear that it was changing, but changing nonetheless.

JR: What is the nature of the change?

JC: I don't know the details. I should know the details. I loved his music, and still do. It's the experience of the same thing being a different thing all the time. Sameness and difference as being together. The expression of that idea is in *Finnegans Wake* too, toward the end—"the scim as new . . . ," I think it goes.

JR: You say, going back to the passage at the beginning of "An Alphabet" in *X*, "The effect for me of Duchamp's work was to so change my way of seeing that I became in my way—"

JC: —"A Duchamp unto my self."

JR: "I could find as he did for himself the space and time of my own experience." Could you say that about any other artist now?

JC: He does it more clearly for me, still does, than anyone else. Say the museum puts up their permanent collection, as MOMA is doing now, you can tell perfectly well when you're with Duchamp. The rest of the time you aren't. The whole feeling changes. It's not one world. It's either art or Duchamp, really. Just think of the dropped strings, and now think of Malevich—the white on white—which is a painting we love; and we would think we would love it as much as Duchamp. But it's different. It really is a *painting*. The dropped strings—what are they? They're memorabilia of dropping strings! *(laughter)* That's how it *was*. *(pause)* Or, that's how it happened, hmm?

JR: Do you think of your own work in a similar way?

JC: Not all of my work. But I'm hoping that my present work is like that. I've moved as much as I could toward this situation where I feel that way. It's hard to say when you're doing something what it is that you're doing. You're always suspicious *(laughs)* that you may not be doing what you think you're doing. You just don't know, hmm? Sometimes you think, oh, I have a new idea, you know?—never had this idea before. And then you discover that it's old as the hills—with you! That it's *your* idea, so to speak. That you couldn't have any other idea *than* that. Why did it seem new to you? Why did it seem fresh, when you know it as well as you know your right hand? It's very strange. Working is very strange. *(Pause.)*

JR: In the years that Duchamp was answering questions about his art by saying, "I breathe," or "I like breathing better than working," and conspicuously playing chess . . . not visibly doing art—*(phone rings)*

JC: Isn't that [the phone] terrible? Maybe we should stop it.

JR: We know now that during that period Duchamp was working on *Étant Donnés*, he had gone—

JC: He was underground. Now it appears—Have you seen the article by

Bill Anastasi about [Alfred] Jarry and Duchamp in *Artforum*?[15] It shows that Duchamp's work, as far as subject matter goes, comes from works of Jarry, that his ideas, so to speak, were not his own . . . but came from another person. *(laughs)* Isn't that interesting? And yet no two people could be more opposite in feeling than Jarry and Duchamp, in my opinion. I have *never* been interested in the work of Jarry. It just doesn't—I can't—what is the expression?—cotton to it? I don't cotton to it. *(laughs)* Whereas I can't get along without Duchamp! *(laughter)* I literally believe that Duchamp made it possible for us to live as we do. He used chance operations the year I was born—do you know this story?—and I asked him how was it that he did that when I was just being born, and he smiled and said, "I must have been fifty years ahead of my time." *(laughter)* Isn't that marvelous? So his ideas may not have been his own. Say, they all came from Jarry. This disturbed me at first. But they have been so transmuted by leaving Jarry and going to Duchamp that I don't think there's anything to worry about. *(laughter)* There seems to be a link with Duchamp's experience of the arts in Paris when he was young. It's very striking. It was at that time that the *Ubu roi* was played in Paris [It premiered in 1896; was performed again in 1908]. *(pause)* You know that Jarry died as a result of taking too much dope, which you would never associate with Marcel.

JR: Interesting that these seeds were planted in Duchamp's mind as an adolescent. They certainly bore strange fruit! *(pause)* I've always felt that I don't understand *Étant Donnés* . . .

JC: Or any other work!

JR: Well . . . true, *but!* *(laughter)* *Étant Donnés* seems to me discontinuous with the other work.

JC: It seems almost to be the opposite.

JR: Yes.

JC: *But*, what is marvelous is that the opposites are not opposite. And that's part of what we might call the spirituality—art in life.

JR: How do you think of *Étant Donnés*?

JC: I think of it as being the opposite of the "Big Glass," hmm? The experience of being able to look through the glass and see the rest of the world is the experience of not knowing where the work ends. It doesn't end. In fact, it goes into life. Whereas you have to look at *Étant Donnés* from a particular position, and you can only see what Duchamp put there for you to see. In fact, you can't see it other than one way—the way he prescribed. So it moves all the way from not prescribing anything to prescribing everything. That makes a great gamut.

JR: Or two sides of a coin?

JC: Now that we know through Bill [Anastasi] that both the "Big Glass" and the *Étant Donnés* come from books of Jarry, hmm? in detail!—what are we going

15. William Anastasi, "Duchamp on the Jarry Road," *Artforum*, September 1991.

to think? Let's just say there are certainly other things that one could take out of Jarry, hmm? *(laughter)* But Marcel *deliberately* took these things that would lead on the one hand toward utter openness and on the other to utter closedness. When I knew him toward the end of his life—at least once a week I was with him, and once every year I would be a week with him and Teeny [Alexina (Mme. Marcel) Duchamp] in Cadaqués, Spain—he was often talking about, why don't artists tell people where they should stand in relation to a work, why don't they say where you should look? Because it's clear, isn't it, that if you're ten feet away it's different than if you're twenty feet away. So, why don't they *say* where you should stand, hmm? *(laughs)* And he brought this up over and over again. He never said, "I'm working on positioning the observer."

JR: Did you hear this question as rhetorical, or did you reply? Did you offer anything about your feelings on the subject?

JC: I thought it wasn't very interesting, you know. *(laughs)* I didn't really have anything to say about that. But other people would come in the room, and if he hadn't asked them what they thought about that, he would. He would turn the conversation to bring up a discussion of that question.

JR: Were there related things going on?—apart from that direct question? Do you remember anything else related, retrospectively, to what we now know he was doing?

JC: No, just that that question is what interested him then.

JR: How many times have you seen *Étant Donnés*?

JC: Well the first time I saw it, he had made an experiment of taking it from 14th Street where he made it. Do you know the story of his two studios? He had two studios. One was the one he was working in and the other was the one where he had stopped working. So that if anyone came to visit him they went into the studio where he wasn't working, and there everything was covered with dust. So, the idea was spread around that he was no longer working. And you had proof of it!—dust collected where he worked. *(laughs)* After he died, Teeny took me to 11th Street, where I now go to get my chiropractic treatment and my acupuncture—the same building. He rented a space to put up *Étant Donnés*. In other words he was taking it down and putting it up in order that when he died someone else would be able to do that too, and he made a book which is called *Approximation démontable*.[16] And that turns it, as far as I'm concerned, since it's a prescription for action, turns it into a piece of music. Because in music all we do is give directions for the production of sound; and if you follow the directions of how to take *Étant Donnés* apart and put it back together, you will of course produce sounds, and they will be music, hmm? How can they not be?

JR: This is close to what I was asking you about yesterday—the *performance*

16. Published in a facsimile edition as *Manual of Instructions for Étant Donnés* (Philadelphia: Philadelphia Museum of Art, 1987). See part III, conversation on music, for discussion of Cage's intentions to compose an opera ("Noh-opera") based on Duchamp's manual.

of your working at Crown Point Press, which also produced sound. You were, perhaps, not aware of it because you were so absorbed—

JC: Concentrated, yes.

JR: But someone else watching it would—

JC: —Hear the music, yes.

JR: Then what about the visual remains—the residue of the directions, the score, the performance—the music of making visual art creates the visual object. Is that music too? Or is it no longer music when—

JC: When it doesn't vibrate?

JR: Yes, when it's still.

JC: Well it's not necessary to think about music if it's not making a sound.

JR: But of course some of your music doesn't make a sound.

JC: But it comes from the fact that sounds take place whether or not you make them. If in doing something you do it without regard to it itself, but to hearing it, it then is music.

JR: What is the difference between looking at a performance of *4'33"* and looking at *Global Village*?[17] Both are focused visual experiences in a context of ambient sound.

JC: The question is what it is that you're doing. If while you're looking at *Global Village*, you listen, then you could say it was musical theater, no? The idea of musical theater, or opera, is when you both see and hear. But if you're so concentrated that you look without hearing, which I think some people do, then it's seeing. Or, conversely, if you close your eyes, as so many people do at concerts, then it's music! *(laughs)*

JR: Ah, so all we have to do is close our eyes, and the concert begins! John Dewey talks about this ability of the sensual media in the arts to cause us to focus so intensely that we concentrate specific faculties to the exclusion of others—we go deaf and senseless, but not blind! before a strong painting, and so on. A trade-off that seems worthwhile because of the rare chance to exercise our dulled senses with such vitality.

JC: At the Mattress Factory in Pittsburgh where I just was, there are two installations of James Turrell. Have you enjoyed any of those? Have you been in the dark one where you have to take at least 15 minutes for your eyes to change? So that when you can no longer see what you are trying to look at, when your iris or whatever it is changes, then you begin to see how active your seeing is in the dark. Isn't that what he shows us? Apparently each one of us sees in this situation uniquely. And we can't be sure. I found what I saw very active. Marsha Skinner[18] told me what she was seeing was very active too. But we knew, just from the fact of that activity, that my activity couldn't be hers. And we couldn't hang on to

17. Cage aquatint, diptych on smoked paper, 1989. See Figure 5.
18. Mixed-media artist.

anything we were seeing . . . really . . . in the dark. It was characterized for both of us by gradations of black and white, rather than a play of colors. Neither of us was aware of colors. The other thing I experienced was, not biomorphic shapes, but rather crystalline or metallic shapes—angles and straight lines in multiplicity. There weren't smooth curves of the kind we associate with Arp or Brancusi. Was that your experience?

JR: The one I entered was at the Hirshhorn, years ago, in Washington. I'm not sure that it was the same kind of installation.

JC: Probably wasn't.

JR: But I remember feeling that I had walked into an entirely different medium, that it wasn't just a case of being in a space with the lights turned off. The dark had a real presence that permeated, saturated everything—space *and* time. *(pause)* Might as well go one more step with this. Supposing, there were—*(phone rings) (laughs)*

(JC answers phone; tape recorder turned off.)

JR: Thinking again of having a *Global Village* diptych in my house. I think I told you on the phone how I had placed it—without realizing it—opposite a mirror which reflects a window giving onto a view outside the back of the house. So because of the mirror this view out the back window is in turn reflected in the glass of *Global Village*. On the wall next to the mirror is a window, also reflected in *Global Village*, looking out to the view in the front of the house. So the total experience of *Global Village* for me is to see the world coming in the front window, and going out the back (or vice versa), and it's clear to me that to follow that curve—*(laughter)*

JC: —You'd go all around! *(laughs)*

JR: So if I had instructions from you (*Cage laughs*) while I was looking at it to listen—and in a way I think we always do—implicitly—have such instructions, given the direction of your work, the result would be *Global Village*, the "home opera" performance, no? Activated whenever I choose to sit before the piece on the wall. But would *you* take that additional step? Of supplying listening instructions with your visual art?

JC: I've tended to think of music as particular to itself. And seeing as particular in a different way to oneself. So that they were different things. I've been—I may be wrong—but it has seemed to me that the horizontal is important to seeing. Whereas—this hasn't to do with hearing, but it has to do with the writing of music—the vertical is much more important in music. Because the vertical is, well, the bar line. Or if it's not a bar line, it's an event in time, a point in time. So if you think horizontally all you have is continuity in time. You don't have a point. Our experience of looking has to do with the sky and the earth. I've thought of those experiences as separating music and graphic work, painting . . .

JR: *Global Village* has, in fact, vertical bars.

JC: It suggests music, yes.

Figure 4. John Cage, *Where There Is, Where There—Urban Landscape*, 1987–89. No. 22 of 48 unique color prints: aquatint with flat bite etching. 22¾ × 30 inches. Courtesy The John Cage Trust and Crown Point Press.

JR: Which I understand you added late in the process.[19]

JC: What happened was, before I decided to call it *Global Village*, I recognized its similarity to the player-piano roll, hmm? You know, the holes in the player-piano roll that make sound. I'm very interested in the music of Conlon Nancarrow, who lives in Mexico. [C.N. has used player-piano rolls in his compositions.— JR] I thought of making the title such that the connection with Nancarrow would be clear. Then I decided not to do that, but to call it *Global Village*, and I'll tell you why. I had been in São Paulo in Brazil. And that's like Los Angeles, it's a very large city over a large expanse of land. It's not centered, in the way Los Angeles isn't centered. It's a series of places all grown together. As such, that is to say, as it is now, it's the second largest city in the world. Did you know that? Tokyo is the largest and São Paulo—or Mexico City—is the second. Whichever is not second at any time is third, and New York is the fourth—and that's quite a "put-us-down"—of how I always thought of New York as the largest city. But São Paulo, besides being a very large city, has skyscrapers, and since it's disorganized the way Los Angeles is, the skyscrapers don't face in the right direction, hmm? I mean, they don't all face in *one* direction. Each faces in its own direction.

JR: Meaning that they have identifiable facades facing in different directions? [Below, Cage is describing the series, *Where There Is, Where There*, 1987, which he changed to *Where There Is, Where There—Urban Landscape* when he added the buildings in 1989, and *Global Village*, the "found" series, or as Kathan Brown puts it, the "by-product" of *Urban Landscape*.—JR]

JC: No, meaning that as you look out your window, you see these giants . . . facing in different directions. And they're alone. *(pause)* Really. *(pause)* So, I had made an etching using smoke on copper, and it was not so much the smoke on paper, as on copper. The effect of the smoke on copper was to make an imprint that resembled smoke, so that it was like an atmosphere, rather than like a thing.

19. Kathan Brown tells me they were there from the beginning.

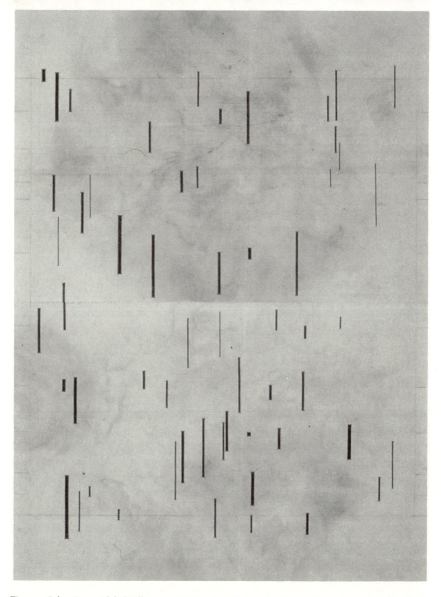

Figure 5. John Cage, *Global Village 37–48*, 1989. Aquatint on two sheets of grey smoked paper. 35½ × 53″. Edition 15. Courtesy The John Cage Trust and Crown Point Press.

And there was a good deal of variety in the edition because different plates were put down in chance-determined ways. I grew to think that that atmospheric quality of the etching [*Where There Is, Where There*] too much resembled book end papers. *(laughter)* It looked as though it had been made for books. So I thought, how to change that? It occurred to me, because of this experience in São Paulo, to put skyscrapers in the margin of the etching, so that they would

come up, in chance-determined amounts, into the etching and go out into the margins. So that it would be like skyscrapers were in São Paulo. [This became the series, *Where There Is, Where There—Urban Landscape*, 1987–89. Figure 4.— JR] The etching would be taken as horizontal, rather than vertical, and the black rectangles would be partly in the margin and partly—they'd be along the edge. And since graphic work is horizontal, the edge of the piece became a horizon. The etching itself became the sky, which was polluted, hmm? I was aware of the thought of Norman O. Brown—that now that we have ruined the environment, we have made the atmosphere beautiful for sunsets. The sunset now is extraordinarily beautiful because we've made the air so polluted. Isn't that amazing? *(phone rings)*

(JC answers phone; tape recorder turned off.)

JC: You know, when I go to work at Crown Point, I have helpers. There are generally three—at least—printers. They work together as the one in charge decides. It was decided when they knew I wanted to make all these little skyscrapers *(laughs)*—to go over what I'd already done, on the edge—that it would be easier for them if they made all the skyscrapers at once, on a few sheets of paper that would hold all of them. I'm trying to think now how the paper was chosen, because it's very beautiful paper. There are two kinds—there's a brownish one and a greyish one. Well, the little black rectangles were all made with chance-determined heights and widths. They were made in rows across the sheet all at once. This was not my work. It was the result of determining the most efficient way possible to make all the skyscrapers that needed to be made. *(laughter)*

JR: In real estate that's called a "development."

JC: So we had these sheets of skyscrapers to combine with the smoke.[20]

JR: One effect of those solid black verticals is that they seem, from most angles at a distance from the piece, to be printed on the Plexiglas in front of the smoke-printed paper. They seem removed from that smoky atmosphere until you look more closely and find the imprint of the smoke on the black, and, at that point, from that angle they are clearly *in* the smoke. It's very nice, in other words, to not be confined to only one point of observation.

JC: Yes. And then there's another thing that's happened. When the skyscrapers are removed from the paper, there's a mixture of charredness and smokedness. That has led to an edition called *Variations II*, and is about to lead to another one.

JR: Another variation on *Global Village*?

JC: Yes. I've done it on the charred pages left over from that edition. In Pittsburgh now four of them are showing, on certain days—through chance. The paper color that I didn't take [for *Variations II*] was the brown—of the charred

20. Kathan Brown clarified this: the plates with all the skyscrapers on them were printed alone, on smoked paper, and called *Global Village*. (Cage, in many of his prints, had the printers smoke the paper before printing on it.) In *Where There Is, Where There—Urban Landscape* the smoke was put on the plate and etched into it, so the image of the smoke is printed on the paper.

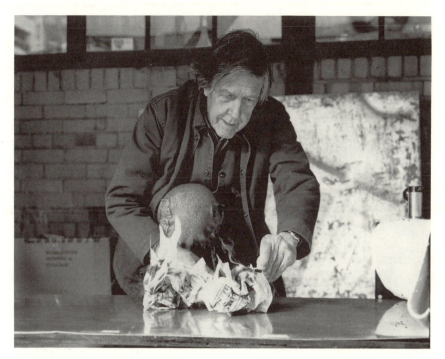

Figure 6. John Cage at Crown Point Press, January 1992, lighting the fire on the etching press bed for smoked paper to be used in the *Variations III* series. This method was used for all smoked paper. Courtesy The John Cage Trust and Crown Point Press. Photo: Kathan Brown.

papers—and those I'm taking this next time that I go to Crown Point to make a new series.

JR: What will you be doing?

JC: I'm either doing nothing or something. *(laughs)* The something is branding, either a circle or a line from a hot piece of iron at a chance-determined point. The possibilities are: to leave the paper untouched, as it is, or as it is found—that is, before we sign it, either we don't do anything; or we do the branding with a circle, or with a straight line; or with both. All of that is calculated very quickly by reference to a [random number] sheet dealing with one, two, three, four.

JR: The earlier idea of the skyscrapers came out of an image of *São Paulo*—a very representational idea—the pollution, the buildings. Does the branding—

JC: Connect with that? No, I'll tell you what it was. [How *Variations II* came about.] Elaine de Kooning died. She had been teaching around the country in various universities. I met her first at Black Mountain College. She was, toward the end of her life, associated with Bard College, where you are too.[21] So they

21. I am a faculty associate of the Institute for Writing and Thinking at Bard College.

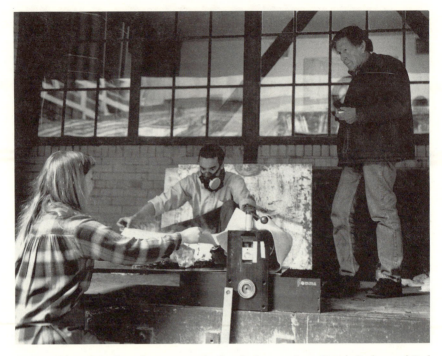

Figure 7. Crown Point Press, January 1992. As Cage looks on, printers Pamela Paulson and Paul Mullowney place damp paper on the fire. Photo: Kathan Brown.

wanted to establish at Bard an Elaine de Kooning scholarship. And they asked a number of artists to contribute works to raise money. I contributed these, but in order to do that I had to use the three helpers that Kathan Brown had given me, and the facilities of her studio. I had to ask her in other words to give me something that was, so to speak, valuable—that she had to pay for. So my thought, since she had objected slightly to my asking her for that—but agreed finally to do it because they asked her too—in other words, in conducting her business, she's continually asked to give her work away, and she can't conduct her business if she gives everything away, hmm?[22] So, since she was willing to give it away in this case, I thought I should work as quickly and efficiently as possible so that she wouldn't be giving away more than necessary. So, I looked around the studio for something that would allow me to work very quickly, and I found these charred pieces of paper from the past work and they seemed very beautiful

22. Kathan Brown explains that this was at a time when a spate of benefits was flooding the market with devalued prints and was endangering the fragile economy of print workshops. Cage, who had experienced real poverty in his own life for many years, and was acutely sensitive to the pervasiveness of poverty worldwide, found working within tight budgetary restrictions a positive challenge.

Figure 8. John Cage, *Variations III*, 1992. No. 10 of a series of 57 monotypes with branding on smoked paper. Varies 17½ to 19 × 25¾ to 26¼ inches. Courtesy The John Cage Trust and Crown Point Press.

to me, and branding them can be done in a second, and composing them can be done almost as quickly. So, in one day we were able to do a whole edition. And that was why I did it—to relate it to Kathan's press and to the cost of employing all those people, and to the request for an edition from Bard College.

JR: After hearing the story of São Paulo, I wonder how important, if at all, is it to you that a viewer—

JC: Know of that?

JR: Know any or all of that.

JC: *(pause)* I'd rather leave the viewer at the point where I was when I made it—not knowing whether it had to do with Nancarrow or "Global Village" or what. When I first saw it, I thought of player-piano rolls, and so thought of Conlon Nancarrow. But then, coming from *Urban Landscape*, I decided to go in the direction of the global village for, I think, very obvious reasons—that I'm more concerned with that—even though I love Conlon Nancarrow's work—I don't think it's important that I *say* that. Whereas, I think it's more useful to say the other.

JR: When you say, "say that"—

JC: With the title. To use the title.

JR: "*Global Village*." I'm still wondering about the degree to which it is or is not "representational" art, or "symbolizing" these things. If you think about the vertical bars as symbolizing skyscrapers—

JC: No! because you see I didn't really make them![23] The kids were finding an efficient way to print all these . . . uh, skyscrapers at once, in one fell swoop, and then more recently I'm finding a way to use the time quickly. So, when they finished putting all the things down—what we had been doing was putting them on the edge of *Where There Is, Where There*—we still had the sheets with all of them together. Leaving them on the paper was a found print, really. Nothing was done. Except what was necessary in order to do something else. It was a found work. And the one which is branded or not branded is, in a sense, also a found work, hmm? Because the amount of branding that is done is very little. Some of the sheets are not branded at all.

JR: That seems more immediately obvious to me as a found work than *Global Village*, hearing your explanation.

JC: Well, you see what I was making was *Where There Is, Where There*. I had bollixed up the idea of "where there is smoke there's fire" and I arrived at these end papers. That's when there was just smoke. Then it became *Urban Landscape* when it resembled São Paulo, you see? When the rectangles went into the margin. Each print received three—by chance determinations; say one here, one here; this might be a little skyscraper in the distance and a big one in the front, or they might be all three together. . . . It became *Global Village* when *nothing* was done to it! All it was, was a whole lot of skyscrapers that we suddenly saw were beautiful. And which were made in order to produce *Urban Landscape*. So it's a step in which there was nothing done except noticing. *Global Village* was not made, really, it was noticed. *(laughs)* O.K.?

JR: Of course, one wouldn't know the direct reference without—

JC: Well I like very much what you have done with it—with the transparencies and the reflections of the mirror—to sense the whole world. It's very beautiful.

JR: Yes, it's another "noticed" piece, or piece of noticing.

JC: Now, with *Variations II*, I also did nothing but brand. And *Variations III* [see Figure 8] will be what I do this winter. It will again be a completely found thing. And it again is done for the same reason that *Variations II* was done—to give away. And it's done quickly in order not to deprive Kathan Brown and the Crown Point Press of too much money.

(We stop for lunch.)

JR: I saw an exhibit of Rauschenberg's work from the fifties recently at the Cor-

23. In his visual art, as in his music (see the conversations on music), Cage seems to have created a kind of dialectic between, on the one hand, relating the reasons for doing certain things to experiences and images in the world, and on the other, exploring medium as medium on its own material terms—all of course in dialogue with chance.

coran Gallery in D.C., curated by Walter Hopps. Thinking of what you were saying earlier about ideas that have been part of you over long periods of time before they erupt into some sort of realization, and often without your being fully conscious of them . . . I felt a close connection between these early Rauschenbergs and at least the surface graphics of a good deal of your own visual art. The untitled black painting-collages [c.1953], for instance, that are oil and newsprint on canvas.

JC: They're so beautiful, aren't they? They're just stunning.

JR: They are, and seeing them again, along with the white paintings, was an interesting experience for me. I was as startled by them, all over again, as I had been the first time I saw them. This time *because* I went feeling they would be familiar. And they weren't familiar at all. They were very disarming. A number of those in the "Untitled Black Painting" series look *as if* they were burnt. I don't know whether they actually were or not—there is an oily smoked effect, that of—

JC: Yes, I don't think they are, but they look that way. I know what you mean. They're just perfectly beautiful.

JR: And of course, I thought of your smoked paper, much of which carries the impressions of newsprint—your use of fire, of burning newsprint, actually to create those [oily] smoked etching plates. I wonder if you think of that work as connected to Rauschenberg's.

JC: Not consciously. But I love those works. I used to have four of the white ones in my apartment down at the river. It was a marvelous experience. And in *Silence* I say, the white paintings came first, and my idea of silence came next, you know.

JR: Yes, this is very suggestive to me—that the idea of silence came, and continues to come, from a spatial experience. You know I've felt that your idea of silence works in any medium. I understand it as what happens—everything that can be noticed—when the intentional is suspended or suppressed. So I see it as present in your language work as semantic and syntactic indeterminacy, and in your visual work as the absence of "design." *(pause)* But to get back to the Rauschenberg show, the large scroll was there, *Automobile Tire Print* [c.1953]. Is that the one you were involved with? You once drove a car over some paper—

JC: That's what it is.

JR: That's it? There was only one?

JC: Yes.

JR: It looked like separate sheets of paper that were attached—

JC: Pasted together. They were pasted together at the beginning. So it was driving over, drawing, with an automobile. *(laughs)* One of us inked the tires and the other one drove the car.

JR: So this was a collaborative work.

JC: It had to be.

JR: I was puzzled because your name wasn't on it. It doesn't indicate that it's a collaboration.

JC: No, I was just a day laborer. *(laughter)* An unpaid day laborer. *(laughs)* No, he had the vision to do it.

JR: Well, seeing it now, after knowing your New River Watercolors, I see a strong connection. [See Figures 9 & 10.] Not only in the graphics of continuous parallel "treads," but in having the feeling—not exactly of having been driven over by something, but of having been imprinted by a process that began elsewhere and continued on past the paper. . . . So, again I wonder if—do you . . .

JC: Do I make a connection? I haven't made one, but I can see that one might. *(phone rings)*

(JC answers phone; tape recorder turned off.)

JR: One of the things these kinds of questions can get at is the degree to which, if any, there is an image in your mind of the finished product in your visual art.

JC: Oh, before you do it?

JR: Yes, there is this coincidence of surface similarities between your work and—

JC: The tire print. *(pause)* It seems to me in my experience that I have more ideas about how something will look than I do about how something will sound. Though I may be getting, from my interest in how something looks . . . I may be getting that very ordinary idea of how it will sound. I mean most composers have an idea of how something will sound, whereas I haven't . . . had that. But I seem to be getting it, maybe. I'll tell you an example. I now have many commissions because of my being eighty.[24] So I have to write music like a bird dog, almost as fast as I can. And I can now write long pieces quite quickly because of the "time brackets."[25] The question arises, are they all going to sound the same, or are they going to be different? If I don't change the way I'm working, won't they all sound the same? *(laughter)* If in the spirit of speed, you see . . . it's very apt that they may all sound the same. And I don't want that to happen. It doesn't seem right. So, I'm thinking of how they sound. How they *will* sound. Which is unlike me. But I think it's not in detail, but rather just generally. But then if I do it just generally *(pause)* those are the questions that arise. And I don't know how to answer them. What I'm doing in the piece I'm writing at the moment—a piece for ten musicians—I'm writing it in such a way that eight of them are divided into two groups of four. And they are separate because four are higher and four are lower. But they overlap so that the fact that they're different is obscure, and that they are getting in each other's way. I'm going to be using chance operations . . . and they'll be getting in each other's way very closely in pitch, so that the sounds will be, as it were, rubbing against one another. They'll be very microtonal. I've found a way of writing so that there are six tones between each of the closest tones.

24. Actually Cage had just turned seventy-nine the month before, but preparations for concerts, festivals, and exhibitions were already underway in anticipation of his eightieth birthday, September 5, 1992.

25. See the conversations on music for explanation of how Cage used "time brackets" in composing. Cage is discussing *Ten* (1991) below.

Figure 9. Robert Rauschenberg, *Automobile Tire Print*, 1953. Monoprint on paper (mounted on canvas), 16½ × 264½ inches. © 1994 Robert Rauschenberg/VAGA, New York, N.Y.

Figure 10. John Cage, *New River Watercolor*. Series II, 1988. No. 8. Watercolor on rag paper. 26 × 72 inches, 66 × 182.9 cm. Collection Lothar Schirmer, Munich. Photo: Courtesy Ray Kass and Mountain Lake Workshop, VA Tech Media Services.

So that if you go from C to C♯—you know that is a half-step—but in the way I'm working now it will be C *(writes this down)* . . . and then three degrees, and three more . . . before you get to C♯. So that it would be one, two, three, four, five, six, seven, eight! . . . to C♯. *(laughs)* And in that very close, very *difficult-to-perceive* closeness, you see, things will do this kind of thing *(points to sketch)* and yet up here—through chance—they'll appear separately from that mix . . . and sometimes fall into it. . . . That's the eight. The other two who are not doing that will be the piano and the percussion, and I'm thinking of having the piano become, even more than it is normally, a percussion instrument. So that the actual

structure, the notation, will be of *where* on the piano a noise is made on the structure. Now I've done that before in a series of pieces called *Etudes Boreales* [1978]. I think I will use that kind of sound, together with some of the keyboard sounds, for the piano. And then I no longer specify percussion instruments, I just number them. And I'll probably just number structural differences on the piano. This very percussive thing, which is not rhythmic, but is rather more like noises, will appear against this closely inter-, inter— *(points to sketch)* Now whether I'm hearing that or not, I'm imagining. I'm not succeeding in hearing it, but it won't sound like anything else that I've done.

JR: As you're describing it, with those gestures, I think of the smoked background with the very subtle gradations and the—

JC: Maybe, maybe. I don't know. Though I think if I set out with *that* idea in mind, I would . . . oh, you know how sounds suggest smoke sometimes *(makes gentle whooshing sound)* . . . you know, that kind of sound. It would tend to be more like a wind instrument, don't you think? Whereas this *(points to sketch and thumps table)* doesn't sound like smoke to me, hmm? Oh, but those others going close together, maybe—I would tend to think of wind . . . of some kind of wind percussion sound.

JR: Does it please you to be working in this way, or do you feel pressed into it by overwork?

JC: No, I like doing a lot of work, and I'm working now quite quickly. Sometimes it takes more time than others, but I can work very quickly.

JR: Your working methods were the result of your not being able to hear the music in advance, in your mind's ear, so you have written music in order to hear it.

JC: Yes.

JR: And that's been a particular pleasure for you—the surprise of hearing it.

JC: Yes. But my tendency, because of the details of music, has been to write in such a way that it takes time to compose. And now I've found a way of writing which is, so to speak, fast. I can write a long piece in one day, or two days, with no trouble at all. This particular piece that I'm working on now will take more time. It might take the rest of October, I don't know. Because of all these fine . . . *many* differences of pitch, I'll have to count and try to not make too many mistakes. *(smiles)*

JR: Do you think that being able to envision, either in the visual art or the music, what will happen in advance is in effect having more control? Having more control over the product?

JC: If you use, as I do, chance operations, you don't have control except in the way of designing the questions which you ask. That you *can* control. I mean you can decide to ask certain questions and not others. But if you use chance operations, you have no control over the answers, except the limits within which they operate.

JR: In choosing the particular elements that the chance operations will—

JC: Change.

JR: Yes. For instance, the verticals, the skyscrapers, the percussive sounds . . . these are early choices that will give you a sense of—

JC: But you see, I knew about the skyscrapers in *Urban Landscape*, but I didn't know what it would look like when they put them all on one sheet. *(laughs; phone rings)* But then when I noticed—*(doorbell rings)* Will you get the door?

(Tape recorder turned off; turned on; sound of vacuum cleaner drowns out sounds of traffic for next ten minutes. We are vacuumed around and under as conversation continues.)

JR: Did Marcel Duchamp use chance operations in the same way you do in the visual arts?

JC: No, I think every person who uses chance operations does it in their own way. And that it's natural in the field of the visual to do them in a simple way. For instance, Marcel put differences in a hat, on different slips of paper, and pulled one out; chose that action—pulling something out of a hat. Bill Anastasi does what he calls "blind drawing" by simply closing his eyes and drawing.

JR: Cut up slips of paper in a hat is a very Dada image, a very Dada maneuver, isn't it?

JC: Yes, well, it's also a way of doing something over which you have no control. But music has so many little things in it, like notes, and the flags on notes, and all sorts of things. So there's a tendency in music, if you use chance operations, to go through a very complex set of circumstances, and that's what I tend to do. I *still* do, even when my music becomes as it does now much simpler and faster to write than it was in works like the *Freeman Etudes* [1977–80/1989–90] or the *Etudes Australes* [1974–75]. But the use of chance is still a very complex operation. Or you might call it "detailed." Whereas that's not the case with [using chance in] graphic work generally. Though the series of prints called *Changes and Disappearances* took me nearly three years to make [1979–1982]. And there are only 35 prints, and there's only one copy of each. It took three visits to Crown Point Press—lengthy visits—to accomplish that.[26] [See Figure 2.]

JR: Was that because of the number of graphic elements involved?

JC: Because it was more musical. It was done in a *detailed* way—the use of chance operations.

JR: I'm trying to remember, was that the piece that had sixty-four elements, or sixty-four plates . . . and strings that you were dropping à la Duchamp? With the size of the shapes decreasing?

JC: Oh no, that's *On the Surface* [1980–82] where the shapes were getting smaller and smaller. Both of them are musically composed though. But *Changes and Disappearances* is the most complex.

JR: Would the observer's frame of mind while, or after, looking at a Duchamp,

26. According to Kathan Brown, there are actually two of each of the thirty-five prints; in some cases three.

Figure 11. Mark Tobey, untitled, 1961. Collection of Merce Cunningham. Photo: David Sundberg.

with its simpler use of chance, differ from what your more complex uses would engender?

(Very long pause; sounds of traffic alternate with vacuum cleaner turned on and off.)

JC: I haven't come to any thought yet. *(pause; laughter)* And I don't know if I would. *(pause)* I've had another influence than Duchamp. And I don't think there were any chance operations in his work. It's the influence of Mark Tobey. I've kept that work of Tobey's that's down at the end of the room as a kind of North Star—isn't that the guiding star?—in my mind [Figure 11]. I've tried to find my way with that work of Tobey. And I don't think he used chance operations. But he was constantly finding things that were beyond his control, I think.

JR: In what way?

JC: Well, did I never tell you the story of what he did when people came to him to learn how to paint? They wanted to become modern artists, you know, under his influence. He'd make a still life on a small table and the students would be seated around. He would have them look at it until they had memorized it, so that they could close their eyes and see it, hmm? Then he asked them to go to the wall—and on the wall he had hung paper, wrapping paper—and to take charcoal. They were to put their nose against the wall and put their toes against the baseboard, hmm? And then, in that position, where they couldn't see what they were doing, they were to draw what they had seen, what they had memorized. You can see that they were no longer capable of doing that. You can't draw

what you're seeing when you can't move your nose *(laughs)* and your toes! to see what you're doing. Everyone became fascinated with what was drawn. They all became modern artists immediately! *(laughter)* Now that wasn't a use of chance operations, but it was a putting of the body into a situation where it could not do what it intended to do. The intention of the mind was put out of operation. And that's what chance operations do. *(pause)* This morning, before you came—I was writing the piece for ten instruments with all these things looking like this— *(points to sketch made earlier)* and I am using numbers that come out of the computer [program] for the *I Ching*. [IC supply sheets. See Appendix G.] And I had had this idea that I was making the kind of sound I described, of things being close together, and one of the places where they change—they make ranges for each of them—came to be no range at all, but just a repeated sound for one of the instruments. So it just stayed where it was through a certain section of minutes, and I looked ahead—like you peek, you know, into the future *(laughs)*— and saw that another instrument was doing the same thing, and that they were very close together, hmm? And I thought how marvelous that that will happen. And then I examined it more closely and discovered that it *wouldn't* happen, hmm?—this marvelous thing that I would have *liked* to have happen . . . didn't happen. Isn't that unfortunate? What I wanted to have happen wouldn't happen, when I thought it might have happened. But I'd made a mistake. Then I see that the thing that's *going* to happen is also very beautiful, hmm? But very different. Namely, that these things that are very close together succeed—it's through their succession that it happens, rather than at the same time. *(laughs)* So that what one would do with intention, if one were thinking that way, is done in another way, by not intending, don't you think? I think so.

(Long pause; JR and JC nod and smile.)

JR: *(looks at the Tobey painting on the wall)* The gentle transparency of the Tobey is striking. The surface certainly can pull you in.

JC: Oh yes.

JR: But it just as easily lets you out.

JC: What's so beautiful is that there's no gesture in it. The hand is not operating in any way.

JR: And your methods are a different means of not having gesture?

JC: I try, yes. But *that* [the Tobey] is an example of there not *being* any gesture. Smoke is also an example of the absence of gesture. Drawing around a rock is another question. That isn't a gesture either, but it *is* something. It's not a personal gesture, but it is the line around the rock. It is something. That one [the Tobey] doesn't have anything.

JR: Well that's complicated though, isn't it? It's not a gesture in the way we usually think of a gesture—as an intentional and personally expressive signal of some sort, or the representation of a thought that preceded it in the artist's mind. But there are cultural gestures too, aren't there? When you draw around the rock

with a feather—that circle is reminiscent of Chinese or Japanese calligraphy, or of the Zen ensō.[27] These could be taken as gestures referring to a cultural context.

JC: Not a personal gesture.

JR: Not personal. And I think we tend to think of gestures, first off, as personal—

JC: Almost like a signature.

JR: Well, yes . . . I think, actually, of your signature as being a gesture. But not the marks you have made on the paper before your signature. I don't think of them as gestural but as something else which requires a different way of looking, from, say, the way one looks at some sort of abstract, or Zen expressionism, with which they might at first glance be confused. I think the marks in your work— actually, I'm not really comfortable with that vocabulary—of "marks"—what do you call, well . . . "the marks," that you make?

JC: I think in this world, people speak of marks. That's what you can say.

JR: Of course, it's a heavily theorized word at this point.

JC: And what kind of mark one's making . . .

JR: Yes, the mark one is making with one's marks. *(pause)* One of the puzzles is how do you "take" those marks as a viewer? You could see the surface of one of your pieces as being akin to abstract expressionism, or akin to certain Eastern forms of painting—particularly the New River Watercolors. And yet the marks in those traditions arrived on their respective surfaces for very different reasons, and in very different ways. In both abstract expressionism and zenga, albeit out of different cultural frameworks—but in both cases, via spontaneous, gestural techniques. How important is it that the viewer of your work understand how your procedure differs from this, that is, understand that it involves chance operations, to benefit from what it has to offer as an art enacting something about the nature of living in this world?

(Pause.)

JR: Does that question make sense?

JC: What is the question?

JR: Well, supposing two people walked into an exhibit of your work. One knew nothing about your having used chance operations; the other was someone who knew—

27. I started thinking about Cage's use of stones to make (irregular) circles in his Ryoanji drawings and prints and New River watercolors in relation to the Zen ensō after reading Stephen Addiss's book, *The Art of Zen. Zenga*, painting and calligraphy of Zen monks, is a practice "to aid meditation and to lead toward enlightenment" (Addiss, p. 6). The traditional ensō is a circle, often made with a single, spontaneous brushstroke. It has the paradoxical (for a Westerner) attribute of enclosing nothing(ness), which makes it equally a spiritual icon and a gesture of the painter. Addiss writes, for instance, that Hakuin's ensō "seems to have been brushed slowly. We can sense the vibration in [his] hand as he rotated his brush" (p. 124). For Cage, the ensō is a collaborative gesture—involving chance (determining which stone would be used, and where), the presence of the stone itself and the emptiness it leaves behind when it is removed, and the hand in an interaction of purposiveness and helplessness revealed in the traces of its vibrations.

JC: —What was going on. Yes. Well there you have it—what visual art does. A person will look at visual art or not, according to whether it arouses one's attention. Many people in looking at art simply move on to the next one, no matter where they are. Nothing catches the attention, hmm? If something catches the attention of someone—something—it's a very mysterious circumstance, because there are so many variables at each end. In the thing that you're looking at there are all sorts of unknowns about how it was or wasn't made. You know this or that, or you don't know it. All important or not important. It brings to mind the marvelous story in the world of Zen Buddhism where the man is standing on the hill in the distance and a group of people come along and see him standing there and begin to wonder why he's standing there. So they have quite a full discussion of the possibilities of what caused him to be standing there. When they finally reach him, they say we've been having this discussion about why you're standing here. Which one of us is right? He says, I have no reason, I'm just standing here, hmm? So, I think the question of looking at something is impossible to answer— how it will draw the attention, how one would become interested or wouldn't. *(Pause to turn tape.)*

JC: A recent experience that's in the back of my head comes from the San Francisco Museum of Modern Art. I was wandering through it with Kathan Brown and I was struck by a very small etching in black and white by Picasso. I don't normally respond to Picasso's work, but I did to this one very much. And I still do. It was extremely . . . like music writing really. It had lots of details. There were changes of black, grey, and white. It's very small . . . but many details all at once. After we had passed it, I said to Kathan, wasn't that Picasso beautiful? and she said, yes. She knew what I was talking about. I will be going to San Francisco in January to work, and this is one of the things that's in my mind—the beauty of that black and white. I've been working in recent sessions at Crown Point Press with colors. Subjecting all the available colors to chance operations. I'm going to concentrate on black and white this winter.

JR: Because of seeing that Picasso.

JC: Because of that. I'm not going to do the same thing . . . but it was because of that I want to go into black and white—different blacks . . . [28] [See Figure 12.] *(Break for lunch. When tape recorder is switched back on, Andrew Culver's skill saw is sounding in background.)*

JR: We were talking about whether or not it would make an important difference to the viewer—

JC: To know something about how things had been done? What I'm proposing, to myself and to other people, is what I often call the tourist attitude—that you act as though you've never been there before. *(laughs)* So that you're not *supposed*

28. "The series called *Without Horizon*, 1992, was the result. It is many different blacks on grey paper." (Kathan Brown)

Figure 12. John Cage, *Without Horizon*, 1992. No. 46 of 57 related unique prints: drypoint, hard and soft ground etching and sugar lift aquatint on smoked handmade paper. 7½ × 8½ inches. Courtesy The John Cage Trust and Crown Point Press.

to know anything about it, hmm? But if you do—and you could have gotten it from a book, as I did as a tourist guide in Versailles—there are so many ways. But even then there can be so many newnesses—say, the effect of light on something. So we really—if you get down to brass tacks—we have never really been *anywhere* before! I mean, even the most familiar places. Losa, the little kitty-cat, gets up each morning as a tourist. He goes around suspicious of absolutely everything! *(laughter)* That it may be dangerous, you know? He lengthens his body—have you seen how they do?—and he looks in every corner.

JR: Actually, he's a good model for you—lengthening his body, holding the head up and out with an air of curiosity that naturally lengthens the body. *(laughter)*[29]

JC: Yes, yes. *(laughs)*

JR: Well what you were saying all seems wonderful, and I have that experience often myself. But I feel there's a dimension of your work that is conceptual. It has to do with the way in which those particular marks came to be where they are in relation to one another. Knowing the extent to which this is a result of chance

29. This picks up on our conversation over lunch about whether Alexander Technique exercises might help Cage's back problems.

operations teaches me something about seeing, and about the radical contingency of events in our world. It somehow restores the dried paint to the flow of living processes—just that awareness of how improbable it was that those marks came to be there at all, or in that way. They become very mobile as moments of contingency that have lightly glanced off the surface. Knowing how chance was involved prevents them from being sort of terminal objects. Opens them back out into, for instance, the coincidence of *our* being here, together, now, with these things in this room—or the radically gratuitous side of any conjunction of things, for that matter! The complexity of things makes it entirely improbable that any two particular things will ever come together, does it not?—much less three or more. . . . But how would one notice any of this in relation to your work—and this involves really a radical conceptual shift—if one knew nothing about how and why you have worked the way you do?

JC: Well, there could be some other path. Don't you think?

JR: Sure. There could be . . .

JC: I think something like that is implicit in the remark in the Bible, I am with thee always. There is always a way to get to that experience.

JR: But why not make the conceptual framework available to the viewer? To help the viewer achieve that kind of attention?

JC: Well, that's part of education, isn't it?

JR: Yes.

JC: What I'm saying really is we can get along either *with* education, or *without* it. *(laughter)* Don't you think? Or maybe you think we have to have—

JR: Well I think that depends on how you define that "we." There are people who belong to a "we" that has been lucky—

JC: *(laughs)* Yes.

JR: —Who have one way or another run across things that have helped them notice those experiences that are so wonderful. But then there are many people who walk into an art gallery very frightened about whether they're going to "understand" what they see, who of course might walk out and become lucky through some other means, but since they're there! it seems to me it would be of optimal value if they *(JC laughs)* could learn something while they were there. *(JC smiles)* The day I was here picking a drawing [1991 *Ryoanji* series, r/17],[30] I had the problem of how to *choose* one—why would I prefer one over another? I looked at them feeling very blank, very confused. I was seeing them as I was trained to see "abstract" drawings, looking for elements of balance and design. Then I remembered that they were tracings of chance comings together. That seems so simple—that little fact about their production—and yet it made all the difference in the world. At that moment of remembering, or realization, everything

30. Cage had offered me a drawing from this series. He put the pile in front of me and said, "See if you can find one you like."

changed. I was no longer seeing "design"—something heavy and portentous; I was seeing the lightness, the grace and fragility of chance—how wonderful that *that* had come together *(JC laughs)* in *that* way. But also how close it was to not happening at all. I would not have had this experience without knowing how you work. It was the conceptual context, that I took on, that opened up that way of seeing. And it seems to me that it is that context, of knowing the chance procedures, that keeps those traces from solidifying.

JC: Yes.

JR: Keeps them from losing the motion that's in them as events that have just grazed this piece of paper. It's as though at any moment they could glance off again, fly apart.

JC: No, that's beautiful. No, I agree.

(Pause.)

JR: Kathan Brown writes in her introduction to the Crown Point etchings catalog, "If minimal art was influenced by Cage, Cunningham, Johns, and Rauschenberg it was because it carried the ideas of detachment and concreteness as far as they could go." [31]

(Pause.)

JC: I question that, don't you? It seems to me things can go further no matter what they are or where.

JR: Do you have a sense that you're carrying "detachment and concreteness" further now in your art?

(Pause.)

JC: You see, I'm thinking now . . . now I'm actually writing music, and going through *Ulysses* so that I'm not doing graphic work at the moment.[32] And my plans for what I'm going to do in January are not using color, but using black and white. Where I do use color, it will be monochromatic. There will be one edition with chance-determined color, one color with an untouched, but not clean, plate of copper. It will be a plate which has received, not from a person, but just from existence, some mark.[33]

JR: Where will it have been existing?

JC: In a junk pile. It won't have intentional, only accidental, marks. I made one such series of prints years ago [34] but I plan to make an additional one. And then the ones that I don't just find, but make, those are the ones I want to be in black and white [*Without Horizon*, 1992. Figure 12].

JR: Do you see these as forms of detachment?

JC: Well, the use of chance operations does that.

31. "Changing Art: A Chronicle Centered on John Cage," *John Cage: Etchings 1978–1982*, p. 10.
32. Cage was, during this time, working on *Writing Through Ulysses (Muoyce II)*, his second "writing through" of James Joyce's *Ulysses*.
33. This became the series *HV2*, 1992. Figure 13.
34. Kathan Brown thinks Cage is referring here to *On the Surface*, 1980–82.

Figure 13. John Cage, *HV2*, 1992. No. 25 of 15 related color aquatints printed in 3 impressions each. 11½ × 14½ inches. Edition 45. Courtesy The John Cage Trust and Crown Point Press.

JR: I'm wondering about other forms of detachment. How will you choose the "found" copper plates?

JC: They have a bin of refused material. I'll go through it. It might be, for instance, that there'd be a big piece which would have some marks from an artist on it, but that could be cut off. The part that was free of the artist, so to speak, but that nevertheless had some contact with circumstances that left marks on it, that's what I would be looking for. Something that had traces of having been in life. That wasn't *clean*, hmm? Something without intentions in it, but just happening [*HV2*, 1992].

JR: Do you find qualities of detachment and concreteness in other artists' work? Any for instance who don't use chance operations?

(Pause.)

JC: I like very much that work of Tobey that I have there. Because it doesn't seem to me to show a mark that he made. And yet he clearly did something. What the nature of that action was with respect to what we look at is to me mysterious. I don't know what happened.

JR: You never asked him about it?

JC: No. And now he's not here. He can't be asked. *(pause)* I'd like very much to be able to do that, to do something of that kind, in that spirit.

JR: Is finding the copper plate with its own marks of experience—

JC: It's different, but it's friendly to it, hmm?

JR: I'm not sure why this comes to mind, but I'm thinking of the series of prints you made called *Empty Fire* and then you changed the title —

JC: To *Dramatic Fire* [1989]. [See cover of book.]

JR: What kind of movement was that?

JC: The smoked paper — when I called it *Empty Fire* — the smoking was very dry. There was no change of dens — of loudness. I don't know what the proper word in graphic work is, but it was light over the whole page. "Intensity." There was no change in intensity. The smoke was light . . . "floating." That was how it was left — for them to make more paper like that. But instead of doing the work in the studio, they went outside where there was grass and they could use a hose to dampen the paper. They used water with the fire and the result was that the marking of the smoke became full of variations of intensity. And that's why it's called *Dramatic* — because it *is*.

JR: Do you like one better than the other?

JC: Yes. I like the one lacking the dramatic character. I prefer the empty one.[35]

JR: It's closer to the —

JC: To the Tobey. The dramatic one is as though it were a climax. It's like a special occasion. Whereas the Tobey is like something that goes on without interruption.

JR: The idea of emptiness, and using that term —

JC: — Is very important.

JR: — Plays across all of your work.

JC: Yes. It begins in my experience, not only from the Tobey, but from the music of Erik Satie. At the top of his *Vexations*, which is to be played 840 times in a row, he says it will be a good idea to begin with "interior immobilities." So . . . that's what I'm thinking — I think in both Christian and — in both Western and Eastern thought — emptiness is important. Emptiness is of the essence.

JR: Emptiness as receptivity.

JC: Yes.

JR: I made a list of some of the kinds of marks I've noticed in your visual art. They range from your use of Thoreau's drawings, in direct replication, and enlarged; smoke, burns, chars, some actually producing holes in the paper; to lines — soft, hard-edged, and blurred, and various kinds of masses — more and less "solid" —

JC: Those curves too, that often come from dropping strings . . . in honor of, in memory of Duchamp. *(phone rings)*

(Pause, phone continues ringing; JC remains at table.)

JR: Are you going to get the phone?

JC: I guess I am. *(resigned laugh)*

(JC answers phone; tape recorder turned off.)

35. Kathan Brown offered to redo the smoking of the paper when she noticed that Cage was not pleased by its intensity. He said, No, he would rename it *"Dramatic" Fire*, and it would be fine.

JR: There's a lot of talk now about "reading" landscapes, "reading" visual "texts" of all sorts. I wonder if you have a sense of reading—

JC: What you look at.

JR: —Of reading these various kinds of marks in different ways?

JC: My mind just went to the experience of looking at a film by Nam June Paik. I think it's called *Zen for Film* or *Film for Zen*—I think *Zen for Film*.[36] In which he made no image on the film. It's an hour long and you see the dust on the film and on the camera and on the lens of the projector. That dust actually moves and creates different shapes. The specks of dust become, as you look at the film, extremely comic. They take on character and they take on a kind of plot—whether this speck of dust will meet that speck. And if they do, what happens? I remember being greatly entertained and preferring it really to any film I've ever seen before or after. It's one of the great films, and it's not often available to see. I'm going to call Nam June and speak of it. *(pause)* Do you know that in the air is a project called the Rolywholyover Circus, do you know about that? *(JR shakes head "no.")* Well, in 1993, beginning at MOCA in Los Angeles—the Museum of Contemporary Art—there will be this Rolywholyover Circus, which will be an exhibition involving not just visual work, but memorabilia and also performances—things happening.[37] One of the things I would like very much to have happen is this Nam June Paik film. The things that will happen, and the things that will be seen, will change every day, so if we do have the film it will be available now and then when you least expect it. The installation I have in Pittsburgh [at the Mattress Factory] I've told you changes every day. I want to extend that principle. The walls are largely empty in Pittsburgh. There is a lot of space. The marks that are already on the walls will be left—like that mark over there *(pointing to wall)*, or these. I love these things that happen. All of that kind of thing will be left.

JR: It's interesting that that's what you thought of when I asked you about reading marks.

JC: Yes. We *do* read them. We read—even into two specks of dust—we read a relationship of some kind. I think when you look at a movie your mind runs to plot, hmm? That something's happening.

JR: True, unless perhaps you've seen a lot of plotless avant-garde movies.

JC: We've seen, say, Warhol. But the extreme of that is the Nam June Paik. Where we don't see anything. We just see projections of dust. It's not dust in the film really. There might be some, but it's mostly in how it's being shown, which will change. It's quite amazing. That's seeing something that won't exist again, hmm?

36. The correct title is *Zen for Film* (60 minutes, 1964). Cage himself made a 90-minute film in 1992, finishing it the summer before he died. Titled *One¹¹*, it is a chance-determined play of light and dark in black and white, to be shown with the orchestral composition *103*, also 90 minutes in length. The world premiere was in Cologne, September 19, 1992.

37. This came to be called *Rolywholyover A Circus*, organized by Julie Lazar at the Museum of Contemporary Art, Los Angeles. It opened there September 11, 1993, and has been traveling to Houston, New York, Philadelphia, and Tokyo.

But that also will exist again—in another form. *(laughs)* Isn't that marvelous? In fact it will never not exist. It's like the silent piece, which you can always hear.

JR: That's true.

JC: It's the silent piece.

JR: That brings me back to what we were talking about yesterday—the ink drying on the prints; my wondering whether you have any regret in the drying, the fixing of the image. If one were to follow the logic of your overall work, not knowing the sort of visual art you've been doing, one might guess that you would be working with an art that continued, materially, to be in process. I mean in some obvious and radical way. Of course it is always in process with the play of light and so on, but part of it is protected from being in process, really changing. Does that bother you in any way *(laughs)*, as the phone rings? *(Andrew Culver answers the phone.)*

JC: This question begins with the wet paper that was drying? Paper changing from being damp to dry?

JR: Yes, all of the activity in the process seeming to come to an end at that moment when every spot on the paper is completely dry. At that point one could say the process of making stops.

JC: We *think* so. Not honestly. We think so, whereas it goes on changing. But changing so subtly that we don't see change. When I hang things as I do in that skylight area, I'm sure it accelerates the change of the pieces that are there. I have a friend who hangs cloth in front of his pictures so that you can't see them *(laughs)* in order to stop them from changing. It seems to me very silly.

JR: There are visual artists who are primarily interested in making that process of change visible—or in speeding it up.

JC: Of speeding it up. Yes, I like that.

JR: But you're not tempted to do that yourself.

JC: You mean, to promote that in the work itself?

JR: Yes.

JC: No. But I see that people are doing it. *(pause)* I'd rather that my engagement would be in that spirit, rather than to *do it* that way. By being "in that spirit" I mean by using chance operations, and the various things I think of doing, rather than depending on that operation to continue through something that I'm not doing, hmm? I think that's what I mean.

JR: Well that brings to mind another contrast between your art and that of those artists who return us to the everyday world through direct representation, or by literally presenting us with a piece sectioned off from it—like Warhol's soup can or Duchamp's "readymades." The readymade can be thought of as both "the thing itself" and a representation of all those other things like it, outside the gallery, without his signature. Or even Johns' numbers and flags as representations, as well as uses, of familiar things. In all this there is still some kind of mirroring of

our world. Or one could say there's a very obvious — on a representational level — pointing to things in the world. Whereas the pointing to the world in your work is much more conceptual — a pointing toward the relationships between things, rather than the things themselves. Even pointing to something about the nature of relationship — contingency for example. Does this seem accurate to you?

JC: I'm trying to think. You're pointing out the use of chance operations as putting things in flux with respect to each other, and with *unforeseen* connections.

JR: Yes, and the object being a record of those things —

JC: Happening.

JR: Yes, happening. As well as being the realization of the "score" — the procedural instructions. So when you return to the world you don't need to see things that look like the marks on the work — though you might. What returns you to the world is not so much images, as a heightened sense of form, of formal relationships. Any object could in principle fill the category of those things that come together at some moment, in some particular way, by chance. *(pause)* I once read an essay by a Chinese-American scholar who remarked that the Chinese culture is pervaded by a sense of form unknown to the West. He said something like, a Chinese child is born into form. That being Chinese is in part developing a sense of the way analogous formal relationships can occur in very different areas. Perhaps this is a way of noticing what can be talked about as the "spirit" of one kind of experience being found elsewhere. With Warhol for instance, to go to the church of the supermarket is to be cognizant of identifications, of iconography, not so much of relationships. Your work seems to be about a different aspect of our encounter with the world, something about the way in which we move through it, it moves through us, in relationship — more like that description of the Chinese direction of attention.

JC: Yes, I think so.

(We end for the day.)

WEDNESDAY, OCTOBER 23

(This morning, with the crisis of the last few days resolved, JC has made the decision to turn the phone off.)

JR: Let's talk very specifically about your use of chance operations with your visual art. Exactly what do you do?

JC: When I'm doing graphic work and want to know where in the space a mark is to be put, I divide the space into a grid of generally sixty-four parts. Then I'm able to pick two numbers between one and sixty-four that give me a place on the horizontal axis. The next two numbers give me a place on the vertical. And that way I am given a point in the rectangular space. Then I can put an object — if it

itself is not a point, but let's say a rectangle or a rock—I can then put it . . . my tendency is to put the upper left-hand corner at the point that I found through the numbers, the chance operations.

JR: To start at the upper left-hand corner at the point within one rectangle of the grid?

JC: That's my general practice. But then, if in putting it there it falls out of the space, I try another corner. Say it goes off to the right too far out of the space—in other words, any point is at an intersection within the space—I try all the corners until it stays on the rectangle instead of falling off. Jasper Johns has done a great deal of work with letting things fall off the space. When he does that, he often arranges it so that if he sees that they are going to fall off the bottom of the space, he then puts the part that would have fallen off at the top. But then he makes a much larger space than I'm thinking of. I've once imitated his way of working and done that. It gives a feeling that doesn't seem, so to speak, at home with me. I don't feel right doing that. It's a nice idea. But I don't feel as though I've *honored*, say, the rock or the Thoreau image.

JR: Yes, I wondered why you feel it's important to have the—

JC: —The whole thing there.

JR: —The whole thing there, in the space, rather than say a fragment as chance might dictate. You talk about "honoring it" . . .

JC: Well, when I have in certain pieces—*Changes and Disappearances* and *On the Surface*—I have arranged the process so that if something falls off, it then becomes something different from itself. That is to say, if a piece of copper intersects the exterior line around the surface, then it is cut at the intersection to a chance-determined point on one of its chance-determined sides. In that way, large things become smaller. *(pause)* I'm afraid something may be burning [referring to food in the oven]. You can cut a piece of copper, but if you're working as I do when I make drawings—if you're working with stones—you can't cut the stone, hmm? It's not practical. So the stone is either in the drawing or not. And I choose that it is! *(laughs)* Rather than not. I've tried drawing the lower part of it that falls within the drawing, and taking the part that fell out, putting it at the bottom, as Jasper has done. But I don't like that.

JR: You don't like the idea of a fragment.

JC: I can't fragment the stone. There's no way to fragment the stone. In *Changes and Disappearances* I did like fragments and used them. And so did I in *On the Surface*. That's quite a way of working—it's a very complex way of working, because the numbers of materials and colors and everything increase . . . well, just the way population does—with respect to society—so that new things, new circumstances come into our experience beyond what we're familiar with. *(pause)* With my drawings, I have kept fifteen stones—the number fifteen for me meaning the fifteen stones in the garden at Ryoanji . . .

(JC gets up to check what's cooking, tape recorder turned off; conversation resumes

with JR forgetting to switch tape recorder back on. We have been talking about the chance-determined arrangement of chairs during the exhibition at the Mattress Factory.)

JC: . . . Is that it contrasts the twentieth and the nineteenth centuries.

JR: I have just discovered—

JC: —That we've been off?

JR: Yes. Now I'm trying to reconstruct where we went. You were talking about the fifteen stones . . . and I'm trying to remember the transition from the stones to the chairs . . .

JC: No, we'll never be able to do it. We'd have to listen to what we've done, rather than do something. It would be better to do something.

JR: O.K.

(Long laughter.)

JC: Because if we discover what we haven't got, we won't be able to get it again anyway.

JR: That's true.

JC: We'll get something else. So we should forget about that.

JR: Though . . . do you think we should forget *entirely* about it? *(laughs)*

JC: No, we don't have to forget entirely.

JR: But without trying to repeat it.

JC: Yes. *(pause)* The principle, as we know, is putting rocks—or, in the case of performances of operatic work—people, or chairs, in space at chance-determined points. We can point out directions of orientation with [a compass?] this thing we don't know the name of [in discussion with recorder off], that goes in 360 degrees. That's the way one works in space—either two-dimensionally or three-dimensionally. And if you come to a situation that you haven't foreseen, and you're aware that there are a number of possibilities that you hadn't thought of, you can then number them and ask which one you're to use. Get the answer, again, through chance operations. So that if you work with chance operations, you're basically shifting—from the responsibility to choose, you've shifted to the responsibility to ask. *(pause)* People frequently ask me if I'm faithful to the answers, or if I change them because I want to. I don't change them because I want to. When I find myself at that point, in the position of someone who *would* change something—at that point I don't change it, I change myself. It's for that reason that I have said that instead of self-expression, I'm involved in self-alteration.

JR: You gave an example of that yesterday with your music. Could you give an example of that with respect to your visual work?

JC: Oh yes, it's very simple. *(pause)* I'm trying to think of the sort of thing that actually happens when one's working. Very often when one is working—well, as we just had happen—we get interrupted, thinking something's burning, or the phone rings, or something else happens, and when we come back we start not

at the right point, but at the wrong point, hmm? *(laughter)* And then a little bit later we discover that we made *that* mistake in addition to the previous mistakes *(laughter)*, and we're impelled to correct matters. And, if we *can* correct matters, we do. That's at least my way of proceeding. But in many cases—say, the chance numbers that you've been using to direct your actions, or to answer your questions—say, you had come to the end of the page and had crumpled it up and put it in the garbage. And, say, a day had passed and you had given the garbage to the city collector, hmm? There's no way to go back, hmm? You're obliged to continue. You can even discover as I did once—I'm not thinking of graphic work now, but of writing poetry, or writing literature—I discovered, writing "Empty Words," which was a very complex process, involving letters and syllables, as well as words and phrases—in that situation, where no number answered more than one question, I discovered that I was getting a repetition, if you please, from these very complicated things out of *The Journal of Henry David Thoreau*. And I knew that it was impossible with the process that I was using for a repetition to occur! So, I examined the chance operations I was using and discovered that the error lay in the chance operations themselves, hmm? In other words, in the computer program that made them. So they were not chance operations "correctly," hmm? They contained repetition, which is the great no-no with chance operations! *(laughter)* So what should I do? I was momentarily nonplussed . . . until I realized that at no point had I wanted . . . that to happen, hmm? And that now, in discovering there was error implanted, I realized I had continually worked, not intentionally, but non-intentionally. I felt now that I had to accept the error in the chance operations as part of the "stance of acceptingness" that was at the basis of what I was doing. That *it* was at the basis, more than the specific chance operations [that had the error in them]. That allowed me to continue with ease, rather than guilt.

JR: Was part of the acceptance, then, to take pleasure in what resulted from the error in the chance operations?

JC: Well, repetition occurred . . . and it's actually very—it can be seen as being very—beautiful.

JR: Did that change your feelings about repetition being a no-no?

JC: No, no. I hadn't intended it. And I didn't use it to produce intentions on my part. What I did actually was to change the computer program, so that it wouldn't do that again! *(laughter)*

JR: So this was a temporary alteration in your frame of mind.

JC: Yes. It was like a disease *(JR laughs)*, or a happening of some sort that was in contrast to the general direction.

JR: Had you not accepted that temporarily, you would have had to redo everything.

JC: And I couldn't. It was quite out of the question. Discovering that error meant, yes, that *everything* was wrong. In terms of "2 + 2 = 4" right and wrong,

everything was wrong; there wasn't anything that was right. And yet I knew that that was not the case, that I had worked as well as I could, and that the error lay in the tool I was using. Isn't that interesting?

JR: That reminds me of the experience with the New River Watercolors—your disliking the pooling of the paint on the very porous paper you were using at first. You changed the paper for the next series, but didn't discard the earlier ones.

JC: Yes, they were actually kept. But it was that pooling in the very large watercolor with the rocks that led me away from water to smoke. Now my experience has changed, so that I feel all right with watercolor, and brushes. In fact, I wouldn't be averse to working with them again. The reason is that in the workshop it's quite impossible to see what you're doing. It's flat rather than vertical, and you're not far away enough to see it if it's very big. But I was at an exhibition in Wisconsin where I was able to see that [large] watercolor from a distance. And I liked it, just as others did. I enjoyed it.

JR: Painting with watercolors could be seen as a more lively process—*in*-process—than printing. You have a medium always trying to flow away from you.

JC: You have more changes in the medium itself. *(pause)* The other thing that I've done besides the installation of *Essay*[38] and the installation at the Mattress Factory is an installation in Munich at the *Neue Pinakothek*. The local museums were invited to submit a list of objects they were willing to contribute to a show. Chance operations were then used to install a show that came from a plurality of museums rather than one. Ordinarily when we go to an exhibition, we go to see one kind of thing. Whereas in this case, one saw a great variety of things in the museum space. It was very refreshing. The museum directors were very pleased, because they all knew their own collections *too* well. They were glad to see them brought into conjunction with things they didn't know at all.

JR: So it disoriented each of the collections—the premises of coherent collecting?

JC: It brought fresh air into the museum. Made it less stuffy.

JR: How long have you been doing installations?

JC: Not very long. I've done the ones I've mentioned—the musical one, *Essay*, and—

JR: Which included the—

JC: Idea of the chairs . . . and lights [placed and changing daily through the use of chance operations]. And the Mattress Factory kept the idea of chairs, but instead of lights had open windows and paintings, prints, drawings, and watercolors on the walls . . . and empty walls. And then this one in Munich. But this work with exhibitions is about to involve me much more. And that's because of the project called the Rolywholyover Circus that will be initiated in Los Angeles and go from there to New York, Philadelphia, and then to Berlin. And I heard this

38. *Essay*—writings through the essay, "On the Duty of Civil Disobedience," by Henry David Thoreau, a computer-generated, multi-track tape of Cage reading through his 18 "writings through" of Thoreau's essay. This was installed, on multiple tapes, in a church in Kassel, Germany, in 1987.

morning on the phone it may very likely also go to Tokyo and to Paris. [It was finally not scheduled for Berlin and Paris.—JR] It will involve not only objects that hang on the wall and sculptures, but performances through the gallery space—unannounced. They'll be part of the place you go to, but it won't be crowded with people because of an advertisement.

JR: So people will just happen upon them.

JC: Hopefully. To bring that about is what I want to do. So that when you go from one room to another in the museum, you happen upon a performance, *possibly*.

JR: Why did you want to do it that way?

JC: I think that the museum in particular, but we could include the concert hall—all the organized social situations—are stultifying, hmm? *(laughs)* And almost anything that you do—and chance operations is a marvelous way to change something—almost anything you do will make it less oppressive than it just is. If you go to a museum, what do you have? You have a number of objects at the same eye level. You see a straight line around the room and the space between the objects is equal everywhere, hmm? So anything you do to that situation will help. The first thing you could do would be to take some of them away. *(laughter)* Or, put things that don't belong there. It's that kind of thing that I've done.

JR: What would be an example of something that doesn't belong there?

JC: Something from another museum. *(laughter)*

JR: So the participating museums in Munich had very different kinds of collections?

JC: Oh yes. One might have just minerals. Another would have just coins. Another, just utensils. Another, paintings. Another would be ethnic. That sort of difference. Or one would be of another culture—Greece . . . all mixed up together. You see how you could carry that—without having anything to exhibit, you could go into any city in the world and make a very lively installation with what they have! By putting it in chance-determined places.

JR: So it explodes category and chronology . . .

JC: Yes, all of that. It's a very practical thing to do if you want to enjoy yourself in the museum, and enjoy what you're looking at. *(laughter)* They had a whale of a time, the museum directors—meeting one another even, when they came together. They had all been very separate, and they thought of themselves as being very serious. When they saw that they could actually produce joy together, they were delighted.

JR: How did this come about?

JC: A man named Ulrich Bischoff[39] came and asked me for ideas about a show in Munich. I suggested that because I had had that idea for some years with respect to museums and I hadn't had the opportunity to implement it. Even with

39. Curator, Staatsgalerie Moderner Kunst, Munich.

this Rolywholyover Circus where I want to implement it differently in each city that the "circus" goes to, I would like the local museum to invite all other local museums to contribute, and to collect a body of disparate objects which could enliven the situation. But even then, institutions are so habit-oriented that the idea of doing that frightens them all, initially. But if you actually set out to do it, it's easy, and it works, and the public is delighted. *(laughs)*

JR: The whole process seems valuable, beginning with trying to persuade people to do it. Because that invites them to think about—

JC: This has all come about, I'm sure, because it's in the air. The idea of becoming less oppressed by museums and exhibitions is in the air. People are thinking in that direction. The reason I'm involved at all is because my life is an example of a multiplicity of interests rather than a single interest. You see, when Schoenberg asked me to devote my life to music, I said yes. In recent years I have involved myself in graphic art. He did too! He's quite well known as an artist. I say that so that he can't blame me for doing what I did. *(laughs)* But the thing that let me do that was the magnetic tape, which is both visual—that is to say, measurable in inches and feet—and useful in terms of time. So it's a cross between the audible and the visual, the visible. Now, with the use of chance operations, I find the more places I use them the more . . . oh, liberating, the effect is on the kinds of things that Satie would have called paralyzed. Where I use the word now, "stultifying." *(kitchen timer rings)* Satie said, experience is a form of paralysis. So, if you know how to do something, you paralyze yourself. *(JC goes to attend to oven; returns)* O.K., did you push it in again? [the pause button on the recorder]

JR: No, this time I decided to record the surroundings, rather than forget to turn it back on.

JC: Satie said experience is a form of paralysis, and then to show how he would respond, himself, he said, show me something new and I will begin all over again. And he said that toward the end of his life.

JR: And did he find something new?

JC: Oh yes, constantly. *(laughs)*

JR: So, he was constantly beginning all over again.

JC: Yes, yes. I've said—I think I say it in *Silence*—we must begin constantly from zero. Mmm . . . well . . .

JR: What?

JC: I was just going to show you the catalog from Munich, but it's not important now for our conversation, because we would have to say what we were looking at. *(Tape recorder turned off to look at catalog.)*

JC: I have the idea to get more copies, because it interests me. Because my interests have been so plural, I'm being thought of, by different people, as a string through the twentieth century—a way to bring disparate things together, hmm? And that's how I came to be invited to Munich. And this Rolywholyover Circus which tries to carry this idea of the togetherness of differences into both static art

and performance art, hmm? I haven't thought of that before—"static" art. But that's what it is. Things that stay on the wall? *(laughter)* That don't move.

JR: Yes, in contrast to coming upon unexpected performances—an enactment in the museum of a "form of life" in Wittgenstein's sense. The form of life that *is* multiplicity.

JC: Yes, yes.

JR: It's not so easy to see how "static" art, as you put it, enacts a form of life. Jasper Johns had said, when he gave you the number prints, "I hope you can live with it."

JC: Yes, *assuming* that I would leave it on the wall, which I do. Which I do.

JR: How does that static art enact a form of life, or help us to enact a worthwhile form of life?

JC: Well his work—and we've remarked the complexity of it, and the filled-up nature of it—does it just that way. We never come to the end of looking at it, hmm? Each time we look at it we are encountering its complexity over again, hmm? And that's true of—not an empty Tobey, like the one I have—but of one of the white writing ones. I remember having one in the house and every time I looked at it, it was different. It had done the moving, despite its always being there in one place. Or I had, I don't know what to say—every time I encountered it, it seemed fresh. Isn't there something of that in *Ulysses*, in the work of Joyce? You can't find it fixed at any point. And the editors and scholars don't seem to know what to do with it, what's the right way to print it—

JR: Yes, there's a lot of—

JC: Confusion! The ones who've improved it seem to have spoiled it for others? Or at least not to have made the proper changes? *(laughter)*

JR: Yes, it's a fluid text historically, as well as semantically.

JC: Yes, yes, very uncertain. I mean *seriously* uncertain. Isn't it? Without losing its quality.

JR: In fact I think it, and *Finnegans Wake* even more so, is akin to complex systems in nature, like the weather—where you recognize more or less stable outlines, but the details of local weather are always different.

JC: Yes, yes. I think it's absolutely marvelous how *Ulysses* does that. It's more obviously done by *Finnegans Wake*. That *Ulysses* does that too is really . . . instructive! *(laughter)*

JR: Thinking about the extent to which each one of us wants to engage in and experience forms of life that open up possibility, help us notice new things, live in better ways; and thinking about the "static" wall art that we have to return to—we move away, we do other things—it's always there, unless the house burns down—in which case it gets to be part of a happening, a performative event. *(laughter)* We come back to it, and each time we've presumably changed in some way. So its very stability makes it a sort of finely tuned historical barometer—of *our* change; a reflection and collection point—absorbing and registering the

micro-climate of changes going on in each individual viewer. Whereas the fluctuating installation, the mobile performance is a change in the macro-climate of our public space. I'm thinking that the two are necessarily complementary. They do very different things for us.

JC: Oh yes. Very definitely. This is true of relationships with people too. What's important in all of it, is the minimizing of security, or of certainty. There's that book, though, by Wittgenstein on certainty, isn't there?

JR: Yes, it's called *On Certainty*.

JC: What's it about?

JR: Well, it's in a sense about the language of epistemology—that is, what it is we think we know when we talk about knowing anything at all. *(JC laughs)* And what it is we think we don't know, or can't know. Another way of putting that is, what we think we can be certain about. *(JC laughs)* For Wittgenstein the only "givens" are not things you can point to, but what is implied by use, by activity. In other words, "knowing" is really making sense of things, and that activity is nothing more or less than participating in certain language games that are in turn connected to larger, contextualizing forms of life. I *think* that's what it's about. *(pause)* You were talking about minimizing certainty.

JC: Yes, don't you think? And heightening liberation from paralysis. I have searched—and this may be foolish, but I'll say it anyway—for what characterizes an art, what it is an art is doing that's different from another art. It seems to me that music is very close to the nervous system. And if you don't like it, it's nerve-wracking. *(laughter)* The way I've put it in the past is that it's irritating if you can't use it, and pleasing if you can. Whereas things you look at either interest you or don't—that means, engage your attention or not. You can look at something and very quickly decide that it doesn't interest you, and go on. With architecture, the home can be imprisoning or oppressive, or it can be liberating. If you feel good in a space—as though you were out of it, really, flowing out of it—then it's marvelous architecture. But if it's spatially imprisoning, it's terrible. Most of the buildings our institutions are in—museums, concert halls, schools . . . are prisons. *(Pause to turn tape.)* But some are better. That's true at Bard, isn't it?

JR: The architecture at Bard varies—from stone Tudor, to mix-and-match Gothic, to neoclassical, and modern, and very much *pre*-postmodern lowslung boxes, and just lately some delightful postmodern buildings . . . and, of course, much eclecticism of country cottages and full-scale manor house fantasies interspersed. It's quite wonderful—the landscape and the buildingscape.

JC: That's my impression.

JR: So architecture and music, it seems you're implying, are more intimately connected to how we feel in our environment. More palpably structure it. Visual art, you can take or leave—

JC: You can sort of ignore it.

JR: That reminds me of Maurice Blanchot saying, "Seeing implies distance."

Which has a kind of double blow—the rather poignant fact that the eyes caress what they can't touch and they can't hold, but also that they can easily turn away. That in some way we are free of what we see?

JC: Yes, that's beautiful.

JR: What about language? When I was in my early twenties—after I met you in Chicago, and then read *Silence*—I felt I had to choose between visual art, philosophy, and literature. Just for pragmatic reasons. Though I had been trying to, I knew I really couldn't do everything. I decided that no matter what I did, I'd never have to give up philosophy. It would always be a part of any work I did. And it is, after all, a form of literature. So then it seemed to me to come down to a choice between language and visual art. But, partly as a result of my exposure to your ideas, the visual world seemed all right on its own, without my intervention. Wonderful, interesting things were already there to be noticed. It didn't need me to rearrange things. But I thought words were generally in bad shape.

JC: Yes.

JR: Because they tend to be used with such oppressive, often manipulative, intentions. And we really can't get away from them, from other people's language. I suppose I feel about words the way you've described feeling about music.

JC: Yes.

JR: That it's very hard to be with language that's oppressive, mean, suffocating, full of thoughtless certainty. . . . Do you have any similar feelings about language?

JC: If you write something and it's going to be published, you confront an editor. The implication is that the editor knows how the words should be together. And that you as an author might not be aware *(laughter)* of these things. This was the position taken by a marvelous editor of the magazine *Modern Music*. Her name was Minna Lederman [later Minna Daniel]. She actually improved the writing of a large number of people in the field of music. The magazine became an important magazine and still is, for the period, say, between 1925 and 1950. Everything you wrote was incorrectly written. The way she proved that it was, was by asking you questions and finding out what it was you had had in mind. And then showing you that what you had had in mind had not been expressed in words, hmm? That's quite marvelous that she was able to do that.

JR: Did she do that with you?

JC: She did it with everybody. And did it successfully. *(laughs)* She was able to perceive the differences between the words that had been chosen and the thought the writer had had. Then when I went to Wesleyan, where my writings were collected, first issued in *Silence*, I encountered another editor who was of an entirely different persuasion. His name was Bill T. Bueno. He's no longer living. He didn't change anything that I wrote. And when I saw that he wasn't changing anything, I was alarmed. I thought, surely my thinking, or my words, have not been the right ones, and he hasn't changed anything! Say, the awful, simple errors like "as" and "like"—things like that. *(laughs)* He didn't change anything. He

came to the conclusion that I was listening. He told me at one point that he felt that *Silence* was about listening. That was *how* I was writing—I was listening to the words. *(pause)* I have since found another editor, and I worked with her only once—Margaretta Fulton; her nickname is Peg Fulton. She's at Harvard University Press. She, with me, produced *I–VI*. And she did it so beautifully . . . it was with her help that I was able to write the introduction to that, which is in great contrast to the texts themselves, whether it's the mesostics or the spontaneous writing at the bottom. The introduction is written in those terms Minna Daniel [née Lederman] was working on, namely bringing about a correspondence between the words and the thought. Not thinking of the sound, really. *(pause)* I'm now engaged in another project which is very elaborate. It brings together the graphic arts and writing. It's called *The First Meeting of the Satie Society*. Have I told you about that?

JR: The transparent book?

JC: Yes. It's been for many years in process, this book. And I've had a great deal of trouble with the man who is producing it [Benjamin Schiff]. And now all that has disappeared. We're able to work together with great pleasure. It's like those serious quarrels which one passes through, and one's relationship is reaffirmed by having almost broken, hmm? I told him, in fact—I wrote a letter to him at one point about a year ago—that we should drop the entire project, that every *minute* of it had disturbed my daily hours *(laughs)* and it had gotten to the point where I could no longer sleep! *(laughs)* so that it was invading the night, and I said that's just too much. We have to stop. That's all changed now, to the point that we're both happy with everything that's happening, both day and night. At one point I asked Margaretta Fulton to help me with the introduction to that text. She didn't find it well-written or well-thought. I never could find the right words. I simply couldn't do it. Then coming toward the re-meeting with Benjamin Schiff . . . and feeling, and *knowing* in fact, that Bob Rauschenberg and Jasper Johns liked what was happening—I had thought they didn't—but now, knowing they did put me in the situation of wanting to resolve everything. The way that I did it was to write the introduction, not by finding the words for the thought, but rather, finding . . . choosing the words in relation to mesostic practice, or rules, but making mesostics that made sense rather than like the mesostics in *I–VI*.

JR: Which make a different kind of sense.

JC: And so, instead of making it like the introduction to *I–VI*—a *thoughtful* text, hmm? *(laughs)*—where the words correspond to the thoughts, or try to—I was making a text which had used the mesostics but used them syntactically. The whole book is otherwise non-syntactic. But, though the introduction is syntactic, being in the form of mesostics, it eliminates, for instance, the problem of explaining what a mesostic is, since it *is* one. With it I was able to find the words that followed the rules, and that *sounded*—that you could listen to, and not be irritated by. It ends by being—and I think this is true of art in general, when

you enjoy it—it's elating, hmm? invigorating, inspiriting. And at that point we can't *tell*, we can't answer questions, really. We can't say, what do we think? We recognize only that it's inspiriting somehow.

JR: That it somehow has enacted what it is about.

JC: It's an example, yes. *(kitchen timer rings)*

(JC goes to attend to what's been cooking; tape recorder turned off.)

JC: *(reading his introduction to* The First Meeting of the Satie Society[40]) [See Appendix B.]

"originally it was a lecture to bring about thoughts that were not in our heads / not about the French composer Erik Satie / but to celebrate his life his work as though it were always his birthday / using the titles of his music / the initials and words of his name to write mesostics / poems read down the middle / or as usual from side to side / to give them to him for no reason / just for his seeing and his hearing / his enjoyment of being alive now that he's dead *(laughter)* / to use the writings of others as source material for these mesostics / Joyce McLuhan for instance Duchamp Thoreau Chris Mann Myself and the bible / a mixture of lovers completely imaginary / that was my idea / now it's become a coming together of artists / Jasper Johns Robert Ryman Robert Rauschenberg Sol Lewitt Mell Daniel / sketches by the man of Concord drawn again by Bastian / "—Bastian is a nickname, a pseudonym for the one who was causing me so much trouble *(laughs)*—"paper made with Satie memorabilia printed on it / printed again with fire with smoke / all of these presents collected in a valise of shattered glass / its metal frame embossed with sentences he wrote / or remarks he's said to have made / a first meeting like every meeting with Satie / is the beginning of the change / a changed attitude toward life toward art toward work toward music / the removal of boundaries wherever they exist / never ending the coming together of opposites / show me something new / and I'll start all over again / living with interior immobility / enjoyment in the midst of countlessness / accomplishing nothing / as though nothing had happened / as though tourists / living as though tourists always" . . . hmm? Isn't that good?

JR: It's beautiful!

JC: *(laughter)* It sort of works, don't you think? *(laughs heartily)* I can give you this, if you want it. You can have it [the copy of the mesostic he was reading from]. And I had struggled over that so long! And having finished it, Joan, it clearly works. *Bastian* was delighted! *(laughs)* Everyone is delighted, and so am I, and all the problems disappear. And his ["Bastian's"] work now has actually been very beautiful—of bringing these objects all together. Now this is printed in a situation where I then draw Satie, or music . . . I draw music just spontaneously on the paper . . . well . . . you'll see it.

JR: When will it be available for people to see?

40. See Appendix B for mesostic text. Line breaks here correspond to Cage's reading aloud.

JC: Maybe in this Rolywholyover Circus. *(laughs)* The books are so beautiful.

JR: So there will actually be books—

JC: They'll exist, surely, by the time of the Rolywholyover Circus.

JR: When will that be?

JC: It will begin in 1993. But this part of it, and the Rauschenberg part will exist in a show of Bob's work at the Castelli Gallery opening this Friday . . . or Saturday. *(pause)* The words, when they're beautifully printed—you know that Marjorie Perloff objected to the fact that *I–VI* was well done, and accompanied by recordings, and so forth—you remember, in her review. But this book, *The First Meeting of the Satie Society*, has been published electronically. You can use your computer to get it out of the WELL[41] in San Francisco, so that you could have it on your screen, you know, anyone. But it's going to be published, by Bastian, in such a way that there won't be many copies. There'll be twenty-five copies.[42] And there will be ten copies that are not bound, for exhibition purposes. There will be so few of them, in fact, that no one will be able to afford them, hmm? Except institutions or museums. *(pause)* You'll have to see it in that institutional situation, though I will own two copies. I will own one bound and one unbound copy. Anyway, when you see something like that, that's so beautifully done—and the paper is beautiful, everything!—you can read what you couldn't read if it were on scratch paper.

JR: What do you mean?

JC: I'm coming back to the *word*. The words when they are beautifully printed have a different readability . . . than they do when they're scribbled. *(laughs)* Don't you also feel that? I remember when I was beginning to write, I would write by hand; and then when I typed it, it had a quality it didn't have before it was typed.

JR: Yes, one of the exciting things about the word is its graphic presence. It does make an enormous difference how it looks. The form always has consequences, I think—in how available it is to us, how much it fills us as we're looking at it. But a less fully formed, or fainter, or interrupted graphic affects us strongly too, in different ways, don't you think?

JC: Yes . . . yes.

JR: But this book project is also interesting as another instance of exploding or blurring boundaries between forms and genres—both book and visual art, and—

JC: And very beautiful graphic work in it. What normally in the book situation would be called illustrations. But they're not illustrations. They are . . . graphic accompaniments of . . . of "word work." *(laughs)*

JR: What difference do you think that indicates?

JC: Which?

41. An Internet service.

42. As of summer 1994, two copies exist: one bound set in the glass and metal valise designed by Cage as a homage to Marcel Duchamp, and one unbound set available for exhibition in galleries.

JR: Illustration versus accompaniment.

(Increasingly loud sirens accompany next few exchanges.)

JC: Well, illustration means that the center exists in another place. So an illustration is not at the center, but is about the center. Whereas with accompaniment, each one is at its own center.

JR: So they're synergistic—each is giving energy to the other?

JC: Yes. Synergy—what Bucky Fuller called synergy—the excitement coming from the collection of things. In this case, both literary and graphic . . . and then beautifully printed. Oh, even reading the colophons, of these books—at the end—unbelievable pleasure! Because, sometimes—because of the mesostics—sometimes the colophons read vertically, and sometimes they read horizontally. The letters are so far apart you can't tell *(laughs)* whether you're supposed to make a word out of them, but you do.

JR: So, zero lies between letters too.[43]

JC: The printing itself looks as though it were something to look at, rather than to read. Not always—but he's tried to make, and has succeeded in making, each book a present, you see, for Satie. So that they have different kinds of paper, and it goes into this shattered glass. . . . It's really very beautiful.

JR: If we think of that book, the making of it, as a form of life—it's turned from an unpleasant form of life to—

JC: —Into a pleasant one.

JR: And what made that change was . . .

JC: There were two things. I told you one of them. You see, I had the impression at one point over the years, from a passing remark on the part of Jasper Johns, that he was unhappy about the printing of the work that he had contributed. That he didn't think it was well printed. So, the idea settled in my mind that Bastian's cohorts—the printers—were not printing Jasper's work properly. But then I had a meeting with Jasper—we had dinner together—and he asked me how the project was going. And I said, Well, I don't know; how do you feel about how they've printed your work? And he said, "Oh, I'm delighted . . . with the whole thing." He said, "It's done very well." So that load went off my shoulders. Then—going as I do once or twice a week, because of my back, to a chiropractor—I was in the hands of the chiropractor, which is a marvelous place to be *(laughs)*, and it occurred to me while she was doing this that I should write the introduction as a mesostic, hmm? *(laughs)* And then I tried to do it and failed, you know. And tried again. And finally I'd kept trying. The first one was good for both of us—for Bastian and myself, or Benjamin Schiff—his real name—but the second one wasn't. It was too literally written, as information. Finally, by persevering, I was able to write this, which works well for all of us. *(pause)* Isn't

43. I am referring here to Cage's statement in *For the Birds: John Cage in Conversation with Daniel Charles* (Boston and London: Marion Boyars, 1981): "We forget that we must always return to zero in order to pass from one word to the next" (p. 92).

it that way—relationships? I don't think we can speak about society as a whole. I think we have to speak about relationships with people. And at a point where we wouldn't speak of society. When we speak of society, as a crowd, or a concert audience, it doesn't have a meaning that's made up of ups and downs, hmm? So it has no reality. It's something you don't remember. But relationships with friends or individual people—there's a beautiful text—a conversation with Jasper Johns and David Vaughan [Cunningham Foundation archivist] which is called "The Texture of Friendship," and Jasper shows in his thinking about friendship how it changes.[44] It isn't a fixed thing that you come to and *keep*. It's something which is not dependable. Even if you think it is, it isn't, hmm? And it gets richer as it encounters obstacles and surmounts them.

JR: Well it's forced into the activity of developing. That keeps it alive.

JC: Yes, yes. And I think it reaches a—it becomes more and more enjoyable. I was going to use a more negative word: it becomes "tolerable." *(laughter)*

JR: One hopes it would be more than tolerable.

JC: When there's space, or emptiness—where things could be other than they are, without wrecking it. *(pause)* That's why I like in the installation at Pittsburgh [the Mattress Factory] that in the 105 days of the exhibition, every day will be different. That's how it should be with everything—that it's not fixed, don't you think?

JR: Yes, in the nature of any living system. *(pause)* The permutations in the installation in Pittsburgh have to do with which works will be on the wall, the positions of the chairs in . . . one room, several rooms?

JC: It's one floor which has a dividing wall down the middle with openings in it.

JR: So each side has its stock of variable chairs, or just one—?

JC: No, the whole floor has its variable chairs. So, for instance, on the second day of the exhibition, one part of the floor didn't have any chairs. There were only two chairs and they were both on one side. The other side was empty. And then the other *big* changing element is that the people who come to see it all change. And they change the time and everything. And I don't have to do anything about them, because they do it themselves. *(laughter)*

JR: That thread of emptiness that runs through all of it. This is the first time you've talked about that in relationships with people as well.

JC: Yes, yes.

JR: It's very interesting to me—

JC: Yes.

JR: —That the thread of emptiness runs—

JC: —Runs through everything.

JR: —Through everything.

44. This is actually titled "The Fabric of Friendship: Jasper Johns in Conversation with David Vaughan," in *Dancers on a Plane*, ed. Judy Adam (New York: Alfred Knopf in association with Anthony d'Offay Gallery, 1990), pp. 137–42.

JC: —Everything, yes.

JR: All of these things always have to be—

JC: —Empty—

JR: —On the edge of—

JC: —Emptiness—

JR: —Emptiness. And have to be able to contain emptiness.

JC: Yes. And will defy, or bring together, the opposites. It's very important. *(Pause.)*

JR: Pushing against that edge then always has to involve difference . . . uncertainty.

JC: Yes, I think so, yes.

JR: How do you see future projects as continuing to push against that edge?

JC: I think each thing we do becomes part of what one is doing in these terms. The one which I know the least about—and that is an important one for me—is the two talks I must give at Stanford. I've chosen the subject of "overpopulation and art." The two talks—in good university style—are to be forty-five minutes long, hmm? And I've decided to write one talk, rather than two, for the two talks. But to use them—I think I will do this, at least that's where I am now—I will do it in such a way that each time I read the talk it will be different. So I only have to write one talk. And the reason it will be different is because it will become empty at different points![45] *(laughs)*

JR: How will it do that?

JC: Through chance operations. *(laughter)*

JR: Can you be any more specific at this point?

JC: Well, if I were to do it today, what I would do would be to find through chance operations the number of words for each remark, each thought. I don't intend to write mesostics.[46] I will write, so to speak, as I wrote the *Diary: How to Improve the World (You Will Only Make Matters Worse)*. Or another text that I wrote I'm thinking of—one called *Audience*. I wrote that while I was driving along the highways. I would know that I had to have an idea which had seventeen words, and then I would write it in my mind until I knew it. And then when I knew it I would park and write it down, and drive on with say twenty-three words *(laughs)* in my head; or that obligation—to write twenty-three words. So now I will write one text which divides the forty-five minutes. Maybe it will be done with time brackets, which is the way I'm writing music now. So where I could begin and where I could end would overlap, so that something could be read quickly, or slowly and still fit the time bracket situation. It may have to do with time brackets rather than number of words. But there'll be some such restriction. And then, there will be the possibility of being silent, of not saying

45. "Overpopulation and Art" was in fact delivered twice at Stanford in January 1992, though, due to an increasingly busy schedule, Cage did not have time to compose two time-values-specific versions. It has subsequently been printed in *John Cage: Composed in America*.

46. Cage actually did use mesostics.

anything. And that possibility will be different for each day. So in effect I'll be giving the same lecture twice. Some of the things I say will be the same, but they might be at different speeds, hmm?

JR: So it will be a Heraclitean lecture, into which you won't step the same way twice.

JC: Yes . . . It's an interesting problem. And it makes it into something I think I can do without becoming worried about the situation, about how I should say something important. *(laughter)*

JR: It will be interesting too as an act of noticing for the audience, to hear it twice, in different ways.

JC: I think so. And it will also be interesting to be hearing a lecture when the lecturer has stopped talking.

(Pause.)

JR: I listened last night to the tapes we've done over the last two days. Do you mind if at this point I ask—

JC: No, do anything you want. But tell me when you want to have lunch. What time is it now?

JR: Oh. O.K. It's 12:15.

(Tape recorder turned off for lunch.)

JR: I want to return for a little bit to your talking about Duchamp's use of chance operations, the fact that he started using them in 1912, the year you were born. I'm curious about your first encounter with the idea of using chance operations. Was it through Duchamp, or was it elsewhere? But also how do you understood Duchamp's reasons for using chance operations.

JC: His reasons?

JR: Yes.

JC: My use of chance operations came out of contact with the *I Ching*, the ancient Chinese oracle which uses chance operations to obtain the answer to a question.

JR: Did you know about Duchamp's use at that time?

JC: Not particularly. I knew about the *I Ching*. It was the *I Ching* that I saw one day as a possible way of writing music. That brought about the *Music of Changes* [1951–52] where the process of composing was changed from making choices to asking questions. The questions were detailed to all of the various aspects of a piece of music in as complicated and thorough a way as I could. So, one of the ways that Marcel had used chance operations was, as I told you, taking things out of a hat.[47] Another way was equally physical. He took a toy pistol, where you put something in the pistol—not a bullet, but it could move toward an object,

47. Marcel Duchamp composed a piece of music using chance. It is called *Erratum Musical*, and is dated 1913, the year after Cage was born. In his Catalogue Raisonné of Duchamp's works, Robert Lebel describes it this way: "Melody for three voices (Yvonne, Magdeleine, Marcel). Notes were drawn at random from a bag in which they had been jumbled beforehand. This composition was played by the family trio." In Robert Lebel, *Marcel Duchamp* (London: Trianon Press, 1959), p. 165.

a canvas, say, and make a spot. If you had put some color on the cork in a toy pistol, it would then put a point on the canvas. And he made a beautiful painting which was the result of shooting one of his former paintings. You can't really call taking things out of a hat or shooting that way chance operations in my sense, but they were in his sense. I have in fact—say I arrive some place without my chance operations, what do I do?[48]—I put everything on slips of paper and put them in a hat and pull one out! *(laughter)* In order to answer the question. I've every now and then arrived some place where I had to make some such decision, and that's how I've operated. I've operated Marcel's way when I couldn't act in my own. *(laughter)*

JR: That's very reassuring. I'm glad to hear that you're not at a loss when you arrive without your chance operations. It sounded at first so much more serious than forgetting an umbrella. But it's not, for you.

JC: No.

JR: Do you know of any other visual artists using chance operations? Have any others interested you?

JC: I don't really know. Though I'm sure there are such things going on. Most people would say no, that they're not using chance operations. Even Jackson Mac Low, who does use chance operations, frequently says that he is both doing that and not doing that.

JR: Yes, he said that just last night on the phone to me.

JC: He sees value in both ways of working. *(pause)* I think he needs both ways, obviously, because he's always saying that he does use both ways, so he needs them. And the reason I think for his needing them is his way of working. That way of working which he calls "seed," using a seed, is extraordinary because it means a letter is not only a letter, but it's a place in the text. So the first letter is in the first place in the text; and if it's the second letter, it's in the second place. So a word is not a word, but is a series of letters in the proper places, hmm? When you work that way, it is so detailed. It's much more detailed than a mesostic, more detailed than anything I would think of doing with words. So he needs more air. He needs liberation from the use of chance to his own determination. You see, his way of working carries him into unusually spelled words, hmm? They're not words that we use every day. He must find them in books, reference books. And with computer technology, he's able to find a lot of them. So, that means he has to have some freedom in the use of them. Otherwise, we wouldn't be able to read with any pleasure at all. And the principle of caesura, pauses, becomes of the utmost importance, as indeed it is for me—to have pauses. Partly because I and he, it seems to me, are renouncing punctuation. Does he do it as much as I do?

48. Cage carried his IC *(I Ching* simulation program) "supply sheets," tables of numbers generated by the computerized coin oracle, in a black "valise" somewhat reminiscent of Duchamp's famous valise, in which he put small-scale simulations of his art. See Lebel, ibid., pp. 82–83, for description and contents of Duchamp's valise.

JR: No, actually, he more generally uses punctuation of some sort. But you're right, when he doesn't, as in the *Twenties*, then he uses the caesura, the big breath.

JC: Well I tend not to use punctuation at all. And I look backward with excitement *(laughs)* to the time in language when there wasn't any punctuation.

JR: And when words all ran together.

JC: When they all ran together. And that's the way I'm writing now, with *Ulysses* [*Writing through Ulysses (Muoyce II)*]. But with "Nighttown" in *Ulysses* what am I going to do—with question marks and exclamation points? Certainly in "Nighttown" and certainly in—what's it called, the next to the last part—the "Odyssey" name?

JR: "Ithaca."

JC: Yes, with the asking of questions.

JR: Yes, a kind of catechism.

JC: Yes—how did Bloom feel about water? And then the answer. Well there, the question mark is of the greatest importance. Otherwise you wouldn't know that it was that chapter, hmm? That chapter is made up of questions and answers. So my transforming of it will be made up of questions and answers. Certainly!

JR: Will they remain syntactically questions?

JC: Oh no. They'll be irrational questions, hmm? But they will be questions. And the question mark will appear. In fact it may appear multiply. Because chance doesn't know that it's only supposed to appear once. *(laughter)*

JR: It's wonderful what chance doesn't know.

JC: Yes, yes. Of course I could say, once it appears we won't take it the next time, but I won't do that. *(pause)* But in the "Nighttown" I have to use exclamation points and question marks. In other words, I'm using punctuation—periods, and commas, and the whole business. I don't know if I'm doing it well. But Joyce, in *Ulysses* in particular, is teaching me that I must use it, punctuation.

JR: I'd like to see it.

JC: I'll show you that, now. *(JC gets manuscript)* I'm obliged to use, not chance, but choice at certain points. I cannot rationally do "Nighttown" without making some choices.

JR: And that's why you say you're brought to the point where Jackson is.

JC: Brought to the point of Jackson. By the nature of the task. Just take one example: the names of people keep cropping up through chance operations. So you have more people than you have speeches. Because when the chance comes to a page, say the twenty-third line, it turns out, nine times out of ten, to be a person rather than something he said. So what are you going to do with Bloom? He's all over the place! *(laughter)* He's constantly present. So you say, Bloom Bloom Bloom. And if you have four Blooms, do you put Bloom Bloom Bloom Bloom? And if you have Zoe, do you say Bloom Bloom Zoe Bloom Bloom? *(laughter)* Or do you say, Zoe Bloom Bloom Bloom Bloom? You have to make a decision. [See typescript page from section based on "Nighttown," Appendix C.]

JR: What criteria do you use?

JC: I was using what Jackson would do—choosing.

JR: But what would be the reason for making a particular kind of choice? Say, choosing Bloom Bloom Zoe Bloom Bloom, versus—

JC: Rather than just as they came up?

JR: No, I mean, what principle would lead you to—

JC: Not chance. But if I used chance, the question then would be formed in such a way that my choice would be evident. At some point in that task, I would have to express my choice.

JR: Would that choice be based on sound?

JC: Well, this is why I say I'm struggling with it. I don't know. I don't *want* my choice to be evident, hmm? I want to be at the point that Marcel so frequently talked of. He talked of the need for disinterestedness. In the finding, in the signing of a found object—to choose as a found object something that you neither like nor dislike, hmm? He wanted his choice to be colorless, hmm? empty. I asked Marcel if he had any relation to the East, to Eastern philosophy, because so much that he said and did was more like, say, Zen or Eastern philosophy in some form than it is like Western thought. And he denied any connection with it. Just as he said, the artist must go underground, I think that even if he were involved consciously with Eastern philosophy, his answer would have been that he had no connection. My tendency, in anything I do, is to let people know what it is I'm doing, hmm? . . . I think. At least I think I'm telling as much as I can, about how I behave. *(pause)* I think he may have not done that. And in particular, the reason that I'm confirmed now that that was his way of behaving, is Bill Anastasi's finding that all of the subject matter of Duchamp came from Jarry.

JR: Which is something Duchamp never—

JC: Never exposed. He kept it secret. And one of his goals was to go underground—which is an Eastern goal—to be a white animal, in the winter, when it's snowing, and so to climb up in the tree, knowing your footsteps are covered by new snow—so nobody knows where you are! *(laughs)* That's one of the ideals. Another ideal is to find . . . emptiness! To search for the ox, and having found him, to realize that you've found nothing. *(laughter)*

JR: Which you can do, though, without needing to keep secrets?

JC: No, I can say that. And believe it.

JR: The humor in all of this strikes me once again. Your humor. Duchamp is widely felt to have been ironic, which is always in some sense a kind of duplicity—both saying and not saying; and which is very different from the tone of your humor, or humors—multiple humors really. You and I have talked about the absence of irony in your work. How was it with you and Marcel? Did you laugh together?

JC: No. I took Marcel so seriously that I didn't even bother him with my friendship. I didn't want to disturb him in any way. So that I lived in New York, oh—for a decade, without trying to be with him. But then, you know, it was the result

of our being invited to the same New Year's Eve party [c.1966], and I happened to see that there was something about his cheeks that suggested a painting more than a human being. He looked a little bit like a painting by Velázquez; with an almost rouged look that suggested a disappearance of health. So I said to myself, you must hurry up and be with him as much as you possibly can. *(laughs)* Which I did. I went up to Teeny first—still not wanting to disturb him—and said, Do you think Marcel would teach me chess? And she said, Well, ask him! So I went up to him and said, Would you consider teaching me chess? And he said, Do you know the moves? And I said, Yes. He said, Well, come any day you like. *(laughs)*

JR: Did he know you, about your work, at that time.

JC: Oh yes. I had written music for his part of the Hans Richter film, *Dreams that Money Can Buy* [1946–47]. And he had used this sign [A-OK hand sign]—to indicate from the other side of the street one day when I was out walking, he made that sign—meaning that he liked what I had done. But I didn't even use that as an attempt to be with him, because I didn't want to disturb him. But, then, after that New Year's Eve, I came once a week to, quote, study musi—uh . . . study chess with him. And you know, he got quite cross with me finally, because I wasn't winning. He expressed his disapproval, by saying, Don't you ever want to win? *(laughs; door buzzer; JC gets up to answer)* That was in Cadaqués that he said don't you ever want to win. And he was really, really disappointed . . . that I didn't . . . want to win. What I wanted to do was to be with him! That was the simplest thing! That was all. *(laughs)* Chess was simply a pretext. *(laughs)* I wasn't really playing chess, I was just being with Marcel. Of course, the game is fascinating. But he was angry that I didn't win. Because apparently I would get myself into a position where I might have won had I been playing properly, but if I didn't, as I didn't, then I lost. Now that he's gone, and I can't be with him, I naturally have improved in my chess playing. *(laughs)* And I win quite a lot— you know, much more. He would be happy if he knew.

JR: You never won a game with him?

JC: No. And I mostly played with Teeny, not with him, but with Teeny—and she would win. Now, if we play together, I win . . . for the most part.

JR: Still thinking about humor . . . do you find Marcel's work humorous?

JC: Yes. And even more so now that we are told that it comes from Jarry. That is almost—well just imagine!—for an artist of his importance and position with respect to other people's art, to not have had that aspect of his work original, hmm? To have rather taken it from someone else, this work. That's unheard of!

JR: Well, what about Shakespeare? And Joyce's use of the *Odyssey*, and all of Joyce's other sources in *Ulysses* and *Finnegans Wake*—

JC: Well, yes, that's marvelous. And he [Duchamp] must have said that to himself. He must have said that to himself.

JR: It doesn't seem odd to me. The ideas, the substance from Jarry—it's in a way another category of readymades, no?

JC: So, it doesn't seem odd to you.

JR: No.

JC: Well I'm going to tell Bill Anastasi this. It seems odd to Bill.

JR: But, what came from Jarry, as I understand it, was not the formal transformations, but only—

JC: The subject matter. Not the images themselves. So little of what it is. But to Bill it seems to be all. But it's not. I haven't taken it seriously. On the surface of it it's not important, because Jarry has one effect—his work has its effect—and Marcel's work is quite different, utterly different.

JR: And, from the perspective of the world of literature or even visual art traditions prior to the twentieth-century preoccupation with originality, it seems quite usual to me that—

JC: —The subject matter should not be original?

JR: Yes. From my point of view, what art is primarily about is the heightening and transformation of our perceptions, the recombining of elements, the relationships between elements. So, for that kind of project, any subject matter will do.

JC: Oh, I want to show you a book, which, when I read it and then continue in my work [writing through *Ulysses*], I feel as though I'm doing something foolish. *(JC goes to bookshelf and gets book of critical essays on each of the sections of* Ulysses.⁴⁹) Actually, not always, but often, I have read the chapter in the book before I do the chance operations [on the corresponding section of *Ulysses*] so I know more or less what they *think* I'm dealing with, hmm? *(laughs)* And then noticing as I write it whether there's any relationship between what I'm doing and what they're thinking. Which, of course, there isn't. There are little bits, little signs here and there. But not much.

JR: I always have to be pushed to read criticism, or any secondary text. Frequently, of course, I find that I *am* pushed by the work I'm doing. So I suppose I end up reading a lot of it. And then, my god! I seem to write it too!

JC: *(laughs)* Well, yes!

JR: But I certainly recoil from any suggestion of an authoritative mediation . . . interpretation of the text. It can be fun, and useful to read a critical text—particularly when it provides a theoretical, or historical, or material context—but the more authoritative it pretends to be, the less I believe in it. I simply don't believe we should ever be intimidated by interpretation.

JC: You don't? But this [*Ulysses*] is such a beautiful book! And it has excited all these people to write about it!

JR: Of course. And it's excited you to do the things—

JC: *(laughs)* What I'm doing!

JR: —That you're doing! Which none of the people in this book could do. What

49. *James Joyce's Ulysses*, eds. Clive Hart and David Hayman (Berkeley: University of California Press, 1974).

you're doing [in *Writing through Ulysses (Muoyce II)*] is amazing to me—both in its relation to Joyce's text and in its departure—back to an earlier texture of language, and forward toward a new kind of relationship between texts of all kinds.

JC: But it's there too! *(pointing to the critical text)* I mean the idea of doing that [a section by section treatment of the text] is there *(opens book to essay by Hugh Kenner).*

JR: Yes, I enjoy Hugh Kenner. He brings a quirky, inventive mind to what he does. He comes up with surprising facts, and connections that no other mind makes.

JC: *(laughs)* Yes. Are you excited by Zukofsky?

JR: Yes, I'm interested in Zukofsky.

JC: He comes up with connections.

JR: Yes . . . do you know the "Zukofsky *Catullus*"?

JC: No, I don't have that yet.

JR: It's his, and Celia's, translation, or "transphonation" of Catullus, using sonic elements—taking the way the Latin sounds into account as much as semantic meaning, and finding the corresponding English. So, it is wonderfully humorous.

JC: Oh, isn't that marvelous. He's a wonderful mind. Is this part of one of his "collected" books—the long or the short of it? Is it in the short collected?

JR: The English is, but not the Latin, so it's really useless. You must have both to enjoy what they did with the phonetics, the sound. It was printed originally with the Latin and English on facing pages. That edition is out of print, and hard to find. In fact I'm looking for one right now. I loaned my copy to someone and never got it back! I'll try to find a copy for you too.

JC: Well, I'm in close connection with Paul Zukofsky. He might do that for us. I'll ask him. I have a big Zukofsky collection, due to him, now. Do you want to see what I have? *(We look and he does not have the* Catullus.*)*

JR: In fact, speaking of criticism, to gain some perspective on it, if one were to read only certain critics of your work, one could get a very skewed impression of it, don't you think? Reading the issue of *Du* for instance, I came across the essay, *Hatte Schönberg Humor, Herr Cage?*[50]—opposite that famous, very dour picture of Schoenberg—by Michael Schulte, who concludes that certainly Schoenberg had no humor, and neither do you! *(JC laughs)* Except that you tend to tell funny stories. In fact, Schulte says that in talking with you, he found that you often laughed at things he could see no humor in whatsoever. He found it quite puzzling. He ends the essay by saying, in conclusion there is no humor in your work and this is entirely understandable in a world where laughter must turn into terror. So he has—

JC: —A very different point of view.

50. *Du: The Magazine of Culture*, Zürich. *Du* No.5, May 1991, was devoted to the work of John Cage.

JR: Yes. One might in fact say he has a tragic, rather heavily Romantic, tragic point of view, which he is using to mediate a sense of your work. You were talking about the Western tragic view of life that comes from the separation of experience into isolated categories, in contrast to the Eastern comedic—

JC: —Comic, yes. Which is the view that Joyce held. He preferred comedy to tragedy—that it was freer of likes and dislikes.

JR: Is "comedy" for you an idea that is coextensive with humor?

(Pause.)

JC: Humor, in Eastern philosophy, must be connected with the mirthful. As such, it's one of the white emotions, rather than the dark ones. The white emotions are the heroic, the erotic, the mirthful, and the wondrous. The black ones are fear, anger, disgust, and sorrow. Sorrow for instance over the loss of something cherished, or the gaining of something undesired. Even that, I think, is very little known in the West. There is the strong flowing through all of these of freedom from likes and dislikes. Which we also find in Duchamp, in his wanting to find an object which he neither likes nor dislikes. And central to the white and black emotions, is the one emotion of tranquillity. So that traditionally in Indian culture, you're not to express any one, or any combination of the emotions, without expressing tranquillity. A piece that I wrote when I became aware of these Indian "rasas," as they're called, is the *Sonatas and Interludes* [1946–48]. There are sixteen sonatas and four interludes, and they are a bringing together of these eight emotions, with their tendency toward tranquillity. So all of the music moves toward its absence, hmm? Whether it represents the erotic, the mirthful . . . or any of the others. So I've seen the mirthful in that context—as being white, opposite the dark. And I've frequently said when asked whether I like comedy or not, that I preferred laughter to tears. That's one of my stock answers. *(laughter)*

JR: That you usually don't find you've left at home.

JC: I shocked an audience at the University of Illinois by saying that the thing I really disliked *hearing* was music. I was talking to a class in the music school. And, I said, I thought that was how everybody felt. They objected, of course. They *loved* music. And I said, Well, do you like other people's music? If it's from your neighbors? *(laughter)* And they saw that none of us like music, really. *(laughter)* We'd rather they turn it off. Isn't that true? Whereas you wouldn't dream of turning off the traffic. You don't think it's possible. But you do think it's possible, and you act upon it, to stop your neighbors from playing music. *(pause)* You get them to turn the speaker in the other direction. *(laughs)* That's what I've done when I've been annoyed by the neighbors.

JR: I think of the importance of humor in terms of figure/ground shifts. Normally, for instance, we think of silence as the ground and sound as the figure. Then we listen to your music and suddenly find that we're listening to, noticing, the ground rather than the figure. Silence has become figure. And I think these shifts are an important part of Western humor precisely because of the Western

habit of mind that polarizes our experience—into dichotomies, like figure and ground. So when we experience a shift, when we see that things aren't rigid and fixed, that they can change places or be transformed in other ways, there's surprise, and delight . . . but most of all an enormous relief. And we laugh. We let go of the conceptual constraints . . . we are released.

JC: Yes. It's that liberation.

JR: Yes. And your work does that, always, constantly for me. In that way, I experience it as humorous.

JC: I remember—I don't know where it was, whether it was in Zürich or somewhere else—when I did something that [relates to this]. You see, I take comedy quite seriously, hmm? *(laughs)* So that if someone says, Did you mean that to be funny? that's not what I meant, hmm? On the other hand, I didn't mean it to be tragic. I really mean it to be—but I don't want to say that it's funny; I want to say that it's serious.

JR: The reason why I like the word "humor" is that I think it accommodates both of those elements.

JC: I think you're right. I think you're right, yes.

JR: That humor is very serious, but it isn't—

JC: —Grim. It isn't grim.

JR: Certainly not grim. But also not "funny" either, in the usual sense of that word.

JC: No. You see, in music, we have the opposition of classic and popular. So that "serious" music is theoretically "unpopular." *(laughs)* Which means it can't be funny.

JR: Yes. There's also that "funny" opposition in opera—of "grand" and "light."

JC: Yes. There's another, even worse, word, *buffa, opera buffa.* But "farce" is an important word.

JR: Yes, interestingly, farce is closely linked to tragedy. *(pause)* But tell me why you think "farce" is important.

JC: Through Norman Brown. It's he who informed me that it was a serious word. *(laughter)* And his book, *Closing Time.*[51] *(pause)* I don't have his friendship as I had it formerly. Not because we're—well, partly, because we live at opposite ends of the country. But every time I used to go to San Francisco, I used to stay with Nobby and Beth. His wife is called Beth, and he's called "Nobby" because of N. O. Brown. Do you know him at all?

JR: No, not personally. I've read his early books.

JC: It was a great joy for me to talk with him. I've written a text about him in which I express the pleasure I had conversing with him.[52] Then after his interest in *Finnegans Wake,* he developed—and I couldn't follow him—he developed an

51. Norman O. Brown, *Closing Time* (New York: Random House, 1973).
52. "Sixty-One Mesostics Re and Not Re Norman O. Brown," in *Empty Words* (Middletown, Conn.: Wesleyan University Press, 1979).

involvement with Islamic culture. He became in a detailed way knowledgeable about Islamic literature and the different sects of Mohammedanism . . . of Islam. They're very important, and of course it's of the greatest urgency from so many different points of view. As he's put it, it's culturally urgent. He puts it this way: now that we can read *Finnegans Wake*, we can read the Koran. *(JR laughs)* Isn't that marvelous?

JR: Yes, that is marvelous.

JC: The Koran apparently makes no sense at all! Have you looked into it?

JR: No, I've at times felt I should—

JC: —Read it.

JR: —Find out more about Islamic culture, but I haven't.

JC: Well, apparently it's almost impossible.

JR: I've had trouble finding—

JC: —Any sense in it?

JR: Well, trouble finding any pleasure in it, which is even worse than not finding sense. I don't expect sense without a good deal of study, since it's such an unfamiliar culture.

JC: Well, Nobby says now that we can read *Finnegans Wake*, we can—

JR: Well, that's a very humorous statement.

JC: Well, he means it very seriously.

JR: But I also mean that very seriously! *(laughter)* Because his statement brings up the possibility of a conceptual, even a cultural, shift with respect to something from which we have felt estranged, just as readers once felt estranged from *Finnegans Wake*, and listeners have felt estranged from silence, no? I think that's very interesting.

JC: Yes, it is very interesting. And I would know more about it if we had conversations, but we don't.

JR: Well, you will at Stanford.[53]

JC: No.

JR: Won't he be there?

JC: Yes, but he won't talk. I'm sure he won't.[54]

JR: I thought he was on the program.

JC: Only—what do we say?—nominally? His name is on the program, but he won't—I don't think he'll be on the panels or anything.

53. For John Cage at Stanford: Here Comes Everybody, a week-long festival in honor of Cage's upcoming 80th birthday, sponsored by the Stanford Humanities Center, January 27–31, 1992.

54. Norman O. Brown did in fact give a talk—a passionate, aphoristic lecture entitled "Dionysus in 1991." Cage and Brown participated together in panels where they spoke to each other with highly charged intimacy from what seemed to be almost incommensurable worlds. At one point Brown said, "John and I are like the two old kings in *The Bacchae*." It was here that Brown stated in response to Cage's optimism that the issue most present and least discussed at this conference was death, that death was everywhere present in the room, and Cage, smiling sweetly at him, said, "Nobby, I'm ready."

JR: Why? I'm surprised, and disappointed.

JC: Yes, I would be too, but I don't think he will be. He wrote to me saying that he had refused.

JR: Refused . . . ?

JC: To be on a panel.

JR: Did he say why?

JC: Well, he wants to be present, but he doesn't want to be part of it. *(pause)* We were together at Wesleyan when there was a concentration on my work, and he wrote—do you know that text?

JR: Yes, the one in the *Bucknell Review* book?[55]

JC: Yes. I gave a lecture on anarchy, and he gave that one, which shows that I'm apollonian rather than dionysiac. And, for him, dionysiac is of the essence. *(pause)* So . . . that's why he doesn't want to be connected.

JR: Ah, yes, the "birth of tragedy"[56]—but this is, I'm afraid, the tragedy of dichotomous categories . . . of separation.

JC: I don't think that the apollonian and the dionysiac are in opposition. I don't think that the notion of "being in opposition" is beneficial to our society. I think that the opposites must come together. And that's what I think is the position of Eastern philosophy. In Tibetan Buddhism, of the sudden persuasion—which is what Zen is in Japan—it's not the gradual learning, or coming gradually to enlightenment, it's the sudden flash. Do you know in one of the Sutras, the Buddha is asked how enlightenment comes. And he says, suddenly; and gives the example of lightning. And then in the next paragraph he's asked, how does enlightenment come? And he says, gradually; and gives the example of a seed growing slowly. So it comes both ways. But in the sudden school *(JR laughs)*—which I prefer—there are three principal truths. They're called the whispered truths. Which means you oughtn't to talk about them. People shouldn't know about them. And the reason people shouldn't know about them is because they won't understand them, hmm? So they have to be spoken of so that they won't know that they're being talked about. *(laughs)* And the first is that creation is endless, hmm? That it's *vast! Incomprehensibly* . . . great. And the next is that your action in that situation—of vast creation—your action should be as though you were writing on water. Isn't that beautiful? Or, pulling yourself up into the tree in winter. In other words, not to make an impression. And the final thing is to realize that the opposites are not opposite. *(pause)* And that's what's so dangerous. And that's why it's whispered. Because if you learn that the important thing is to meditate when you're not

55. "John Cage: A Lecture by Norman O. Brown at Wesleyan University, February 22–27, 1988," in *John Cage at Seventy-Five*, eds. Richard Fleming and William Duckworth (Lewisburg, Penna.: Bucknell University Press, 1989), pp. 97–118.

56. Referring to Nietzsche's *The Birth of Tragedy*, in which the struggle between the apollonian and dionysian seems so fundamental as to be irresolvable—a dynamic, generative tension, rather than an either/or.

meditating, hmm? then how will we persuade people to meditate? *(laughter)* And when you speak of utopia, generally, people are worried. About letting everyone have money, for instance, hmm? If everybody had money, wouldn't they do the wrong thing? But we have to bring about richness among the poor. And it's certainly been the office of religion, to try to bring poverty to the rich! *(laughter)*

JR: Well, yes, in principle at least. When there is talk about the humor in Zen, there are always stories that demonstrate that the moment of enlightenment is humorous.

JC: Yes, yes.

JR: And it's often demonstrated by a story using—

JC: —Non-sequiturs.

JR: Yes, yes. The thing that the master does that's completely—

JC: —Irrational.

JR: —Out of the blue, and that produces enlightenment, suddenly, surprisingly, making no sense. And the moment of enlightenment is accompanied by a laugh, a "Ha!" *(JC laughs)* Thinking about that in relation to what I was saying about the connection of humor in the West to figure/ground shifts, or exchanges—I think that the moment of enlightenment, and therefore of that particular kind of Buddhist humor, may be about the *disappearance* of figure/ground—the sudden experience of the collapse of those divisions. And here I'm thinking about fitting your work into the line of artists and inventors and scientists in Western culture who have created figure/ground shifts—and I think you have done that with your reconfiguring of silence; I believe that that's true. And yet, I think your work is about the complete disappearance of figure and ground, as well. So the humor that I find in it is connected to both Western and Eastern needs and structures. And in its dissolution of opposites is particularly close to the basis of Eastern spiritual thought.

JC: I hope so.

JR: But humor is, I think, of—

JC: Well it's very much like the sort of thing we were saying earlier. The humor accompanies it, rather than illustrates it. Isn't that it?

JR: Yes, I think the humor is in the process. Or perhaps it just *is* the process itself—movement, the fluidity of shifting percepts, concepts, emotions. . . . Or to put it another way, one could say that humor is structural—it's the enactment of structure. I think, interestingly, that this is very close to the medieval idea of humors—shifting moistures.

(JR turns tape.)

JR: But to return to Michael Shulte, suppose he had been interviewing you and had asked you directly, Herr Cage, is there humor in your music?

JC: *(laughs)* Music has often been said to be an art that is incapable of humor. It's not the place for humor. On the other hand, Kant says that humor is automatically with music. Well, he doesn't really say that. What he says in the *Critique*

of Judgment is that two things can give aesthetic pleasure without having any "meaning" at their basis—one is music, and the second is laughter. You can enjoy laughing, and laugh for no reason at all. And you can enjoy music without knowing what it means. People frequently say about the music of Satie that it's funny, hmm? And the only reason they say that is not because of the notes, which are not funny at all, but because of the remarks he puts over the music, where he says "like a sour plum," or—I'm making something up, but it's that sort of thing— "as though you were a giraffe hunting for snails." He says such silly things.

JR: For the pianist to read.

JC: Yes.

JR: He didn't want these to be divulged to the audience.

JC: Yes, he also said, don't read these out loud. Anyone who does that will not be given a passport. *(laughter)* And yet people do that all the time, reading his poetry along with his music. I always propose that they don't do it, following his request. But I don't find his music funny; I find it very very beautiful. Apparently the Juilliard students who played this summer in the Satie festival in the Modern Art garden [MOMA Summergarden series]—Paul Zukofsky had the greatest trouble in getting them to take Satie's music seriously. They thought, because of his remarks, that it was all foolish. And I must say, the piano music for the most part was played very badly. By bad, I mean too fast, and with too great contrasts, so that it didn't move toward what Satie himself called "interior immobility," hmm?

JR: Do you think there may be any humor, in the broader sense of humor that we were just talking about, in Satie's notes?

JC: I am made—when I hear Satie well played—I'm made to . . . sit on the edge of my seat! *(laughs)* You're very alert. You're made very alert . . . by the beauty of it. In the most unlikely musical circumstances—the entrance of the woman in *Relâche*, the ballet, which is repeated at least twice. It's so incredibly beautiful, and so close to what we call popular or vulgar music. It's just amazing. Each time it comes, it's orchestrated with the greatest skill. He's always spoken of as someone who didn't know how to orchestrate. But it's orchestrated with such skill and . . . oh, attention to detail. So each time it appears, it appears as a new experience.

JR: A number of years ago, in Washington D.C., there was a concert of your music in what is now the National Building Museum, and what had been the old, I'm not sure, maybe the old Pension Building? It had been used as a hospital during the Civil War. At any rate, it opens out into an enormous central space with immense, high columns, and several stories of open galleries around all four sides.

JC: Oh yes, I remember. It was a very big space and it was possible to have concerts going at both ends.

JR: Yes, and *Apartment House 1776* was performed, with Paul Zukofsky, actu-

ally, playing the violin. You were laughing, heartily, all the way through it. As were many others. Not because there were jokes, or anything intentionally funny, but I think because of surprise and delight in what was coming together by chance. You were talking earlier about sounds moving toward their disappearance. Chance does that, in a sense, to everything it touches, doesn't it? It brings things so close to their own contingency, so close to the fact that they might never have happened at all. And with indeterminacy structured into the score, it will never happen again that way. So it shifts one's attention to the edges between appearances and disappearances—and oddly, interestingly, that's humorous. *(long pause, JC smiling)* Well, I think we're on the edge of disappearance, or at least depletion *(laughter)* if we don't have some lunch. Shall we stop at this point?

JC: Whatever you want. What time is it?

JR: Oh, it's very late. It's 1:30.

JC: Well, I'll put the phone on, and . . .

(Tape recorder turned off for lunch.)

III

MUSIC

Cage's Loft, New York City
July 15–17, 1992
John Cage and Joan Retallack

On the Saturday before we taped the following conversation, John Cage was mugged in his apartment by a man who claimed over the intercom to be from UPS. Cage was shaken by this experience but, not surprisingly, did not want it to interfere with anything scheduled for the coming week.

In discussing the sorts of things we would talk about with respect to his music, Cage had told me he wished to concentrate on the way in which he was currently working, "So that I can find out what I'm doing. . . . In the course of the conversation, we will discover things." He felt that James Pritchett's upcoming book[1] would do a good job of dealing with his earlier music. The more recent work was what needed illumination. He said, "Before I begin to work I think I know something; then when I'm working I discover I don't know anything at all. What we are doing is finding out what it is we are doing."

Our conversations, beginning on the fifteenth, and over the next few days, took place during the Summergarden concert series held in the Museum of Modern Art Sculpture Garden with Paul Zukofsky, Artistic Director in collaboration with the Juilliard School. The entire series in the summer of '92 was devoted to John Cage's music. What this meant was that we would be intermittently taping in Cage's loft, and making trips to MOMA, as well as to the sound studios at the FM radio station WNYC, which, in conjunction with the Summergarden concerts, featured Cage's music (a performance of *ASLSP* [1985] by Michael Torre) along with an interview by John Schaefer on the live program *Around New York* (July 17).—JR

WEDNESDAY, JULY 15

(The tape recorder is turned on as we're discussing JC's need to be at MOMA at midday to supervise a sound check for the concert that night.)
JR: *(referring to the schedule for the next few days)* . . . So we'll operate in our alloted time brackets, trying to develop illusions of infinite time in a hurry—
JC: I haven't called the lady who's in charge of the publicity for the museum. I'm not sure of her number. I had a letter from her with the number, but I threw it away. *(laughs)* What I would like to do for the sound check is to be at the museum at 12:15.

1. James Pritchett, *The Music of John Cage* (Cambridge: Cambridge University Press, 1993).

JR: O.K.

JC: And then, the other appointment, either today or tomorrow—I don't know which—at something like 3:15, is to go to WNYC. I'll check that now.

(After we set our schedule for the next two days, the talk turns to eczema, from which Cage had suffered for many years until a recent "cure." Cage says the treatment that brought about the cure was an outcome of Einstein's theories, which led in 1928 to the therapeutic use of a "superficial x-ray called a Grenz Ray.")

JC: After six applications I was free of the disease. . . . Did you ever see that awful play about the Marquis de Sade?

JR: *Marat Sade?*

JC: Yes. There were people in tubs scratching themselves. *(laughter)* Wasn't it awful?

JR: There was a serialized play on TV about eczema, by a British writer who's chosen television as his medium, for interesting reasons actually . Because it's the medium that reaches the most people, so he chose that rather than theater. And he did a—

JC: Democratic greed. *(laughs)*

JR: The interesting, surprising thing—the pleasant surprise—is that his motive doesn't appear to be greed, but that the TV audience cuts across economic and class categories. He wrote a sort of tragicomic, dermatological detective musical. And it all happens because the central character, a writer of detective fiction, has eczema. [The playwright is Dennis Potter.]

JC: *(laughs)* Oh really!

JR: It's called *The Singing Detective*. And the writer, who is also the detective who sings, has horrific eczema. The show operates on many levels—serialization being an important one. It's delightful. Though, with your experience, you might find it unbearable.

JC: I don't know. Maybe I'd enjoy it now.

JR: *(adjusting position of tape recorder)* I'm going to put this where I can see that it has a living pulse.

JC: What are we talking about today?

JR: What I have in mind is that we concentrate on music with both a wide-angled and discrete focus—because in your work, music radically involves everything that interests you, but also is very specific in details of structure and method and process. I thought today we might start with the wide-angle. In preparing for this opening conversation on your music, I found myself thinking about your position on the place of the experimental in history—particularly as you articulated it in the "History of Experimental Music in the United States" in *Silence*. I wonder if you think your statement, written in 1958 or '59, still procedurally situates us and, if so, how? I'm thinking about this in terms of your own recent history and your current sense of the problems we are facing in these complicated and violent times. You wrote in "History of Experimental Music," echoing, in

part, Sri Ramakrishna, " 'Why, if everything is possible, do we concern ourselves with history (in other words with a sense of what is necessary to be done at a particular time)?' And I would answer, 'In order to thicken the plot.' In this view, then, all those interpenetrations which seem at first glance to be hellish—history, for instance, if we are speaking of experimental music—are to be espoused. One does not then make just any experiment but does what must be done."[2] History being "hellish" at very least seems to connect right now with your experience [of being mugged] on Saturday, this encounter with . . . well, what would you call it?

JC: *(pause)* The situation of having and not having. And the necessity on the part of those who don't have to take from those who do. It's a problem that confronts the whole world now, I think, very seriously. Russia, for instance, as against the United States. And you could say what's called the East in European terms as opposed to the West. For instance in the unification of Germany. And with respect to the unrest which baffles President Bush. That unrest in our country will continue until something is done about the economic imbalance *(JC pronounces this "im-bay-lence")*.

JR: Pronouncing that "im-bay-lence" brings to mind Baal, bailiffs, balefulness, not to mention Beelzebub.

JC: Beelzebub! *(laughs)*

JR: Well that's similar to—*(phone rings)*

JC: Let's let it go.

JR: Similar to what you said after the opera house was burned down in Frankfurt.[3] This is part of our continuing history, both past and present, isn't it?—the enormous gap between desire and need: what is desired by those whose means have removed them from need; what is needed by those whose circumstances make desire itself a luxury. If the experimental must always be what *needs* to be done, what needs to be done now, with experimental music?

(Pause.)

JC: I don't think the extremity of the economic problem will be solved by musical measures, hmm? *(laughter)*

JR: All right, granted that it can't be a solution . . .

JC: Can it help?

JR: Or how does it—

JC: What's the relationship?

JR: Yes, what is the relationship to social problems? If not one of solving, what is it?

(Pause.)

JC: Well what baffles President Bush, I think, is that order isn't working. And he wonders why. Order is no longer respected, even by those who make it, hmm?

2. John Cage, *Silence* (Middletown, Conn.: Wesleyan University Press, 1961), p. 68.

3. This occurred in 1987, postponing and relocating (to another concert hall in Frankfurt) the world premiere of Cage's *Europeras 1 & 2*. The arsonist was an unemployed East German.

There's no confidence in it. I ran across a statement by Marcel Duchamp some time ago which is relevant. *(gets book from shelf; reads)* "At lunch in the gallery, Duchamp suggests that in fact everything in the world happens anarchically. Laws are simply pretexts, are not respected, and we could do without them. If money could be abolished, life would be much easier. The baker would continue to bake bread because he enjoys it. Someone must do it. You could take one or two loaves a day without paying. You cannot eat more and it would be useless to stock more because you couldn't sell it. *(laughs)* In the evening Duchamp returns to the same subject declaring that the family is a good example of human beings living in anarchy. The children take what they need from the table or the kitchen. There is no price paid or legal formality. Everything takes place freely between father and son. Things are settled between them. There is enough for everyone." [4]

(Pause.)

JR: You said even those who make the order don't respect it, respect perhaps the idea of *the* law, but not laws that would regulate their own behavior.

JC: So you can really do without laws. But that won't help. I mean the establishing, say, of anarchy in music, hmm? won't help the economic problem in the world. That things are beautiful without laws is true. But I don't see that it helps . . . the problem of not having what you need. Which is the case with those who become violent, because they don't have what they need. They take intolerable means to solve their problem. On the social scale it's called looting; on the individual scale it's called mugging. They have to do something in order to have what they need. Or you could say "have *something*" because they don't know by those means what they'll get, that it will be what they need. When they rob the billfold they don't know how much is in it. Or whether it will in fact pay the rent or whatever it is that's needed.

JR: So you could not have said to the man who mugged you, "I'm not telling you not to worry, but actually I'm someone who is working on the problems that create your need."

JC: No, he wouldn't have understood. He was without . . . well, he was talking constantly, threatening death and so forth. He had no time to stop talking. He was intent on finding out where the money was. I was looking for it but I was in his grasp so I couldn't look very well. Sometimes, without him, I lose my billfold. *(laughter)*

JR: He couldn't have listened at that moment.

JC: No.

JR: His sense of his own need blotted everything else out.

4. Cage is reading from a translation of Denis de Rougemont's *Journal d'une époque 1926–1946* (Paris: Gallimard, 1968). This excerpt is from de Rougemont's account of a conversation he had with Marcel Duchamp at Lake George, New York, August 3, 1945.

JC: True. And I'm afraid that that's what we're living in on a very large scale. I don't see the end to it. We can only have our sight at the distance of utopia to find a solution, hmm? We can't keep our sight local to achieve a glimmer of utopia. The sum of my impression after being mugged the other day was, how is it that I could be so foolish to be optimistic? *(laughs)*

JR: Ahh. Have I ever told you my definition of hope?

JC: *(laughing)* What is it?

JR: The willingness to be pleasantly surprised.

JC: Yes?

JR: Which sounds perhaps trivial. But I think it is a complex and devious undertaking to remain in a state of willingness, to maintain even the ability, to be pleasantly surprised. It means countering all the good sour sense in both pessimism and skepticism. But one must acknowledge that there is always good *and* evil. That there's a struggle going on and we live in the midst of it.

JC: Yes, that's the truth.

JR: In fact, one of the things that has bothered me about the statement of Suzuki's that you often quote, "I think there's a tendency toward the good," is that it projects an image of a continual line of progress, as if at any moment you could look at what's going on and gauge—

JC: He didn't necessarily mean that. He may have meant that there was in *us* a tendency toward the good. That in coming to him we were thinking that we were getting better. *(laughs)* He may have been talking not about "facts" but about us, as students.

JR: Not "world us"?[5]

JC: I never knew what he meant, and I still don't really know. But when I get an inkling of something good happening, some acceptance of the necessity of unemployment for instance, then I think . . . I remember . . . what he said. *(laughs)* That he might have meant that. *(looks toward stove where a pot of beans is cooking)* Let me see if I have enough water in that.

JR: I think about this in terms of those of us who monitor what you're thinking and doing and the degree to which your optimism is a working optimism, a part of your methods, and your *poethic*, to use that word that comes to mind always in relation to your work. For instance, in our first conversation [in this volume] your optimism about the possibility of settling the Gulf crisis non-militarily—which would have seemed like a real advance in the sociopolitical scheme of things. At the time you linked this possibility with Suzuki's statement, and then, look at what actually happened! The old forms are reiterated: war breaks out. Does this make you feel as though you need to go back to square one? An analysis of what

5. Referring to Cage's "Overpopulation and Art," where he says "our picture that's now Visibly/dEveloping/is woRld us." In *John Cage: Composed in America*, ed. Marjorie Perloff and Charles Junkerman (Chicago: University of Chicago Press, 1994).

the Cagean optimism is about could be seen to rise and fall in this way. So I think it's important to talk about how you assimilate something like this happening into an optimism that can allow—

JC: That continues . . .

JR: That continues and can allow the acknowledgment of—

JC: —The possibility of a reason for pessimism, hmm? *(laughs)*

JR: Yes. Knowing that you have admired Kierkegaard, I think of his saying somewhere that his life in philosophy was his way of working on the struggle against despair. His particular humor seems to come out of the possibility of despair countered by inventively courageous acts, leaps of work and faith. I wonder if you identify with that at all.

(Pause.)

JC: I feel at a distance from that. But I admire it . . . from a distance. I don't have the experience of needing the struggle in order to do the work. *(pause)* In fact, I identify more with the haiku poem that I've referred to often, "without lifting a finger I pound the rice," hmm?

JR: Accepting rather than struggling?

JC: It's working in such a way that it doesn't require muscle, hmm? So that it's not feeding on a sense of accomplishment, hmm? I don't know if this makes sense. So often work goes toward an end, but if the end is nothing but time or space that's coming anyway . . . whether you work or not, the actual work, then, is simply like going through the motions and not suffering, hmm? In fact, throughout my life, through the use of chance operations, I've noticed that people who take art seriously—not that I don't—but most of the people who take it seriously think you should suffer in order to make it. That if you don't suffer, as I don't, it's highly questionable whether it's *art*, hmm? *(laughs)*

JR: I wonder then, having invented ways to do your work so that—

JC: —So that that doesn't happen.

JR: And so that the work can benefit from the possibilities that in some sense would be there anyway, without the work, I wonder about the life in between work projects. I've heard you say, for instance, such and such "gives me the courage to go on." Or that you need the courage to go on.

JC: You mean, what is *that*?

JR: Yes, what is that about?

(Pause.)

JC: *(in a very faint voice)* I don't, I don't really know. I'd have to come to needing that again.

JR: It didn't happen after you were mugged?

(Pause.)

JC: Well, after being mugged I had one not entirely sleepless night, but I had a night that mulled over what happened, and prepared for the day to come, and wondered what would be sensible on my part in the way of continuing. Should

I continue, for instance, as usual, or should I take some precautions which I had not before taken. And you find out, of course, that you don't need to do anything, but just do what you always did. Which is to say, open the door, go out, and after a while come back. The overwhelming fact is that we continue, and we continue even though these extraordinary, unwanted events . . . happen. And you could if you wish say the unexpected opposite kinds of things, good things, happen too—the extremes. But the *fact* is that we continue, without either great benefit or great loss.[6]

JR: There are many who would say, have said about and to you, that your social concerns, particularly in the face of blatant instances of desperation and violence, should result in an art that more directly addresses, say, the terrible gaps in the distribution of wealth and power in this country—that is, as we discussed earlier, the possibility of a more explicitly political art.

JC: So that you change the work in order to mollify the opponent? *(laughs)* I'm not akin to that kind of drama. I don't feel that I can . . . as you quoted from Kierkegaard—you say that so beautifully—I can feel admiration for it. And I'm sure that's close to the feelings that Nobby Brown[7] has when he's faced with the idea of things getting *better*—having a tendency toward the good.

JR: Your persistence in your views in this respect is particularly interesting because your work does not seem to have to do with denying what is, or shutting out life. Though it does have to do with disciplines of attention. And attention, to the extent that it involves heightened focus, means excluding things, leaving certain things out. At the same time, the challenge to return to life with open ears and eyes seems to be at the core of your work. So your refusal to be an activist, to be politically involved, can be confusing. *(pause)* And then I think of Adorno's ideas about the relation of art to society and his feeling that the future of music, after Schoenberg, looked pretty dismal, except for John Cage's work, with its inclination toward silence and the meaningfulness of its "terrifying" contingency.[8] All of this coming out of his notion of art operating like Leibniz's monads— unconscious, windowless, and yet reflecting everything else.

JC: It's like the Oriental thought of each being at the center, of interpenetration and nonobstruction.

JR: Adorno uses that idea in saying, to directly quote him, "The relation of

6. Cage's friend William Anastasi took it upon himself to arrange that packages for Cage and Merce Cunningham be delivered around the corner to an entrance to the building with a doorman, who brought them over. Cage protested, and then accepted this adjustment with some dismay.

7. Norman O. Brown.

8. Theodor Adorno writes, "The dividing line between authentic art, which engages the crisis of meaning, and resigned art . . . is . . . whether it represents an adaptation to the status quo; whether the crisis of meaning is reflected by the work or whether it is immediate and bypasses the subject. Highly revealing in this connection are musical phenomena such as John Cage's piano concerto, which imposes the strictest contingency on itself and gains a kind of meaning in the process, meaning in the form of an expression of terror." "Consistency and Meaning," in *Aesthetic Theory*, trans. C. Lenhardt (London and New York: Routledge & Kegan Paul, 1986), p. 221.

works of art to society is comparable to Leibniz's monad. Windowless—that is to say, without being conscious of society, and in any event without being constantly and necessarily accompanied by this consciousness—the works of art, and notably of music which is far removed from concepts, represent society. Music, one might think, does this the more deeply the less it blinks in the direction of society."[9]

JC: I wonder if he's thinking of music as a number of people working together. For instance, the orchestra acting as a model of society. Or is he not thinking that way at all? Would he be thinking in terms of, say, the piano sonata, in relationships of repetition and variation? I doubt it. I mean I can't see in the image of music as repetition and variation any hope for utopia! *(laughter)*

JR: Well, yes, it's puzzling. He admired Beethoven, I think, as much as Schoenberg—each in his view bringing something historically timely to musical forms. He says, and I think this is the heart of the matter for him, "The greatness of works of art lies solely in their power to let those things be heard which ideology conceals."[10]

JC: I find my response to those words confused—going first in one direction and then in another. The things that Schoenberg emphasized in his teaching were repetition and variation, which would tend to what we call relationships. And then he said—to simplify it—he said that everything was a repetition. Even a variation was a repetition, with some things changed and some things not. But then something that you just quoted leads in another direction as though there were a subject. As though it was about something. Which could be the emotions. Ideology would conceal by relationships. And those things being heard would be, so to speak, speaking the mysterious language of the unknown! *(laughs)* Which music could be imagined as being able to do. *(laughs)*

JR: And yet if you read Adorno as being interested in the way in which music has an historical presence, a material presence which moves us away from distant conceptualizations—

JC: Into the nature of its material.

JR: Yes, and into the possible.

JC: Ah, then I feel easier with it.

JR: I bring this up—Adorno with all his baggage—because when you say that right now you don't know what it is you are doing in your music, I wonder if this has to do with questions of formal and material process or whether it might have to do with the relation of your music to the world in which we live at this historical, social, political moment. Or possibly these considerations can't really be separated.

(Long pause.)

9. In Martin Jay, *Adorno* (Cambridge, Mass.: Harvard University Press, 1984), p. 133; quoted from Adorno's *Introduction to the Sociology of Music.*
10. Ibid., p. 155; quoted from "Lyric Poetry and Society."

JC: I'm thinking about a situation I'm actually experiencing these days. I have many commitments to write music. I've agreed to do it and I'm at the moment where I must also tour. I went to Europe recently for concerts and before that to make a film [*One¹¹*, 1992]. I have so many different things to do that I try to foresee the best use of my time, hmm?—the most practical. When I write a piece of music I give it to Paul Sadowski to be copied. And generally I give him manuscripts just before I make one of the trips involving other work, with the hope that when I return from the trip he will have done his work, and, having just made it, I will recognize it, hmm? It turns out that that's not what happens. I gave him three pieces of work and then made a two-week tour to Europe and when I came back no work had been done . . . on the copying. My notation for various reasons has become very, very sketchy. It's largely a result of making use of computer facilities, or so-called facilities. Instead of writing notes, I use time brackets; and in the time brackets I place, not notes, but letters which describe the pitch, and the instrument is specified by name. The pitch is given by its letter and is associated with a mark describing the octave in which that pitch occurs. Fortunately the copyists have learned to read this kind of computer printout that I give them, which they then turn into something much more conventionally musical—with staves and so forth, which I don't provide. Well, Paul Sadowski himself went on vacation, so I was left with his assistants and my work, which they had not understood. I was then obliged to understand anew what I had done, which actually I no longer recognized. I had to figure out, insofar as I could, what it was that I had meant. The notes were very slight, and the idea had escaped me, hmm? So I studied my work as though I were a musicologist, trying to figure out what could have been in my mind. I finally discovered—there were three different pieces, each one different from the others—and I finally figured out what they were and what was to be done by the copyists. I can show you the sort of thing.

JR: When you say you had to recover the idea by becoming a musicologist studying your own work, do you mean the procedural idea?

JC: What in heaven's name I had expected them to do copying the material that I had given them. It's that simple.

JR: And generally—

JC: —It would have made sense, if it had been done closer to the time that I gave the material, because I described it to them then. But they didn't do it then, and they couldn't understand it when they did look at it. In this case the principal copyist had taken a vacation, so I was talking with ones to whom I hadn't explained it. I had to try to—well, I had to *succeed*. I didn't have to try, I had to succeed in figuring out what it was *(laughs)* that I had expected them to copy, hmm? I'd better show you the sort of problem specifically. It was actually not difficult, and I think it wasn't even difficult for the copyists. *(pulls out manuscripts for Two⁶)* These are the time brackets, and this is the writing of the notes, and there

was a lot of it to be done, but it wasn't a mystery. And it was finally somewhat easily accomplished. *(pulling out another)* This one was quite difficult. When it first came back to me, these two pages were missing. They weren't brought to me when I had to try to figure it out. What they are, obviously, is time brackets, but there's nothing in the time bracket, hmm? They're empty time brackets, so how were they to be conceived? One is for the violin and one is for the piano. And these are the notes. This is not in my handwriting. It's in Paul Sadowski's handwriting. [See excerpts from *Two⁶*, Appendix D.]

JR: So this was based on what you told him orally?

JC: Apparently. It says here "time brackets to be placed on pages with room for content." That is to say, empty. But this expression, "with room for content," means that the content could go in them. Which is not the case. So I finally discovered, after studying these other pages — and this was very peculiar — it says "Piano: Duchamp Train" and there are these curious signs, and then there are six numbered gamuts.

JR: What do the gamuts include?

JC: They go from low notes to very high notes. See this *C* with five marks is the very highest note of the piano, and this is the very lowest one — *A* with two lines below. I finally discovered that these referred to Marcel Duchamp's idea that the different octaves, or different areas of the piano, need not repeat themselves. There shouldn't be the same notes going in the first and second octave, and so on. That each one should have its own notes. And he likened this to a train that had freight cars, and each car could have its supply of notes. Instead of giving the freight cars coal, for instance, you could give them notes — different ones for each freight car.[11]

JR: So each freight car would be a unique octave?

JC: Well, whatever. Whatever space.[12] And so these *(pointing to manuscript)* had been enactments of Duchamp's idea. Since it's an idea based on happenstance, each of six such trains would have different notes, hmm? and could be played by the pianist. This *(pointing to manuscript)* is a microtonal notation which could be played by the violin. And I finally discovered that I had written two such series with microtonal passages for the violin.

JR: And the notes that get poured into a particular time bracket would be determined by chance operations, using the range in one of the gamuts?

JC: No, I had yet to figure that out. But I found it, on one of these pages here.

11. Cage has written this on "Duchamp's Train": "A moving freight train, cars passing below a note-giving funnel, each car representing a different octave so that a scale nonrepetitive from one to another results, upon which new melodies may be composed or improvised (Duchamp: *La Mariée Mise à Nu par ses Célibataires même 1913 Erratum Musical*)," from "Music and Art," in *John Cage: Writer*, ed. Richard Kostelanetz (New York: Limelight Editions, 1993).

12. Each "car" has 7 or 11 tones.

So, for the pianist, these time brackets could be expressed by silence, that is to say, nothing; or *(reading from manuscript)* "They could be part of an ascending gamut, played pianissimo, as softly as possible, giving no sense of periodicity. Depress the key silently until you feel the escapement releasing. Knowing where that is, play the piano on the edge of immobility. Sometimes after a pause, picking up the tone or tones earlier played, continuing upward; or, a fragment of *Extended Lullaby*." Those were chance-determined variations of Satie's *Vexations* which had already been composed and which were in another piece called *Four³* [1991], that was used for Merce's dance called *Beach Birds*. So I finally figured out what the pianist could put in his part, which could be otherwise empty. And it would be the pianist's choice—either of silence, or part of this gamut, or part of the Satie chance-determined business. [*Extended Lullaby*, Appendix D] So the question is, what does the violinist have to do? And it turned out that this rough circle here enclosed a number of chance-determined notes that were within the range of the violin—the lowest being B♭, just above the G string, then F, and going up to a very high note. I divided the range, you see, from G to the top, among eight notes. Underneath it says "sustained interval." In other words, I thought that what the violinist could do was look at this series of notes and choose any two of them, an interval being two; that is, to play any two that she wished. I found somewhere a note . . . "For the violinist: from one bracket to the next, silence. From the gamut of pitches given, any sustained . . . a sustained interval, played pianissimo, as softly as possible, nearly immobile, using or not using harmonics." Because you can't play those very high notes without harmonics. "Sustained with imperceptible bowing." Then the microtonal passages from the G string up to the E, from the low string up to the higher one. In other words, there was this sense in the piece of things going up.

JR: Why up?

JC: I don't know. *(pause)* Then I show how the microtones are notated. "Phrasing, use of silence, articulations free. But play the tones that are written only once, searching with them for melisma—florid song. When durations or phrases are long, keep the amplitude very low. (Single short sounds can however be of any amplitude.) Let successive passages be for a string of the same or higher pitch." In other words, to start with the fourth string and go up to the first string. So, anyway, it took some time . . . to figure out that those were the possibilities for a performer to put within the empty . . . within these brackets. And that I wouldn't put anything in. It's actually quite a beautiful piece! It doesn't exist, so to speak. Until it's performed, hmm?

JR: It exists—as indeterminate, material possibility.

JC: Indeterminate, yes. Even when it's copied, the copy will not be an image of what we are to hear. The only thing that will relate to what we hear is the performance of it. . . . It took me some time to reimagine the piece and now I see that

hearing it will be the first time I get a good idea of what it is! *(laughs)* It will be done in December in Orléans.

JR: Where it will come to ears . . . momentarily . . . and disappear once again.

JC: Yes.

JR: Did choosing melisma, and choosing the upward sweep, relate in any way to your starting point with the image of Duchamp's trains?

JC: You couldn't make a convincing reason for a relationship between those things.

JR: Why don't we trace the steps you went through in order to generate these pages. I think it's very interesting as an account of your compositional process. Your starting point was . . . a commission?

JC: I agreed to make a piece for violin and piano for two very good musicians, the Parisian violinist Ami Flammer, and the pianist is Martine Joste. Then I had the experience of having written a piece for Merce Cunningham's dance called *Beach Birds* [*Four³*], of having done a similar thing of giving empty sheets of time brackets to . . . in that case, four musicians. And giving them different material to put in the empty time brackets. In other words, this was the second time that I did that kind of composition.

JR: You had been happy with the results the first time.

JC: Yes, and I tried to imagine it as a violin and piano piece.

JR: Did you need to fill the emptiness temporarily for yourself, to generate a procedure, by coming up with the image of the Duchamp trains? It strikes me as interesting that you often have very specific images in mind that lead to the procedures that you choose, or various aspects of the procedures. But then the images disappear in the music. This piece won't sound like a train.

JC: No. I hear this piece, or imagine hearing it, as being extremely soft, and one of the difficulties in playing the piano is to play the low notes as softly as you play the middle or high notes. But if you study the piano, whatever piano you're using, if you study the escapement—in other words when, after pressing a key partly down, you begin to feel the hammer change its position, hmm? and then when it won't have any strength given from its sweep, but when it's already partly over the sweep, and then play it—you'll get it as soft as you possibly can get it. So that fact of playing low notes and high notes very very softly could conceivably be beautiful to hear in the first place, and also difficult for the pianist who's a virtuoso to do, hmm?

JR: And you wanted that difficulty . . . in this piece, *Two⁶*?

JC: No, I just wanted the good will of the pianist. I didn't want her to feel that . . . that it was too easy *(smiles)* and that I should have given it to someone less gifted.

JR: You've at times explained the difficulty of your pieces in terms that have social implications. You've said that when we find out that things that look as if they are almost impossible—

JC: —Impossible can be done . . . yes . . .

JR: —Almost impossible can be done, that it heartens us in the midst of a world where it looks like much that is important is impossible.[13]

JC: Yes. This is not that. It was a regard for the prowess of the violinist and the pianist. I think they'll be pleased.

JR: Even if you can't recover at this moment just how you came to Duchamp's train, can you say how you—

JC: How I was aware of that?

JR: Yes, and at what point you decide on something like that, an image that gives you a procedural rationale.

JC: I had already used the chance-determined variations on Satie's *Vexations* in the piece called *Beach Birds*, and I was going to use that again in this piece. So I needed to find something else—since that was going to be used by the pianist—I needed to find something else for the violinist. And I think it was unlikely, actually, to think of the Duchamp train because the train is for a pianist and goes through the eighty-eight notes of the keyboard. The violin doesn't have eighty-eight notes. Nevertheless, I took the idea and transferred it to the violin, divided the violin into . . . was it eight sub-ranges? . . . counted the number of notes between G and the top, and then used chance operations to find out what note was within which freight car. I think there was just one note in each in order to bring about the possibility of an interval, from one to the next.

JR: So the elements in this include chance-determined notes, indeterminacy in the score so the performers can make choices, gamuts of pitches . . .

JC: *(pointing to manuscript page)* These are the ones for the piano—a gamut of pitches from low to high, and for the violin that became a gamut of pitches from which one could choose an interval . . . that would be practical. Just a sustained interval . . . florid song . . . which the violin can do very beautifully. You see, the piano *can't* sustain sounds; the violin can. But the piano could make this ascending gamut audible; the violin wouldn't be able to because it doesn't go that low.

JR: When we talked in April I had a feeling that you might be moving toward abandoning time brackets, moving toward an undifferentiated temporal process that you described as being sort of like a lake that you could dip into in any spot. Perhaps I misunderstood at the time, but I had thought that the numbered pieces were no longer going to be using time brackets.

JC: No, that hasn't changed. Which time brackets are used changes, but the principle of times that will accept contents that are short or long has remained.

JR: *Had* you been thinking of moving out of time brackets?

JC: I don't myself remember, but as you can see from this I don't remember much in any case. *(laughs)*

13. From my notes after a visit with Cage, April 6, 1992, "John says, talking about *Etudes Australes*, 'We need to know the practicality of the impossible.'"

JR: Actually, I noted down what you said at the time. You said, "I don't know what I'm doing these days. I could compose, but I don't do that. I transcribe numerical results of chance operations to notes." So you made a distinction between composing and what you said at the time was transcription. You said that your previous ideas of composition that had to do with structure—which I take it could include time brackets—have become "process that is shapeless. What is different from music as we know it is that music doesn't have to do with counting and being together. We can think of it as a space in time, rather than a point in time."

JC: Right.

JR: "Like a lake. You could go into any part of the lake." And the "space of time" has to do with "metaphors of society and how we can be together."

JC: I don't see a giving-up of time brackets there. I don't find myself at a point of not using time brackets. I'm actually at the point in this piece for violin and piano and the previous piece, for the Cunningham Dance Company, I'm at the point of brackets which don't have anything in them, but in which the performer can put something. One of the things which can be put in is nothing, hmm? and the other two things are something, hmm? So, what two somethings would the piano have, and what two somethings would the violin have, were the questions that were put to me. And my answers were that the violin would play a microtonal passage, or make an interval, or be quiet. The pianist would make this very soft, going from the low part of the piano toward the high, or the Satie variation which I already knew, or the silence. Then, we can foresee the nature of what will happen in the performance, but we can't have the details of the experience until we do have it.[14] *(pause)* . . . This is another piece, this one called *Thirteen*, which has a very curious history [see Appendix E]. I had written a piece called *Ten* [1991] which was microtonal, as the violin melismatic part is, with six possibilities between each half-step. I had made that for ten instruments, and I had heard a cassette recording of it sent to me by the musicians, which I actually listened to. I don't normally listen to recordings. But since it was microtonal and I didn't know exactly how it would sound, I did listen to it and I liked it. So I offered, in the case of this piece called *Thirteen*, I offered to write a microtonal piece like that for this other group. I had been told they had seventeen players, so I wrote some parts of a piece called *Seventeen*. Then it occurred to me that they might not be able to play microtonal music, or might not want to play microtonal music. So I took the precaution—I'd written about four of the parts—of getting in touch with the [group of seventeen] people in Germany and put them in touch with the people who had played the other piece called *Ten*, which was microtonal. And the people who had played it explained to the people who had

14. Somewhat like weather, whose broad patterns we can more or less predict, but not the fine local details. This is characteristic of all complex turbulent systems in chaos theory. From my notes: John Cage, "I like music being like weather."

not that it was not easy, that it was very difficult. And so I was asked by the people in Germany *not* to write microtonally, if I would please *not* do it. And I agreed. Then they said, since the name of the ensemble is "thirteen" [Ensemble 13], though they had given me a list of seventeen players, they asked that not only would I not make it microtonal, but would I please change it to the number of their name. So I did both of those things. I changed it to *Thirteen* and I wrote it chromatically.

JR: What led you to anticipate that they might not like a microtonal piece?

JC: Because they might not be able to do it. Microtonal pieces are difficult because no one studies, is taught, how to play them. Anyway, I then wrote this piece, not microtonally, but—in my own way—thinking of it as microtonal.

JR: How did you do that?

JC: I limited the range, to very few tones, again through chance operations. So that in this part, only one tone can be used, and here it's ten, here six, here two, here five, and here five. So that rather than there being available many tones, the attention was placed on few. And, in the few, the idea of many was introduced through letting the chance operations make the melodies, or the number of notes that would occur within a time bracket, in an unlimited way. You can see, this one begins here and continues there, so that all those notes come in this small space. It's almost as though they were microtonal, but they aren't. I think when they're actually played, they'll become . . . they'll go in that direction.

JR: So you want a microtonal effect that can be played by musicians who don't have the skill—

JC: I don't know yet because I haven't heard it, but I think it will go that way.

JR: That interestingly values the microtonal to the point of giving any musician a way to do it—

JC: —Whether they do it or not.

JR: The value in the microtonal that you had talked about earlier was that it would be challenging to a very good violinist.

JC: Yes.

JR: But then you heard it and it took on another value.

(End of tape. The decision is made to stop, since it's time to go to MOMA for the sound check.)

AFTERNOON

JC: *(continuing to talk about* Thirteen*)* When I came back [from Europe] I was not immediately given this piece, but then had to explain it to the copyist. And the puzzling thing that happens in it is that when you get to the first percussion part it says "in unison with second percussion" [Appendix E, page 14]. And second percussion says nothing. So it looks as though they're both playing the

same part. And, having written it much earlier and not remembering it, I didn't see something else, namely that the two parts have numbers beside the time brackets. You see here [page 14] it goes 2, 6, 7, 9 . . . here [page 15] it goes 1, 3, 4, 5, 8. Fortunately—I didn't notice this at first—but fortunately one of the new copyists did notice it, and proceeded to write a single part which had twice as many brackets as either the first percussion or the second percussion, and to note that those two parts were to be played in unison, which is what should happen. It's quite a surprising idea, and one which I had totally forgotten. It involves playing things that can be played easily, but it also includes things that have too many notes to remember easily, and to play in unison would be quite impossible, especially when the brackets are free, flexible. So that when you have two percussion players—they're going to be xylophones—playing the same thing they'll be playing in a unison which can't be a unison, hmm? It's a very curious thing. I'm looking forward to hearing it. And it was discovered this time, not by me, but by one of the copyists, who took these numbers, as they should have been taken, seriously. I'm very anxious to hear this piece. I'm curious about it. Largely for the reason that I told you—I was thinking microtonally, but writing chromatically.

JR: When will this be performed?

JC: It won't be 'til January or February, I think. So I'll forget that I'm interested. *(laughs)*

JR: The fact that the music that you compose essentially flows through you, and leaves you when you're moving on to the next—

JC: And I don't hear it as I write it.

JR: That all seems as it should be with your spiritual ideas about the virtues being in the kinds of processes that don't leave a trace.

JC: Yes. I think so.

JR: And actually, because I think of your work as trying always to find the material parts and characteristics of a medium, and then to investigate and explore them in some way—the disappearance of the score from the composer's mind seems in keeping with the very transitory nature of sound, which is always destined to disappear instantaneously from the field of audition. The attempt to hang on to it, to give the mind ways to remember patterns of sound, is after all what is responsible for all those things in Western music that you set out to change. Things like repetition, periodic rhythm, melodic line—aids to memory, designed to stop the flow, thereby occluding the ears and the mind, preventing them from hearing fully the next sound that comes along. So I see it as a—

JC: As a good.

JR: Yes. But it also seems important to work out arrangements with the copyists so you don't have to—

JC: —To do it twice. *(laughs)*

JR: Unless you feel you're learning something so valuable the second time around—

JC: No, no. I'm going to try to do it once.

JR: I read the interview you did with John Corbett in the *New Art Examiner*.[15] You did it with a card game.

JC: Oh, I've never seen that.

JR: Oh really! I have it. Would you like to see it?

JC: Yes. *(JR gives JC a copy of the interview; JC reads it.)*

JR: You commented that you liked what Kierkegaard had said about *Don Giovanni*. I guess mainly that he was so delighted by it.

JC: Yes, he loved it. Did you read it? Don't you think it's a beautiful text?

JR: Yes, I went back and read it.

JC: It's like a love letter. *(laughs)*

JR: I was curious why Kierkegaard felt so strongly about *Don Giovanni* and how he linked it with other thoughts on music. I found he had said some things which again reminded me of you. You may tell me they don't remind *you* of you, but— *(laughter)* he says, "Music has time as its element, but it gains no permanent place in it; its significance lies in its constant vanishing in time; it emits sounds in time, but at once it vanishes and has no permanence." Then he goes on to say, poetry is a greater art than music. "Finally, poetry is the highest of all arts and is therefore the art which knows best how to set off to advantage the significance of time. It does not need to confine itself to the moment the way painting does, neither does it vanish as music does, but nevertheless, it is compelled . . . to concentrate in the moment."[16] *(laughter)*

JC: Beautiful.

JR: This brings to mind what you could see as a tension, between the desire for some kind of fixity— *(JC notices strange sound which he thinks may be coming from the ice-cream machine, which has been making peach tofu ice cream.)*

JC: I'm afraid that it [the ice cream] might be just plain freezing.

JR: You must know how it's supposed to sound. *(pause)* I can't tell whether that sound is coming from the machine or not.

JC: I think it's O.K.

JR: The desire to fix something, in some way to create something that's determinate—in your case, something that is yours in some way—and yet this thing about the nature of music, of your music in particular, that it—

JC: —Goes.

JR: —Comes and goes literally with the speed of sound. The balance between those logics seems problematic, not taking either to its extreme, its terminus. The extreme with the quality of impermanence might be to just say, we will all just listen, no need to notate anything—as some younger composers whom you've influenced have done. Do you know about that piece called *Listen*? I can't recall the composer's name. Shall I try to find it?

JC: No. We can say it's imaginary.

15. May 1992, V. 19, No. 9, "The Conversation Game: John Cage Composes His Own Interview."
16. Søren Kierkegaard, *Either/Or*, V.II, trans. Walter Lowrie (New York: Anchor Books, 1959), p. 139.

JR: Well, anyway, it's a piece in which the entire score is composed of the single word "Listen."[17] And then someone else, Max Neuhaus, took that idea a bit further and wrote a piece called *Listen: Field Trips Thru Found Sound Environments.*[18] He takes people on buses to power plants and stamps the word *listen* on their palms. That's one way of letting go of the process even further. Really giving up almost entirely any part of music that's fixed. But you haven't gone that far. You haven't gone in that direction, though it's clearly implied. Why not?

JC: Oh, I haven't done it as a composition, so to speak, but I've done it. At the University of Wisconsin, I think in Milwaukee rather than in Madison, I gave what was called a "demonstration of sound" in which we set out from the hall where we had met to make a chance-determined walk through the campus. And we were to walk silently, so that we would hear the sounds of the environment. Then we came back to the hall and talked briefly about what we'd heard. I gave sort of a lecture.

JR: When was that?

JC: Some years ago.

JR: I'm curious about the date, in relation to these "Listen" pieces.[19] So you feel the life, the work, of a composer demands doing more than that? The act of composing itself has value.

JC: Yes, I thought of that as a lecture or a demonstration.

JR: Rather than a—

JC: —Composition.

JR: —A piece of music. *(pause)* The reason why Kierkegaard likes *Don Giovanni* so much is because it's about sensuality, what in my translation is called "sensuous genius"—I don't know what it is in Danish. Kierkegaard thinks music is what connects us with our sensuality more than any of the other arts because of its immediacy, and that Mozart picked in *Don Giovanni* the perfect story for his medium and the perfect medium for the story and did it in the perfect way, and the only way to emulate this achievement would be to compose *Don Giovanni* exactly as he did all over again. *(laughter)*

JC: It's like a love letter. It's just amazing. It goes to excess, doesn't it? *(laughter)*

JR: Yes, that's certainly the spirit of it—going to excess. *(JC laughs)* What other music do you particularly enjoy?

JC: Well, my tendency is to prefer music I haven't heard to music I have heard, but that's by its nature an unknown quantity. So I prefer music that doesn't include periodic elements. I find what is connected with rhythm something that particularly doesn't interest me. But there is, for instance, a Chinese composer— Tan Dun. I wrote a rather good statement; I wish I could find that. *(looks for it; brings it to the table)* Critics haven't known what to say about his work. They

17. The piece is *Listen*, by Dennis Johnson, and is described in *Experimental Music, Cage and Beyond*, Michael Nyman (New York: Schirmer, 1981).

18. Ibid.

19. Neuhaus's *Listen* was done between 1966 and 1968.

haven't known enough to say anything. So he has no impression of what they, or anybody, thinks about his work. He brought a tape machine and a cassette of his music and played it for me and asked me to say something about it.

JR: Is he working here, in New York?

JC: He's living here in New York, and he intends to go back to China. He told me what he wanted me to do, and I said I would do it. I had met him some years ago when I was invited to a meeting of Chinese composers that was formed by ASCAP. I had met him then but I hadn't heard his music. So, anyway, I wrote this the other day, after hearing his work, and gave him a copy: "What is very little heard in European or Western music is the presence of sound as the voice of nature. So that we are led to hear in our music human beings talking only to themselves. It is clear in the music of Tan Dun that sounds are sounds central to the nature in which we live, but to which we have too long not listened. Tan Dun's music is one we need as the East and the West come together as our one home."

JR: That's a beautiful statement.

JC: And the curious thing that makes it audible as having something to do with nature is that it is microtonal. And this of course, as I've told you, has been recently on my mind. Not *as* nature really, but as the part of sound that was beginning to take my ear. As it gets microtonal it gets away from our scales, hmm? And our rules, etcetera. I think that's why . . . why it seems so close to nature.

JR: You're thinking of "nature" as opposed to culture?

JC: Yes.

JR: What "we" haven't constructed.

JC: As opposed to language, for one thing, and repetition and variation. When you hear sounds that have microtonal relations that are unfamiliar, you tend to think away from law toward nature, I think.

JR: Why do you think that is?

JC: Well, if the wind were blowing, its sounds could very well be microtonal.

JR: Yes, that seems to be true of some of the complex, rushing sounds in nature.

JC: And of traffic as well. Not so much the twentieth-century sounds of people, but the twentieth-century sounds of traffic could be microtonal.

JR: Actually, the blur of all the sounds we make—

JC: Traffic almost seems like it was done by animals, don't you think? *(laughs)* As though it were a part of nature.

JR: When there's a lot of it, it doesn't have distinct separations of tones in it, except with the random honking of horns.

JC: It doesn't have the element of musicality.

JR: So the microtonal, you think, takes us away from the repetitive particulars of our intentionally constructed world, including the constructed world of music, into a sound field that presents itself as audibly "other"—like nature, apart from particular intentions, and you think that's healthy for us to attend to.

JC: I think so. And for the environment.

JR: The environment is so complicated. Volcanoes erupt, trees snap and crash down, fire crackles, thunder claps. We've tended to incorporate that kind of drama into our forms—pizzicato, rolling timpani, crescendi . . . forgetting the other field of sound that isn't so startling. It's sort of what you were talking about in the cab [on the way to MOMA for the sound check]—we've had the habits and proclivities and tastes of imperialists, so we've colonized what we've thought of as the "strong" sounds in nature, while leaving a whole spectrum unnoticed.

JC: Yes.

JR: What about the—(noticing JC looking toward the kitchen) we have five minutes.

JC: Before the ice—

JR: Yes. What about the way we have to be, as audience, in order to hear the microtonal?

JC: I'm trying to think how to answer that, or how to respond. It seems to me that if you have microtonal experiences, or the experiences of sound in nature, that you recognize it no matter what, if you pay attention. You might hear it without thinking that you should be listening, hmm?

JR: Yes, it seems to me that for an audience it's a very different kind of experience from the "wake up and listen" alarm of some of your own more dramatic pieces, the distinct noises of percussion . . . it's not a tat, tat, ta . . .

JC: No, it's not that. The situation we're in at the museum [for the Summergarden concerts] with the ambient sounds of traffic, and horns, and the air conditioning system, and—though we didn't just now have any—fountains . . .

JR: Right, they were off. Are they turned off for the concert?

JC: I think they may be. Tan, when I gave him last week *Empty Words*, wrote, "I cannot imagine something more peaceful, more silent and deeper than the voices, and natural and thinking environment that you provided for us in the Summergarden last weekend." There's something about hearing all those noises together in the environment, not in a concert hall, not in a place protected from such sounds, but together with them; I think it's very good. In other words, if doing what we're doing there now is pretending that it's a musical situation and people are allowed to come and pretend to listen, hmm? but they see that they're hearing everything else too, at the same time—

(Phone rings; JC answers it; tape recorder turned off; JC returns with ice cream and cookies.)

JR: What do you mean by "pretend" to listen when they come initially to the concert?

JC: To sit still and listen.

JR: To be docile, well-trained auditors. To hear only the "right" sounds?—the sounds that are supposed to be part of the concert. But at one of your concerts it could happen that the environment is providing more noise, more music than the musicians. The question is how and when does the realization come that *all* of it is the concert?

(Pause while eating. JC and JR discuss variations on the recipe for these cookies, which they have both been experimenting with. JC has substituted macadamia nuts for the almonds in the original recipe.)

JC: You'll see how thick this is with flour, but blame it on the macadamia. *(pause; eating)* It's almost like a cake, isn't it?

JR: It is. It's like shortbread. *(JC laughs)* They remind me of the cookies Laura [Kuhn] made using oat flour. Interesting.

JC: Anyway, the next cookies, which hopefully I'll have before tomorrow, will be made with almonds.

JR: This [cookie] is the sort of thing you could eat one of, drink two cups of water . . . it would expand in your stomach *(JC laughing)* and you wouldn't have to eat for the rest of the day. This could perhaps solve world hunger, if macadamia nuts weren't so expensive. *(laughter)* The ice cream has a lovely flavor.

JC: It should be more like ice cream.

JR: I often, intentionally, let my ice cream sort of semi-melt. I like the contrast between part being frozen and part melted. So this just came that way.

(JC and JR decide to end for the day.)

THURSDAY, JULY 16

(As the tape recorder is turned on we've been discussing changes in JC's methods of composition.)

JR: I think what you were saying earlier about "sudden texts" bears on this. We've talked about them before, but, for purposes of this discussion, would you explain what they are?

JC: It's a form of Buddhism that has the quality of Zen, of being sudden rather than gradual in the coming of enlightenment. It grew up in Tibet, rather than Japan, and has perhaps a more dramatic quality due to the high altitude of Tibet. *(JR laughs)* I'm thinking of Gertrude Stein's remark that people are the way their land and air is. These are the whispered truths and the reason that they're whispered is that if they were noised about many people would not understand them, would not be able to profit from hearing them. The first is that creation is limitless. We don't know the amount. We can't describe creation. This refers to the great variety and the great number of the centers of creation. Each one being in the center. Then the proper action, or the way of acting in this situation of vast multiplicity, is to act without leaving traces, and the instance is given of writing on water—where your marks would not remain. The third of the whispered truths is that not meditating is meditating. So that the opposites are not opposed to one another, hmm?

JR: Writing on water, reminds me of your nonexistent scores.

JC: Well I keep these things . . . I keep a number of things more or less in mind. Sometimes they slip away, and then they come back. When I was younger, an

idea that was foremost in my feeling was that of the seasons, and their description as it were in Indian thought—spring as creation; summer as preservation; fall as destruction; winter as quiescence. And then the new year, in other words spring coming again, produces a kind of celebration. Continuation after quiescence . . . tends to produce celebration.

JR: You wrote a piece called the *The Seasons*— [1947]—

JC: Oh yes, at that time.

JR: —That formally reflects that, tries to express the nature of the characteristics of each season.

JC: Tries to do that, yes. Whereas now my concern is not so much there. Or those ideas are not foremost in my thinking when I go to make a piece of music. Rather these whispered truths are more prominent. And another thing which has been prominent for me both then and now is the conviction that music takes place wherever we are and is expressed by the sounds that we hear and call simply ambient sound; or, we call them silence! If we ourselves are not making the sounds, then all the sounds we hear we call silence, hmm?

JR: I'm struck by your interest in the past of "describing" the four seasons. And that term "description" I think applies to the kind of piece you were composing then.

JC: Yes, I was still close to the teaching that is common in the West that artists should have something to say and say it to their best ability. So what I was taking as something to be said was the cycle of the seasons, hmm? *(laughs)* And then later I transferred that to hope . . . or to work in such a way . . . that I would not offend silence, or spoil silence, hmm? That was my conscious idea. And I was still thinking of the work having that idea in it. So that the work wouldn't be just sound, but would convey that idea, hmm? Now I don't have the feeling of the need to say anything, in view of these whispered truths. In other words, I try to work, or *watch* my work, to see if it's leaving any traces . . . of how it was made, hmm? And does it leave any traces on me, for instance? Do I, as being the one who wrote it, do I know anything about it? So when I was telling you yesterday that, due to the copyists not doing the work quickly, I found that I didn't know how to answer any questions by the copyists who had to finish the work—and I actually had to take the attitude of a research worker, or a musicologist *(laughs)* to see if I could figure out what I had had in mind—of course my hope was to not have anything in mind. But what was going to be printed that would show that I had nothing in mind? *(laughs)* It's a clear paradox. We're clearly at the point where the opposites come together. In this particular case the opposites are the same. So that if no traces are left, that is to say, as though it were written on water . . . but it is of course written on paper, hmm? . . . and the traces are very clear, then what are they? There is no difference between no traces left, and what traces *are* left.

JR: Because, as you said earlier [when the tape recorder was off], writing on paper has *become* writing on water.

JC: Or writing on water has become writing on paper. *(laughs)*

JR: The traces that are there in some way do not betray, do not be*trace* the process . . . they are really no longer traces of that process that brought them there.

JC: But they had to be sufficiently examined in order to tell copyists what to print. They don't bother with water or paper so much as they bother with computer technology and programing *(laughter)* and you know how exacting that is.

JR: So what is on the page, then, is really a point, a locus . . . of transformation—

JC: At that point it's very curious, the vastness of creation has to become the particularity that the computer demands, hmm? Otherwise it becomes confused. So it has to know *exactly (laughs)* what to do, hmm?

JR: So that we can know it. So that it can be mediated. We, along with our media, are somewhere in the middle.

JC: Yes, it's very curious.

JR: Because of what seems must always be paradoxical in enacting these whispered truths—as opposed to your former mode of trying to describe or replicate what you felt were the truths of nature—the enactment must cancel itself out. You must make marks on paper that are in some way like writing on water. The marks on the paper are instantly transformed from traces of the process that brought them there into the beginning of an entirely new process for the performer and for the audience. So the moment they hit the page, so to speak, they glance off the page. Their nature has been transformed. They are not traces anymore. I mean "traces" in the sense of a residue from an old process. They are emptied of that. They are the beginning of a new process.

JC: Yes.

JR: So the distinction between the old way of working, description, and the new way—enacting the whispered truths in this kind of transformative process—must still be located in the trace. The act of describing left traces—not so much of what was described, as of the descriptive act itself, an act caught in the past. But the notations you are putting on paper now literally mark the end of the past, a process that is consumed in the act of making the mark, so that the present can begin. These marks are the indication that an entirely new process can begin for the performer and the audience which indeed bears no referential traces of its past.

JC: *(smiling)* I can hear anyone who is not sympathetic saying, Ah, ah, inconsistency!

JR: Yes.

JC: And that's where we're working—right in the midst of it.

JR: Well, that comes, I think, from confusing paradox with contradiction. Contradiction shuts things down. It's logical gridlock. Paradox, I think, generates energy. It's a dynamic system that creates life out of the interaction of so-called opposites. I think you've found ways of working with complex realities that don't get stuck in logics of contradiction.

JC: Here's another paradox, not in music, but I'm thinking of *Muoyce II*, which

is writing through *Ulysses*. I've given you a copy, but you don't have this copy which I've prepared in order to facilitate my reading of it. What I did to the writing of it, in order to be able to read it, was to make these short vertical lines between letters to indicate the ends of words, or the beginning of the next—the end of one word and the beginning of the next—which of course would normally be done with a space. But in this case the spaces disappeared because I wanted to make the text be a column. So with chance operations, the number of characters, including spaces, from one line to the next is the same number. But, particularly with the word "a," questions arise. As here for instance. This could be read as "bath worshippers at he" but it is, it was written as "bath worshippers a the." I can now read this, which I will have to do under rather strained circumstances in Germany. I will have had a performance the night before of *One*[11] and *103*, which will be very interesting to me. It's the combination of film and orchestra work. And I will have helped in the rehearsals of the orchestra, and I will be seeing for the first time the realization of the editing work which I did on video, not on film, but which is being transferred from video editing to film editing by a lovely editor who can do that work. Her name is Bernadine Colish. So I will be involved in that performance which is in Cologne, and I will not hear either the playing of the *Etude Australes* by Marianne Schroeder nor the *Freeman Etudes* by Irvine Arditti because I have to be at the rehearsals in Cologne. I can't be in two places at once. Those piano and violin pieces are being played in Frankfurt, whereas the orchestra work is being played in Cologne. So early, quite early in the morning, after the first performance of the film with orchestra, I have to be driven from Cologne to Frankfurt, and once I arrive in Frankfurt I have only an hour before I have to give this reading through *Muoyce II*. So I knew from experience that I couldn't read it with any equanimity if I read it as I wrote it, that I would have to take away the ambiguity which is in the way I wrote it, and make it so that I knew immediately what to say as I read.

JR: Are you implying that—

JC: There's a paradox there—between the love of ambiguity, for one thing, and the effect of chance operations on a text used in such a way as to increase the ambiguity, hmm? and the need under exigent circumstances to have security in the performance of it, hmm? to know what to read. That certainly is a paradox. It's a shift from the act of composing to the act of performing. And for that reason I accept for the performer in me to deny the work of the composer.

JR: So in any single performance of any piece, in order to feel comfortable in what you're doing, you must choose one way to do certain things, thereby eliminating other possibilities.

JC: This brings to mind also the talk which you gave at Stanford, because it's the ambiguity which you found very interesting as a reader, but that you also might drop if you became not a reader alone at home, but someone reading out loud in a public situation. There's where the difference lies. Or you could read, as you

if you exi ted
~~becauSe~~

we mIght go on as before

but since you don't we ~~wi'~~Ll

mak
~~chang~~E

our miNds

anar hic
~~so that we~~Can

d to let it be
convert~~Enjoy~~ the chaos/~~that~~ you are/
 stet

Figure 14. "(untitled)." From *X* (Middletown, Conn.: Wesleyan University Press, 1983), p. 117.

did, as though you were not reading, but describing the possibility of reading, or the multi-possibilities.

JR: Reading in multiple ways to give a sense of how many possibilities, how many senses, a text could give rise to.

JC: Yes, yes. And that happens, of course, all the time. It happens with the newspaper.

JR: Though you, of course, found it disturbing at that point that I did that, because you had wanted the reading that conveys the message that silence doesn't really exist. And it is a text that can be read on that level—of having a message. It can be read as saying something very beautiful about silence [Figure 14].[20]

JC: It may be my Achilles' heel. *(laughter)* I like that particular mesostic about silence. I didn't find it easy to come by, hmm? So I . . . I'm searching for the word . . . I found it *apt*. *(laughs)*

JR: Which is actually a reductive principle when it comes to poetry.

JC: Exactly! Exactly! *(laughter)*

JR: To say that a poem is "apt" is not—

JC: *(laughs)*—Not very poetic. *(laughter)*

JR: Not the most exciting praise. *(more laughter)* But I do feel there's a difference

20. Because Cage told me he wrote this poem after "finding that silence didn't exist," I assumed, perhaps erroneously, that it dates from the early fifties. This would make it one of his earliest known "mesostics." It was in 1951 that Cage went into an anechoic chamber at Harvard expecting to experience silence as a total absence of sound. He discovered instead that, in the absence of other sounds, he could hear his own circulatory and nervous systems. This led him to redefine silence as ambient noise outside the scope of our attention. My multiple readings of "(untitled)" appear in "Poethics of a Complex Realism," *John Cage: Composed in America*.

in the way you work with language and, say, the way I work with language, perhaps reflecting our starting points—mine as a poet, yours as a composer. I tend to worry that the sense of my language doesn't tend enough toward music. You tend to worry that the music of your language doesn't tend enough toward sense. My concern has to do with feeling that so much of our language is silent, inaudible. We speak it so much out of habit that we hardly know what we're saying and not saying, or hear what is being said or not said to us. I notice, when you read aloud, a desire to return the language that you've composed into a strange "newsense" back to—

JC: —To what it was.

JR: To its ordinary—

JC: —Use.

JR: Yes. And I'm curious about that. Because one could conceivably find a way of reading aloud, performing, that is a sonic analog to the ambiguous structure that's on the page. In this case, for instance, a way of reading the words without inflections, evenly spaced . . . that doesn't present syntactic or grammatical patterns to the audience.

JC: Yes. I don't know. I haven't read this yet. But I will, under these unusual circumstances that I've described, do it. I know several details about what the performance will be, in preparation. I know, for instance, that it won't last for two hours. It will last for *close* to an hour. I mean quite close. I think the expression to be used is "more or less." *(laughs)* It will be an hour more or less, probably less. That comes from the fact that I've decided to—well, I haven't completely decided what to do. I have thought of what you just mentioned, of reading it as it looks; that is to say, a space on this page between "flower" and "in tha a an No refuge" . . . and then a space . . . "instant hair . . . transferred bright the soap . . . The . . . you . . . like to about . . ." But then having read that, as it is printed, and then, now reading it as though there were spaces between every word, and knowing where the words that run into one another begin and end, by means of these little lines, I can then read it this way, "flower/in/thaaan/No/refuge/instant/hair/transferred/bright/the/soap/the/you/like/to/about . . ." And somehow the continuing reading, without the spaces in between—I hear it more than I hear the introduction of the spaces. [See *Muoyce II*, Part 5, in Appendix F.]

JR: Yes. Actually, that sounded very good.

JC: So, my tendency is to do that.

JR: And in fact when you read it that way, the second way, you had a flow to it that—

JC: Then the ambiguity goes to the listener. Because the words don't make sense, except as words. Almost never as two words in a row. Sometimes they do. Say, "bright the soap." But it's not an ordinary description of soap.

JR: No, not a common expression . . . yet! *(laughter)*

JC: So, it seems to me that it remains ambiguous as you hear it. On top of

which it's going to be read in a bath, or in an ambience, rather, of sound. And the sound will be recorded traffic noises from places to which the Cunningham Dance Company has gone, and will at that moment be—in Frankfurt. They're performing three nights before I give the reading, and the night of the day I give the reading. As they travel around the world, recordings are made at my request of the traffic sounds of wherever they are. So my voice will be coming from the center of that circle of sound, hmm? caused by the history of the dance company. And that somehow relates, or could be thought to relate, to the subject of *Ulysses*.

JR: Does this come from ten years of travels by the dance company?

JC: No, unfortunately, it just comes from the recent year or so.

JR: Well, you know, I misunderstood at first how you were marking this text. You are marking it only to show the words, not to show patterns of breath, or phrasing, in the way you've marked the mesostic texts for reading aloud. So really you are doing much more the sort of thing that I've tried to do with texts like this, trying to retain audible ambiguities. It doesn't reflect the way words flow into one another and make new words between them—an interesting form of linguistic reproduction—but I'm not sure it would be possible to do that with the voice.

JC: This, for instance, could be so many different things, "the a of a for" *(reads it with different inflections, four ways)* [from *Muoyce II*, Part 14], but it would be hard to read it without those lines—to decide quickly what it was you were going to do.

JR: Which way will you read it?

JC: I don't know until I do it. This is the end of a longer absence of spaces, the full—almost a line and a half—"leaping under sent his into glad to that said woman the a of a for . . ."

JR: That's going to be wonderful. You do have a—

JC: And you'll hear all these traffic sounds.

JR: Your voice tends to take up the sounds in the words so fully and move them along in a flow that gives them more or less equal weight, while still having breath. I admire that. It's very hard to do. It's something I can't do.

JC: I'm going to have to practice a good deal. The language is so strange. This, "awful of the whatness," and here I made a mistake, you see, in putting my lines, and I've given the stet, *(JR laughs*[21]*)* which doesn't make it clear, "whatness so some."

JR: Did you write these lines with a pen?

JC: It's done with pen.[22] I'm going to make some of these pages over where there is that kind of confusion. In this case [Part 15] I've decided—at present my deci-

21. One of the things Cage had objected to was my saying the "stet" in some of my readings of "(untitled)."

22. Cage was writing this as he traveled from one place to another during this time. He completed it on the Amtrak Metroliner from D.C. to New York City.

sion is this—since it's not written to be said by one person, it's written to be said by different groups, and that's impractical, and this is impractical as a text, I've decided to read just the part that would be spoken by a single voice. So that this whole page will leave out all the parts in parentheses and in caps, and also what's in parentheses in the course of speeches, so it'll actually be quite short.

JR: Will you read this then as a continuous text as though those other elements weren't there?

JC: Yes, I think I'll read "Dublin This that," then I might read, "Which the thee," and then as an answer or response, "ani my virgin six. smoke. I cause That's Keats are the on said . . . spoiled house. Namine. of parisian can do is O."

JR: Ah, this is such a beautiful text, I think it will transmit equanimity to you as you read it.

JC: Here's a mark that I don't understand, I'm going to have to study: "macadamise . . ." [from Part 17].

JR: I thought—isn't this one word, "macadamised"?—"macadamised The departure . . ."

JC: There's an O there. I can't understand that. I'll show you what I do in that case—go back to the manuscript. There it becomes clear how it was first written. That is to say, in response to the chance operations. *(leafs through manuscript)* And I had to write this penultimate chapter of *Muoyce II* as Joyce had written the penultimate chapter of *Ulysses*—to write it in two ways, one as questions and the other as answers. In other words, I didn't use questions by chance that would fall into answers. I let the questions fall into questions and the answers fall into answers. *(laughs)* Here it is, "macadamisedThe."

JR: So the O just isn't part of it.

JC: I don't know what that O refers to. This is a *d*.

JR: Yes.

JC: I don't know. It's very hard, don't you think so? One makes with a pen or pencil all sorts of marks that don't seem to make any sense. *(laughter)* But it is clear that this should be "macadamised"—

JR: Now, I don't know. Was that the O? *(pointing to mark on manuscript)*

JC: —And that that first line doesn't exist. Oh! I see what it is. This looks like an O, and it isn't. It's this expression of "stet." I didn't want that line to be taken—

JR: You *did* want that line to be taken away, after the first line. So that's actually the delete mark.

JC: It's *this* line I wanted to remove as part of the revision. Yes. So it's not an O, it's part of a delete mark. *(laughter)*

JR: We're seeing, as you say, the terrible problems of leaving traces.

JC: Yes! *(laughter)* And because of the absence of space here, that other delete mark could be thought to be having something to do with this *L* on the line below. *(laughter)*

JR: This tension between needing to fix things, on pages for instance, to write

very specific letters in order to create words that you then wish to flow into ambiguities, or to make marks that are notes, reminds me of something you say in "Lecture on Nothing"[in *Silence*]—you say something like, structure makes things visible. So we need it to give ourselves some sense of where we are, but—

JC: Yes. The question, though, seems to me, as the years have passed, to have changed with respect to needing that. *(door buzzer)* It may be Ben Schiff.

(Tape recorder turned off.)

JR: I've found the quote from "Lecture on Nothing." You say, "Structure without life is dead, but life without structure is unseen."

JC: Now I'm having more and more the feeling of not being involved with structure, hmm? And the first way it came to me to seem to recede from concern was when I spoke of process, so that I could liken a process to the weather, and I could liken structure to an object, hmm? So I could distinguish between the table—which seems to remain as a structure, a structure being literally something that can be divided into parts, hmm? So that it can be isolated. It *is* a table rather than something else. And the weather can also be divided, but less efficiently. *(laughs)* At the same time it remains the weather no matter what is going on, whether there is a storm or not, so that the structural elements that do appear in weather don't change the way we *see* weather—I'm now referring to this statement [from "Lecture on Nothing"]. Process, in other words, can be seen as though it were not a structure at all, or it can be seen to include structure.

JR: Process is the richer, less limiting . . .

JC: If we let it have structure *in* it, as in fact it does have. . . . So, I'm not certain, about *either* structure *or* process.

JR: Well, thinking again about the marks on the pages—

JC: I can—yes, go ahead, and then I have one idea.

JR: Well no, let's hear your idea.

JC: Yours might be more interesting.

JR: No, no. *(laughter)* We must stop this Alphonse-Gaston.

JC: What I'm thinking of is Joyce's work itself, *Ulysses* originally, which has been so much studied by so many different people that there seems to be a consensus that it's a demonstration that Joyce could write any kind of writing that he wanted, hmm? And that *Ulysses* demonstrates this, that it moves . . . from one success to the next success! *(laughter)*

JR: Without having to dip into failure?[23]

JC: And each one of them is different. Not only does he not dip into failure, but it seems from the people who study it, its success seems to *exist* in imperfection, hmm? One doesn't know what the perfect *Ulysses* is, hmm? *(laughs)*

JR: Yes, I love the idea that it is *all*—

23. In "Overpopulation and Art," Cage quotes the Basque sculptor Jorge Oreiza, "from failUre / to faiLure / right up to the finAl / vicTory."

JC: Yes, everything.

JR: All versions and permutations scholars have and will come up with. It really is, as you say, a text that moves.

JC: And what was in his mind is open to question. *(laughs)* It's really an amazement. So, knowing that, if I'm writing with chance operations as I did, using that text, should my voice then change? From chapter to chapter? It could change. In fact, I may do that. In electronic, or sound terms, we call it "equalization." I could easily, with technical assistance, change the sound of my voice with each chapter, which would be—shall we say—literal in relation to *Ulysses*. It would also emphasize the structure—the division into parts. Then the question is, do we want to do that? Joyce obviously wanted to do that. But do I want to do it?

JR: Why not?

JC: Well, because I look back on such concerns as being virtually antique.

JR: In what sense?

JC: In the sense of structure. I would be imitating *Ulysses* in its structural aspects, hmm? Did I mean to do that? If I meant to do that, why did I use chance operations, etcetera? *(laughter)* In other words, I'm not really imitating. So why pretend that I am?

JR: But is it a pretense?

JC: It is, because it would be unsuccessful. Unless I obtained the help of a *really* knowledgeable scholar, hmm? *(laughs)* A scholar not of any water, but of the first water. *(laughs)* And all such thinking takes us back to where we no longer are.

JR: Though it seems to me there's another way to think of it. When you began to talk about this, approximately 2′37″ ago, it was posed in the sense of, wouldn't it be interesting to try this.

JC: Well, it's one of the things one might do.

JR: Yes, and the fact that it to some extent would be an attempt to make a structural analog between Joyce's *Ulysses* and a performance of *Muoyce II* doesn't seem to me to dictate that it would have to be either a pure or scholarly attempt. Why?

JC: It could just be the idea of change, from one chapter to the next.

JR: Yes. Your work, it seems to me, is inevitably, always an intersection of chance and decisions, choices that you're making.

JC: Yes. Well these things do go through my head. And my tendency is that we won't know what the actual doing is until I do it. But I'm at the moment, a month and a half ahead of it, at the moment I'm opting for not changing, I think. That may change. I don't know. I have another principle that I follow, and this is with respect to the use of chance operations. To not use, oh—and it carries one over to not underlining anything, that is to say, not emphasizing anything—not using chance operations twice for the same effect, or for the same reason. Now these are close enough, it seems to me—I mean the difference between the chapters—as things are, not by chance operations, but by counting, counting the pages in *Ulysses*, translating them in my text into, not pages, but lines. So that

a chapter with 27 pages will end up having 27 lines. That was the action I've already taken to differentiate one chapter from the next. And, having done that makes me question whether I should do anything else, like change my voice.

JR: Ah, then I think it's a serious question —

JC: Don't you think so? If you hear something being done twice —

JR: Yes. It *would* be like underlining.

JC: Wouldn't it be?

JR: It would be, yes. But I tend to be curious about options that transgress principles.

JC: I remember being in this kind of quandary years and years ago and asking Virgil Thomson which solution I should choose between the ones that were apparent to me as possible, and he refused to give any assistance. He said we define ourselves, or we tell who we are . . . we sign, in other words, our work, by making our own decisions.

JR: Yes, that's true.

JC: Isn't that beautiful?

JR: Yes.

JC: Now the question is, are we more interested in signing something, or knowing what it would be like? *(laughter)*

JR: But of course the two come together. If you decide to do something because you want to know what it would be like, then that's your signature.

JC: Yes.

JR: But you couldn't do it because *I* wanted to know what it would be like, or someone else.

JC: No, you'd have to do it only if you were serious, of course, if you mean that.

JR: The whole question, or problem, of being consistent with one's principles and values is double-edged. There is your desire to "mean" what you're doing, to do things for reasons that make sense and seem important to you. But then there is also how people from the outside are monitoring those choices, *their* concerns about your integrity and consistency. What is an energizing paradox to you may look like a confusing contradiction to them. I think about one recent writer who worried about how you could possibly have composed *o′oo″* given the other things you were doing at the time. What was the logic of it? How was it consistent with your other work? You have seemed to me to work with specific kinds of questions and procedures in a complex atmosphere of values, rather than within a logic of one step leading inexorably to, justifying, foreshadowing the next step. But if we can't predict where we're going, and don't leave traces, don't we worry about getting lost?

JC: If we don't know something?

JR: We're taught very early that we should know where we're going and we should leave a well-marked, indelible, in*edible* trail. Otherwise we might end up like Hansel and Gretel.

JC: In my opinion, at present, not fifty years ago, but at present, we get along better with our work when we know less about it. When we're more or less ignorant of it. And that happens very quickly. I mean you don't have to study long to become ignorant.

JR: Why do you think that? Ignorant in what sense?

JC: Well, in this sense, for instance. I'm frequently now in the situation of having to listen to music which I've already written, which is finished as far as I'm concerned. But when I haven't made it clear in many ways what it is, it becomes of course the way that it is made by other people. It's never boring then, and is frequently beautiful. I don't know anything to expect in relation to it—whether a sound is going to be soft or loud, long or short. Now with the concern with microtonality, which is not entirely accepted by performers, as I told you, but if it were, any certainty with regard to pitch would disappear. Because it's just not possible in the space of a half-step to put six other degrees with any security, hmm? And there won't be any time in which to measure whether something was wrong or right—either for the performer, or for the listener, or for the—well, the only one who could write it correctly using chance operations would be me, but I wouldn't have time to ascertain that a mistake had been made, or that a success had been achieved. In fact, I could by the various means that I'm using, I could approach what you said about Hansel and Gretel—I could approach not knowing, hmm? with pleasure, much more closely than knowing would give me.

JR: And so—

JC: So, get lost. To get lost, but not worry about being lost.

JR: Actually microtonal composition is really not so much writing on water, but writing in air, isn't it? *(JC laughs)* And it strikes me that this may relieve you of a burden—

JC: That's what I'm saying, yes, yes.

JR: You wouldn't have to be disappointed in a performance, and yet it's so hard to do, isn't it? Both the fingering and the bowing techniques are very difficult—to control those imperceptible shifts.

JC: Yes, that can be very beautiful and it can also be done very poorly, but at least you can know whether it's being done in—what do we say?—in the proper spirit? But maybe the proper spirit isn't even needed on some occasions. I'm thinking of the perfomance [of *ASLSP*] yesterday [at WNYC] by Michael Torre, hmm? He said that he was a novice with respect to my work, and I think that may be the case, and so I listened—how is this going to be played? how is it played?—and I found I was interested in listening.

JR: I wondered as I was watching you listen to him—

JC: —Whether I was enjoying it or not.

JR: Yes.

JC: And I enjoyed it. The experience that I had, carried me to an awareness of

chromaticism, of notes that were close together. And that increased, it seemed to me, toward the end of his performance.

JR: Yes, it did.

JC: So that there was a sense of things impinging on things, hmm? In Zen, Suzuki spoke—as I've often quoted him—of interpenetration and nonobstruction, so that even though there are all these things, they don't interfere with one another. If we're—each one of us—on opposite sides of the street, and a truck comes between, does it obstruct?[24] Or does it simply continue on with nothing really having been obstructed?

JR: It obstructs if it—

JC: —If it parks. If it doesn't move, just stays there.

JR: Or if there's something you urgently needed to see at just that moment.

JC: But if you could see through it. *(laughter)*

JR: That would help!

JC: And if for instance rays of one kind or another *do* see through it, such as for instance radio waves. What kind of obstruction are we speaking of? *(laughs)*

JR: Well, yes, but that has to do with sound more than sight. I thought of experiences I have had of driving on a highway, trying to get somewhere I haven't been before. I don't want to miss the turn-off and an enormous truck goes by just as the sign is coming up that will tell me whether or not this is the exit I want. That is very upsetting and there is no doubt in my mind that the truck is obstructing something! *(JC laughs)* But I find your response to Michael Torre's playing interesting. You know I had been curious about the name of the piece [*ASLSP*] which itself could be taken as a kind of instruction for dynamics [As SLowly and Softly as Possible]. If I were the pianist, which I'm clearly not, I would take that—

JC: —As part of it, yes.

JR: Yes, as the instruction to play as slowly as I possibly could.

JC: Even softly.

JR: Yes, yes. So, having seen the music, I was anticipating a piece that would be very soft and slow, that would have an enormous amount of space and breath between the notes. Because of where I was sitting, I could see the score with *ASLSP* written in very large letters at the top, and all the spaces between notes. When Michael began to play, having just played Satie, I immediately felt he was still playing Satie—

JC: Yes.

JR: —And that's interesting. It's interesting that he manages to still play Satie with this score by John Cage, but, I want to hear *this*! I want its transparency. I enjoyed hearing the Satie, and now I want to hear something else. Why do I want

24. Cage is thinking here of an effect in his *Europera 5* that he calls "truckera," discussed later, in our July 30 conversation.

to hear something else? I'm not going to have a chance anytime soon to hear another pianist play this as I suspect it should be played. But also is there some way in which I want to see the sign on the other side of it? It would, I think, be transparent if it were played correctly.

JC: Oh yes.

JR: So I want to see through it, hear through it.

JC: Yes, but Michael isn't at that point. And he's been carefully trained to be at the point where he is, hmm? So . . . so, that's where we are.

JR: Then it makes a difference that he's a student [at Juilliard]. He was clearly excited about doing this. I think it would be very nice for him, though, if he could learn from the experience with this piece that there are other ways of playing. I'm thinking now as a teacher that there's a wasted possibility in this somehow. It might have been not only a more interesting listening experience—

JC: —To hear it the other way.

JR: —To hear it the other way, but also productive for him to be challenged to think differently about music. I'm reminded of what you said about the language of inclusion when we were discussing the pronouns in "Overpopulation and Art"—that it's not just a matter of words, it's a matter of a way of thinking, of a whole way of being, actually.[25]

JC: Yes. Musically, it's finding the dynamic, actually, the amplitude of each separate sound. Not having two in succession with the same dynamic, or closely related dynamics that would suggest either getting softer or getting louder. But you would want to have, in order to have this transparency, you would want to have each note at its own center with respect to amplitude. And that's not easy to do. I'll tell you another place where it was lost by a pianist much closer in her experience to my music than he [Michael Torre]. Her name is Marianne Schroeder, and she's playing the *Etudes Australes*, which are very difficult, which I wrote for Grete Sultan. Marianne Schroeder just played, not all of them, but some of them in Perugia where I just was. And now she will play them in Frankfurt, where unfortunately I won't be able to hear her because I have to be in Cologne for that orchestra piece I mentioned. Anyway, the *Etudes Australes* begin with most of the notes being single notes, instead of aggregates or chords, and that was controlled by chance operations. So that the whole work—there are thirty-two etudes—moved from an etude in which the likelihood, through the use of chance operations, of arriving at aggregates was small, and it moved to the thirty-second etude, where the likelihood of there being aggregates was almost equal to there not being. So it went from simplicity to complexity. When she played the simple pieces, she played them not in the same spirit in which she played the

25. Cage revised "Overpopulation and Art," which talks of "the necessity tO find new forms/ of liVing/nEw/foRms of living together/to stoP the estrangement between us/tO overcome/the Patriarchal thinking," in order to replace generic male usages with more inclusive ones. See the appendix to *John Cage: Composed in America* for an account of what led to these revisions.

complicated ones. She played the complicated ones beautifully. She found them challenging, hmm? And so she met the challenge. But where they were simpler, she didn't find them challenging, hmm? so she gave a whole series of tones the same dynamic and they lost their strength. Or they were, with the other illustration, they were in Michael Torre's world, or Satie's. In other words, they were in the world of melody and things going smoothly from one state to another, rather than a complexity of centers, and a transparent relation. So I told her, make the simple ones difficult, by giving each note its own dynamic; if you do that it will be almost impossible, hmm? It will certainly be as difficult as the complex pieces that she played beautifully.

JR: Ah, and now unfortunately you won't be able to hear what she's done with it.

JC: I won't be able to hear her. One of my problems now is to write to her — because she just wrote to me — to write to her and explain to her that I can't hear her this time, that I'll have to hear her at some future time. And I have to do the same for Irvine Arditti.

JR: I've now been with you a number of times when performers have not performed in the spirit of the piece they were playing. And it seems to me there are clearly times when you feel they should have known better. You feel impatient, and that it's not worth —

JC: —Fiddling with.

JR: Yes. I think of that pianist who played one of your pieces as though it were Liszt — much worse than mistaking it for Satie! Again, grouping the notes, looking for phrases.[26]

JC: Yes, exactly.

JR: —For dramatic effect, looking for crescendi. That pianist clearly had no point of contact with your work at all, whereas Michael Torre likes Satie. He could conceivably be on a road that would take him to your work. Have you thought of talking with him about the piece?

JC: I haven't thought because I don't see when I would do it. In the heat yesterday [during the noon sound-check in the MOMA sculpture garden] he asked me if I would listen, but I said no. I didn't say it was an uncomfortable situation, but it was. And I was more concerned with Michael Bach.[27] Which now I'm less concerned about. It seems to me that even if the sound is not well amplified, that it will be all right anyway. Even if there's feedback. I think the way he plays, the presence of feedback would not be an obstruction. *(laughs)*

JR: Yes, I think that's true, luckily, because there may well be feedback. If there's an opportunity. If it doesn't rain. That could be an obstruction.

26. This pianist, in fact, was later reported to have said he preferred playing Liszt. Cage was sitting in the last row of the small hall at the Phillips Gallery, in Washington D.C. The moment the concert ended, Cage said, "We'd better go. I'm afraid I will say something very bad if I have to talk to him."

27. The cellist who was going to play *One*[8] in the concert that evening.

JC: Even that won't be bad for Michael Bach. His reaction to that possibility was one of amusement really. I mean if he'd come all the way here [from France] for no reason at all, so to speak. *(laughs)*

JR: Well for him it will be productive anyway.[28]

JC: In any case.

JR: We were talking about things that have developed and changed in your thinking about music and your compositional processes. I'm aware of one pre-occupation that began very early on in your work, and has remained a constant; that is, thinking about what you take to be the "elements" of music, of sound actually, and then respecting in your composing what you take to be almost their internal, natural logics. I wonder if it's this kind of "elemental" thinking about the medium that differentiates your work from that of many other composers.

JC: We have had different experiences. One of the common experiences of a music student is training oneself so that one hears music in one's head, rather than in one's ears. It's called solfège. Did you ever study it?

JR: Yes, in a way, without knowing what I was doing. As a child I practiced on a fold-up cardboard keyboard, making really silent music.

JC: *(laughs)* Yes, the good student of solfège is able to recognize a pitch on hearing it as having such and such a letter, and is able when writing that letter to imagine hearing that pitch, hmm? That way one gets to know something! . . . about sound. *(laughter)* I never could study that. And I have also never been able to memorize a melody. I couldn't do this even in church. We'd go once a week, you know, or twice, for a prayer meeting and there'd be singing and I never could do it.

JR: This was a Protestant church with the traditional hymns?

JC: Yes, any Protestant church. The closest one to home was the one we went to. Didn't matter whether it was Baptist, or Presbyterian, or Methodist . . . just so it wasn't Catholic was the idea. They were considered to be in error somehow. *(laughs)*

JR: Yes, I grew up in that kind of family too. So, the early conjunction of the sounds with the letters—

JC: —Never took place.

JR: And that allowed you to think of the sounds by themselves—

JC: —That don't have any letters to begin with. *(laughter)* Like the sound of traffic, or the sound of a tin pan . . . striking anything. In other words the whole world of percussion. And I thought of myself—having to think of myself, having to place myself in the world of music—I excused my inability to relate pitches to my work, by calling myself a percussion composer, hmm? And that's what I became known as, a percussion composer. And then with the prepared piano, I

28. Cage was planning to work with Michael Bach on a cello part for *Ryoanji*.

became known for that—which is like introducing the freedom of the percussion world into the world of a piano.

JR: So, instead of investigating the various things that have to do with pitches—

JC: —Became investigating sounds—each one for itself. And then having two experiences that are inherent in percussion, that two drums—say you write a piece for three tom-toms, and you change your location, and discover that the tom-toms they have there are not the tom-toms you've had in another place, so that it sounds entirely different, hmm? differently, when it's played in one place rather than in another, according to which instrument is played. Then you begin to notice that no two pianos are the same either, hmm? That if you take the screws and bolts out of the prepared piano at home, to one in a concert hall, that you don't get the same result. Is it your mistake, or is it the fact that each piano is itself? And of course it's the latter that's true.

JR: And that's a lot more noticeable with a prepared piano than with an unprepared piano?

JC: Oh yes! I think Michael Torre said there was something wrong with the piano pedal [at the studio at WNYC] and there very likely is. There should be something wrong with it because they don't take care of it. That means that he was unable to hold something that he wanted to. In my piece he was supposed to hold certain notes through others being played.

JR: So had you not been concerned primarily with percussion, you might not have noticed—

JC: No, but I had had this other experience before—that I couldn't hold a tune. And then I was told in grammar school that I didn't have a voice, so singing was out of the question. Never when I was in church did I ever open my mouth. I didn't even try to sing.

JR: That's such a horrifying thing—that people are told they don't have voices.

JC: Yes. And I took it to be true. Well, when you go to a doctor and are told that you have such and such, you believe that you do. And so you do in school too; you believe teachers. So I was thirty-five before I opened my mouth to sing. And then when I sang, I sang so that nobody else could see that it was I singing. That was when Alan Hovhaness came backstage and said, who sang that song? and I said what do you want to know for? *(JR laughs)* and he said, I want that voice in my next opera. *(laughter)* Experiences like that led me to be listening to sounds, and particularly to sounds that were not considered musical. The last such experience was seriously modified for me by Marcel Duchamp's note about *sculpture sonore*—sounds coming from different places, and lasting, creating a sculpture which continues. That opened up the enjoyment of that kind of sound, in contrast to traffic sound, because mostly we ignore this kind of sound. I think the fact that it lasts diminishes its importance for us. Whereas Marcel's noticing it increases its importance. He tells us that we have to have at least three of these

[sources of sound], and each one different, in order to have a sculpture, a sonorous sculpture, which is true. If you have two sounds, you only have a straight line between them; but if you have three, you inevitably have a sculpture you can walk around in. And you can hear differently. You can really hear differently. Once you know that, you can look for them, and that way you can pay attention to things that you otherwise tend to ignore.

JR: And yet my experience of multiple sound sources has been mostly that they saturate rather than create space. But then I'm thinking of things like quadraphonic speakers, that are usually not playing your music.

JC: Yes. You're quite right doubting it, because it's very hard to do that, to have three or more and to let people, particularly if they're sitting still, hear it as sculpture. They won't hear it. They'll tend to hear it two-dimensionally.

JR: With three as well as two if they're sitting still?

JC: Even with five. Particularly. They'll tend, actually, to hear things all together as one. But then you can make efforts, as I do, to bring about that sculptural experience, the feeling of space, with sound. One piece is the one I'll give you a copy of, that violin and piano piece [*Two⁶*], where they're doing different things to fill the empty brackets. You'll become very aware of where they are coming from.

JR: This must be affected by the acoustical space—whether the sound tends to come clearly, straight at you, or to saturate the whole space.

JC: Well, it is according to what space you're in. This space—and Michael [Bach] is very interested in that, I don't know if you heard him say it—but he likes to hear this piece [*One⁸*] in different spaces. And he doesn't object to the air conditioning or traffic. He wants to know what that experience is.

JR: When did you start thinking that sound has four elements—pitch or frequency, timbre, amplitude, and duration—and begin working with that?

JC: In the forties.

JR: You said, of the four elements, duration was the most important one to work with, because it was characteristic of both sound and silence.

JC: At that time, of thinking that, I thought that silence existed. But you see now, with the mesostic ["(untitled)," Figure 14], we know that it doesn't exist. *(laughs)*

JR: Yes, and that's what I want to ask you about.

JC: We thought it existed, but it doesn't. Therefore we have to become anarchic. *(laughter)*

JR: Yes! I agree that what you're saying in that mesostic [Figure 14] is wonderful. I do agree; which is why I believe in reading it anarchically. *(laughter)* But then the existence of silence means that it's not only duration that is characteristic of both sound and silence, but also amplitude. Since silence is ambient sound—

JC: Yes, so it complicates the situation even more. Then if we connect our art experiences with our life experiences, it becomes very very complicated, hmm? We know so much about our own likes and dislikes, hmm? And we are able to

change them in the world of art, but we have more difficulty in the actual, in—what do we call it?—the "real world"? *(laughter)*

JR: It is a very funny term.

JC: Yes.

(We decide to break for lunch.)

JR: We had been talking before lunch [off tape] about the television piece you had done at WGBH in Boston [*WGBH-TV*, 1971] and I think that relates to the question I had started to ask you earlier about amplitude. That is, when you discovered that silence doesn't exist as an absence of sound, but that silence is actually always filled with the presence of ambient sound, did you find—as a result of that—that you were beginning to explore amplitude as well as duration as a major factor in your composing? Maybe it could be called turning the volume up on the silent world—taping or miking ambient sound into the performance. Or, in the case of the television piece, where you are writing music on camera and the voice is saying, "The music isn't finished yet, so there's nothing to hear," the microphone is picking up the silence, which in that case is the sound of music being written, which is of course the music in that piece. All of this seems to have to do primarily with sonic figure/ground shifts that might involve amplitude.

JC: Amplitude has a very special characteristic, it seems to me, in music. I was closely associated with Morton Feldman, and almost all of his music, with his thinking, went to pianissimo. So as I was doing my work and seeing Morty a great deal, I naturally thought of maintained, soft sound as being his, and that I would keep a place in my work for a variety of amplitudes. Now I find myself drawn—of course he's not living anymore—I find myself drawn, for the majority of sounds, to a softness that would be easily thought of as Morty's amplitude, hmm? The nice thing about low amplitudes is that they don't obscure other amplitudes. A short sound has seemed to me to be one that could be loud without really bothering other, say, soft sounds, because it wouldn't last long enough to interfere. So I have in recent work very often, in the flexible time brackets where sounds can be short or long according to the decision of the performer, I advise him or her that if a sound is long it should be soft, but if it is short it can be of any amplitude. But I've recently written, one of the pieces I've shown you, the one we payed less attention to, a piece called *58* [1992] which will be for 58 brass and other wind instruments. Now all of those instruments are connected with bands and . . . well, with loudness. The kind of loudness that we think of in relation to celebration and joy. There I have omitted any control of the amplitude at all, so that whether it's long or short a sound can be soft or loud. I think somehow what's changing my mind there, or changing the use of amplitude, is the fact of breath in wind instruments. There's something else that I don't do there that could be done. I discovered it with a very fine clarinetist [David Krakauer] who played a piece of mine, a very early piece that I wrote in '33, that's usually played by starting out very softly and then going to a central part which is loud, and then coming

back at the end to another soft sound.[29] But this very fine clarinetist played it by going to what's usually the loud point because it's the highest point, and wind instruments generally can't play softly in the high register—their nature is to be loud at the top and soft at the bottom—but he played it pianissimo all the way through, through the whole range of the clarinet, and I never heard it played more beautifully than the way he did it. I had a meeting with him in which I complained about wind instruments in general—that they always play without much control, particularly of soft sounds—and he said it's because they're taught to make a full tone, and that if they're willing to make a tone which is not full, then they can make a beautiful soft sound on any one of the instruments. But if they want to have a full sound, as they get higher they have to play louder. I've had the experience over the years of finding the flute, for instance, too loud. It's just played too loudly. So that when I wrote the piece called *Two* [1988], which is for flute and piano, I specifically asked the flutist to play almost inaudibly, and the piano to play a variety of dynamics, through the gamut of soft to loud. Those are the kinds of thoughts I've had about amplitude. As you know, thoughts about frequency have taken me recently to finer divisions of pitch to the point where we can't be sure what pitch it is.

JR: And overtone structure?

JC: As far as overtone structure goes, sometimes called tone-color, it's the characteristic that distinguishes two different instruments when they're both playing the same note for the same length of time with the same loudness. I don't have many thoughts about the difference between such colors. I leave that to chance. I think they're all interesting to hear. What I don't like is when with some electronic instruments, by pushing certain buttons, every pitch you hear has the same overtone structure. I like a variety of colors.

JR: Have you ever written music for instruments like the electric violin, instruments hooked up to amplifiers where the amplitude could be controlled electronically?

JC: Where you could control it. No, I haven't done that.

JR: Have you added anything to your list of the musical elements you take into consideration?

JC: No, the tendency has been to reduce. Oh, but I try to keep the state of my thought about my work up to date in that piece called "Composition in Retrospect,"[30] which is, of course, the basis of the Harvard lectures, *I–VI*. The fifteen different words upon which mesostics are written are what struck me as being the things that concern me in music. Recently, I was asked to give a talk in Czechoslovakia, in Bratislava [June 13–19, 1992]. For some reason I don't understand, I decided to read "Composition in Retrospect" in a country where the people almost surely wouldn't understand what I was saying, and they were unable to

29. *Sonata for Clarinet.* Cage heard Krakauer play this piece at the Aspekte Salzburg New Music Festival in Austria, June 1991.

30. First written in 1981, updated in 1988.

translate it into Slavic. I sent them the manuscript but they didn't do it, so they must have decided that they weren't able. Now they're publishing it. They're going to find a way of translating it into prose, with the English on the opposite page. Anyway I had the thought of bringing it further up to date than I had a few years ago. But then I read it in Bratislava and I decided I didn't have anything to add to it. I'm going to have that published in this country by the way. In *I–VI* it can't be read as a mesostic. It's only published as prose in the source text.[31] There's a publisher called Exact Change—have you come across them?—in Massachusetts somewhere. They asked if I had some book and I told them I have this. It would be useful for me if it were published. And they will publish it as mesostics.[32] Those mesostics in "Composition in Retrospect," as far as I can tell from reading it, and trying to examine in my head what it is I think or feel about music . . . sum it up. The last set of mesostics are on the word "Performance," and they include that story of the monk in Japan holding a knife in one hand and a cat in the other, and he's demanding a word of truth—otherwise he will slit the cat's throat.

(Pause.)

JR: Can we get a copy of that to have before us?

JC: Yes. *(JC brings a copy of "Composition in Retrospect" to the table)* It's interesting that the four that I saw before were "Structure, Method, Material, and Form."

JR: So you've added a lot—

JC: And I've taken out Form and Material.[33] I gave up Form because I have no control over it, other than chance operations. Because the form—in other words, what happens—comes about through chance, and is, so to speak, not connected as a concern. Because I use them all—whatever comes. So form in this comes under the word Discipline really. I'm trying to see where material might have gone. *(JR laughs)* Well, it can go in many places—

JR: Circumstances . . .

JC: Contingency, Circumstances . . . I don't know, many places.

JR: Well, where would you put the considerations in choosing, say, a gamut—the sounds you're going to work with, and the instruments you'll use?

JC: I think it would be Circumstances. For instance, I thought I was writing a piece called *Seventeen* and it turned out that they would be happier that it be *Thirteen*. That was the circumstance of their not wanting to accept a microtonal piece. And the circumstance of their name, which was the Ensemble 13. Then, it's under Discipline that I discuss chance operations.

JR: The disappearance of form, though, does puzzle me.

31. The 1981 version was published by Kathan Brown in her *John Cage Etchings 1978–1982* (Oakland: Point Publications, 1982). It was reprinted in *X*.

32. The Exact Change volume, with Cage's 1988 expanded version, was published in Cambridge, Massachusetts in 1993 as *Composition in Retrospect*.

33. The fifteen headings as published in *I–VI* and *Composition in Retrospect* are: Method Structure Intention Discipline Notation Indeterminacy Interpenetration Imitation Devotion Circumstances Variable Structure Nonunderstanding Contingency Inconsistency Performance.

JC: My thought about form was that it was the fever chart of the patient, you know, the progress of the disease. *(JR laughs)* The progress of the disease is the form of the disease. So when that happens through chance, that is to say, when the series of events is chance-determined, you can't really say that you have any control over it. You can only really say that you've given up control.

JR: Let's talk about chance as you've used it. The giving up of control has always involved for you intricate procedures which began, I take it, with using charts of various kinds and, beginning in the early fifties, using the *I Ching*.[34] Did the texts associated with the various hexagrams ever enter into your musical considerations?

JC: No.

JR: So it was only—

JC: —The numbers.

JR: Did you use the Bollingen edition from the beginning—that chart in the back of the book?

JC: Yes, that particular arrangement of the sixty-four numbers. Many of the charts you see for the *I Ching* are different. If you lose the one you're using you can't depend on finding it in any other book of the *I Ching*. *(laughs)* They all have different arrangements of the sixty-four numbers. Not entirely different, but largely different.

JR: That edition has the foreword by Jung.

JC: Yes, and the translation from Wilhelm, and Cary Baynes. I met Cary Baynes and she was shocked by my use of the numbers rather than the wisdom.

JR: Did you ever use the wisdom in—

JC: Not in my work. No.

JR: —In your personal life?

JC: I would use it if I had a question, not with regard to my music, but with regard to my life. Then I would use it. Insofar as I could, in terms of wisdom.

JR: I know you used coins. Did you ever use yarrow sticks to obtain the numbers?

JC: I may have used them infrequently. I never had enough time. The moment I was given the alternative of the coin oracle, I took it. And then later, of course, I used the computer simulation of the coin oracle.

JR: Actually there's a third way that I've heard of, using tea leaves. Did you ever use that?

JC: No.

JR: You look at the patterns that tea leaves form at the bottom of the cup and try to identify hexagrams. It's a faster, softer method—more subjective. When you moved to the computerized version, did it—and here's where I think form comes in, as material ways in which you structure what you're doing—

34. When asked whether there was an earlier, simpler technique, like pulling things out of a hat, Cage said, "Oh, it was the magic square; there was no hat." See James Pritchett's *The Music of John Cage* for a detailed history of Cage's compositional procedures.

JC: I call that structure. People have very frequently questioned my use of these words. But the truth of a word is that you can define it any way you choose. So in *Silence* I give my definitions of structure and method, material and form. *(JC gets out* Silence *and reads)* "Structure in music is its divisibility into successive parts from phrases to long sections. Form is content, the continuity. Method is the means of controlling the continuity from note to note. The material of music is sound and silence. Integrating these is composing" [p. 62].

JR: "Form is content" is a rather startling—

JC: The continuity—what happens, or the course of a disease. The nature of what happens. Which is often thought of as what you're "saying," hmm? what's being said. But if you're not talking, which I never have been, or maybe exceptionally have been, then you can toss coins.

JR: When you moved from tossing the coins yourself, to the computer, there was the first simulation of the *I Ching* that—

JC: —Had a bug. Produced repetition, which, as I told you, I accepted since I knew I had been working with nonintention.

JR: It's interesting that "nonintention" isn't here—

JC: Isn't there.

JR: —Among the fifteen words in "Composition in Retrospect."

JC: I think, between Intention and Discipline, you'll find it takes place. Don't you think so?

JR: Yes, under "Intention" you talk about "purposeful purposelessness" and how you will not accept the role of composer unless, you say—I'll quote you directly—"Not to accept it unless I could remain at the same time a member of society, able to fulfill a commission to satisfy a particular need, though having no control over what happens. Acceptance, sometimes written out, determinate, sometimes just a suggestion. I found it worked. Therefore I nap, pounding the rice without lifting my hand." This is something you kept from the 1982 version of "Composition in Retrospect" [*I–VI*, p. 425]. And then discipline is for you training the mind to notice what is given, and of course the very particular and complicated use of chance operations. Discipline—

JC: It's repeated three times, which Nobby objected to, you know, in his essay when I was seventy-five. He spoke in particular of this text, "Composition in Retrospect," and just as he objected to my quoting Suzuki about moving toward the good, so he objected to my use of the word Discipline, and laying such importance upon it as to repeat it three times where the others only get stated once. He thought that discipline was apollonian rather than dionysian, which has been his statement all along—that I should be more dionysian.[35]

JR: I find that such a strange struggle. At Stanford the two of you seemed so

35. In *John Cage at Seventy-Five*, eds. Richard Fleming and William Duckworth (Lewisburg, Pa.: Bucknell University Press, 1989).

connected to one another, and yet you were at such odds, you seemed to be coming from incommensurable worlds — hardly enough overlap to really have a conversation.

JC: But we used always to converse with great pleasure.

JR: What happened?

JC: He developed, first of all, an interest in something of which I could have no experience. It began to take all of his attention. It no longer does.

JR: Islam and the Koran.

JC: Yes. It followed his work with *Finnegans Wake*. But he doesn't do that anymore. At least I said something to him at Stanford about that, and he said he wasn't working with Islam anymore. It's very curious, because he was doing it in a highly detailed way, which I couldn't follow. Knowing the different flavors of Islam, as you would know, say, the difference between Presbyterians and Baptists.

JR: Do you know why he stopped the work?

JC: No. I've had no conversations with him during it, or, unfortunately, after it. He wrote me a note, which I haven't answered, saying how exciting it was for him and Beth to be with me at Stanford, and hoping that I would come see them . . . again. I don't know. That brings to mind the title that Jap [Jasper Johns] wrote about friendship, "The Fabric of Friendship," which changes, of course. And one doesn't know what causes those changes, hmm? You can remember anything you like, but you don't know what brings about a change.

JR: Well, the two of you met in the sixties, yes?

JC: Yes.

JR: And I have the feeling that — in an atmosphere with the presence of Bucky Fuller and Marshall McLuhan — there was a sense among you of all being engaged in the same project — to save the world.

JC: Utopia.

JR: Yes. That was a time when you felt that music was — I don't know if you ever called it therapeutic, but —

JC: Beneficent, I called it.

JR: And weren't you doing, during that time, work that had more open structures, with some similarities to the improvisational nature of happenings . . . more that could have been identified by N. O. Brown as dionysiac? Your work has changed a good deal since then, but I have a feeling his is still closely related to that time, particularly after hearing him talk at Stanford. I was struck by how close his eruptive, aphoristic talk was to the spirit of *Love's Body*, and, of course, *Life Against Death*, wrestling with Nietzsche's oppositional categories — wanting the dionysian to come out on top in what he sees as a fundamental, antagonistic dualism. I had reread Nietzsche's *Birth of Tragedy* just before coming out to Stanford, and I was struck once again by how Nietzsche leaves Apollo and Dionysus in a dynamic tension — doesn't, can't, declare one or the other the winner. And then, most strikingly, your work seems very fundamentally to have moved beyond dualisms altogether.

JC: I hope so. Well, I think the absolute statement of an irreducible opposition is just not helpful. I think we must understand the identity of the opposites, together with the idea of endless multiplicity, a multiplicity not of things that can be counted, but of things that are countless . . .

JR: Even more than ten thousand things?[36] *(laughter)*

JC: Don't you think? It's just amazing. I think that goes beyond adherence to the idea of apollonian and dionysiac as essential opposites. There's a piece of mine—to give you an idea of what Nobby recognizes as dionysiac—in connection with my work I mean—there's an early piece called *Amores* [1943], and there are two solos—one for prepared piano and two percussion pieces, one for drums and the other for wood blocks. Well, in the fourth piece—which is the second piece for prepared piano—there are several sections, there may be ten, actually—and the last two phrases struck Nobby as being dionysiac. There's a descending line, not an ascending line as I was describing yesterday *(laughs)*, but it's a heavy downward thrust—

JR: Toward the grave?

JC: —And an insistence upon it by repetition. And even the use of a kind of sound that, that seems to—oh, it could have the feeling of a scream in it, hmm? at the same time that this downwardness is felt. So he was quite impressed.

JR: Actually that makes immediate sense—

JC: Dionysiac sense, yes.

JR: —Given what he was saying at Stanford.[37] It sounds like at least your concluding phrases could be used as incidental music for *The Bacchae*.

JC: *(smiling)* Something like that, yes.

JR: So the upward thrust in the music we were talking about yesterday [*Two⁶*]—it must be that you choose to go in that direction now, no?

JC: Uh huh.

JR: That it's coupled with—

JC: It was a very curious instance of it at any rate, because I was ostensibly looking for things to fill these empty brackets with, and I had the variations of Satie's *Vexations* on hand, so to speak. I pulled them out of a drawer. And I pulled this microtonal business for the violin out of, say, a recent drawer. And then the two other elements that are included are this ascending gamut, and that brought about—the other one is stated as an ascending series of possibilities for the violin to make an interval, but in fact it will simply be an interval, it will be static, it won't have any sense of ascending in it. The only one that will really have the ascending business is the gamut on the piano. And I don't know . . . whether it will be convincing, as ascending. Because they're not regular steps. So it may be more impressive that it's leaping, than that it's ascending, hmm? If you're thinking about "ascension," you can tell very well if it's regular steps, like a stairway.

36. Referring to the ambitious music project of the fifties that Cage called "The Ten Thousand Things." For a descriptive analysis of this, see James Pritchett, *The Music of John Cage*.
37. That the subject of death should be addressed.

But if it's a series of unequal jumps, which it is, through chance operations, it may not give the impression of ascending to a listener. That may not be what one hears. I don't know.

JR: So you think it may sound like leaping, but not progressively leaping upwards.

JC: I don't know. I rather think it will be recognizable. I don't know.

JR: Would you be disappointed if it wasn't?

JC: No. *(laughs)* Or, another answer is, I've been disappointed that way many times. *(laughter)*

JR: Oh, I like that. There must be two possible answers—at least.

JC: I wrote the *Music of Changes* [1951–52] distinctly of the opinion that it would get more spacious as it continued. I thought that the tones would be close together at the beginning and far apart at the end. And it didn't turn out that way. It should have, but it didn't. *(laughs)*

JR: In a case like that, did you do something after that to try—

JC: No, no. It's very clearly stated in the *I Ching* that if you don't like the results of chance operations you have no right to use them. *(laughs)*

JR: So you didn't change the *Music of Changes*. But did you in any subsequent works find yourself working on a piece where notes might get progressively farther apart—not in order to correct an earlier mistake, but because you were still interested in that kind of structure, and wanted to see it realized?

JC: The most serious changing process that I got involved in was with a piece called *Apartment House 1776* [1976], and it was the variations on the hymns that were written by various composers two hundred years ago.[38] I wrote some of them one way, and then discovered that the way I was writing was not good.

JR: Not good?

JC: That is to say, it wasn't really radical. It only worked for the pieces that were good before I started varying them. But it didn't work at all for the ones that were no good to begin with. They didn't become good by my working with them.

JR: "Good" in what sense?

JC: Well, that's hard to answer. It's in the sense that you can tell when you hear the music that you haven't heard it before, hmm? It's revealing something about music to you. And if it doesn't do that, it isn't good, hmm?

JR: And how does it do that?

JC: Well, it does that—if you're writing a variation of something—it does it by its radical nature. You've touched the beast where it hurts! *(laughs)*

JR: And when the beast is touched, what does that mean in terms of quality of sound?

JC: That it sounds like something you've never heard before. *(pause)* And it

38. These were drawn from the spiritual songs of four traditions active in this country at the time of the Declaration of Independence: European Protestant, Sephardic Judaic, African, and Native American. See also a discussion of the composition of this piece in Pritchett.

would have worked, the radical way of writing would have worked, for all the pieces that I was working to vary, but I didn't . . . I was working against a deadline, so that as soon as I had a piece which I could accept, I accepted it and went on to the next. I had a lot of work to do, very quickly. So that I was finally left with eight pieces which resisted becoming acceptable.

JR: Meaning "radical."

JC: I had to find a radical way of varying them, and I ultimately did. It was curiously by subjecting each line in a four-part hymn, each line to chance operations in that each note in a line became either active or passive. If it was active, then I wrote the note down that was in the original, and I held it until the next active number in the line, and that began a silence which continued until the next active one, which became the next sound. So in that way a line of say fourteen sounds was reduced to a line of say four sounds, or four events. One line could be two events and two of them sounds. And when you hear that, you hear something that you know is harmony, still sounding like harmony, but removed from the laws of harmony. Literally removed from them.

JR: So that's a revelation—

JC: Yes.

JR: —Of possibilities lying dormant in conventional harmony.

JC: It was very very exciting to write that, to have that experience. I remember being excited about it and able to . . . oh, to spontaneously give a lecture at Harvard in front of a harmony class about how thrilling this was, and conveying that excitement to them.

JR: So, in the case of the *Music of Changes* turning out not to be as open—

JC: —As I had thought it would be.

JR: —Your response was to accept how it had turned out. But in this case where you had noticed that you didn't like what was happening you found new ways of working so that—

JC: —So I changed it until it became more radical, yes.

JR: I'd like to talk some more about chance operations and how you operated with them. Was the replacement for the first, flawed *I Ching* computer simulation at the University of Illinois one of the programs you're still working with?[39]

JC: I think I had perhaps two from the University of Illinois. And then when I became convinced by Hubert Hohn, a computer specialist in Banff, to have a computer and to have someone do the programming for me, that's how Andy Culver and Jim Rosenberg became involved. There's a new version of the *I Ching* [by Andrew Culver] which is called IC, and another one called IC Supply where I can get a page for any number transformed in relation to 64.[40]

JR: So those are the pages you carry in the black briefcase—the IC Supply sheets?

JC: Yes.

39. See Appendix A for Andrew Culver's annotated list of Cage's computer programs.
40. See Appendix G.

JR: I was delighted to find that you have a briefcase full of chance operations. It reminded me of Duchamp's valise—open it and art pops out. *(noticing the chair she's sitting on is getting more and more unstable)* I have a funny feeling that this chair—

JC: Oh, yes, it's coming apart! Merce noticed that this morning. He said he would fix it this evening. Do you want to shift chairs? It wouldn't be good if you fell out of the chair. See whether that's sturdy. Take a pillow.

JR: Yes, this one's better. That one felt all right to begin with and suddenly started feeling wobbly. I'm afraid I've further weakened it by rutching around so much. *(pause to rearrange the furniture)* At the editing session for *One¹¹* [Cage's film], when you pulled out a page, I asked Laura Kuhn, What is he taking out of that briefcase? She said, Oh those are his chance operations; he travels with them everywhere. *(laughter)* It fits into such a wonderful group of images—in addition to Duchamp's valise—the doctor with the black bag making house calls, the traveling salesman with the sample case . . . Here you come with your case of chance operations. *(laughter)*

JC: I take them when I travel for instance to make etchings, or if I'm going to be anywhere where people are going to ask me questions. *(laughter)*

JR: That's so enviable. It truly is. It's enviable—to be so fully equipped for any occasion, for any question! *(JC laughs)* I'm struck by the fact that when you were using coins you were very physically involved, over long periods of time, in composing. Recently when you said, "I don't compose anymore, I just transcribe numbers," it created in my mind what is certainly a picture of greater distance from the act of composing.[41]

JC: Yes. And you see most people have connected composing with speech, and they've connected speech with feeling. *(sneezes)* If you disconnect it from both feeling and sense, isn't that it?

JR: You mean from having something to say?

JC: From having something to say, and believing or feeling the truth of what you say, the honesty of it—all that—then it's quite different. I can remember, even when I had in other ways modified my feelings, hmm? that it was still time-*consuming* to make a musical continuity of any length. Now, of course, all I have to do really—as you put it—is to transcribe numbers. *(laughs)*

JR: Well, I was quoting you.

JC: No, I know, it's true. Then I can write really quite easily, if I know what I'm doing, which I don't always know. For instance, I didn't know with this piece called *Seventeen* that it was going to become *Thirteen*. And I didn't know that they would refuse to play microtonal music! *(laughs)* So, I have—in the other room—I have four parts of a piece called *Seventeen*, which may never get fin-

41. I would not say this now. It is clear to me at this point that Cage's work with numbers *was* composing.

ished. But if I do need, say, or could take advantage of having four parts written of a seventeen-part piece, I already have it! *(laughs)*

JR: You have a head start.

JC: Have a head start! *(laughter)* But all such benefits only arise when you don't have a thing in your head, or in your heart, as they would say. Which doesn't mean that my head and my heart aren't any longer functioning. *(laughs)* They function, you might put it, at different times in different ways.

JR: Yes. And at different times, in different ways in relation to your music.

JC: Yes.

JR: That I think is a very important point, because I think there are people who truly misunderstand that; who feel that—

JC: —All such things have gone to hell, yes, or have been let to slide.

JR: Yes, that what you're doing is somehow totally arbitrary, totally gratuitous, and that comes—I think—I'm asking this as a question, isn't it from mistaking—

JC: It comes from the whispered truths! *(laughs)* Spoken too loudly! *(laughs)* I think. Don't you think?

JR: There is I think a widespread lack of understanding of the sources of your process of composing a piece of music, in contrast to the notion of content in the piece of music itself. The sources have a lot of content in the sense of—all the good senses—of being meaningful, of being things that you care about, that you think are important at this moment in our history—

JC: And that comes up to this film idea too, and McLuhan's statement that you showed us, about pure information being the absence of content. Isn't that beautiful? [42]

JR: Well, perhaps we should stop here today. *(It's late afternoon.)*

JC: Today? O.K. I have things I can do. I have that proofreading over there. And I have my mail, and a possibility of a game of chess.

JR: With Bill?

JC: With Bill Anastasi.

FRIDAY, JULY 17

(As we begin, Cage is concerned about the fact that Andrew Culver will be making some repairs in the vicinity of the tape recorder.)

JR: That's all right, Andrew is always a benign presence. We've worked before with him close by, so I know it will be fine.

42. Cage's film, *One¹¹*, is entirely composed of images of the chance-determined play of electric light. It brought to mind this passage: "The electric light is pure information. It is a medium without a message as it were, unless it is used to spell out some verbal ad or name. This fact, characteristic of all media, means that the 'content' of any medium is always another medium." Marshall McLuhan, *Understanding Media: The Extensions of Man* (New York: McGraw-Hill, 1966), p. 8.

JC: O.K.

JR: By the way, when I pushed the buzzer this morning to get in, I noticed some graffiti over the bank of buzzers that I haven't noticed before—which of course doesn't mean it wasn't there. One word: TRACE! *(JC smiles; pause)* It occurred to me that the reason why form no longer has to be one of your preoccupations as a morphology of continuity—as you had defined it early on—is because now you discover it along the way.

JC: Exactly. Through chance.

JR: Yes, you don't have to *make* a continuity, artificially.

JC: I can observe it. I just observe it. I'm a tourist.

JR: Yes. But the reason why it's still important to me, as audience, is in noticing the shapes of the poethical environment of your work, and the way that unfolds and changes over time.

JC: But they would, if there were another performance of the same piece, or another writing of the same work, using the same process, turn out to be different.

JR: Yes.

JC: For instance, my drawings are like that—where there are the same stones but they take different positions through chance.[43]

JR: Yes. So that the form is one of constantly changing patterns brought about by chance procedures manipulating material variables. In other words, what comes of your prescribing some things, out of poethical convictions and, also out of poethical convictions, leaving other things alone.

JC: Yes, yes.

JR: Yesterday in talking about *Apartment House 1776,* you said that when you started working with those eighteenth-century hymns you realized what you were doing wasn't radical enough to reveal anything of interest about them.

JC: Well, if they were good to begin with, the way I was working when I was working superficially, rather than radically, was acceptable. It didn't in any way transform it. So if it was beautiful to begin with, it was beautiful when it was varied in the way that I was working. If it was not beautiful, or not interesting to hear, then it was not made interesting, hmm? When I worked radically it became interesting even if it wasn't interesting to begin with. For instance, harmony was not practiced very profoundly in New England in the churches. They would take, for instance, the tonic chord, without the dominant, and just repeat it, and find it very pleasurable, hmm? Without doing anything more. You can't really say in this day and age that that's interesting. *(laughs)* So, when I took something out of it with my first idea—which was to ask the question, Instead of four voices are there three or two or one?—nothing happened to it. But later when I separated

43. Cage used the same set of fifteen stones both for his *Ryoanji* drawings and his *Ryoanji* music scores. For the latter, he made thick paper templates with orientation markings around the perimeters.

the four voices, and counted the number of notes in each, and then added the question of activity or passivity that I described, where activity meant first sound and then silence—this had the effect of surrounding a single sound or a single center, you see, with space. If you have space between the centers, then you have a multiplicity of centers in interpenetration and nonobstruction. So then, by its nature, you have a situation which is true, or radical. It hasn't been made well or badly; it's, rather, acting the way nature does.

JR: The word radical, of course, means root.

JC: Root-like. Getting to how it operates, how it is in nature, really, rather than how it is in art.

JR: And actually working with units that are somewhat analogous to roots in language. I don't know, could you see those individual tones separated out, but still carrying with them something of their harmonic and melodic functions, being like—more than just phonemes—those monosyllabic Indo-European roots that sound in so many overlapping ways in words and phrases? So that some of the interest is in what you were doing with roots of musical phrases, melodic lines?

JC: Whatever it was, in the case of these last eight of forty-four hymns I was obliged, because they were just really not interesting, I was obliged to find a radical way to work—to get at the real, at the root of the matter. And the root of the matter was why didn't I like harmony, hmm? What was it in harmony that I didn't like, or didn't find lively? And it was, of course, the laws of it. In the example I gave, it was a law that wasn't really being followed well. It was only being half stated; it was just the tonic without the dominant, hmm? So it was really stupid. It was a stupid following of a law, which is that you should have the tonic and then the dominant.

JR: Would it have been more interesting, because more complex, had they included the dominant?

JC: No, no, not that. It just happened to be just the tonic. You might admire it for being that. For not having an idea.

JR: Yes, sort of like the simplification in Shaker furniture.

JC: Yes, you might. Except it wasn't really. I found it dull as dishwater! *(laughter)*

JR: Oh!

JC: And it could have been Shaker dishwater. *(laughs)*

JR: Yes, I suppose Shaker dishwater would be as dull as any other. But, perhaps that was not a fair analogy—with Shaker furniture—which I think is very lovely in its simplicity.

JC: Yes, well there are beautiful old musics, but this wasn't one of them. But it became so when the voices were separated and each sound was at its own center. Then the flavor remained of what it was originally—that is to say, just the tonic—but there was no presence of law, or any idea.

JR: I think of your delight in Christian Wolff's just letting "sound come into

its own."[44] Actually, strike the "just," because it's obviously very difficult to let sounds be. But also how you try to have this happen with different units of sound. You seem to look for the units that reflect something about the nature of sound itself, as well as the nature of the source. I wonder how this works in the *Europeras*, where you're working with larger units—arias, for instance, snatched away from their operatic plot lines? Do you think of it as having liberated them from the plots against them?

JC: It's very curious with music, because things change enormously if you're using material that already exists, that is to say, source material that you're treating with chance operations. What happens to it varies greatly according to how much time is spent, or how many notes, or how many measures are going to remain, or be used. And all those things that might not seem to add up to a real difference do make a great difference when any detail, even minutely, is altered. This is almost part of the nature of music, hmm? That it's concerned with detail, and the details don't make any sense the way they do with poetry, or with words. But, if you leave one note out, or two—one is very different from two, hmm?—numbers become emphatic in their effect.

JR: Are you now talking about your music, or all music?

JC: Any music. I am, of course, talking about using chance with regard to existent music—hymns, or we could say arias. . . . Now, in the case of the *Europeras 1&2*, when it came to the notes of the orchestra, I used chance operations with regard to the number of notes, and determined from which source by numbering all the composers. But when it came to the arias on the part of the singers, instead of counting the notes, I let them choose complete arias which they were willing to sing, and didn't do anything to them. Didn't take any notes out, or put any notes in. But the orchestral accompaniment is a mosaic of fragments for each instrument, arrived at by means of chance operations. So nothing gets expressed fully, as it does in the arias.

JR: Ah, I didn't realize all the arias were complete. I haven't seen it. I've only heard a tape.

JC: They are complete even as far, in some cases, as the singer choosing to include the recitation before an aria. That's sometimes done to take up the time which was given the singer in the first place. Where the arias of several singers singing together are, where the relationships of their beginnings and endings are, is put into a kind of what you might call "fixed" bracket, rather than flexible bracket. And there, the length of the song is of importance. If it was too long it was evidently too long. If it was too short it was evidently too short. So the various lengths worked together in such a way that they either overlapped or didn't overlap.

JR: Laura [Kuhn] sent me tapes of *Europeras 1&2*, and together with my sound

44. In *Silence*, p. 68.

system it's definitely a matter of low fidelity, no doubt about that. The tapes don't indicate where this performance was. I don't know whether it was the Frankfurt or the SUNY-Purchase performance. But the effect in hearing the tapes is one of interpenetration and *obstruction*. All of those wholes coming and going at various times simultaneously in an environment with all the other sounds has the effect of fragmenting them.

J C : You mean the arias.

J R : The arias. There were relatively few that I was able to hear as intact arias. But I found that refreshing. If the live performance gives that effect—and it may not—I think I would consider it a positive case of obstruction, as opposed to nonobstruction. There's a way in which the identifiable fragments were refreshing broken loose from their totalities.

J C : It's very difficult to say . . . what happens. I think listeners will have their own reactions according to the experience of the original arias, hmm? If they know them, by heart, if they're chestnuts, then when things overlap, they'll either feel it as an obstruction or as a change having some effect. It might have, oh the sort of thing that we associate with the word "meaning," of bringing two things that are not together . . . bringing them together. Or, really have the effect of collage that was possibly meaningful. Now in my case, where I can't keep a melody, or remember one—or very few—I wasn't troubled by any of that. But the thing that I did do was to pulverize, you might say, the instrumental parts, but make no changes in the arias.

J R : How many different arias might be sung at once? What was the range?

J C : Well there were nineteen singers altogether—ten in *Europera 1* and nine in *Europera 2*. The reason there were nineteen is that there are nineteen different kinds of singers—lyric baritone, dramatic soprano, and so on. There was one of each. That was one of the difficult things about writing those operas. It was a two-year process, and it wasn't until very late—the last few months—that I knew who the singers were and had any contact with them. The operatic world is very much in flux. Each singer looks for the best job, and when the job comes—regardless of other commitments, he or she takes it. So that even if you have a run of many performances, very frequently singers suddenly disappear and someone comes to take their place. So you have to do what Merce is doing now with his dancers—replace and retrain and everything to . . . to let the show go on.

J R : The story is, or one story goes, that you were hired as a kind of mercenary, to kill off opera as a genre. That the two directors of the opera house in Frankfurt—

J C : —Metzger and Riehn—[45]

J R : Yes.

J C : —Wanted that to happen.

J R : Yes. In Metzger's program notes for the premier, he declares victory in the

45. Heinz-Klaus Metzger and Rainer Riehn, artistic directors of Oper Frankfurt.

form of your "Hegelian 'determinate negation'" of opera as a form, and says the process is irreversible. Opera is prophetically pronounced dead. They wanted the end of opera, and you were the hired gun.[46]

JC: That, of course, didn't happen. *(laughter)*

JR: It not only didn't happen on a broad scale, it didn't happen for you.

JC: No, I've become interested in opera.

JR: So what was that process for you? How did you change from being uninterested in the form—

JC: Through paying some attention to it, which I hadn't done. That always happens. Whatever you give your attention to, you discover that it's worthy of receiving the attention. The number of operas that I am willing to listen to has increased rather than diminished. When I wrote the *Europeras 1&2* I thought that *Don Giovanni* was great, but nothing much else. And I thought of a completely different kind, but beautiful in itself, was *Pelléas and Mélisande* of Debussy. *(doorbell rings, Andrew Culver comes in)* Now I find the *Falstaff* of Verdi a beautiful work, and interesting to hear.

JR: How did you come to *Falstaff?*

JC: I was actually living at the opera house in Frankfurt. The apartment I was in was in the same building as the opera, which eventually burned, you know. So that it was the simplest thing in the world for me to go down the hall and hear things.

JR: So while you were there *Falstaff* was performed, and what else did you hear?

JC: Well, I'm just thinking now of the ones I would jump at an opportunity to hear again—for which I would change my plans. If there were a good performance of *Falstaff*, I would like to hear it. Oh, and one since then, since the experience of Frankfurt, I've seen a marvelous production of *Moses and Aron*, of Schoenberg. I think as a whole, I remain estranged as a musician from opera. I don't like the idea of opera, hmm? which involves for the most part, plot, and a heavy weight on the emotions. Heavy use of the emotions. So much so that when they were removed, as they were by my use of chance, in both the instrumental parts, and in the juxtaposition of the arias, it was clear to the singers, though it was not to me, it was clear to the singers that this was *not* opera.

JR: With the exception of some moments when arias, and therefore opera, came through more or less intact. That happened as I heard it on tape with "La donna è mobile"—

46. "Rather than negating the operatic abstractly by selecting a different form of musical theatre, [Cage] chose instead the 'determinate negation' of opera in the Hegelian sense; which is to say, that which is to be negated is incorporated in its entirety in the shape the negation takes, constituting the specific substance of negation and sublated concretely within it. Such a process is irreversible, and we can wait with bated breath to see whether the blossoming opera composers of 'our time' will immediately comprehend that their hour has come: they are from now on also sublated." Heinz-Klaus Metzger, "Europe's Opera: Notes on John Cage's *Europeras 1&2*," in Oper Frankfurt program notes, December 1987.

JC: One of the chestnuts.

JR: Yes, a chestnut that was really on display because chance had—

JC: Permitted it.

JR: Right. Very few other things going on, so it's heard almost solo. The audience applauded, gratefully? Could they have been moved?

JC: I think it was amusement, because he [the tenor] was also blowing bubbles, soap bubbles, with a very big blower.

JR: Ah, well, yes, there is the theater in these as comic operas. And, in that, they are perhaps closer to a more familiar tradition of audience response. I read recently, probably in the Tuesday *New York Times* science section, an article about an animal ethnologist who thinks that most animal sounds are made with the express purpose of manipulating other animals. The bird songs and chirps, squeaking, growling, rasping sounds . . . all are made to shape the behavior of others rather than for sheer vocal pleasure or some less manipulative form of communication. By this view you could think of nature as an ongoing grand opera—full of the drama of variously costumed characters noisily trying to influence one another in *the* big plot—Life, Death, and the survival of the species. *(laughter)*

JC: Opera is a situation where everything underlines everything else, so that the point is unavoidable, hmm? *(laughs)* Whatever it is—whether it's *Nixon in China*, or Bush in Desert Storm—which it could very well be—any opera you like.

JR: Well then how do you listen to *Don Giovanni*, or *Pélleas and Mélisande*, or *Falstaff*?

JC: Oh no, all those three, and *Moses and Aron*, they're all very beautiful to hear. Apart from this thing that we object to about opera, hmm? I mean they're just plain—they engage your interest. Verdi, because of its extreme musicality, with fugues and everything toward the end. It's a very extraordinary musical composition, which is very rare in opera. And the complexity in that piece [*Falstaff*], it makes it very unusual as an opera, even among Verdi operas. Wagner of course I find hopeless. *(laughs)*

JR: That certainly doesn't surprise me. But I'm still surprised by Verdi. Because Verdi has such insistent, nonstop rhythms, many of which are in that bass line, oom-pah-pah form.

JC: The other nice one, of course, is Bizet's *Carmen*.

JR: I'm amazed!

JC: That it's come to this point? *(laughter)*

JR: Yes. For the first time? Was there ever a time in your extreme youth when—

JC: When I heard opera? The only one I heard was *Aida*. I didn't grow enamored. That's Verdi, isn't it?

JR: Yes, Verdi. And that was—

JC: In other words, I grew up as a non-lover of opera, someone who just didn't take opera seriously.

JR: My experience of opera was that it fit perfectly into adolescence—that period

of emotional turmoil and extremes—when you want the tumult of all of that reflected in everything you're reading or listening to. Opera was wonderful for that. So I've tended to think of it more as something you might grow out of, rather than into.

JC: And my experience is the other way around. The other thing I didn't like about opera was vibrato. Vibrato singing. *(pause)* Andy, do you want help?

ANDREW CULVER: No.

JC: Are you sure?

AC: Yes. I might disturb you though.

JR: What are you doing?

AC: I'm fixing the bookshelves.

JC: These are Merce's bookshelves, and they have collapsed. Andy is going to de-destroy them. He's going to let them act the way they used to act. *(laughs)*

JR: He's going to reverse the process of deconstruction.

AC: Exactly. I'm going to de-deconstruct. It used to be called reconstruction, but that's not possible now. *(laughter)*

JR: Deedy-construction.

JC: Deedy!-Construction! *(laughs)*

AC: D. D. Construction—that'd be a great name for a construction company.

JR: Or for a character in an opera *(JC laughs)*, a woman, a soprano whose name is DeeDee Con-Struction, with an intense vibrato that could drill holes through walls. There'd have to be a drill section in the orchestra.

AC: *(waving electric drill)* This could be what she carried around when she was emotionally charged.

JC: That makes a noise, doesn't it?

(AC begins to drill.)

JR: But, actually, do you have to do that right here? *(laughs)*

JC: It doesn't make a loud sound.

AC: No, no, I can take it around the corner.

JC: Well, I became interested in vibrato. Not to the point of using it in my songs, except very rarely when the kind of singing is subjected to chance. Because I'm given, both in string playing and in singing, to non-vibrato.

JR: Yes, which is hard for singers to do—to sustain a clean, pure tone.

JC: And string players too. They can make a mistake and correct it by vibrating in string playing. I suppose they can do the same thing in singing. They can land more or less anywhere and then vibrate over to where they belong. *(laughter)* So, my history was one of not being happy with either the fact of opera or the details of it.

JR: So exactly how does the change in your feelings come about? You're working in the medium, so you're beginning to notice things—

JC: Through the circumstances, and through having to use vibrato, because one of my first questions to whoever was in charge was, Can I ask the singers to not

vibrate? And he said, Certainly not! That's what they do! *(laughter)* And then I noticed that each one vibrated uniquely. In fact, they do another thing which I had never heard before. To save their voices, because they're really like race horses—they're very delicate and they're afraid of catching cold and all sorts of things—at least half of the time they can't sing, even when they're supposed to. *(laughs)* So in rehearsals, they never sing. Instead, they—I forget what they call it—they "sketch it"? They indicate that they know what the tune is, but they don't actually sing it—vibrating or not. The result is a sound that is never heard in public, but is absolutely beautiful to listen to, because it's an individualized sketching. Not doing the whole thing, or trying to make anything full, but just briefly sketching what the melody is.

JR: Are you using that in anything?

JC: No. People suggested that I do that, but I didn't.

JR: Do you think you might in the future?

JC: Under certain circumstances perhaps. That would be a real not-knowing, because each singer does his or her own sketching. In *Europera 5* [see Appendixes H and I] I ask the pianist to simulate playing the piano, to not actually play it, but to act as though he were playing it, letting through that action some sounds occur. So it's called—what does Andy call it?—shadow playing. He's written instructions for directing the operas, and he's done it himself.

JR: So it's fingering in the air over the keys, sometimes hitting the keys accidentally.

JC: Right. And that's what the singing would be like if you did the comparable thing with the voice. That arose because in *Europera 5* there are two singers, and there's one pianist. The piano plays material that is frequently so loud that if you played it you'd not hear the singers at all. And the same is true of the singers. There are only two of them and if they both sing together at the same volume, you hear an obstruction, as you put it. So I've arranged *Europera 5* so you only hear one of those three things clearly at any given time. The second singer, for instance, you'd hear less clearly because he or she moves to space different from the first one. Backstage or underneath the stage or off somewhere to the side. So, where the pianist is playing while one of the singers is singing, or both, instead of playing fully, he simply simulates playing as I've described.

JR: In *Europeras 1&2*, the collaging, but also the obstructions, give an effect of fragmentation, as well as, of course, the "pulverizing" of melodies. All of this conspires to turn the closely plotted form of the traditional opera into a very blowsy, baggy, humorous, metamorphic shape. I wonder if perhaps this has sprung certain elements of opera out of the system of grand opera culture and given them independent life. Or, to put it another way, when you say that in *Europera 5* you're doing things to avoid obstruction, I wonder if writing *Europeras 1&2* didn't in fact, unintentionally, serve as a kind of positive deconstructive critique for you that enabled you to identify things that to your surprise you like in opera, so

that in subsequent operas you may be no longer obstructing to deconstruct, but exploring—

JC: —In a way that I never could before.

JR: Yes.

JC: Since the *1&2* there was *3&4*, and then there's *5*. There's a change. The thing that changes *1&2* to become *3&4* is that instead of having an orchestra in *3&4*, or costumes, or sets, we have just record players which give the sound of the orchestra, but you get many orchestras at once, so that the obstruction increases, both instrumentally and with the singers. With the singers it remains at about the same obstruction level that it was in *1&2*, but the accompaniment becomes equally confusing . . . obstructive, or complex.

JR: And those are recordings of nineteenth-century operas, from Gluck to Puccini, still the same—

JC: Yes, the same material. But in *5* the material changes to include radio and television. So that what happens in *5* is a juxtaposition of the two centuries, nineteenth and twentieth. And that takes one's mind off opera. There's no pretense of a twentieth-century opera. Opera is stated as being of the nineteenth century, through the victrola, of which there's only one. It [the statement] is made very clearly. Whereas in *3&4* there are something like six record players, and each has a stack of fifty to a hundred records, organized through chance. So a lot of records are being heard at once. It's quite a marvelous sound because the sound of those old machines has another quality of its own. They're called pie-boxes, where you stack records.

JR: You mean the wood cabinet with the lid that opens up? Are the records stacked on the spindle to drop down?

JC: Well the player has to follow instructions and do what is appropriate to use the pie-box. It could be done that way. But what I'm trying to say is there isn't a single direction that's followed from *1&2* to *3&4* to *5*. But a new idea creeps in in *5* which is the opposition of the centuries; and the radio and the television represent the twentieth, obviously, and the television does it silently. Never opens its mouth. Yet it has, so to speak, the last word in the whole piece. So that you're faced with the silence of the twentieth century. And that's very touching when you consider the meaning of opera to singers and to audiences. It means the emotions, hmm? And with television that's gone.

JR: The emotions?

JC: Don't you think? I mean when you see a television image, a silent one, you don't know what to feel really. All you know is that you know it very well, and that it isn't any good. Or you could put it this way—if you were looking for a low level in culture, that you wouldn't even improve it by going from CBS to PBS, hmm?

JR: The format is the same.

JC: Something like that. So the silent image, when it doesn't have any help from sound or from any underlining, and it's just silent—as it always is for me when

I fly, I never put on the earphones—I find that somewhat interesting, to wonder rather than hear what they're saying. *(pause)* The way this *Europera 5* came about was that I became, through *3&4* which has two pianists, I became more closely associated with Yvar Mikhashoff. He is a very frequent performer of piano music. He's a busy pianist. He teaches at the [State] University of New York in Buffalo, but he tours much of the teaching year and almost all of the summer vacation period, and he's a soloist. Even if he performs with somebody he remains a soloist, hmm? I've heard him practice rubato—irregularity of the beat, of the periodicity. The reason I heard him do this was that, following my macrobiotic diet, I had gotten some food. He was in the theater practicing and I found the only place I could go to eat the food was right near the piano. The only exit was on the other side and if I had left where I was I would have disturbed his work. So I didn't. I was a captive audience. I had always thought he simply played as he felt. But he didn't, he practiced feeling. It was quite amazing for me. I thought if you were going to play rubato you could do it anytime you liked, just do it. But he practiced it. And the result is that his rubato is breathtaking! *(laughs)* It's just amazing. You can't believe how beautiful it is; I mean how convincing it is, as emotion, hmm?

JR: Because it has attained the level of high artifice.

JC: Very much, very amazing. So the *Europera 5* was made for him. We had *3&4* in which he had someone to play with, hmm? but he himself wanted another opera which would have a different length from *3&4*, in fact it would be one hour long, and which he would play himself. So he has merely to get two singers, a radio, a television and a phonograph, and he can give the performance—which he has done a great deal, both here and in Europe. Now there will be six performances in the end of July and August [in the Museum of Modern Art Summergarden series]. So, I don't think that through all those circumstances I continued from one of those operas to the next, so to speak, in a straight line. Each one came up because of circumstances that were different. The first difference was that there was no orchestra. I could have two pianos. And I could have, say, six singers. And I chose to add to that six phonographs, which were the pie-boxes, and then at the end, in *4*, just a victrola. So in *Europera 5* I kept the victrola and none of the pie-boxes, only one of the pianos and the two singers, added the radio and the television, and I tried to let each of the elements, including the silent television at the end, have its presence. Its presence as a soloist.

JR: After a performance of *Radio Music* [composed in 1956] in Rockville, Maryland, you said to me you wanted to do another piece for radios, featuring a television as soloist. That was in 1989. Did you do that subsequently? Is there another piece where a television is a soloist and radios are the chorus or the orchestra? Or is that something you thought of doing and—

JC: It's something I thought of doing, but I haven't done it. This [*Europera 5*] is really in that spirit.

JR: Did you conceive of the other piece as an opera, or perhaps a cantata?

JC: I thought of it as a concerto, for twelve radios and television set. *(laughter)*

JR: With implications of transition from the old rite to the new rite, it sounds more like a cantata to me.

JC: No, but if it's silent.

JR: Ah, the television would be silent!

JC: It would be the concertizing TV. *(laughter)* It would be the soloist.

JR: A silent soloist, how nice. *(pause)* I want to ask you too about the "Noh-opera" project.[47]

JC: That's off in limbo. If it happened, though, it would be interesting. It follows from the work of Marcel Duchamp, and would attempt, foolishly or not, to use all the musical . . . or all the works of Marcel Duchamp that produce sound. So I was going to call it "Noh-opera, or the Complete Musical Works of Marcel Duchamp." It would be a collage of both Oriental theater and Western theater. It would also be a single work of Marcel's. The piece would begin with an elaborate, set-up construction, which would fill the stage. In the same way that the *Étant Donnés* of Marcel, when you peep through the hole, fills what you see, hmm? And then, in the course of the first act, what you saw would all be taken apart. And as it was taken apart, other pieces of Marcel's would be played. So it would be a complex action in the midst of the Orient and the Occident.

JR: *(Andrew Culver has come over to the table)* Andy is—

JC: Well, he's interested.

JR: Oh, you're listening, or do you need—

AC: Yes, I was thinking as I woke up this morning about bringing the subject up.

JC: Of the Noh-opera?

JR: Do you want to join the conversation?

JC: When he hears it being discussed he's very anxious for it to happen.

AC: Yes, I would like to do it.

JC: He would of course be very much involved. He makes structures. And one of the thoughts has been that the structure that would fill the stage would be of his design. So it would be taken apart, as Duchamp planned for the *Étant Donnés*. He wrote a book explaining how to take it apart and how to put it together again. So the opera would in fact be, in the first act, the taking apart of something that was together, and the second act would be the remounting of what you saw.

JR: The taking apart of the *Étant Donnés* for what purpose?

JC: In order to move it from one place to another, if you wanted to do that.

47. Andrew Culver tells an interesting story about the spelling of this projected opera. He says that when Cage began thinking about it, he spelled it "Nohopera." Then, during the stressful and precarious composition and production period for *Europeras 1&2*, culminating in the burning of the opera house in Frankfurt where it was to have premiered, Cage took to proclaiming, "No hope, no hope!" At which point Culver made a joke about the "No-hopera." Cage, who always fought valiantly against any tendencies toward pessimism in himself as well as others, did not like this joke at all. He thereafter inserted a hyphen in the title to clarify that it had nothing to do with despair: "Noh-opera." (See Cage's letter to Hiroyuki Iwaki on "Noh-opera," Appendix J.)

JR: So, nothing other than the practical necessity.

JC: We don't know. We don't know what circumstances would bring about following his plan, which was *Approximation démontable*. I think that's the title. Do you know the book?

JR: No, I don't.

JC: Oh it's very important.

(JC goes to get the book, past the bookshelf construction site.)

AC: *(calling out to JC)* Watch your step! The original move [of *Étant Donnés*] was from the studio here to Philadelphia. Presumably he planned always that it would be done after he was dead. So he made a very elaborate document on how to go about it. And that would be a kind of starting point for the set as a score. The sculpture as a score.

(JC returns with large black book.)

JR: I knew there were instructions, but I had no idea there was a book.

JC: It's a book largely due to my insisting that it exist. *(to Andrew)* Did you know that?

AC: I never knew that.

JC: I knew that he had made this book. In reality it's not this thin. In his making of it it's about so thick *(gestures with thumb and index finger)*, because all these photographs are mounted on thick pieces of paper. What is the title of this book? They've translated it: "Manual of Instructions for *Étant Donnés*." [48] I pointed out to Anne d'Harnoncourt [49] that if Marcel wrote a book, being in fact himself in relation to us in the twentieth century, many of us feeling that anything he did was of the utmost importance, hmm? — if that book was not published that there was some kind of crime being looked favorably upon by a person like herself, who owned! in her museum! this work! and who possessed the book! and who *did not* release it! *(laughter)* So she finally did it. [50]

JR: I would think so!

JC: It's called *Approximation démontable*, as I thought, (reading) "*exécutée entre 1946 et 1966 à* New York, *par approximation j'entends une marge d'*ad libitum *dans le démontage et remontage.*" By approximation I understand a margin of *ad libitum* in the démontage, and remontage. In other words in the taking apart and putting back together. So, he envisaged having something up, taking it down, and putting it back up. That inevitably will produce sound. It can't do otherwise,

48. Published by the Philadelphia Museum of Art, 1987.

49. Director of the Philadelphia Museum of Art.

50. In a telephone conversation about the circumstances surrounding the publication of the "Manual of Instructions," Anne d'Harnoncourt said, "I always wanted to do it, and loved having John's enthusiasm as a goad. But I'm not sure he was aware of a number of complicating factors, one of which was that by the terms of the gift of *Étant Donnés* to the museum in 1969, the book of 'Instructions' was not to be published for a period of at least fifteen years. He was understandably impatient, and I was very happy that he was so delighted when it was finally published in that 'thin' form."

hmm? We know that from attention to ambient sound. Therefore it's a musical work. And if we're doing his complete works, this is of course the most musical. *(laughter)* You can see that by the study of this.

JR: *(laughing)* That's wonderful.

JC: Isn't that true? And then you can see that the study of this would be amazing. In fact the whole structure of *Étant Donnés* is done with something that corresponds to a chess board, in principle at least, that allowed him to be very precise about where something was put, and which we have used—a grid—in all the operas for the positioning of the singers, and the objects. So this would continue that. This book tells all of the aspects of that work, how to take it apart, and how to put it together . . . isn't that amazing? [See Andrew Culver's *Europera 5* grid for the MOMA Summergarden series, Appendix I.]

JR: Hmm.

JC: It's the most fantastic cultural fact.

JR: So this was published in 1987.

JC: He had to die, of course, before it moved to Philadelphia. He didn't want it moved until after he died, he didn't want to set it up himself. So he wrote this in order for people to be able to take it from 10th Street in New York to Philadelphia. This book was to be used, and has been used, once. Hmm?

JR: How much have you done on the Noh-opera so far? Is it basically in this stage of—

JC: —Of not being done.

JR: —But knowing what you want to do.

JC: It would be very very expensive. I'm in close touch with probably the wealthiest man in Japan, and he could easily commission it.[51]

JR: Do you think he will?

JC: I don't know. I've asked him several times and he hasn't said yes.

JR: Does he care about Duchamp?

JC: Everybody does.

JR: *(laughs)* You mean, whether they know it or not?

JC: He's part of the Seibu company which opened its museum in Karuizawa

51. On the back of a "tbrack" sheet among Cage's papers were the following "Noh-opera" notes:
4) We want computerized lighting with ability to have many cues (in the thousands). For audio—the amplification of the tensegrity structure + whatever else Kosugi & Tudor want.
5) The length of the work I imagine to be between 2¼ & 3 hours.
6) Fees

Teeny Duchamp (royalties)		20,000.
David Tudor		20,000.
Merce Cunningham		20,000.
Takehisa Kosugi		20,000.
Andrew Culver	40	30,000.
Myself	70 / 60	~~80,000.~~

Since it is not yet crystallized or detailed, it is impossible to think of everything.

[September 1981] with a Duchamp exhibition. I was present for that and so was Teeny Duchamp. His name is Tsutsumi. . . . [52]

JR: Have you given him your—

JC: —Desire to do it.

JR: —Your passionate exhortation, as you did with Anne d'Harnoncourt?

JC: Yes.

AC: You told him the whole plan?

JC: No, not the whole plan, but as much as I've said just now.

JR: How would the Eastern elements enter into this?

JC: None of the questions that you might ask can be answered. *(laughter)*

AC: Yet.

JR: An Eastern element just entered in. *(laughter)*

JC: Quick! A word of truth! *(laughter)* Or I'll smash *Étant Donnés*! *(more laughter)*

JR: This is it.

JC: You know *Étant Donnés* itself is the nude, and it is the nude figure of Teeny Duchamp, or if not Teeny, then it's of the lady in Buenos Aires whom Marcel was close to for many years. So, in any case, Teeny put her foot down on my project as being literal. She said it should not be a female figure. It should not look like *Étant Donnés*. And that's how we moved over to Andrew's sculptures, which are sound sculptures. That is to say taking it apart, but also producing sound.

JR: Is Teeny disturbed by *Étant Donnés* itself?

JC: No, she's not disturbed, she's self-conscious.

JR: And she doesn't want it on the stage.

JC: Yes. She says she doesn't want to be on stage. Or for any other nude woman to be on stage.

JR: Good for her!

JC: She doesn't want to have anything done like that to the figure of a woman.

JR: But how does she feel about the voyeurism in the work itself?

JC: Oh, you mean the plan as it stands now?

JR: No, I mean of *Étant Donnés* as it's installed [at the Philadelphia Museum of Art]—the way in which one experiences it. Does that bother her as a figure that you peek at?

JC: No.

JR: Why not?

JC: Because Marcel made it that way. . . .

(Pause.)

JC: Do you know my article including this? I'll try to find it. *(brings it back)* It

52. Seiji Tsutsumi, President and CEO of the Seibu Corporation. The museum in which the Duchamp exibition opened was the Museum of Modern Art, Seibu Takanawa (Karuizawa), just north of Tokyo. It is now called the Sezon Museum.

was written for a catalog in Stuttgart. And it wasn't written on time to get it in. They were doing an exhibition of music and art, to show the correspondence between the two, and I wrote an article in which I said virtually nothing. I just collected things that other people had said. *(points to text)* This is by Satie. And this is by Savinio, a composer who was the brother of de Chirico. Then these are my remarks, and they have to do with Duchamp as a composer.[53] So the three composers that are presented are Satie, Savinio, and Duchamp, hmm? And there is a close connection between painting, or art, and music.

JR: The Noh-opera project as you've described it would clearly move out of the nineteenth century. This would be an opera that would be in . . . the future. *(JC laughs)* So, while you say you don't feel there's been any particular line of progression, or development, or logic from one to the next, it seems to me that "no" opera makes sense as a chronological development at this point.

JC: One of Marcel's musical words is, do you know it? his term *"infra-mince"*? *Infra-mince* means super-thin, or sub-thin, thinner than thin. He was very interested in pointing out examples of super-thinness, and that's what the book called *Notes* is about.[54] One example of super-thinness is if you're on a bus or subway, and someone gets up, to go and sit where that person was. You would then feel the warmth of that person in a very thin way.[55] *(laughs)*

JR: Yes, I felt that on the subway this morning. *(laughter)*

JC: That interested him, that sort of thing. One way of doing that, he said, to produce sound, an *infra-mince* sound, would be dancers with corduroy trousers. *(laughter)* Without any music other than legs against legs. So that would be . . . probably, that would end the first act [of the Noh-opera].

JR: So this would involve Merce Cunningham.

JC: Yes.

JR: And dancers with corduroy trousers.

JC: And that would clearly make it quite expensive. *(laughter)* There would be so many such things, coming together. And there would be so many people who would have to be paid, and so much research that I would want to conduct, that it would . . . it would require the wealth of Mr. Tsutsumi.

JR: And it would also move you off the track that you're on right now of going to

53. "Duchamp's *Approximation démontable* is a score for a performance, like his other musical works, seminal." John Cage, "Music and Art" [unpublished].

54. *Marcel Duchamp Notes*, trans. Paul Matisse (Boston: G. K. Hall, 1983).

55. Duchamp on what is translated in *The Writings of Marcel Duchamp* as "infra-slim": He is quoted by Denis de Rougemont as saying "[I] chose on purpose the word slim which is a word with human, affective connotations, and is not an exact laboratory measure. The sound or the music which corduroy trousers, like these, make when one moves, is pertinent to infra-slim. The hollow in the paper between the front and back of a thin sheet of paper. . . . To be studied! . . . it is a category which has occupied me a great deal over the last ten years. I believe that by means of the infra-slim one can pass from the second to the third dimension." In *The Writings of Marcel Duchamp*, eds. Michel Sanouillet and Elmer Peterson (New York: Da Capo, 1989), p. 194.

performances of past things, doing these smaller works, because you would have to—I would think—become very immersed in this. You would have to open time, and space, for yourself in order to do it.

JC: That's very difficult to see. It presents another problem. It's hard to imagine.

JR: I'm thinking of it as a possibility, rather than a problem. If you decided to do it, then—

JC: I won't decide to do it. Until it's made possible. I won't give it a thought. And the trouble now is there's this other project which is very time-consuming—a question of four or five years—and that's the Rolywholyover Circus which begins more or less a year from now.[56] So that by the time I would get to this [Noh-opera], I would be doddering. I mean more than I am now.

JR: That project stikes me as the sort of thing that might—

JC: *(laughs)*—Keep one from doddering?

JR: Yes, keep one from doddering.

JC: *(laughs)* You wouldn't have any time to dodder.

JR: Or, sort of like vibrato—perhaps the vibrating would get you from one thing to another. *(laughter)*

(We stop for lunch.)

JR: John, before we officially begin, would you say a word, or two? *(laughter)*

JC: Yes. Is my voice working? . . . as usual?

JR: *(looking at level meter on tape recorder)* Yes. It's working as usual. Good. When we discussed doing these conversations on music, you said that they could be useful to you in talking about what you were doing now, because you had questions about what it actually was that you were doing.

JC: Yes, I think we've more or less gotten into that as much as we can, though we may continue to go farther than I have. But you can see how I'm in a state of not thinking and not feeling. Not doing any of the things that a person is said to be able to do.

JR: And do you mean this generally because of the rush of your life?

JC: No, just the nature of the work.

JR: I wondered if you were adding a new layer to that.

JC: I can see that into what I'm now calling thoughtlessness, thoughts do enter. For instance, in the piece called *Thirteen* the thought entered to compress two percussion parts into one and to require that both percussionists play the same thing which they can't possibly do; which will be, of course, something to hear! *(laughs)* I can't imagine it, but I look forward to hearing it. So that exists. That exists apart. That's not like writing on water, hmm? That's not only knowing something about what you're doing, but doing something that could be . . . could have many ramifications, many ways to be understood, hmm? As a thing. It could

56. *Rolywholyover A Circus*, organized and curated by Julie Lazar at the Museum of Contemporary Art in Los Angeles, realized by Andrew Culver, opened September 12, 1993.

for instance be funny, hmm? Or sad. It might go pell-mell into an emotional, trace-laden situation, hmm?

JR: Trace-laden for—

JC: *Heavy* with traces. *(laughs)* And one of them is very common and very musical. Since they're both playing the same thing, what is called "canon" is almost bound to appear. But it'll be unlike any canon, I think, that one has heard. It will be in the general area of what Lou Harrison has called "Chinese canons." In other words canons that don't follow . . . don't do what we think they do.

JR: In that case that would be a very light trace, wouldn't it? not a heavy trace. Sounds quite delicious as a possibility.

JC: It actually still interests me. But it doesn't interest me in terms of what yesterday I called a whispered truth—which is what I'm *really* concerned with. But this piece may be fated, it seems to be fated, to not do what I'm doing. Because I wanted to write a microtonal piece which they then didn't want me to write, and then I think that I'm writing it microtonally even though I'm not, hmm? So it's a very curious piece.

JR: It's a piece in which circumstances are—

JC: —Are taking over.

JR: Actually, it might be possible, with any of your pieces, to assign values to the various elements which, through either circumstances or design, dominate or recede, or become more or less equal in weight, and in this way derive a musical calculus of relations of chance to intention. *(pause)* The attempt to enact the whispered truths, as I understand it, comes about procedurally by using numbers. You said at one point "thinking about numbers, rather than notes, to bring about all sorts of things freed of theory and emotion." It occurred to me as we broke for lunch that the talk about the possibility of Noh-opera—a wonderful ambiguity including the possibility of "no opera"—a possibility coming directly from very clear visual images, makes it easy to forget that in fact the composition of that work would again consist largely in transcribing the results of numerical chance operations. It would again be numbers. The kind of person who, as you were saying at lunch, writes to you and says "you have ruined music for me, you've taken all the good things away, you've depersonalized music," finds all this, to say the least, unsettling. The prospect of taking the emotional and communicative freight away—depersonalization—is a particularly frightening thing for people in this century. Turning identities which were warm with life and emotions into numbers has a terrible history in this century—the things that were done to people who were given numbers and effaced.

JC: Like our zip codes.

JR: Actually I'm thinking of the full spectrum, from Auschwitz to zip codes.

JC: No, I know. No, I know. *(pause)*

JR: Yes.

(Pause.)

JC: And it increases too, doesn't it?

JR: Yes.

JC: Do you notice how the zip code now has four more numbers added to it?

JR: Yes, and it's hard to imagine that there won't be in another ten or twenty years—

JC: More.

JR: —Another hyphen followed by another set of numbers, and people being of interest, being valued, already, only to the degree that they belong to one zip code market or another. So it's understandable that numbers tend to frighten people who want art, and those things that they call humanities—

JC: And, well, who *know* the past as having it, hmm?—the past as being the home of it. And it *is* for most people, because the books are not just any books, they're the *great* books, aren't they?

JR: Yes, the great books and music and art that supposedly mirror our humanity, straight from the great souls who can let us know what it is to be really human. And all this greatness, of course, concurrent with all the great atrocities. *(pause)* We were talking yesterday and the day before about the need, in following the whispered truths, to turn away from self-expression, to turn away from emotion as some kind of direct transmission. And yet it's quite clear that the numbers don't come from just anywhere, or nowhere. The use of these numbers for you is very much connected with human values—social and political values, as well as respect for and participation in nature. But their use leaves to the audience the possibility of their own connections. I'd like to talk some more about the sources of the numbers, the cultural sources—both Western and Eastern.

JC: Speaking literally, they come from China, the numbers—the *I Ching* numbers. Now, how they're used is various. They are used in the case of music I wrote around 1952, the *Music of Changes*, to locate specific points in time, sounds at specific points. Writing now, they don't come to a point, they fall into a flexible [time] bracket. They only get to a point through the physicality of the performance. And if that physicality is plural, as it is in chamber music or orchestral, the more numbers there are, the more impossible it is to imagine that there could be such a thing as one version, hmm? There are too many possibilities. So the numbers, even though they specify something, don't specify—now, in the music I write now—don't specify anything we can conceive of as being repeatable.

JR: I've always thought of the operation of the numbers in the *I Ching* as being very much subservient to the images of the hexagrams—of the broken and unbroken lines. There are sixty-four hexagrams and each one has its number, but—

JC: Well, there you come to sixty-four hexagrams, each one with six lines, and a six or a nine giving a change, so that something is seen in another light. But even that is less numerous than the way I'm able to use it with computer facility. Of

course I'm not dealing with wisdom, I'm just dealing with numbers and what I want to say is I can deal with higher numbers. *(laughter)* And I can pluralize the effects of numbers so that for a single sound that we hear there may be five or six or seven numbers coming to produce it. So it wouldn't be, again, something like sixty-four having control over possibility.

JR: My sense is that the Chinese, or anyone who uses the *I Ching* as an oracle, looking at those very beautiful lines [of the hexagrams] which have something very directly to do—just in terms of graphics—with openness and closedness, flexibility and stability—in using that chart it seems to me the real trust in its significance has to do more with being led by visual images to wisdom than to some sort of significance that is primarily numerical. The contrast I think of is with the Western philosopher and mathematician Pythagoras, whose trust *was* distinctly in numbers, who felt that numbers expressed something essential about the composition of the universe. Through numbers, through mathematics, through music based on numbers—the belief that you were participating in the logical order of the universe, which he thought was *made* of numbers, essentially. As I've mentioned before, in his mythology we had fallen from our former state of perfection in the stars, and the way to bridge the gap between our state on earth and that of the stars was through numbers. So numbers had a powerful, mystical logic for him. He was, you might say, counting on them, to give us access to . . . participation in the order of the universe. Anyway, I've had a sense that you are in some ways closer to the spirit of Pythagoras—I think of Buckminster Fuller too as having been close to Pythagoras—with respect to numbers, than to the *I Ching*. I think of these things when I ask what it is that an audience is being connected with when it experiences the result of your work with numbers. A Pythagorian would say they're being connected with the order of the universe. Or if you were a modified, up-to-date Pythagorean—a chaos theorist, say—you could say something similar, only the dynamics of the universe would include both order and disorder: chance.

(Pause.)

JC: My tendency is not to think of something like the order of the universe. There's something very detailed about music. Everything becomes a detail. Out of many it becomes one. I remember as a child those questions they would give us in drugstores. There would be a big jar of jelly beans, and one had to guess how many there were. *(laughs)* I remember thinking it would be quite impossible to know how many jelly beans were there, and it wouldn't make any difference whether I said 489 or 496.

JR: Really! You never tried to guess?

JC: I think I assumed the necessity of failure at that point, or of losing.

JR: I know someone, a woman from England, whose grandfather was the Strong Man in a circus. He guessed the right number of jelly beans in a jar—

JC: He did? *(laughs)*

JR: —And he won, I think it was, a Pierce Arrow car—

JC: He did! *(laughs)*

JR: He immediately sold it and bought a house, so the whole family ascended in its economic and class status.

JC: Isn't that marvelous! Isn't that amazing? *(pause)* I think of . . . I guess I do think of numbers very much—used with the *I Ching* as I do—I think of them as answering such questions constantly.

JR: Such questions as?

JC: Well, which is the one of many?

(Pause.)

JR: That's a very potent question.

JC: And then of course when you actually do it, "the many" changes all the time, is constantly changing. And if you assume that you're winning at every point, then you proceed. It's something like that that I'm doing. You can see how thoughtless one would become.

JR: Which takes us back to the whispered truths.

JC: I think so. *(pause)* I can see what you were saying about Pythagoras, and number, and that being like . . . like an intuition of the order of the universe, would you say? Or bringing about belief? But I don't feel that way.

JR: I think in the case of Pythagoras that he thought that it was just a given— that things occurred at ordered intervals and that numbers, as an ordinal system, represented that. Everything that exists is in relation to everything else in terms of intervals, so numbers therefore express everything that exists. Did you and Buckminster Fuller ever talk about—

JC: About numbers? Oh, I became concerned over the possibility of a disagreement between us, on that subject actually—order and disorder and chaos. So I rented a plane, with one engine. I was asked whether I wanted to rent a plane with one engine or one with two and I said one with one. I figured that if it only had one engine it would be a good one. *(laughter)* I flew from Cincinnati to Carbondale to see him about this question. He said that there was no trouble between us, that he was wanting to make a world in which the use of chance that I was advocating—as opposed to his geodesic dome and so forth—that he was trying to make something in which what I was doing would work, where you could do that. We were always very close, and seemingly in contradiction. Don't you think? *(pause)* But I listened to him and even followed him in my use of chance operations. For instance, he said that nothing—how did he say that, Andy—Bucky Fuller, about 5?

AC: Things start to get interesting after 5.

JC: Well more than interesting, what else? Interesting in what way?

AC: The number of types of relationships surpasses by twice as many the num-

ber of objects. It's in *Synergetics*; I can look it up. *(AC gets the book)* Here it is, *Synergetics I*, page 59.[57] This diagram here. Number of relationships: one, three, six, ten. If you have two objects, you have one relationship; three, you have three; four, you have six; five, you have ten.

JC: The number 5 has been important for me as a result of Bucky. So that I have the feeling that we're really getting outside of . . . we're getting into a mysterious set of relations if we get to 5.

JR: So how do you use that number in composing?

JC: Well it's led me to—I've had different answers along through the years. Now, it's no longer a matter of 5. It's a matter of making a time bracket flexible rather than fixed. So that higher numbers are invited. Such that I don't think you would get from such a score a repetition.

JR: I recall a specification in some of your earlier scores that there be a gamut of 5.

JC: It could have led to that early on.

JR: But I also recall your saying that when you were young, learning to play the piano, you liked fifths very much. That was your first love as an interval. . . . You asked earlier if I thought you and Fuller would be farther apart than you actually felt. I suppose I wouldn't have thought that; though, he was so preoccupied with structural integrities—

JC: Yes, and he was very interested in things that *work*, structurally. Andy has that gift too. I don't have it at all.

JR: Ah, I know why I wouldn't have placed you so very far apart in one sense. Because I think in order for you to work in the way you do, that you do have to have a fundamental belief in a kind of overall structural integrity. The sort of thing that we were talking about this morning with respect to time—that you don't have to make continuities because—

JC: —They happen.

JR: —They already exist. You don't have to make connections; they already exist. On the macro level there's a kind of structural integrity that you can—

JC: —Depend on.

JR: Right. And just make available at any given time in a variety of ways.

JC: Yes, I think so.

JR: And don't you think Fuller believed—

JC: —That too? Yes, but I think he thought of his relation to it as being different than I do. He thought of finding it in nature, I think, and simply—*(pause)* Let's see, what am I trying to say? *(pause)* I come back to the importance of 3 in his case too.

JR: Yes.

57. *Synergetics: Explorations in the Geometry of Thinking*, R. Buckminster Fuller in collaboration with E. J. Applewhite (New York: Macmillan, 1975). The chart we were looking at was "Underlying Order in Randomness."

JC: To make stronger things than were made by 4, hmm? So these triangles that fitted together to make the domes and spheres were important to him—

JR: Out of his conviction that the triangle was the strongest of all structures, since the three sides in a triangle all reinforce one another.

JC: Yes, yes.

JR: But when you say that he thought of finding it in nature, don't you also find these things in nature?

JC: Yes, well, but when he shows it to me, then I see it.

JR: Yes.

JC: But I wouldn't have found it myself. I don't have that kind of way of seeing.

JR: Ah! *(pause)* But, no, I'm not sure I see the difference. Do you feel it's different because you aren't trying to show aspects of nature directly?

JC: It's a difference in trying to construct, as he was, to make something work, hmm? And I'm apparently not. Or music isn't doing that. Doesn't need to do that. *(pause)* One interesting thing about music is that it doesn't fall down, hmm?

JR: *(laughing)* You don't have to cross a body of water on it. You're not depending on music to get us from here to there over some sort of chasm?

JC: Or even wrapping a package. Or having something stand up, the way the bookcase does now.

JR: The Grimmer sculpture is a structure in which chance operations are realized as music almost as they occur.[58] It doesn't look like anything Fuller would have constructed, but—

JC: Somehow the cone of ice and pebbles looks like he might have done it.

JR: Because of the pyramidal cone shape?

JC: That looks more like his sort of thing than the supporting structure does. And I think with the melting, coming to a point that way must help it, so that one stone falls at a time rather than a whole group falling at the same time, hmm?

JR: Yes, initially, at least.

JC: So that there's not just a great plop.

JR: Yes, so actually, there are engineering concerns—

JC: —There. And also musical ones. Mineko Grimmer knows how much to let it melt before the performance begins, so she doesn't put a completely frozen block that won't melt at all before the audience. She melts it in advance to the right point . . . like our baking the cookies, getting it right so that they don't spread too far on the sheet, not too many at one time.[59]

JR: If music can't fall down—

JC: Such things could make it fall down. *(laughter)*

JR: Actually, yes, in the Grimmer case, music is literally falling down. Or falling

58. Mineko Grimmer is an artist who makes sound sculptures. See discussion in July 18 conversation. The Noh-opera structure, if designed by Andrew Culver, would have been characteristic of Fuller. It would have been a "tensegrity."

59. We had baked a batch of Cage's favorite almond torte cookies before taping that morning.

down becomes music. Which makes it begin to seem that you and Bucky Fuller were working on different sides of the same coin. With a twist. His failures could be your music. A bridge or a dome falling down is music in the same way that disassembling *Étant Donnés* is music, no?

(End of tape; pause to insert new tape.)

JC: My part in that assemblage of events, with the Grimmer sculpture, is the violin playing [of *One⁶*, 1990] on János's [Négyesy] part, which is within long, flexible time brackets sometimes going from one bracket to another with imperceptible difference, so that the sound actually lasts an unusually long period of time. As stones fall, the sound is distinctly different from the continuation of the string playing. Does that make sense? In other words, it's a short sound against a very long sound, unusually long. And then I wrote another one for her [Mineko Grimmer] which would be the same idea but with harmonics [*One¹⁰*, 1992].

JR: To use with the same sculpture?

JC: No, with a different sculpture.⁶⁰

JR: It's quite apparent from this collaboration with a sculptor, as well as from other things, that the link between music and visual images, visual art, has been very strong for you. And recently there have been periods when you were doing both. In at least one case your procedure has been virtually the same. I'm thinking of your using the same group of fifteen stones both for pencil drawings and for composing music—and both have been called "*Ryoanji*" [*Where R=Ryoanji*]. The drawings are outlines of the stones placed on the paper through chance operations, and using a range of chance-determined thicknesses of graphite. There is in effect a score for each drawing, which is realized in the placing and outlining of the stones on the paper. The scores for wind and string parts for the musical composition of *Ryoanji* go to something like this stage as well—outlines of sections of the stones between pitches on staves—but then of course are further realized in the performance of the music. I wonder if we could talk about the composing of that *Ryoanji*—the one intended to be heard. You composed it in '83–'84, and I understand there's a second *Ryoanji*. Is that the case? Also done in a similar way?

JC: There are about five or six of them for separate instruments. And there are two accompanying parts—either the percussion part to go with any one of the instruments, or there's an orchestral version in which the orchestra is a small one of about twenty-four players. They play any pitches, or make any sounds that they choose, but they make always the same sound, as though they had become percussion instruments. The first *Ryoanji* was for oboe and the accompaniment was for percussion. Then there was a version made of the percussion part for orchestra. And then I think the next one was for voice, and then for flute, and then for double bass. And now Michael [Bach] wants one for cello.

60. Actually, the same sculpture in a new configuration. See Figure 17, page 276.

a

b

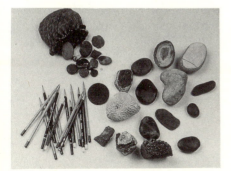

Figure 15a. John Cage, *Where R = Ryoanji, 1992, 13 R/5*. Graphite on paper. 10×19 inches. Collection of Merce Cunningham. Photo: David Sundberg. *b*. Excerpt from *Ryoanji for Bass*. For Joelle Leandre, 1984. © 1984 Henmar Press; courtesy C. F. Peters Corporation. *c*. Rocks and pencils used by John Cage to realize Ryoanji drawings. Collection of Merce Cunningham. Photo: David Sundberg.

c

JR: And outlining the stones for the wind and string parts creates glissandi?

JC: Creates curved lines which go from left to right. They don't go back to left.

JR: So they are ascending—

JC: —Or descending, but always from left to right as music does. They don't go in a circle. Music doesn't go in a circle. *(JR laughs)* The only way a circle could be expressed in music would be with two instruments, both of which went from left to right. *(draws two musical lines that begin at the same point, separate in reverse arcs, and reconnect at the same point)* That way.

JR: *(laughing)* So you could have a musical circle.

JC: You can't go this way, you can't go like that. *(draws a circle which curves back, right to left)*

JR: You'd be going—

JC: You'd be going backwards in time. We think we can do that, but we don't.

JR: I'm interested in *Ryoanji*, again in terms of sources for the way you structure your composing. How did you come to decide to make *Ryoanji* in the way you did?

JC: In recent years, as you said, I've been continuing to write music and I've been making etchings and drawings as well. In the course of this an oboe player was going to make a tour in Japan. He wanted me to make a piece for him to play in Japan. I got to thinking after hearing the oboe, hearing it slide, that it could be a sliding sound, and what could bring that sliding sound about would be the perimeter of a stone. And in the garden in Kyoto called Ryoanji there are fifteen stones. I don't know whether I was already making the drawings or not. I may have been doing that.

JR: I think you were, prior to '83.[61]

JC: Well, all of that led me to use the same stones to make a piece of music. After the first *Ryoanji*, I made it for additional instruments because those performers wanted pieces.

JR: You've talked about creating space-time on the musical page. How does this work in *Ryoanji*?

JC: I think of *Ryoanji* as being fifteen stones, hmm? and I think of the garden or the space for the fifteen stones as being four staves, or two pages—each page having two staves. And the staves are actually the area of the garden. Knowing the whole of it, I can find by chance operations where to put which stone. And knowing that it has to go from left to right, I know, once I put it there, where to draw. Then if two lines go over one another, I know that to distinguish them I must draw one one way and the other another, so that they don't ask that the same things be done at the same time. You don't involve doing something impossible. You have separate lines, one over the other, rather than the same line over itself. Does that make sense? *(draws)* If this one is playing this line, you don't ask

61. Kathan Brown thinks the *Ryoanji* etchings and drawings came before the music.

him or her to play something at the same time somewhere else. You ask someone else to play this other line. *(laughter)*

JR: So you used a procedure that was very similar to the procedure with the Ryoanji drawings.

JC: No, it's different. Because it's divided into at least four different ways of drawing. One is a straight [unbroken] line. Because these lines, through chance operations, are going to overlap and the same thing can't overlap itself. So you have four different ways to draw: the straight [unbroken] line, the dash line, a dotted line, and a dash and a dot. You make the piece by placing the stones [62] at chance-determined points [pitches] in the total garden, and draw from left to right.

JR: So there are more rules for the use of the stones in the music than in the drawings. In the graphic pieces you also place the stones by chance operations —

JC: It's quite different. There I'm not dealing with time, so I can draw around the whole stone. Music is characterized by detail and by having to do things that work in time.

JR: I've never been to the Ryoanji garden, and I wonder —

JC: The stones are arranged in such a way that there appear to be three, but in actuality there are fifteen. *(laughs)* They're in three groups.

JR: When *Ryoanji* is performed, does the sound for you relate directly to the garden — creating a similar experience of space-time — and to the marks on the page? Is there more of a formal continuity than in other pieces where the way the score looks really doesn't function in the same imagistic way as a visual analog to the sounds that you will hear, or vice versa, a sonic analog to what you see?

JC: I think they do relate to one another. I think that with proportional notation, you automatically produce a picture of what you hear. Perhaps more so in *Ryoanji*. But as much so, really, in *Etudes Australes*. And as we were discussing with *ASLSP*, right? you get in the score a picture of what you're going to hear, because it's not written according to counting, 1, 2, 3, 4. It's written according to the space in which you are. So that if you can see that notes are close together, then you can hear that they're close together — or far apart — I think. Michael Torre didn't go very far in that direction, but he must have gone somewhat.

JR: Yes, I think so. Now — that is, over the last few years — do you have a kind of menu of ways of working that you draw from? What is on that menu now?

JC: These time brackets — a particular number for each piece, twelve for this one. *(pointing at "tbrack" printout sheet)* Sometimes used, sometimes unused in the computer run. In this case *(pointing to sheet)* just the first three got used. Sometimes empty, sometimes filled with notes. *(looking through some sheets on the table)* Here are some brackets for the piece called *58* [see Appendix K]. This shows how they got used. Here are the brackets for the first flute [65 brackets in all], and

62. Actually paper templates of the stones.

here they are for the second flute [68 brackets in all]. Each time the computer ran these it was running according to chance, so you can see that the computer run the second time was different from the first. Here's the second flute. This begins "00:00–00:30" whereas the 1st flute was "00:00–00:45"; this is "00:35–01:20" whereas this is "01:10–01:25." You see it's quite off. *(pause)* That's where I am now.

JR: *(laughs)* That's where you are! In time brackets. In reading James Pritchett's manuscript [for *The Music of John Cage*] I was struck by how many different compositional methods you've used over the years and I had the impression that there were periods when you felt quite free to move from one method, and structure, and notation to another—that is, ready to use various ways of composing depending on the situation. Last year [October 22, 1991], for instance, you composed a piece for the squatters in . . . was it Hamburg?

JC: Hanau.

JR: You were using a map to find—

JC: Places for them to make recordings. What I proposed was that they go to the chance-determined points on their map and themselves make recordings, at chance-determined times of day. They wanted to know that—the times. I think I gave them directions for that. Then they were free to superimpose those sounds to make a piece which would represent the city in which they were squatting, and their forebears were living.[63] They're actually continuing.

JR: Are they? They're still there?

JC: They're still there.

JR: Do you think your piece—

JC: —Helps them? I don't know. They're about to publish a book with texts, and the last letter they sent me includes a remark to the effect that an idea has become a reality. So it may be that the older people have accepted the children. It might just be.

JR: It's a nice instance of music being drawn into—

JC: —A life situation.

(Pause.)

JR: Yes. *(pause)* Perhaps we should stop now.

JC: No, it's not necessary. I have, probably, another twenty-five minutes. If you want.

JR: You don't feel—? I sense a decrease in energy.

JC: Uh huh, that can be. Over that I have little control. But I do have my watch on and I know that I have to leave at a quarter of four [for a chiropractic appointment]. That's the only physical constraint.

JR: I think it might be more productive to start—

63. See "Project for Hanau squatters by John Cage," Appendix L.

JC: —To start again?

JR: —To start fresh tomorrow morning. There's sometimes an after-lunch decline. I feel it too. I think we would get more done in a better way tomorrow, don't you?

JC: O.K. Good.

Cage's Loft, New York City
July 18, 1992
John Cage, Joan Retallack, and Michael Bach

During the summer of 1992, the Museum of Modern Art in New York City devoted its Summergarden music series to the work of John Cage. Paul Zukofsky was Artistic Director for the series. On the evening of July 17, the cellist Michael Bach performed Cage's *One*[8] in the MOMA sculpture garden.[1] After the concert I suggested to John Cage that we invite Michael Bach to join the conversation we were planning to tape the next morning. Bach, who was developing a new bow mechanism and technique, was scheduled to meet with Cage the following Sunday and Monday to consult on the cello part for *Ryoanji* that Cage intended to compose for him. I thought it would be interesting to record a technical conversation about composing between Cage and a musician with whom he was currently working and whose artistry and technical innovations he greatly respected. What I did not anticipate was that Cage would actually begin the process of composing the *Ryoanji* cello part during our recorded session. — JR

(As the tape recorder is turned on, JC is talking about a man who has written to him several times seeking advice; his last letter was signed "The idiot from Seattle.")

JC: . . . He wanted advice. His confusion comes from his thinking. It doesn't come from outside him. He produces his own confusion. My last sentence [to him] was, "If this doesn't help, write again."

JR: That's very generous of you. My cure for idiocy, last night, was hearing Michael play [*One*[8]; see Appendix M for first page of score].

JC: Nobody knows what will happen. *(pause)* He wrote three letters, *(to JR)* do you remember?

JR: Yes.

JC: One was typewritten. He ends that letter by saying, "This took me a long time to write," but he fails to sign it.

JR: Do you answer all of that sort of mail—people asking for advice?

1. Michael Bach Bachtischa was born in 1958 in Westhofen, Germany. He studied with Janos Starker and Pierre Fournier. The adjustable curved bow, which he developed in 1989, makes it possible to play four tones simultaneously on the cello. Bach performed *One*[8] on the 17th and 18th in a program which included the Juilliard student Michael Torre, performing *ASLSP*. See my essay "Poethics of a Complex Realism," in *John Cage: Composed in America*, for a detailed description of this concert.

246

JC: I try to. It seems to me that, since I don't teach, that if someone asks me a question, I should provide an answer of some kind. I shouldn't just say, Go to hell. *(laughter)*

MB: They would ask the second question: how to get to hell. *(laughter)*

JR: Right. "Would you send the road map please." You could tell them to read Dante for that. *(pause)* Well, I thought last night that this would be a wonderful opportunity for John Cage and Michael Bach to have a conversation about *One*[8] because, John, your music is so tied to circumstance—to performers, to instruments, to the technology of specific instruments—and here is Michael who is developing the technology of the bow for your music.

JC: Michael sent me a text he prepared, which illustrated the stretches he is capable of making with his left hand on the strings.[2] And then of course the right hand uses the bow. The bows, we already knew, were mysterious, and so your text showed what could be done with the different bows, isn't that right?

MB: I showed the finger positions on four strings and the idea was to play the four strings together, not separately.

JR: Where did that idea come from?

MB: Well, it's obvious. I'm wondering why nobody before me had this idea. Because you have four strings.

JC: And they had the bow like that in the Middle Ages, hmm?

MB: *(laughs)* I'm not sure.

JC: They didn't?

MB: I did research on that, because when I started to develop such a bow I thought the same. Then I found out that this is perhaps a misunderstanding.

JC: Oh really!

MB: Yes, but a good one. Perhaps I never would have started so fast with that development if I hadn't thought it already existed. But then found out that there was no curved bow in history. I mean there was a very primitive bow, perhaps in the pre-Baroque or earlier time, but without a mechanism at the end. I think that that's the main point, that you can change between the strings—one, two, three, and four. Perhaps this ancient bow was an archaic archer's bow—that's where the name comes from. They were primitive and perhaps you controlled the tension with the fingers somehow. But there are almost no bows [from that time] left. I was told that perhaps in Milan in the museum you can see such a bow, or in Munich, but that's all. You see it sometimes in paintings in churches.

JC: Curved bows?

MB: Curved bows. But, for example, Johann Sebastian Bach never thought of that bow. At that time you had the Baroque bow. It's a little bit curved, not very much. And with that bow you cannot play three or four strings together. The

2. From Michael Bach, *Fingerboards & Overtones* (Kassel, Germany: Baerenreiter Publishing Company, 1991).

music groups which specialize in Baroque music, they break the chords, they don't play them together.

JC: No. When Paul Zukofsky arranged these concerts he originally had a Juilliard student playing the piece that you played last night [*One*[8]] and I pointed out to him that this would be quite impossible for the cellist. He said she's a very good cellist. I said it doesn't matter how good she is if she doesn't have the right bow to play the music. And he said, Well you must correct the piece, why can't we arpeggiate the chords? And I said that's not what is intended, and that has nothing to do with the piece. Finally he agreed.

MB: I remember when we worked on that piece you had that in mind, that it should be possible to play with a normal bow and to leave it open. Now you've revised your thinking?

JC: Now I so enjoyed your playing that I think it should be as it is. Do you think I'm wrong? Do you think it should be arpeggiated? Did you try arpeggiating?

MB: No, I didn't. Why should I?

JC: Well, I just wondered. *(phone rings, JC goes to answer it)* I'll have to turn this off.

(JC returns. He says it was Dorothea Tanning on the phone.)

JC: Do you know her work? She is the widow of Max Ernst, and she herself is a painter.

MB: And she is coming to the concert?

JC: Oh yes.

MB: I think we have very complex sounds with the curved bow. And if we have a four-pitch chord, we get more pitches because of the interferences, you get the differential tones. And that's what's very interesting.

JC: Yes, and even with an ordinary, straight bow, you have extended the nature of the harmonics. So you've investigated higher partials, is that right? Ordinarily, in the examination of harmonics of Paul Zukofsky, you begin with natural harmonics and then you don't go farther than the major or minor third. Isn't that what he does?[3]

MB: Yes. You say "natural harmonics" . . . well you go—

JC: —From the natural harmonics. And then the fingered harmonics, the artificial, go for him—in his table—go as far as the major and minor third. But you've gone much farther than that. When you go to what you call 31 and 32—

MB: Partial.

JC: What would that be in terms of intervals?

MB: 32? It's the fifth octave of the open string.

JC: It's much farther.

MB: It's much farther. Well, Zukofsky plays the violin, and I think on the violin you cannot go much farther than the 8th or the 10th partial.

3. Paul Zukofsky, *All-interval Scale Book: Including a Chart of Harmonics for the Violin* (New York: G. Schirmer, 1977).

JC: I see!

MB: On the cello you can do more. But usually in contemporary music I've played not farther than the 16th partial; it's very, very high. But I developed a technique to play up to the 32nd partial. This I cannot do with the curved bow. I have to use a normal bow because it's so near to the bridge that there's no space for the curved bow, because I only use a few hairs of the bow.

JR: So the bow has to be tipped.

MB: Tipped, yes. And with a curved bow you cannot do that. And then I use the nail of the thumb, because the nodal points, between the 31st and 32nd partial, are only 0.07 centimeters apart. So a finger is too thick for that. I developed this technique to play up to the 16th partial with the work of Morton Feldman, *Untitled Composition*.[4] You know how he is notating double—

JC: —Flats. Double flats.

MB: And double—

JC: —Sharps.

MB: He uses this notation for the string instrument and mostly these are harmonics. The piano has a tempered notation, no double flats and sharps.[5] So the cello hasn't to play tempered then. It should be something in between. And if you use all 16 partials on all four strings on the cello you have a microtonal scale, but you have to develop a technique—

JC: —To play it.

MB: To be sure that you get these partials. And that you combine, let's say, the 16th partial of the fourth string with the 15th on the A string. One partial after the other.

JR: Could you say more about the technique you developed?

MB: Well, I can play all these partials almost over all the string. Usually a string player touches the nodal point next to the bridge, but if you have the 16th partial you have 15 nodal points on the string because the string vibrates in 16 parts so you have 15 possibilities to play the 16th partial. *(laughs)* His [Cage's] notation in the score of *One*[8] is very complicated. We decided to notate two ways—the fingering and the sound resultant. The fingering sometimes is very complicated. If I touch a nodal point—

JC: Which is not near the bridge, which is somewhere down in here. *(pointing to imaginary cello)*

MB: Yes, you cannot use traditional notation, or you have to use arrows, because it's not in the right—

JC: —Not in the conventional place.

JR: So you're notating the part of the string the finger is to touch.

MB: Yes, we did, but it's much more complicated than that. Sometimes I use two

4. *Untitled Composition for Cello and Piano*, Composed in 1981; originally titled *Patterns in a Chromatic Field*.

5. With the exception, according to Michael Bach, of "two very short passages where the piano is also microintervally notated."

or three fingers to play one partial, one very high partial, to be very sure that I get it.

J C : Two or three fingers. Does that mean that you get two or three notes?

M B : No, only one, but I touch two or three nodal points to exclude other partials. Or, let's say, if I want to play the 15th partial, I can play the 3rd and the 5th, and together they make a 15th. And it's interesting in combination with other pitches too.

J C : Yes. Or, practical.

M B : Yes. But you also get big intervals. If you have a stopped tone and you want a very high partial on the other string, your hand is too small. You can't get every nodal point of the high harmonic, but you take the next—

J C : You take the nearest one, not to the bridge, but to the one that's already stopped.

J R : Michael may ruin the imprecision built into microtonal music.[6]

J C : Well, I was going to ask you—I've become, independently of our work together, I've become more and more interested in microtonal music. There's a group in Amsterdam called the Ives Ensemble—John Schneider is the pianist— they sent me a cassette of their playing of a piece called *Ten* [1991] which is microtonal. What I do is to, between each of two notes which are a half-step apart, like C and C♯, I have C with an arrow going up, from below it, to it; and then I have, as a second step, an arrow going alongside it with the arrow head above the note, so it's more or less equal with the note. Once, it's below; once, it's equal; and once, it's clearly above—that is to say, the end of the arrow begins with the note, and the arrow itself is much higher. So there are three degrees from the C up to this point. The next three begin with downward arrows that come from the C♯. So the first one is a C♯ with an arrow beginning opposite the note, that goes down; and the next one, alongside the C♯, goes down, equal with the note; and then one from above the note to the arrow head being near the C♯. Then the next step, of course, is C♯ itself. Just as the first step was C itself. So you have six degrees between two half-steps. That produces such a small amount of space, pitch-wise, that it would be a challenge . . . to almost any musician. Such a challenge that some musicians won't accept it. [See Appendix N.]

M B : For which instruments did you write this piece?

J C : For all of them. The two that don't play it, of course, are the piano and the percussion, *(laughs)* but the rest played it—the strings, the woodwinds, and brass.

M B : And are they harmonics or are they stopped pitches, or both?

J C : They could be any, anything. They're just indicated as far as microtonality goes. And they involve the lines [as notated with the arrows], involve not just microtonal steps, but involve microtonal leaps!

6. I am referring to an earlier conversation in which Cage said he liked the fact that the smaller the intervals become, the less certain you can be of the "right" note.

MB: Yes. Glissandi?

JC: No. Not glissandi, or steps—but jumps. So that you can't depend on sliding, but have to go from one, so to speak, unknown point to another unknown point. *(laughter)* The result is that you go . . . well, at least, to unfamiliar points— unfamiliar both to the performer and to the listener. And that gets us into the pitches that traffic is in, just normally, hmm? . . . or nature.[7] I think traffic sound is quite an important sound for everybody's listening. Because it is something which we hear no matter where we go. If you do get to a place where you don't hear any traffic sounds, you know that you're in a special place, hmm? And you can *enjoy* it. Or if you can get traffic in the distance, you can enjoy that. But you immediately know that you are in an acoustic situation with which you are un- familiar, hmm? So, since most people find that annoying, I consider it important to make it appreciated. And the path to the appreciation of traffic seems to me to lie through microtonality. *(pause)* For instance, Lou Harrison, another com- poser, who invented musical instruments—made clavichords. The clavichord is so quiet. The reason he made it so quiet is that he hated the sound of traffic. The sound of traffic irritated him to such a point that it would . . . oh . . . give him a headache. So he made this very quiet instrument that would bring him back to his senses, to his acoustic senses. But the direction my music has taken is to move, with love!, *toward* traffic, toward the irritation. If that became beautiful, which it could through microtonality, then we don't have to worry about any- thing! *(laughs)* Since we'll enjoy *any* pitch we hear, hmm? If we don't, if we won't, require that sounds be beautiful, which Lou required—that they be right—on the right pitch. And he was able with his clavichords, if they weren't on the right pitch, to tune them so that they were! *(laughs)* And that's what everybody does who plays a clavichord—tune it constantly.

MB: Yes. It's a different attitude if you play a clavichord where you have fixed pitches. If you play a brass or a string instrument, you have to find the pitches.

JC: You have to find it, yes.

MB: And that's what I'm thinking the whole time about your notation now. If you have a half-tone step and you divide it in six parts—

JC: You have then, don't you have seven divisions then?

MB: Uh . . . yes, seven.

JC: Between each half-step.

MB: I made an experiment. I wanted to find the smallest interval I can hear, or I can recognize as an interval. And it was I think something near the Pythagorean comma—that means it's a half-tone step, I think divided by five.

JC: And this [Cage's notation] is beyond that.

MB: Yes. And . . .

7. See footnote 29 for an interesting parallel in Charles Ives's thinking about the uses of "smaller tone divisions."

JC: It's very difficult. And you can't be *sure* . . . whether you have done the right thing.

MB: Yes. The question is if you would like to be sure.

JC: Well, we'll dismiss that. *(laughs)*

MB: "Dismiss"?

JC: I mean, we'll just say that that doesn't interest us—the idea of being sure doesn't interest us. *(to JR)* Isn't that what Wittgenstein said in his book, *On Certainty*? The philosophy of Wittgenstein doesn't admit certainty, hmm? It also doesn't know what blue is. There's an instance of not being able to be secure too. If you say "Blue!" you're not saying anything. Or you're saying something, but you're not making sense, you're not being certain of what you're saying. And the same is true of any other color, like if you say "Red and blue," what are you saying? You're just making nonsense, hmm? *(laughs)*

MB: *(laughs)* You are separating the blue from the red.

JC: Because you don't know what blue it is you're talking about, and you don't know what red you're talking about.

JR: Actually, what he says is the only way you ever know—

JC: —Is to give a sample.

JR: Yes, to point—what's called ostensive definition—you point at a sample.

JC: Yes. But in this case, we can't point. In dividing the half-step into seven. Let's say that Michael is right. That, not only he, but nobody else could hear as an interval something smaller than a fifth of a half-step. Say that's true. Then seventh is obviously in the area where you can't point! *(laughs)*

MB: But what do you mean with the challenge? What is the challenge in that case?

JC: It challenges, well, how you behave in the face of uncertainty, hmm? And that's one of the exciting things about music—that it's instantaneous behavior, hmm? It's based on, necessarily based on, doing something immediately, hmm?

MB: Yes. I remember when we first met you said, Performance is necessary.[8] If that's what you mean.

JC: Yes. Performance is so close to life that it isn't able to alter its nature once it's made the step, hmm? once it's done. You know the material that Oriental calligraphy is done on is often very valuable—very valuable silk, for instance. And it certainly is such that once you've made the mark you can't correct it; and you've either ruined or improved the silk! *(laughter)* So, it's dangerous.

JR: Nothing in between.

JC: It's dangerous. It's dangerous to make an action, hmm? So what do they do? They practice. To make any image, like a leaf of bamboo—you know, just one stroke—they practice and practice and practice and practice. Then, after a while, perhaps because they're tired, they decide that they're right. *(laughter)* Anyway, I wanted to bring [uncertainty]. . . . One of the annoying things about a violinist,

8. 1987, in Cage's loft.

for instance, I won't say a cellist *(laughter)*, and I'll specify—the annoying thing about Paul Zukofsky is that he *knows* what the right pitch is, hmm?

MB: *(laughs)* Well, we had a long discussion about what the right pitch is,[9] but he tries to find an answer.

JC: Yes, yes. So, anyway, he gets very uncomfortable when you give him any freedom, hmm? He told me. He told me, in fact, that he could not accept any freedom. If he was told what to do, he could behave with the finesse and accuracy of a surgeon, of someone cutting up a live body, you know? You understand?

MB: A live body . . . cutting up?

JR: A surgeon.

JC: You know, a surgeon . . . who can cut up a live body and take out the heart and all that. That he could do that. He could do that kind of thing successfully, if you told him what it was you wanted him to do. *(laughs)* But if you tell him something that he can't understand, like something too fine . . . in fact, it was his situation of "knowing" that led me to discover this way of *keeping him* from knowing. *(laughs)*

MB: But the notation of Morton Feldman, for example—it leaves you freedom too.

JC: Yes. It's probably better. How many . . . what point do you get to with that? In terms of five or seven [intervals between whole notes].

MB: I'm searching, but I cannot tell you.

JC: Well, we could do it right here, couldn't we? *(pulls out paper and writes)* We have a note, and we have say the sharp, and we have the double sharp, and then the next step could be C♯, and we'll flat it—a flat sharp? *(laughs)*

MB: Yes, you can write, let me think, Feldman would write D, D♭, and then he will flatten it, perhaps.

JC: D♭, and then he will make a double flat. So he would make . . . four steps between C and D.

MB: But we don't know which is lower or which is higher.

JC: Well, let's assume that—well, we could become *certain* in this case. We could try!

MB: We can try different, different—

JC: Different meanings of C♯.

MB: Yes, that means different . . . intonation systems. That's what I tried first, and this was the idea of Zukofsky.

JC: He did that too?

MB: Yes, he told me about that. You have different systems, but you don't know if Feldman had a system in mind or not. You don't know that. I think not, perhaps not.

9. Bach reports that conversations about Feldman's notation in *Untitled Composition* occurred in 1989 and 1991 in Paul Zukofsky's apartment.

JC: But whether he had it in mind or not, he had it in his feeling—to bring about differences between double sharp and double flat, surely!

MB: Yes. But for me it was clear that double flat D is not a C.

JC: No, it's not that.

MB: So, the question did arise, what is it, what else is it?

JC: Could it be . . . above the double sharp? Could we go, for instance, to sharp, to double sharp, to double flat, to flat? I'm sure you could. At that point, I'm sure! *(laughter)*

MB: I cannot remember any intonation which allows you this. Because in the Pythagorean system this would be lower than this, and in the mean tone it would be higher, but this way it looks like this goes higher, because this D, of course, is higher than C.

JR: You mean it's an optical illusion?

MB: Optical illusion? Yes . . . yes, that's what I mean.

JC: This looks like it has to do with C. And this looks like it has to do with D.

MB&JR: Yes. Yes.

JC: Therefore it must be higher than this! *(laughter)* This will be easier than what I'm doing now. *(JC writes a sample of his present notation.)*

MB: Your notation looks very technical. It gives the illusion that you can be certain.

JC: It looks that way. But it's awful. You can't.

MB: And the notation of Feldman, I feel it's more poetic. You can—

JC: You can think about it more flexibly.

MB: Yes, yes.

JR: In what way?

JC: *(pointing to Feldman's intervals)* This is closer to convention. This *(pointing to his own)* is quite far away, in a *seemingly* logical way, it's farther away from convention. And I think it carries you to a position which is closer to the traffic. This position *(pointing to Feldman's)* is closer to music. This [Feldman's] is closer to what we know is beautiful. Whereas this [his own] is closer to what we know is ugly. *(laughter)*

JR: *(to MB)* Is that what you meant by "poetic"? Because the word "poetic" at a point of the sort when you used it, often does become interchangeable with "beautiful." More poetic means—?

MB: I meant it leaves room for your imagination, this [Feldman's] notation. Because you cannot interpret this in a scientistic way. It's not a science.

JC: You're not sure here [his own notation] which is higher and which is lower.

JR: Yes.

JC: This might even be higher than this. If we agreed, though, that it wasn't—if we agreed, in a note, what the relation of these things were, just as we can agree here [Feldman's notation], then each one would be just as dull as the other. The

only difference would be that this [Cage's] is more degrees, and this [Feldman's] is fewer.

MB: I'm not sure about that too. Because I'm not sure if the double D♭ always is the same pitch.

JC: No, say we told what it was.

MB: Oh! O.K.

JC: So we went to what numbers. And we could specify what it was. If we could specify this, we could specify this [indicating the two notations, his and Feldman's]. And what we would be specifying in that case would be larger distances here [Feldman's] and smaller distances here [Cage's]. That's just logical. And these [Cage's] would be so small that we wouldn't be sure whether or not we were reaching them. So we would be accepting the fact that our action was *either* right or wrong. *(laughs)*

JR: Michael, are you saying that the combination of what *looks* like mathematical, scientific precision in John's notation, along with a totally elusive goal on some level, boggles you, or that it stops you in some way?

MB: Um-hum . . .

JC: Yes, and what I'm saying is—well, this [Feldman's], which seems to him more friendly—

JR: Yes.

JC: —*Could* become unfriendly, and *should* become unfriendly, hmm? So that two cellists who are reading it would read the same thing rather than different things, hmm? ideally. I mean the ideal of notation *has* been to enable two people to play on different occasions the same piece and get more or less the same results. *I'm* moving in a quite different area now. Not only with regard to pitch, but with regard to time. I'm moving to a point where there is no point, where you don't know what the point is. Of course, with the production of harmonics, you have to know. Otherwise it doesn't *speak*. It only speaks when you know, as Michael knows through practice, where those notes are, and which ones to use.

MB: This is also a challenge—to get these partials. That was my question to you, what challenge do people have who are playing this chord? *(pointing to JC's notation)* And that refers to your last question too, Joan.

JC: I'm using the word challenge, quoting a clarinetist who, looking at this, said, That would be very challenging. He meant, I think, that he *could* do it, but only with difficulty. His name is [David] Krakauer. He's quite an astonishing musician.[10]

MB: Krakauer?

JC: Yes. He's a very fine clarinetist. You know my piece, I don't know if you

10. Krakauer is on the faculty of the Manhattan School of Music. In addition to playing classical and new music, he also plays with a klezmer band called Klezmatics.

know it, often played on the clarinet. It's three pieces, and the middle one goes up to a high note and comes down to a low note.[11] It goes through, so to speak, from one extreme of the clarinet to the other. So, almost everyone who plays it, plays it beginning pianissimo . . . and going forte, fortissimo . . . and coming down to pianissimo. Krakauer played it maintaining a pianissimo through the whole piece. It was one of the most beautiful experiences I've ever had to hear. And he explained to me that the only way you can get the wind instruments to play beautifully is to ask them not to make full sounds. If they make full tones they play loudly. But if they deviate from full tones they enter into a world where they have complete control of the dynamics. Normally they don't. The oboe, for instance, almost always plays at the same amplitude level. The flute is terribly loud. The only instrument of all the woodwinds and brass that is tolerable is— well I won't say that completely—but the most tolerable is the clarinet, wouldn't you agree? It's the closest to the string instruments . . . in its flexibility.

MB: It's very flexible, yes. I know, for instance, the sounds in Helmut Lachenmann's music are always between white noise and silence, very soft pitches. The clarinet should be able to do that too. It's the perfect instrument for that.

JC: Yes.

MB: And it goes along very well with the cello too.

JC: Are you talking then in terms of overtone structure? Of the sound—change of color?

MB: Yes.

JC: Change of color in Lachenmann—it's not pitch, or time, but color?

MB: I'm not sure if I understand your question, but the white noise, for instance, is—

JC: Is *all* sound.

MB: It's like a scale.

JC: Complex.

MB: Yes, complex, but also, he has a scale of white noise—you can say a certain pitch, perhaps, of white noise—so he . . .

JC: He divides . . .

MB: He divides the white noise in different sections, like a microtonal scale.

JC: Yes. But not a change of pitch.

MB: Well, on the cello—yes, you are fingering a pitch. But you don't play the pitch. You only play—

JC: —The overtone structure.

MB: Not that. You only play—it sounds like *(air whistles)*—it's not a real pitch, but you have a scale.

JC: What of?

11. Cage is referring to *Sonata for Clarinet* [1933], which is in three short movements with no dynamic markings. See his remarks on Krakauer's performance in the conversation of July 15, 1992.

MB: Well, it's a complexity of sounds . . . of pitches. But it's not defined. If you hear it you don't say, this is a pitch. You hear white noise, but it's darker or—

JC: Well, when you say white noise, if you're using white noise as it's generally understood, it's understood as opposite the sine wave. Sine wave is a simple sound, and white noise is a complicated sound. In fact, it's called a "noise."

MB: Oh, O.K., let's say noise. I mean something like that here. *(pointing to floor fans)* This is noise. So he has a scale of noises. Higher ones and lower ones.

JC: You mean more noisy or less noisy?

MB: *That* is a question of . . . loudness, of amplitude.

JC: Then it's not a scale of noise, if it's a question of amplitude.

MB: No, it's not a question of the amplitude. It's a question of the . . .

JC: Of the noise. And if the noise is not amplitude, and not pitch, it must be overtone structure.

MB: You're right. Yes. You are. But you . . . try to avoid to give a certain pitch, to hear a certain pitch, to play a certain pitch.

JC: In order that it *is* a noise.

MB: Yes. But . . . I don't know . . . these two fans perhaps sound different, but you don't hear a certain pitch. So you hear . . . differences.

JC: No, I agree. I agree. And I think that's very interesting. And it is characteristic—to come back to it—of traffic. How does he [Lachenmann] notate *that*?

MB: Lachenmann's notation is conventional. He has a treble clef, a bass clef, and he notates the fingering.

JC: That would be for the cello.

MB: For the cello, and also for the clarinet.

JC: But the fingering is different, isn't it?

MB: Yes. For the clarinet he notates the pitches, and for the cello part too. That's what I mean. He notates the pitches. But the head of the note is a rhomb.

JC: A space. *(laughs)*

MB: Not a harmonic; it's something else.

JC: Open?

MB: Yes. Well, it looks like a harmonic, but it isn't *(drawing it on JR's yellow pad; Figure 16)*.

JC: A diamond.

MB: A diamond, yes. You make a glissando to the higher one. But you don't hear a harmonic, or you don't hear pitch. I could play a harmonic here, and I could play a harmonic here, that sounds like what we know. But, if he doesn't want to have that, it sounds like *(air whistles)*, rather than *(whistles with tone)*.

JC: It's not vocalized.

JR: How do you do that on the cello?

JC: It's not "spoken." They often say in string playing that something "speaks," the harmonic "speaks," or doesn't "speak." So you want an unspoken harmonics.

MB: Yes, "unspoken"—that's good. *(to JR)* I play it—well, there are different

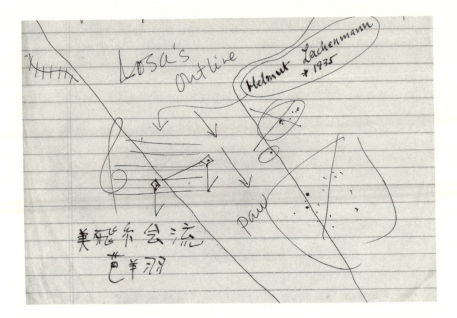

Figure 16. Working notes on which Losa had been lying.

ways to play that. If I play with many fingers and the highest one gives the pitch, I can stop the string with the other fingers. If I only play with one finger I get harmonics, because the string can vibrate behind the finger. If I stop the vibration of the string, I only get the noise. But it has a certain—I don't know how to say it—"pitch." A certain height, right?

JC: It's a different noise than another noise.

JR: So how do these differ? (*pointing to the two notations, Feldman's and Lachenmann's*)

JC: This [Feldman's] has to do with pitch and this [Lachenmann's] has to do with overtone structure.

JR: But that is pitch that's trying to blur interval.

JC: Yes, blur pitch.

JR: Blur pitch. And—

JC: But I think that what Michael is talking about is not blurring, but *knowing*—in a poetic or friendly way, as he says. To know these different possibilities of having a gradation of noises, a gradation of pitches. Noises in the case of Lachenmann, and pitches in the case of Feldman. I think where we're in agreement . . . certainly, we're equally fascinated by more possibilities than are conventionally employed, hmm?

MB: I think you always have noise and pitches together, as an instrumentalist—

MUSIC

JC: A performer.

MB: Yes. You always have both components together, and the question is how much of each you hear. In the case of Morton Feldman, I decided—to come back to this notation—I decided to use—because these are all harmonics mostly in the score, *Untitled Composition for Cello and Piano* [1981], I decided to use this microtonal scale on all four strings. Let me give you an example. If you have an A harmonic, and if you have a double flat B, and you have a double sharp G— if you play in a tempered scale, all pitches are A, but these are three different pitches. And now I can play the A, for example, as the fourth harmonic, the fourth partial tone of the A string. It's a very clear sound. And the same pitch, the same frequency, I can get on the D string as the sixth partial, but it sounds more noisy, and it has another color. And I can get the same pitch as the ninth partial on the G string and it has even more noise. So I have the same pitch, but I have different—

JC: —Colors.

MB: Different qualities, colors of that pitch.

JC: Yes, but what we were talking about with Lachenmann was not that.

MB: No.

JC: But was this *(pointing to notation)*. So we're talking about more things. I think that those differences of color, by changing from string to string, are fewer. You could for instance *know* what they were, and be quite sure of it; and you could decide which one you wanted. You could specify clearly. Here [in Feldman's notation] it begins to be unclear, but poetically so. And here [Cage's notation] it gets unclear, *actually*. Without helping you, hmm?

JR: In a way it [Cage's realization of noise] suggests a non-Euclidean geometry. If you think of line in Euclidean geometry, which is always defined by discrete points, any divisions lie between points you can identify. If you try to imagine an interval without the points—

JC: No, a line is incapable of being divided into *any* number of points.

JR: Euclidean geometry suggests there could be an infinity of points—

JC: Well, the turtle and the—comes to mind. *(laughs)* I mean, there's some point where there wouldn't be any space left, hmm?

JR: Well, no! Because in Euclidean geometries you could, in principle, always divide any space that you have, again . . .

JC: Yes, but it's not true in terms of performance.

JR: That's true. But I think the image of performance in the Feldman score and in this [Lachenmann] is one where you still feel you have the divisions that you can locate—

JC: Yes.

MB: Umm hmm.

JR: Whereas here—

JC: You don't, or you can't.

JR: —You don't.[12]

MB: Yes, I hope that performers will get to that point . . . *(JR laughs)*

JC: Right. Some will refuse to do it.

MB: They won't try.

JC: Feeling that they don't want to do that. That was the case with the group in Karlsruhe [Ensemble 13].[13]

MB: Reichert?

JC: Reichert [Manfred Reichert]. Yes. They asked me not to do that. Not to write such music. So I did something else for them. In other words I wrote chromatically. So that they're on the pitches that they're familiar with. But I wrote *as though* I were writing microtonally.

MB: Pardon?

JC: I wrote chromatically, *as though* I were writing microtonally. You see, when you write microtonally, a very small range becomes enormous, because you've made the spaces smaller. So, I wrote for a sixth—for example, from C to A in the treble and the bass. I wrote as though it were . . . what is it? . . . *seventy* pitches instead of—

MB: Seventy, you say, or seventeen?

JC: I wrote for a sixth as though it were all that that instrument could do. As though it was its whole range. But it's just a part of its range. So that's what I mean by writing for it microtonally even though I'm not—I'm writing chromatically. I don't know what that will sound like, but it makes a different kind of music than I'm used to writing. With rather idiotic melodies, for instance, being written, but being written on top of one another. And I think the result would *tend* toward microtonality. Even on the performers' parts. I think they'll begin to—instead of trying to be together—I think they'll try to be not together, intonation-wise.

MB: Yes . . . you think they are not trying to be together?

JC: No, ordinarily they try to have good intonation. But I think they may be led by this music to have bad intonation. At any rate, bad intonation would sound better than good intonation.

JR: *(to MB)* This isn't a fair question, but if you were to try to work with a score like that, what do you think you would do?

MB: How?

JR: If you were to try to work with a score, like that, of John's, how would you begin—?

JC: He would have to try it first, and then he would know what his feelings

12. I had in mind (and later discussed with JC) an alternative: a kind of fractal geometry of noise—i.e., of the sonic "surface"—where an infinite number of sonic points might be both actual and precisely unlocatable.

13. Cage is referring to the composing of *Thirteen*, 1992. See conversation of July 15.

were. You see in *Ryoanji* another thing occurs which is that everything is step-wise. So that even though you would do this [microtonal notation] even more than that, I mean more divisions, you would be doing them in glissando, so that they would sound perfectly reasonable. But that's just because the easiest thing in microtonality is to follow the steps, to slide.

MB: Yes, if you have to jump—

JC: If you have to jump, it's hard in fact, it's difficult. But sliding is not difficult at all, and particularly on the strings—which are made almost for sliding.

MB: *(to JR)* Well, I don't know what I would do with that notation. I cannot tell you now. I think I would try to realize it. *(laughs)*

JC: He'd try to do it. That would be the tendency. But then what might arise is what the clarinetist said. He said, That would be challenging.

MB: It's even more complicated if you play together with other instruments, I think.

JC: You could have more arguments. *(laughter)* "You were higher than you should be!" *(laughter)*

JR: I think Michael has the question, if it is impossible in some sense to do, then what is the challenge? *(to MB)* Is that your question? Where do you find the challenge in the impossible?

MB: Well, I would not say "impossible." What I said at the beginning was for me a reasonable step, which I can clearly—

JC: —Know.

MB: —Know, is a fifth of a half-tone step.

JC: Yes.

MB: Of course it can go—

JC: —Farther.

MB: —More far, yes.

JC: But your certainty diminishes. You're not sure.

MB: Perhaps I would try to divide the half-tone step in . . . into quarter-tones, and then the other signs I would—

JC: *(laughs)*—Put them in between.

MB: —In between. But I'm sure about the quarter-tone steps. So it's more . . . inflected quarter-tone playing, or something like that.

JC: String playing is quite amazing . . . when there are no frets, then you are really putting your finger . . . where there is no indication, no *visual* indication of where to put it. So the string player becomes used to being *right* in a situation where there are no *signs*. It's quite amazing. And in the cello case, the lake is bigger.

MB: Yes, I think the string players are too proud of that. For example, I think about half-tone divisions on the fingerboard. For years I've had one little white point on the fingerboard—perhaps you saw it—it's the E on the A string. This is the third part, the third harmonic. It helps me a lot. I save a lot of time *(laughs)* practicing because I have this point—only one. That helps a lot. You could, of

course, have more points on the fingerboard, and perhaps it would help. If you had too much perhaps it would confuse again. *(laughs)* So you must find a balance. But in your mind you have this scale on the fingerboard. I have a scale . . . more than this, I have a scale of harmonics, because they're very clear locations. There are many techniques to find a pitch on a string instrument. I once saw a book about the ch'in, you know the Chinese ch'in?[14]

JC: Beautiful instrument.

MB: Yes, and there are books on how to find a pitch on the ch'in, and there are little poems and drawings . . . I once saw such a book. I was very impressed by it.

JC: *(to JR)* Do you know it, the ch'in?

JR: I'm not sure whether I do or not.

JC: The strings are of silk. The loudness is minuscule. You can scarcely hear it. You have to be as close to the ch'in as we are to one another to hear it.

JR: Ah, lovely.

MB: It has no resonance—

JC: No, none at all.

MB: —No corpus. It's only a piece of wood. But it's very noisy too. So they do noises on the strings, along the string. . . . It's a very interesting—

JC: —Instrument, yes. It could be said to be the most beautiful.

JR: Have you ever used it?

JC: No. Classically, the music is played for the performer. He plays it for himself.

MB: Yes, to concentrate.

JC: Yes. So the question of an audience is thrown out. Because he's in the right place to hear it. *(laughter)*

MB: It must be a good feeling.

(Pause.)

JR: *(to MB)* Do you want to talk about *One*[8]? I'm curious how you came to it. What you were doing with music before you came to John's music. And then the specifics of how your work on it developed.

JC: Wasn't the first question the question of the bow?

MB: No, I didn't have the [curved] bow at that time, when I first spoke to you—I think it was in '89 that I played here, and shortly before I had played in Stuttgart, where Mr. Jahn[15] had told me he would like to have me play with the orchestra. Then I came here and we met, and I think it was at Peters[16] that I asked Don Gillespie[17] if there's a second cello part for *Music for* [1985], and he said, Let's ask John, and you said, No, there's no second part. You mentioned perhaps you

14. The ch'in is a fretless zither with seven silk strings, played horizontally without a plectrum. *The New International Dictionary of Music*, ed. Philip D. Morehead (New York: Meridian, 1992), p. 82.

15. Hans Peter Jahn of Süddeutscher Rundfunk [South German Radio].

16. C. F. Peters Music Publishers, publisher of all of Cage's music.

17. Vice president of C. F. Peters. Gillespie worked closely with Cage and his music publications from 1970 until Cage's death in 1992.

could write a second part but you would need time. And then I combined these things. I thought, if you would like to do something, and Mr. Jahn would like to perform something, we can do something together. The question that for me was first very interesting was, what would we do with the cello and orchestra together. That was something which was a social question too for me somehow. Because I was aware that you wouldn't write a cello concerto *(laughs)* in the traditional way. And then, after that [autumn 1989], I developed the curved bow.

JR: And what did you mean when you said this involved a "social question" for you?

MB: Well, there are many people and there is the soloist.

JC: If you write a concerto.

JR: Yes. And what was your question about that?

MB: I was curious how John would solve this question, or problem. I mean, it is a problem, I think.

JC: And with my solution it remains a problem. *(laughs)*

JR: What is the problem?

MB: *(to JC)* But it makes the problem clear.

JC: Yes.

JR: But, what is the problem, Michael, as you see it—as a performer?

MB: As a soloist you mostly have a hard time with the orchestra, because they all want to be a soloist in the orchestra. So they are in a situation where they feel they are . . . *Konkurrenz*—

JC: In competition.

MB: —In competition with the soloist, and also with the conductor. But John eliminated the conductor. And that was what happened, I think, in Stuttgart, because they played too loud. So I thought I had no chance to make myself audible. It was too loud.

JC: Well, I wrote in such a way that the orchestra *was* too loud. Normally, in such situations, one would use amplification, as we did last night [at MOMA Summergarden performance of *One⁸*]. Last night we used amplification because the orchestra was the ambient sound, and was in a sense necessary whether we liked it or not. Actually it sounded beautiful last night. Last night the amplification was acceptable, I think, because it brought the cello into relation with the traffic, hmm? There were harmonic-*like* sounds, related to the harmonics in the music, very curious.

MB: Sometimes the same pitch.

JC: Almost.

JR: Yes!

JC: Or, at least—or, you could say, the same overtone structure, hmm?

JR: And at one point, some feedback—

JC: Well, our sound engineer is rather poor.

JR: But that particular bit of feedback was—

JC: He produced feedback that sounded very good! *(laughter)*

JR: Yes. And there was a bird. *(to MB)* Were you aware of the bird?

MB: Yes, yes! *(to JC)* You started to say something about Stuttgart?

JC: Well, I was sitting in a good situation, so I could hear . . . I could enjoy what I heard. And I think many people did.

MB: Yes . . . I hope.

JC: I think, for *me* what was disturbing in Stuttgart was the inevitable disagreement—poetically and psychologically and every way—between the orchestra and the composer. Primarily, if I may say so, between the orchestra and the composer. Due to the professional status of the orchestra, and the fact that they are being paid to do what they do, they figure that they do it better if they don't give it any thought—that they can play badly if they wish. It's almost like that. In the school, in the university, the orchestra is used to being criticized, hmm? And used to being educated, hmm? So that they were able to play softer, seeing that if they didn't the cello would not be heard as well. So they played much better.[18] But I don't think the professional orchestras will do that. In fact, I think the better the orchestra is, the worse they will play.

MB: This piece.

JC: This kind of thing, yes. And the sum result of this is that my work is simply not played . . . by orchestras. Now, of course, time is changing due to my old age, and they *may* begin to play well. And I think if they do, without a conductor, that we will have made a step forward.

MB: I remember one answer you gave to the orchestra.[19] They asked you some questions, or the conductor asked you to answer questions, and you said, If I tell them the right thing, they will get an idea of the worse—

JC: Of the wrong.

MB: —Of the wrong thing. But in Evanston you did give more advice to the orchestra. Perhaps because it was possible to give advice.

JC: To students.

MB: Yes. Because you felt that they would enjoy to—

JC: —To get better. I think so. Whereas you feel that the professional orchestra doesn't want to get better. They feel they *are* better. This problem still exists for me. And I don't know what the solution is. I'm beginning to think that I can say to an orchestra that there are two ways of playing this kind of music. One is to enjoy it, and the other is to *not* enjoy it. And if you enjoyed it, you would enjoy this, this, this, and this. And if you didn't enjoy it, you would be annoyed by this, this, this, and this. But if you're professional and are annoyed, you can

18. Cage is referring to a concert by the Northwestern University Symphony Orchestra, March 6, 1992.

19. At rehearsal for the Radio Symphony Orchestra of Stuttgart premiere of *One⁸* and *108*, November 30, 1991, Stuttgart, Germany.

do better by doing such and such. I would have to figure out the problem, and see if I can find something to say that would let people know that [even if] they didn't like it, they nevertheless could play it better by doing such and such. I don't know. *(pause)* It's the problem of the *police* in an anarchic society, and in a music that wishes to be anarchic. But you can't say that to a hundred people and expect them to react in a favorable way.

JR: You can be professional with what you already know. You have to be a student with what you don't know, with what is new — if you are going to enjoy it. Is there any way to invite them [the professional orchestra] into being a student *with* you? You're always a student.

JC: No, they won't do that. I don't think they'll do it. I don't think so.

JR: No? I mean along with you *as* a student. I notice you always wanting to learn, always feeling that in some sense you don't know . . .

JC: Well, I'm in a very funny situation too. An example of the strange situation I'm in is the program that we gave last night, will give again tonight. There couldn't be greater difference between the two performers than there is between Michael Bach and Michael Torre, the pianist. He [Torre] has been taught in the Juilliard School that the purpose of music is to express the emotions, hmm?[20] Those emotions are not only expressed by the music, but must also be expressed by the pianist, hmm? And they are expressed with the most curious, unnecessary use of the body. And if he doesn't do that he's not being a good musician, from the Juilliard point of view. I saw one [Juilliard student] last year playing Satie. Unbelievable! He looked like Dracula. *(laughter)* The piano was in danger! *(laughter)* That whole difference between you and Michael Torre became clear last night, and will be clear again tonight. My position, with regard to Michael Torre, is to listen, if I can, to what it is he's doing. To listen to the *sound* of it; not to look at the expressivity of it, hmm? And to see what it is he gives us to *hear*. Is it tolerable? Or isn't it? And why.

MB: Because . . . he plays for the public and he should not, uh —

JC: Oh yes! And he's not yet comfortable with the public. He considers it very important to do what he's doing.

MB: Perhaps this is also the same attitude the orchestra has.

JC: Exactly! The more professional you get, the more concerned you are of doing *right*!

MB: And to express yourself.

JC: Because, as you said, you're in competition with others — who could take your place! *(laughs)*

MB: It leads me to the idea that if you have three — the soloist, the orchestra, and

20. In what follows, "Michael Torre" becomes synonymous for Cage with "Juilliard student." He was highly critical of the Juilliard approach to music education, not of Michael Torre as an individual.

the audience, and if the orchestra plays too loud and makes it impossible to hear the soloist, the audience is not happy with that, I think. Perhaps, some of them would like to hear both. *(laughter)* So, I thought if this—

JC: —If it's too bad—

MB: —If this is not a satisfying situation, we can invite the orchestra to be in the public and have the public play with the soloist.[21]

JC: There was a thing like that. There was an exhibition of modern art in Portland, Oregon, in the museum. They had on one side of the room—like over there—watercolors by modern artists, and in the middle of the room they had brushes and watercolors, and this wall *(gesturing)* was empty. So, the public who didn't think these were good watercolors *(laughter)* could make some watercolors of their own and pin them up. It then became perfectly clear to the public that they *couldn't* do as well as the artists. . . . And it would be clear here too, unfortunately, it would be clear that the audience would not be able to play the orchestra part as well as the orchestra did. That's the trouble.

MB: That's what I thought later. If we give the public the chance, they will be—

JC: They won't play well.

MB: It will be a big risk.

JC: Yes. I'm now struggling with this, but the struggle—and I will try to make another step—but it is a problem and I don't know what the solution is. It leads me to think that students are better than professionals . . . for my kind of music. When I want not to have a conductor, and when I want every performer to feel at his or her own center . . . and to listen to what they are doing . . . and to do it with interest . . . in the sound . . .

JR: And yet Michael Torre is a student . . .

JC: *(pause)* He asked me over and over again, How should I play? Last night when I spoke to him he said, I have tomorrow to improve if you want. But I can't say, Give up your education . . . and in one day learn to play in another way. You can't do that. I couldn't possibly say to him, You don't need to make these expressive gestures. He wouldn't know how to play! He wouldn't know how loudly to play. By these curious means he arrives at his dynamics! *(laughs)* It's not easy, it's not easy! *(laughs)*

JR: But John, if he played *ASLSP* "aslsp"—

JC: Uh huh.

JR: —*Truly* as slowly and as softly as possible—he could not do that, could he? He would go into spasm.

JC: Yes, I know. But what he was doing, besides all of this, what he was doing was making the piece into an expressive continuity. And it wasn't an expression

21. Michael Bach had the idea, which he told Cage about in Perugia in June 1992, that the audience, taking the place of the orchestra, could perform *108* simultaneously with *One⁸*.

that came from the sounds, it was an expression that came from his *reaction* to the notation, hmm? Sound never entered into it.

MB: Or, not even that, I would say, it's trying to make sense of it as with the old music, perhaps, or the education he has to—

JC: Oh yes, he tried to convert this into an old piece. And he did it quite well! Don't you think? I mean it sounded very . . . very *musical*, hmm?

MB: Yes! So, can it sound differently? I'm sure.

JR: Yes.

JC: Yes, different pianists could play that differently, and I made all sorts of such possibilities when I composed it. Because I was asked to write a piece that would be used as *the* piece that pianists would have to play in order to win prizes. It was a competition piece. So, I left it very free, so that the pianist—[22]

(End of tape.)

JR: And yet it's clear that it's not at all that "anything goes." You have a sense of how the piece should be played. Would you ever discuss this with the performer?

JC: Yes. *Outside* the requirements of performance, hmm? Then I could talk to him and say what I think. What I think may not be good, but I could at least converse with him about the performance of music. But I don't intend to when he's *doing* it.

MB: Perhaps if he sees a video of himself or he gets more experience he will find another way.

JC: Perhaps. I think more instructive to him will be the way you behave.

MB: If he sees that.

JC: If he sees your performance. I think he was impressed, and I think he may imagine that there is something of the way you do it that would be good to put into the way he did it. I think this experience will give him some instruction . . . which might alter his ways.

JR: *(to MB)* To bring the conversation back to your beginning to work on *One⁸*— which I interrupted with, What was the problem with the orchestra, as you saw it?—You said you were curious to see how John would handle the concerto because of the social problems. But then it didn't work out that it was going to be cello and orchestra. So what happened next?

JC: Oh it *was* cello and orchestra.

22. *ASLSP* was commissioned for the University of Maryland Piano Festival and Competition (now known as the William Kapell competition). In 1984 the pianist Tom Moore, who was coordinating the competition, asked Cage if he would write a piece of five to ten minutes in duration for the 1985 semi-final "compulsory" round. The title is an abbreviation of "as slow and as soft as possible" and also refers to "Soft morning, city! Lsp!"—the first exclamations in the last paragraph of *Finnegans Wake*. The piece consists of eight sections, any one of which is to be omitted and any one of which is to be repeated. The sections are to be played in order, with the exception of the repeated section, which may be placed anywhere within the performance. Tom Moore says, "This way, John told me, . . . the competition jury wouldn't have to listen to the same piece over and over."

MB: It was?

JC: It was cello and orchestra.

JR: On the way to *One*[8], what happened next? You had first—

MB: Well, I developed the curved bow. And yet there was one question. Oh, you already mentioned it: what can I finger on the cello? That was in Darmstadt, and at that time I showed you [Cage] the curved bow too.

JC: Yes, and even though you sent me the texts, and the prints, I still needed more help. Until I finally got Michael to come and sit here with me, so that I could ask questions, get answers, and demonstrations.

MB: Yes, and at that time I improved the harmonic technique here too, so I asked you if we could include harmonics *over* the 16th partial.

JC: Yes. And we did.

MB: And we did do that, and we worked out new questions too.

JC: The notation changed too in the course. Because they were notations, as Michael has said, that are not conventional, so that it's doubtful whether a cellist looking at this piece would even know what to do.

MB: *(laughing)* But it's very clear notation!

JC: Yes, it's as clear as it could be.

MB: It shows you where to put your fingers, and it gives you always the resultant. The resultant always is shown. So it's very clear.

JC: It's very clear.

MB: And we separated—we didn't write underneath—we separated the pitches, so we can read clearly—

JC: One thing that is not clear is perhaps my fault, and that is that these are to be aggregates, rather than arpeggios. So that Paul Zukofsky was able to program this, and give it to someone who couldn't do it. *(pause)* So, I told him that you had to do it.

MB: But, didn't you write something about a curved bow . . . in the foreword . . . of the piece . . . you didn't?

JC: I think so, but I don't think he took it seriously. He finally said that it was his fault, he hadn't studied the piece sufficiently.

MB: *(reading)* It says "with single sounds produced on one, two, three, or four strings." So that means—

JC: It's very clear!

MB: —Together.

JC: Yes.

MB: For me it was funny to see. I got a corrected copy from the printer. There were some mistakes from the copyist, and the mistakes were all—he did a good job—but the mistakes—I think three or four—were always when it was a new technique to produce the pitches which are written here. He didn't understand what we, or I, mean with that notation, so he made a mistake. He wrote a wrong notation always in that case, when it's a new development—

JC: Of notation.

MB: —Of notation, and playing the cello. ·

JR: There's some kind of intellectual entropy in confronting the new. A tendency to decrease the energy—to interpret the new as the old.

JC: Well, a good copyist corrects the composer's mistakes. *(laughter)*

MB: That's what happened.

JR: So, after working together with what was possible for the technology of the bow and the cello, how did you make decisions about duration, dynamics . . . ?

JC: Those are the time brackets.

JR: For duration. And dynamics?

MB: No fixed dynamics or bow positions. We left it open, because each sound has its own characteristic.

JC: Yes.

MB: And some sounds are better loud, and some are very soft. Also that's another difficulty if you play on three or four strings. You have low pitches, and you have sometimes very high pitches, but you only have one bow position. So you have to find a solution for that. Sometimes it's something in between both extremes. Sometimes you can only choose the bow position for the highest pitch because there is no space between the bridge and the finger, so you choose the highest position, and then the lower pitches sound more ponticello-like because it's too near the bridge for them. It's not the right bow position for the low pitches. They get a different color.

JC: Yes.

MB: So we left this open for that reason. At that time we didn't know either how it would sound, because I could show the fingerings, but I couldn't play the chords at that time. I could finger it, but to play it, I had to study and to practice that and to perhaps develop some other muscles I had never used. It was for me a new technique too. So we didn't, really didn't know how it would sound. We only knew that it will be possible.

JR: Yes . . .

MB: Yet that was important. At the beginning I showed John some very high harmonics, I remember, or pitches. At first we limited it a little bit. But then, after a few days, he saw that I could control the pitches, so we used more extreme harmonics, and pitches too. So, *One*8 is getting more and more difficult too, to play.

(JC goes to kitchen, returns with a large grocery bag.)

JC: I have some fresh corn. Do you like that?

MB: Yes.

JR: Ah!

(JC shucks corn as conversation continues.)

MB: What do you think if we invite the public to play? Usually they come to a concert in order to hear something.

JC: Yes.

MB: If they are able to play something too . . . do you think they don't want to hear?

JC: I wouldn't want to do that.

MB: Hmm?

JC: I wouldn't want to. Even when I went to church I wouldn't sing. You know, when everyone was asked to sing. I had been told by my teachers that I didn't have any voice. So, I couldn't sing. *(laughter)*

MB: So you were free of singing.

JC: The only thing I could do, eventually—and I decided to devote my life to music—the only thing I thought I could do was make a noise. *(laughter)* So I thought of myself as a percussionist. But I couldn't roll either. You know, I couldn't do—

MB: Oh, *tttttrrrrrrrrrtttt!*

JC: I couldn't do that either.

MB: Oh, you played percussion!

JC: Yes. So I could play percussion, and I could play interesting rhythmic patterns, but I couldn't roll. At no point have I become a virtuoso! *(laughs)*

MB: A virtue?

JC: A virtuoso! *(hearty laugh)* That means to say a really good performer. I'm not.

MB: Oh, you think? Well, I was very impressed *(JC laughs)* by your last performance in Perugia. I told you, it's like . . . I felt like in a cathedral. *(JC laughs)* You did sing. And I'm wondering what the score looks like. It shows only numbers? Or also pitches?

JC: It's just numbers.

MB: And the pitches you sang—?

JC: Nothing, no.

JR: What is this score? How did you write it?

JC: It's a new piece, called *One¹²* [1992], which I made for myself to perform. And basically it's improvisation. I've always been opposed to improvisation because you do only what you remember. So I gave myself a problem in improvisation which was not easy to do. It was to vocalize the letters of the alphabet, but every now and then when I came to the number 12 or the number 1, I had to not vocalize but speak a word. If it was a 12 it was a full word, and if it was a 1 it was an empty word. I had to—instead of reading such words, or preparing such a list—I had only the numbers. So I was obliged to, by myself, to *think* in the performance situation of a full word, of an empty word, and to vocalize. If I came to the number 7, I had to choose seven letters, vowels or consonants, and give them pitches, which I have no ability really to do. I just have to . . . *(pause)*

JR: —Improvise? *(laughs)*

JC: —Do what I can. The other was improvised thinking too. And I had to practice and practice until I wouldn't be *afraid*, you know, to perform, in a situation

where there would be people who know my work very well. I didn't want to do badly for them.

MB: And this work can last longer than half an hour?

JC: Yes. It could.

MB: So, did you make a part of it and stop somewhere?

JC: I decided that thirty minutes was enough. *(laughs)*

JR: What led you to want to work with improvisation?

JC: Well, I found myself, perhaps incorrectly—I may have made a series of mistakes, I don't know. But my first reason for wanting to go to Perugia was that Mayumi Miyata [virtuoso shō player] was coming. Just as I wrote the piece for Michael, with Michael's help, I wrote a piece for shō[23] and percussion with Mayumi's help. And I had never heard it except when she was sitting across the table. She kept writing and saying how much she enjoyed it, could I come to Japan? And I couldn't. I knew she was going to do this in Perugia. So that was one reason for going. The other was that a number of musicologists were going, and it was called my name in Europe—

JR: It was called Cage in Europe.

JC: Yes. I thought they were going to study this problem of my being in Europe, that there would be something like seminars. So I thought, Why not go? I went for those two reasons. There were no seminars. Oh, but before I went, the question arose of Michael's going.

MB: You had told me in Evanston perhaps I should contact Alfonso—

JC: Yes, and finally I did contact this man. His name is—do you know him well?

MB: I stayed for two summers, one week in his farm house near Perugia. He's not a musician. I think he's involved in music because of his wife. She's German and a cellist. They have had a festival there for a few years.[24]

JC: *(pointing to shucked corn; to MB)* Do you think you could eat two? I also have some bread.

MB: I'll eat one, I think.

JC: You can have two, if you want. I have enough.

MB: I don't know, John.

JC: You don't? Well then we'll have two so that you can continue . . .

MB: Good. Or somebody else . . . Joan perhaps.

JC: I think Joan will want one.

JR: You're right. . . . What is the name of this man?

MB: Alfonso Fratteggiani.

JC: Bianchi.

MB: What? Bianchi, oh yes, right.

23. A Japanese mouth organ. Cage is referring to *Two³*, 1991.

24. Alfonso Fratteggiani Bianchi and his wife, cellist Ulrike Brand, are founders and directors of the Quaderni Perugini di Musica Contemporanea in Piere Caina outside Perugia. This is where MB was staying.

JC: He says he's Bianchi in Germany and Fratteggiani in Italy.

JR: To get back to the improvisation, though, why a piece that . . .

JC: Well, just to continue, I finally reached Bianchi by letter or somehow. He had already made a printing [of the program] which didn't include Michael, and I wanted Michael to come, I think largely because Mayumi was coming too and you know her. In other words, I thought this situation would be nice if it included both of them. So I proposed, after I saw his announcement, where I was to do something—give a lecture—I said, I will make a new lecture for you, if you will have Michael on the same program. He agreed, provided I would let him publish the lecture. Then I had to go to my publisher [C. F. Peters] with whom I have an agreement that *they* publish everything, and I said I've just put my foot in it, I've agreed to let Bianchi publish this, and they said, That's perfectly all right; he can do it with our permission. *(laughter)* So that's the way it was done. Everything happened.

MB: That's interesting. Thank you. I have a beautiful picture from Assisi. Would you like to see it now, or later?

JC: Any time.

MB: *(to JR)* Excuse me, because your question of improvisation is waiting.

JR: Yes, and we must finish the narrative of *One*[8]. *(laughter)*

(Tape recorder turned off while MB shows pictures from Assisi taken during the Perugia festival; we begin to talk, with the recorder still off, about the relation of technical problems presented by the structure of a musical instrument to the development of the performer's thinking about music.)

MB: . . . So in that way you, if you think you cannot play this harmonics, this complicated harmonics, you are working on it and . . . you will perhaps change your thinking too. I mean with the practical problem you are facing, you are changing your view of the thing too.

JR: So, in other words, you would feel, approaching things as you do, you would feel that in order to solve the practical problems, you have to change your thinking, your whole sense of why you play music, why you play the cello.

MB: Yes, of cello playing, for example, or of why you are playing an instrument. It's an extension of yourself, the instrument. It's not an object you are . . . *traktieren?*[25] . . . I don't know the English word. It's an object you can use as an extension of your thinking. So, if you have a technical question . . . that's what interests me very much in playing music, not only to hear music, or to compose music, but also to play it, to realize it, to make hearable what you have on paper. This is a process.

JR: To reveal it as sound.

MB: Yes. This is a process. We've spoken a lot now about how the process for this piece for cello and orchestra was developing, and the questions which were

25. To treat (as an object), with a connotation of thoughtlessness.

involved. Now we are speaking about also the details. This whole thing belongs together. We cannot separate them.

JR: John? *(calling to JC, who has been working in the kitchen since the tape was turned over)*

JC: Yes?

JR: Are you coming back?

JC: *(a bit reluctantly)* Yes.

(Laughter; JC returns to table.)

JR: Michael has just been saying, partly with the recorder turned off, something about the fact that in playing your music he would have to change his thinking and his whole sense of music, why he plays music, why he plays the cello. He said something very wonderful that we'll put in brackets, because I still want you [JC] to answer the question about improvisation. He said . . . well, Michael, why don't you tell him.

MB: Oh, perhaps I won't remember everything, but I said these details we are speaking about now, solving the problems with technical questions, changes also your thinking, how you think about that problem. Let's say, this problem in your notation—

JC: Would make you do something that you hadn't done before.

MB: Yes. First you have a technical problem you have to solve, and you're starting to work on that, and perhaps you overcome this problem in another way. I don't know. If you find out you cannot hear, for example, you have to find a way to play it. You have to change your attitude toward the problem.

JC: Exactly. This is the basis of Zen Buddhism.

(Pause; tape recorder turned off for a few minutes.)

JC: Can we speak of a poor instrument?

JR: Well, we speak of a good instrument.

JC: A poor instrument requires very good playing. *(laughs)*

MB: Yes. But also a rich instrument too. I remember the cello I played before. It's a four-hundred-year-old Maggini cello from Brescia. It's a very, very fantastic instrument, and a very famous cellist played it before me in the sixties. I loved his playing. He was a very interesting cellist. Pierre Fournier was his name—he died recently—and he gave it back to the owner. He said, This cello has a too-rich character; I cannot deal with that; it's too hard for me to play; I want a more simple instrument, to express myself. What interests me in that instrument is exactly that point, that I had to deal with another character too. But now it's no longer possible for me to play this instrument. They want to put it in a museum because it is the only Maggini cello in the world. The value is very high, so they want to sell it to a museum in Brescia. I was lucky to find this new cello [Paolo Vettori, Firenze] and I am very happy that it is still possible in the twentieth century to build a good instrument . . . which is loud enough and flexible. It has not the age. The age changes the instrument too. You cannot build that. But it

has the possibility to get old because it's a good instrument. And now I'm in the situation to build a new curved bow. Yesterday I had an interesting conversation with Andrew Culver. Did he study with Buckminster Fuller?

JC: He studied Buckminster Fuller's work.

MB: When I started to think about a new bow, suddenly this name came up, in my mind—I must find somebody like Buckminster Fuller who has a sense for inventing.

JC: Maybe Andy could do it. Andy has a great gift for making things. Really.

MB: Yes, I thought so too. He understood what the problem is. He drew this picture. *(opens his sketchbook)*

JC: Oh, did he make that?

MB: Yes, he drew this. And he said this should be wire . . . and an octet truss so it will have less weight.

JR: That is a very Fulleresque bow, yes, that internal structure. Interesting.

JC: Try to continue that and see what happens. He may very well do better than others.

JR: John, can we—because you said we were about to be interrupted—can we get back to the question of improvisation. You said you had never been interested in it because you felt it returned you to habit.

JC: Well, very formerly. But lately, for a variety of reasons, I've become interested in improvisation.

JR: Why?

JC: For just that reason. I became interested because I had not been interested. And the reason I had not been interested was because one just goes back to one's habits. But how can we find ways of improvising that *release* us from our habits?

MB: Yes. That's the main question to me, because mostly performers are occupied by their habits. They're repeating what they've already done.

JC: What they already know. Then you might as well not continue. If you already know something, you might as well stop. Other people think that's when they should start—is when they start repeating themselves. *(laughs)* When they *know* how to do something.

(JC goes back to kitchen and brings food to the table.)

MB: What should I do with the microphone?

JC: You can leave it there.

MB: The cat! *(laughs)*

(Losa has been lying on the table next to the microphone all along.)

JR: How do we induce Losa to leave without hurting his feelings.

JC: We take his body and separate it. *(laughter)*

JR: From his feelings? *(laughter)* From the table! *(laughter)*

(JC picks up Losa and sets him on the floor.)

MB: It seems she likes to be separated.

JR: Actually, Losa is a "he," an enormous "he."

(JC begins serving food.)

JR: Michael, what was the experience for you of playing on the verge of rain last night? *(JC laughs)*

MB: I saw Picasso's goat in front of me [in the MOMA sculpture garden] in the rain, and I was reminded of the hike I will do next month in Austria.

JR: Yes, there could be goats in the rain in the mountains in Austria.

MB: And birds . . . but hopefully no traffic. *(laughter)*

JR: The tent you played in was wonderful.

MB: Yes, it was a tent?

JR: It was, and you looked like a priest of transparency, or the weather *(MB laughs)* playing this piece under the billowy translucent plastic. Because it was misting and the top of the plastic was articulated by the breeze, when moisture collected and the breeze moved it, there would come this stray rivulet. It became part of the performance, of course—chance revealing itself in this rivulet "readout." It functioned very much like the Mineko Grimmer sculpture, making the chance operations of nature visible.

MB: Which sculpture do you mean?

JR: It's a sculpture that is . . . how to describe it?

JC: It's a wooden structure with stones encrusted in ice, suspended over a pool of water.

MB: And it's in a sculpture garden?

JC: No, it's a piece of sculpture that could go in any place. It's made by a Japanese sculptor married to an American. Her name is Mineko and her husband's name is Grimmer. Mineko Grimmer. They are friends of János Négyesy, who's a violinist, and she wanted him to play some of my music while her piece was exhibited. When the ice in her sculpture melts, the pebbles fall and strike wires, which sing, and the pebbles fall into the pool of water. And that continues. So he wanted to use this first with the *Freeman Etudes* and I said that's silly. I'll write a piece for you, which I had already written for Paul Zukofsky, which has very, very long, held tones, very long.[26] Over six or seven minutes, for instance. With the dropping of the pebbles throughout that long tone, that was of course beautiful. So they did that. Then she wanted to make another sculpture and wanted me to make another piece to go with János's playing. I hadn't used any harmonics in the first piece, so I used nothing but harmonics in the next one. *(laughs)* And they were very pleased. Now they're making, I think, a movie of the whole thing. *(We stop talking and eat for a while.)*

JR: The tent, I think by accident, served similar purposes—a visual display of chance. What I liked about the tent was that because you were seated in it, you were part of it. With *One*[6] the violinist stands behind the sculpture. And it's very

26. The piece with long tones to which Cage is probably referring is *Two*[4], written for Paul Zukofsky in 1991. It is scored for violin and piano or shō. The piece for János Négyesy is *One*[6], 1991.

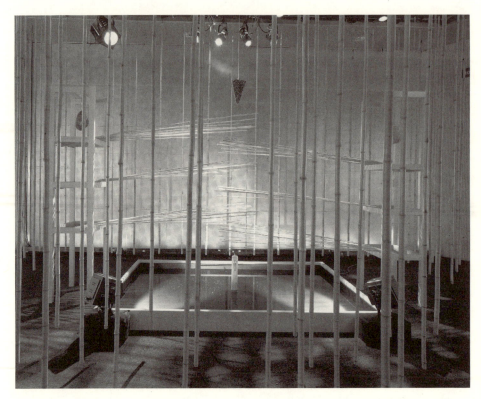

Figure 17. Mineko Grimmer Sound Sculpture in its *One*[10] configuration. Courtesy of the artist.

beautiful, but the performance and the sculpture are not integrated in the same way. I loved it; I thought it was beautiful. But you were *in* the tent.

JC: Beautiful too.

JR: Yes . . . as well.

(Pause.)

JC: Or, if we don't know what the word beauty means . . . as Wittgenstein tells us *(laughter)*, then we don't know what the meaning is of more beautiful. *(more laughter)*

JR: That's true. And even more beautiful we probably know even less. *(laughter)* Well, I think he [Wittgenstein] would say we only know it by family resemblance. We may think one thing is beautiful because it has a family resemblance to something else we once thought beautiful.

JC: *(eating)* There are two pieces of bread here. Do you want—I can get more.

JR: Actually, I have enough.

MB: I have here too, thank you.

JR: *(to JC)* How about things to go on *your* bread.

JC: O.K.

JR: John, there's a little bit of mold on part of the top of that [piece of bread].

JC: Oh. Teeny once said that a little bit of mold wouldn't do her any harm.

JR: *(laughing)* Well, I'm sure that's true, I just like to avoid the places where it's visible.

JC: Where . . . where is it visible? Oh, this one here?

JR: Yes, there's some there and there.

JC: Well isn't that too bad. That means I have to—*(eats the piece with the mold on it)*

JR: You have to eat it. *(JC laughs)* As the host.

MB: Are you eating it?

JC: Uh huh. *(laughs)*

MB: You're eating it.

JR: John is the perfect host *(JC laughs)*; he eats the mold. *(laughter)*

MB: Are they mushrooms?

JC: Very tiny mushrooms.

(More laughter; JC offers MB another piece of corn.)

JC: You can have this one if you've finished that one.

MB: Thank you. Perhaps I will.

JC: This will have a different taste, as you can see.

MB: More yellowish?

JC: *(pointing to the other, paler ear of corn)* Its relation to that is not even chromatic, it's diatonic. *(laughter)*

MB: Perhaps I should mix both.

JR: Playing two ears simultaneously?

JC: Is it sweeter?

MB: No, it's different. Actually, this *(pointing to other ear)* is sweeter.

JR: John, will we have time to go over the [*Ryoanji*]? You said we were going to have some interruptions.

JC: Oh, I can stop the interruptions. Because I had to prepare these things, I turned the phone on so I expected it to ring, but it didn't, so we haven't had any interruptions.

JR: So it's not that—

JC: No, not that.

JR: O.K. Good.

JC: I can remove them by changing the phone again, but I thought that since we could be interrupted [while eating] that we should be, or we should open the possibility.

(End of tape.)

(JR has asked JC to discuss the Ryoanji *cello piece he is planning to write for MB. He and MB will be meeting on Sunday and Monday to work on it.)*

MB: Do you have some questions for tomorrow?

JC: Oh yes, for the *Ryoanji*. I think that you want me to write a cello piece for *Ryoanji*. So that means I have to look at *Ryoanji* and discover how I do it. And I'll do that. I haven't done it yet. And then I would have the questions which you could answer, but I thought we would do that tomorrow. *(to JR)* Unless you want us to do that now. I could ask the questions, more or less, today, instead of tomorrow.

JR: Yes, go ahead. That would be interesting.

MB: Perhaps I misunderstood, but did you say you would like to work on a new piece, rather than to work on an old piece? What did you mean by that?

JC: Well, you have been using the bass music for the cello—

MB: Oh, right, that's what you mean.

JC: So I thought it would be better to write a new piece for cello.

MB: For the *Ryoanji*, with the same title. Ah, yes. Ah, I see.

JC: Instead of your doing it with the music for double bass. It seems to me to make more sense.

MB: Yes. It makes more sense.

JC: That's what I meant. I have heard another double bass player, not in Perugia, but in—

MB: In Japan?

JC: No, in Fiorenza. You must know him, [Stefano] Scodanibbio. I thought he played beautifully. He played *Ryoanji* absolutely . . . *better*, than anyone I ever heard.

MB: Did he sing?

JC: No. He didn't bother with that. That was something that Joelle could do, and so she wanted me to do both.[27] But Joelle doesn't play the double bass as beautifully as Scodanibbio. And neither does Frances-Marie Uitti. In fact I haven't heard better double bass playing than Scodanibbio's. I was just amazed! And I think everyone who heard him was amazed. Many musicians, faced with the freedoms that my notation provides, or *directions* provide, take—well, as Paul Zukofsky says in the notes [for MOMA Summergarden program]—where I give them a little freedom, they take more, and so on, until the piece is quite out of reach of my original work. And this is certainly the case with many musicians, so that instead of making a solo, and making three recordings of it, which is part of my directions [for *Ryoanji*], they choose three other musicians with different instruments and make a kind of chamber ensemble, which is not what I had in mind. What I had in mind was a person becoming four people, hmm? and then playing in this complicated way, one over the other. And Scodanibbio actually did that. He criticizes himself—the way he does it—and each year improves his tapes that he plays with, so he doesn't think of his work as being finished. He's

27. Joelle Léandre, for whom Cage wrote the double bass part of *Ryoanji*—for bass solo, and "vocalise ad libitum."

always carrying it further. He's really extraordinary. *I* think. So, I've decided to write a microtonal piece for him, using *(pointing to notes with arrows)* this kind of notation. To write three such pieces for him, which he will again play with themselves. So that he would be surrounded by, say—there would be two double basses standing on either side of him, while he would be playing the middle one. And they would all be heard together . . . from three loudspeakers. I think it would be marvelous if the loudspeakers were not greatly amplified, so that the instrument he played wouldn't have to be amplified at all. Or maybe, I don't know yet, maybe just enough amplification to the ones beside him, so that you hear the three as being together. I'm actually thinking of the experience of one of Feldman's pieces—

MB: The "Voices"?

JC: *Three Voices*, which I didn't like—the piece.

MB: Me too.

JC: But this one would be good. *(laughter)*

MB: There is one problem with this [Feldman's] piece I think, apart from the acoustics—it's different if something comes out of the loudspeaker or if it's played—but the voices had to be together.

JC: Yes, the fact that it is the score is difficult, hmm? Is it a fixed score?

MB: I think so.

JC: O.K., well that's an error, yes, that's a mistake. And the other error—well, go ahead, what do you think?

MB: The singer is always trying to—

JC: —Be with herself.

MB: —To follow the loudspeakers.

JC: Yes. Well, we won't have that problem.

MB: Yes, that's the problem with the Feldman piece, I think.

JC: Yes, and the other problem is it's too beautiful.

MB: So it's very obvious if the beauty is disturbed by a bad performance?

JC: A good performance is even worse! Because it's *more* beautiful. *(laughter)* It's in meter too. It's in threes, isn't it?—one two three, one two three, one two three . . . isn't it something like that?

MB: Oh, I don't remember that.

JC: I think so. It's like a triplet.

MB: Like a waltz . . .

JC: Triplets. Ta ta ta, ta ta ta. It's enough to drive you crazy. Finally, if you pay attention to it, it's irritating, triplets.

JR: Yes, triplets *can* drive you crazy. Oom-pah-pah cultures are frightening.

(Tape recorder turned off; pause to eat dessert.)

JR: Can we take up the *Ryoanji* questions?

JC: O.K., I'll get them. *(gets sketches of score, leafs through pages)* Where these lines are written, which refer to actual pitch, how I did that I don't understand. I don't

understand how I put them. There's this other business, 2R over 2. R is 15, so 2R is 30. There are 30 of these lines, which come from stones. I have the stones. I would have to study this enough so that I could ask you questions. I don't think I can do that now. *(continues to look through* Ryoanji *papers)* Oh! *(pulls out the templates)*

JR: Ah!

JC: Here are the stones! *(laughter)* Because I obviously couldn't write music with stones, because when you draw around a stone you don't necessarily draw the same way each time. But this enabled one to.

JR: How did you make those, John? What are they—

JC: I made them with the stones and they're now templates, which is to say patterns that take the place of the stones.[28]

JR: Are they on plastic, or—

JC: No, they're on paper. And there are fifteen of them I'm sure.

(Tape recorder turned off while JC continues to study the Ryoanji *manuscripts until he discovers how he worked.)*

(JC is now explaining how the drawings of the curves on the staves link the two pitches—determined by chance operations—that form the range of the glissandi.)

[See Figure 15c, page 241.]

JC: This range *(pointing to manuscript)*, which is a tenth, covers this space. Just as this one, which is much less, covers the other, covers the same space. Do you follow me?

MB: Yes.

JC: So, apparently what I did was to decide what space was going to be used by any of the pieces, and then find out for each piece how much of the space was going to be realized. So it could become either roughly microtonal or very fine—very much so. See, this is all from E to G. *(pointing to manuscript)* So that this is more microtonal than this one, don't you think?

MB: Yes.

JC: Though this is over a wider range, so it doesn't really—and since there are going to be eight pieces, chance operations makes some pieces one way and some another. *(pause)* So, the first question we would ask for the cello would be—if you were writing *Ryoanji* for it—would be, What would be the range within which you would want to slide, hmm? Not that every piece would do it, but what's a good range for the cello—to be able to slide in any way in it? Obviously you could slide—well, I don't know. You could answer that. That's my first question. If you're sliding, where do you want to slide? *(laughs)*

MB: Yes, we have the whole string.

JC: That's the trouble. You have four of them. So it's hard to answer the question.

28. Cage used the templates made from his fifteen "Ryoanji" stones to draw the patterns of the glissandi by tracing along the edges, positioned on the staves by chance operations.

MB: Oh, you mean—there's only one answer allowed—

JC: Only one answer. And you have to take into consideration that chance opera-tions are going to be used. So you can't answer for one situation, you have to answer for all *conceivable* situations, hmm? within which chance would deter-mine what would happen. So if, say, you took one of the strings, is that true? I mean do you only want to play as though the instrument had one string?

MB: No.

JC: So, if you're thinking of it as having four strings, then what is the answer? Then it's what is in common to all four strings.

MB: Well, that would be . . . on the C string, on the lower string, the range would start with the pitch of the A string.

JC: Exactly. So, you would take the A string as answering the question.

MB: Yes. And the highest pitch on the C string would be the other limit. The lowest limit is the A string, and the highest is the C string. How high can I go on the C string? How low can I go on the A string?

JC: You think that would answer it? *(pause)* Would that mean then that if you were playing a curved line, it should be played on any of the four strings?

MB: Yes.

JC: Well let's find out what that is then. That was our first question. *(pause)*

MB: There'd be a very big range . . . of what is possible on the cello. *(MB draws staves in his sketchbook)* This is the open A string, and this is the 32nd partial on the C string.

JC: O.K. That's a C. So we have forty tones.

MB: Oh, you counted. Yes, forty.

JC: So we take forty, and then I find out which range—what's the lowest and what's the highest—within this, for each of the pieces. There would be eight pieces, hmm? And then I find out from those whether I use one or two sets of stones. I notice all the time . . . R/3—that means fifteen, having three different lines, I think. I'd have to find that out. I have to study that. This is R/1—that means fifteen. This says 2R/1. So there's a difference between R and 2R. And then I would find out for each piece whether it was 1R or 2R. And then I would number these, I would find out what the ranges were. Then I would measure these spaces . . . and make one for cello which divided it into as many spaces as were necessary.

MB: Do you think it [the cello part for *Ryoanji*] could be a curved-bow version?

JC: I don't know. I won't write it with that in mind. I'll write it with *Ryoanji* in mind, and then you can do what you can. You could, as a performer, decide which kind of bow to use.

MB: I'm asking because you have sometimes more than two voices overlapping.

JC: No, I won't ever do that. I have instead this situation. Here's this, and then this, and then that, and this, and this, and this. I don't have two. In the other case, where they do overlap, then I *draw* them differently, there.

MB: Yes, different lines.

JC: And I wouldn't ask you to do that.

MB: Together. They should be—

JC: They should be separate. Coming from different loudspeakers.

MB: Oh, I see, yes.

JC: I don't think you could do that. *(pointing to two lines at once)*

MB: Could be possible. I mean it depends, but—

JC: But I don't think you could. It would be very, very difficult. It would be like doing two things in opposition to one another. If you're going straight here, and here you're climbing up suddenly, it would be very difficult. I wouldn't tend to do that in this piece. *(pause)* I'll work further on it and then we can talk, the next time. If I go through all these pages more carefully, I may be able to discover more.

MB: You have a picture from the garden?

JC: Yes.

(JC shows us a picture of the Ryoanji garden in Kyoto in the file with his Ryoanji *music manuscripts. He explains that every pair of facing pages in his glissandi scores is conceived as a "garden of sounds.")*

JC: *(continues to look through the* Ryoanji *manuscripts)* This one *(pointing to a glissando)* starts here and goes backward, because if it had gone this way it would have gone outside the garden, so it had to go back. . . . *(long pause, continuing to study)* If you count these, you'll find there are 30 [2R], I think, . . . yes, 30. So, I don't see any 3R. That means I thought 3R would be too complicated. It had to be 1R or 2R, because the old garden in Ryoanji has fifteen. So it was either fifteen or thirty. After I found out what the ranges were, I would find out whether it was one or two and I would make that number of chance operations to find out what the range was, and then I could begin doing this [determining by chance where the templates would be placed on the staves] and then I could lay the stones down, and then I could give you the music. *(laughs)* It's no problem at all! *(laughter)* So, I'll do that. And I'll work in the range you give. But what that means is that you play with any bow you want. But I don't want to give you the problem of playing different lines with the force bow. I don't think it's practical. It would not only be very difficult, but I think it would be a kind of difficulty that didn't make sense, hmm? The difficulty that makes some sense is whether you could in the end play what is written. Which would be hard enough to do! It would be difficult enough. If you succeeded in playing it with the curved bow, you would remove the difference in space.

MB: That's what you would like to have.

JC: Uh huh.

MB: And also you would like to have that it's played by the same player with loudspeakers—recorded.

JC: Yes, the people who have played *Ryoanji* and who haven't done that, who have taken liberties—substituted other instruments and so on—don't do as well as

Scodanibbio did. His performance was absolutely magic, as I think yours could be too.

MB: And it doesn't matter where the loudspeakers are placed?

JC: Well, they should be placed around the people who are listening.

MB: Around, not on stage, around.

JC: Well . . . you could decide that too, I suppose. But if you, if you were a listener, you could fuse things easily that were at one distance. But you'd have more difficulty fusing things that went around you. You'd tend, in fact, to turn that way. If the sound was coming from here *(pointing)*, you'd tend to look there. And you'd know that you couldn't look all around.

MB: Yes . . . now I understand . . . right.

JC: The interesting thing about sculpture is that you get different points of view from different places. Architecture too. But music, very rarely. Though Ives was interested in that. Remember? He had the experience when he was young of hearing a band playing, and being in different relations to it, and that interested him in his own work. His father and he were both interested in microtones.

JR: Really? In what way?

JC: In the fact that they were small. Sidney Cowell was telling me that both he [Ives] as a child, and his father as a grownup, made a board on which they could have wires, and they could hear microtonal differences, and they did that. Could hear a pitch, and then another pitch that had a microtonal relation. It's very curious, because neither one of them, I think, was playing a string instrument. I think the father was involved with bands—wind instruments.[29]

JR: They had a need for strings, clearly. *(pause)* In the only performance of *Ryoanji* I've heard, the sounds came from three different parts of the auditorium, and that was very nice. Actually, John, you were there and you didn't like it. The acoustics in the auditorium were strange.

JC: Oh, in Washington [D.C.].[30]

JR: You said afterwards you were in a sound vacuum and couldn't hear all three

29. Actually, Charles Ives's father taught violin. Very interesting in relation to Cage's remarks is Ives's essay "Some 'Quarter-Tone' Impressions," in which he writes, "By extension of medium we don't mean to imply, necessarily, new material. The selection and use of different vibration numbers in some orderly plan, as we all know, is not new in the history of music. The music of many peoples and countries, ancient and modern, is full of smaller tone divisions than we are accustomed to. . . . But if an addition of a series of smaller tone divisions is to be added to our semi-tone system 'to help round out our old souls,' how much of a fight will the ears have to put up? What help can be found in known laws of acoustics—the physical nature of sounds? And how far may we trust in the free play of the mind and instinct—aesthetic principles? How far will our emotional reactions, our ear-habits, our predilections, help or hinder? . . . But that [consideration of various difficulties] needn't keep anyone from trying to find out how to use a few more of the myriads of sound waves nature has put around in the air . . . for man to catch if he can and 'perchance make himself a part with nature,' as Thoreau used to say." In *Essays Before a Sonata, The Majority, and Other Writings*, ed. Howard Boatwright (New York: Norton, 1970), pp. 107–09.

30. This concert, "Cagefest: Chamber Music of John Cage from 1983–1991," was sponsored by the Library of Congress chamber music series at the National Academy of Sciences, November 15, 1991.

instruments. You couldn't hear the percussion, could you? *(JC nods)* But where I was sitting I could hear everything and it was a wonderful experience. It *was* sculptural. The music formed the space between the three sound sources. So we as audience were in the music sculpture.

MB: Which instruments did they play?

JR: Percussion, oboe, and double bass. Wasn't that what it was?[31]

JC: Yes. It's again an example of people taking liberties, mixing up the instruments.

JR: Taking liberties, yes. But the placement of the sound, I think, was interesting. And the choice of the instruments —

MB: But would it be possible to combine different versions together? You wrote in the foreword that you could combine the bass version with the trombone version.

JC: Yes, and they do that, different people. The best, as I say, the best I've heard is Scodanibbio doing the bass version, without the voice.

MB: I made an experiment with the glissandi. If you play the glissando on two strings with the same pitch, the fingering, it gives you very full, complex sound. Perhaps I should show that to you. It gives . . . it's not a clear glissando like that, but it's a glissando like that. *(MB draws two glissando curves, the second over the first.)*

JC: Yes, that's beautiful. On two different strings?

MB: On two different strings. Perhaps you should hear what you think about that.

JR: Could you describe that verbally? The microphone unfortunately can't see. *(laughs)*

MB: Oh, yes. *(laughs)* Well, actually, you have two lines and you have two different colors also. But they are very close to each other. You have the shape of a stone. And you have the shape of the glissando line. And the shape of the stone is always not very defined or clear. That's the question you [Joan] asked John, what is this —

JR: Template.

MB: Templates. These [the templates and the lines produced by tracing their edges] are very clear here, but the stone is different. So, my idea was to play on two strings in order to have a more —

JR: Complex.

MB: Complex curve, glissando. But it depends on the range. Perhaps with some ranges it wouldn't be possible, I don't know. But I'm sure some of the glissandi are possible to play like this.

JC: And you do that with a curved bow?

MB: No, with a normal bow. Because these are only two strings. You don't want to do with three strings the same thing. It must be —

31. Robert Black, double bass; Joseph Celli, oboe; Jan Williams, percussion.

(Laughter.)

JR: Bigger and bigger stones.

MB: Perhaps it would sound very good, I don't know. It depends on what you will write down, and I can see if it's possible or not.

(Pause.)

JR: *(to JC)* In a way that's the kind of thing I was talking about yesterday when I asked you about the visual quality of *Ryoanji* as a piece. That it's more visual than some of the others. You've done many pieces that have a visual component—

JC: Right.

JR: —A visual component that is very strong all the way through—from the beginning conception—the connection with the sculpture garden—to the shaping of the sonic space by both the percussion and the glissandi, to—in this case—your [MB's] thinking [by sketching trajectories of glissandi] about how to play it.

MB: Yes.

(At this point JC begins to compose the cello part for Ryoanji.*)*

JC: We could find those ranges for eight pieces, and then you can have a copy of that and tell me what you've discovered about the different ranges. Then I can take them into consideration.

(Pause while JC goes to get his IC Supply *sheets [for example, see Appendix G] in order to begin doing chance operations once the range has been determined.)*

JC: Your range is A to C. Is it this A, just below middle C?

MB: Yes.

JC: It's *that* A. So, A . . . *(JC is sketching the range decided upon with MB.)*

MB: You will leave open now on which string to play?

JC: Yes. That'll be up to you. *(pause)* You can tell me though—from a distance, when you are with the instrument—which ones you want, if you wish. *(pause)* Or you can wait until you see what happens and change according to what you want to do.

MB: Isn't it a big range?

JC: No.

MB: No?

JC: What I mean is, it's not too big. *(laughter)*

MB: I was thinking how big the range is on bass, or violin.

JC: And this one is the three [the third octave in the range], isn't it?

MB: Yes.

JC: This is one, two, and now we go to three octaves, and a third above that. Are you sure you want to go that high?

MB: That was my question, of which string it's played on, because on the A string it's not so high; on the C string it's very high, and on the G string—

JC: Very, very high.

MB: Yes, but if you leave open which string—

JC: So that the distance is to be microtonal in here . . . almost non-existent.

MB: Yes, but if you leave open the string, I can play either on the A or C string . . . if you choose a higher range.

JC: Let's see what happens with this. If we get into a quandary, we'll have to write to this young man who's having trouble in Seattle and ask him what we should do. *(laughter; JC continues to work)*

MB: We take a risk. *(JR laughs)*

JC: Now . . . that's the end of it [the range], isn't it?

MB: Yes.

JC: So that's what it is. O.K. *(JC takes out IC Supply sheets* [32]*)* So, we'll have eight pieces [glissandi], and the first one will be between twelve and twenty-six. That will be piece number 1, hmm? from G#—above middle C—to A#, an octave and a second above. The next one will be . . . just . . . these two notes.

MB: Oh! *(laughter because they are so high and close together)* See!

JC: That's our chance playing.

MB: Ask your friend in Seattle and find out what he thinks about that. *(laughter)* No space for thinking.

JC: A# and B next to the top. I think you'll do that very beautifully. *(MB laughs)*

JR: Yes, I think you'll be particularly wonderful with that.

MB: *(laughing)* Thanks a lot!

JC: *(finds next pair)* This one you can't do.

MB: What?

JC: *(delighted)* It's to stay on the same note . . .

MB: Ohhh.

JC: . . . The whole time. You want to do that?

MB: Uh huh.

JC: You do? You won't be able to make any curves.

MB: Well, if you have inflections . . .

JC: So, maybe you could do it with changes of amplitude. You could give that feeling.

MB: Yes.

JC: O.K., so let's take that as a prize.

MB: We'll have an extreme version.

JC: And the pitch is F#, just above middle C. That'll be good.

MB: Hey, you know what?

JC: What?

MB: I'll do that perhaps with the curved bow. I'll change the strings.

JC: Yes, that will be very nice. O.K.? *(finding the next pair)* Then from F# up here, to thirty-three, to F above that. Then from G up to D, above that—from

32. The numbers on these sheets will enable Cage to find pairs of notes that will form the beginning and ending pitches of each glissando within the range they've decided to use on the cello. Cage identifies specific pitches—having numbered all pitches that fall within the decided-upon working range—by finding pairs of numbers on the IC Supply sheets.

G2 up to D3. And then the next one is from 7, which is D♯ up to G. From this D♯ to this G. And then this is the seventh one [glissando], which is from A♯ up to F. And then the last one is from this F♯ down here, up to this G. Shall we see if we're in agreement now? *(MB has been copying these pairs into his sketchbook)* [Number] 1 is from G♯ up to A♯, 2 is A♯ and B, 3 is just F♯, and 4 is F♯ up to F . . . is that right?

M B : Very high, yes, this F.

J C : Yes, the last F. *(MB chuckling)* And 5 is from G to D, 6 is from D♯ up to G, 7 is from A♯ above that to again F, and 8 is from F♯ up to G. O.K. *(MB laughs)* So, I'll send them to you as I draw them.[33] I won't have them copied until we come to a conclusion. Because various things may develop as we continue . . . like two strings, and three strings. Hair bows and so on. *(laughter)*

M B : Yes. Since you don't define the strings —

J C : You can do that if you want.

M B : Yes. But we excluded all lower pitches now, which are not possible to play on the A string. *(JC nods yes)* Right. So every pitch which is lower than the A string we don't take into consideration.

J C : Every what?

M B : Every pitch which is lower than this A—open A.

J C : Actually, lower than this. *(pointing)*

M B : Oh yes. But, I mean, before we made chance operations, we excluded all pitches which are lower than the open A string, the first string.

J C : You mean not using these. I thought we decided on the range to begin with. Which was from A—

M B : This range, yes. Because it should be playable on all strings, what you write. That's the reason why. *(JC nods yes)* Uh huh.

J C : Nothing is excluded. It's just that everything is *in*cluded. All the strings are included. I think it can be played on all the strings. But with difficulty on the C and D, I mean more difficulty. Less difficulty on the A string.

M B : Uh huh . . . O.K.

J C : You want to change it?

M B : What I was thinking about was . . . the whole lower register of the cello—

J C : Is missing.

M B : —Is excluded in this piece. I was thinking about why.

J C : Do you want to think over again about the range?

(Long pause.)

M B : Well the other way would be—

33. Cage is referring to tracing the edges of the chance-positioned templates as they are placed on the staves between the pairs of notes, in order to inscribe the shapes of the glissandi. See Fig. 15c for an example of this. He was not able to finish this work because of his death three weeks later. Cage had actually suspended work on the *Ryoanji* part for cello in order to work on an entirely new piece for Michael Bach which would have been, had he finished it, *One¹³*.

JC: When I asked Robert Aiken what the range of the flute was for this piece, we settled on one octave—C prime to C-two, just one octave.

MB: Uh huh . . . so he chose a very small range, to begin with. Was there any reason, why you limited it?

JC: It's hard for me to answer that. He was thinking of being able to slide convincingly. That would be the area in which the effect of glissando would be controllable.

MB: The other possibility with the range would be to take the lowest possible pitch on the cello and the highest. That would be, on the A string, more than one octave higher—

JC: Octave and a half at least, wouldn't it?

MB: Yes, right. And then if a very extreme situation appears, like here now, I play it on the A string. If we get a range from C [string] to, let's say A [string], I have to play on the lower strings. That would be the other possibility.

JC: Take that if you prefer. How many notes is that?

MB: Let me see . . . I'm not sure if I prefer that.

JC: Then I'll have to write a letter to you.[34] *(laughter)* You must not know —*(laughing)* No! Forgive me. *(laughter; pause)* I think the trouble arises here in thinking that between two things there might be a better decision, hmm? Whereas, one decision is just as good as another, hmm? Because each decision will give you something the other one couldn't. So there's no possibility of making a poor decision, hmm? You don't need to make the right answer, because any answer you give is right. This [F♯] will give you that fantastic problem of having to curve, or give the impression of curving in pitch, where you have to also stay on the same pitch! Hmm? That's remarkable!

MB: Yes, so we should keep that version because—

JC: I think we should.

MB: Yes. That seems that we like this—

JC: What?

MB: That expresses that we like this accident here [the two notes that are the same pitch]. *(laughs)* So, we fall in love with that and we don't want to—

JC: —Have the other? *(pause)* It doesn't matter. I think it's true that it doesn't really matter . . . what decision one makes.

MB: But, for example with *One*[8], if I had given you only a few possibilities to choose, it would be a much different piece.

JC: Than it is.

MB: Than it is. For example, if I only had a very small range, perhaps only three fingers, it would have a totally different character. And that's what I'm thinking of here. We decided to have a very—if we decide this, we have another character of the piece than—

34. Referring to the letter he wrote to the young man in Seattle.

JC: —Than another decision. Yes. So! Think about it and decide what you want. I'll be glad to work with either. *(pause; MB is looking at sketch of other range)* How many pitches does the other one have?

MB: Let me see—C . . . oh, it's too much here! G . . . C . . .

JC: How many octaves is it? *(MB is counting)* Is it an E at the top? How high is it above this A?

MB: *(counting)* . . . The highest pitch I can get on the cello is A, the fifth octave above the open A string.

JC: No, no. It should be more like an octave and a half above the A.

MB: Why an octave and a half?

JC: So that you can play fully. You don't mean five octaves above this [open] A. You must mean above this one.

MB: No, six and a half above the C.

JC: Really!

MB: Yes, because this is the 32nd partial from the A string.

JC: But those tones you would only be able to play on the A string.

MB: Yes.

JC: And that was one of the things we decided not to do [in order] to make it playable on all four strings.

MB: Yes, that's the one decision we had already worked on.

JC: But now you're working on another one?

MB: No, I just would like to answer your question. Perhaps I misunderstood. I thought there are two possibilities: to have a range which allows me to play on every string, this range; and another possibility would be to use the whole range of the cello, and then if we have a range too low, a range which is lower than the A string, I have to use the other strings. And if we find a range which is higher than what I can play on the C string, I have to use the other strings.

JC: I think if you get too extensive a range, that you'll get a series of pieces that will go through such a great range that they won't be microtonal anymore. They won't have glissandi. Or, if they do have glissandi, that you wouldn't be able to play them, because they would have to go through several octaves, hmm? You wouldn't be able to do that gracefully and convincingly, hmm? Your glissandi should take place on one string. Because if you jump, it won't sound like a glissando.

MB: Yes.

JC: On the other hand, that might be an interesting problem. *(laughs)*

MB: Oh right. *(laughter)* Yes. I'm sure it's possible to solve that. You start on the C string and then you go smoothly until you have the hand spans that could be possible. But, now I understand, you don't want that the strings are changed during glissandi.

JC: It would be very noticeable, wouldn't it?

MB: It depends. I mean it's possible.

JC: But you were speaking about Lachenmann, and the difference in noise between one string and another. It certainly must be a real difference—between the four strings.

MB: Well . . . let me try it out today. Let's see.

JC: Try it, and talk about the difference between the strings, what the range is that you want.

MB: No, I think this solution is good . . . I think . . . now.

JC: Well, there's nothing wrong with one solution, and if it leads you to another idea—of another piece—that could be written too.[35] *(laughs)*

JR: Michael, would you spell Lachenmann's name on this pad.

(MB writes "Helmut Lachenmann, born 1935" on JR's note pad.)

JC: *(looking at the pad)* That doesn't mean "laughing man," does it?

MB: Yes. It does mean—

JC: —Laughing man. He's a very nice person, Lachenmann. *(pause)* What does Stockhausen mean?

MB: "Stock"—that is a stick.

JC: A stick house?

MB: Well, it's not Stockhaus, it's Stockhausen. "Hausen" you use in village names.

JC: Stick village. *(laughter)*

MB: Yes.

(More discussion of German names.)

JR: Well, thank you for this. I think this is a wonderful conversation to have on tape, and to have as a part of the book.

MB: Thank you for the invitation.

35. The idea for another piece, which would have been *One*[13]—for cello and three loudspeakers —did come out of these considerations. See the July 30, 1992 conversation.

Cage's Loft, New York City
July 30, 1992
John Cage and Joan Retallack

In the weeks before this conversation took place, Cage and I had talked on the phone about, among other things, variations in baking the almond torte cookies he liked so much, and the materials on nanotechnology he had received from the Foresight Institute in Palo Alto. The Foresight Institute is dedicated to reflecting on potential uses and abuses of this new molecular-level technology. Cage heard about their work in January 1992 while in residence at the Stanford University Humanities Center for a week-long program, John Cage at Stanford: Here Comes Everybody. This was the first technological paradigm that had really excited him since the work of Buckminster Fuller. He liked the ingenuity and the subtlety of bringing about large-scale changes through molecular interventions. This fit well with his cherished Buddhist principles of interpenetration and nonobstruction. As described in the literature he had been reading, nanotechnology seemed particularly promising for the improvement of the world's environmental prospects.

Cage was trying to maintain the buoyancy of his humor, the pleasures of everyday life, and his sociopolitical optimism—all in the face of the recent violent attack in his home,[1] increasingly disturbing world events, and more and more pressures due to the up-coming, almost-impossible travel schedule necessitated by the many eightieth-birthday concerts and symposia taking place in the fall of 1992 in Europe and the U.S. In some cases he was going to have to fly on the Concorde in order to get from one engagement to another on time. Even with these dauntingly strenuous arrangements, he would miss events he wanted to attend. All in all he was feeling apprehensive about the rigors of so much travel, the degree to which it taxed his health. Had it not been for the opportunity to hear his music, he would have much preferred to stay home and work. He said—sometimes laughingly, sometimes not—that he didn't know whether he would survive the celebration of his eightieth birthday.

What follows was intended as a kind of interim follow-up conversation that we both thought would be useful on the eve of his travels. We had in fact scheduled two days for this, but when at lunch on the first day I learned that he was on the edge of panic about all he had to do before setting out for Frankfurt on August 27, I told him I wanted to give him a "gift of time," that I would not come back the next day. He was disturbed by this, saying he didn't want me to do that: "If I hadn't just told you all this, you wouldn't be suggesting we stop today." I told him we really had done more than I had imagined we would during the morning, and that the rest could wait. Toward the end of the summer of 1992 I was more confident than he of there being commodious time on the other side of his travels.

So we agreed to tape a "real" epilogue to complete the book project some time after

1. The mugging discussed in the conversation of July 15.

all the frantic travel was over, and after we had both had a chance to read the transcripts of what we had done so far.

Cage died on August 12, 1992, thirteen days after this conversation was recorded. What follows is therefore an inadvertent epilogue. This is luck which needn't be characterized as good or bad. Cage always said he didn't want to know when a composition was going to end. —JR

(On this particular morning the street is being torn apart just below the open windows of Cage's loft. New York City has begun renovating water mains. The pneumatic drills are so noisy, they cause one to long for the peace of mere traffic sounds—even those of the ceaselessly busy intersection at 18th Street and 6th Avenue. As usual, in the heat of the summer months, all the windows in the loft are open. Three large floor fans are whirring at more or less equidistant points from the table on which I have set up the tape recorder. They create a turbulent micro-climate just over the mike.

Before sitting down to work we had been talking about Marcel Duchamp, and Cage wanted to show me something in a book he had been reading. As he reached to take it down from the shelf, Luigi Russolo's The Art of Noises *fell to the floor. We looked at it lying there and laughed so long and hard we didn't take up the matter of the Duchamp book again until later. As our conversation begins we are literally shouting at one another across the table in order to be heard.)*

JR: There'll be no whispered truths today! *(laughter)*

JC: No! *(laughs)*

JR: Somehow the brutality of this noise, and of the events here in this space two weeks ago, seems to underscore how inescapable the circumstances of disorder in the world are—how they constitute the framework for everything we do, whether we like it or not.

JC: Yes. This concerned even Duchamp. Even Marcel Duchamp. The problem lies in the having, as opposed to the not having, of possessions.

JR: The "wanting" you mean?

JC: No. The having of possessions. He [Duchamp] also looked forward, as I do, to an anarchic state of affairs. But he sees the having of things by people, separately from one another, as a serious problem.

JR: Yes. Actually I want to end today with talking about anarchy and, if we can make it audible, the whispered truth of interpenetration and nonobstruction as a vision of a kind of anarchy.

JC: I think a lot of this—well, we can come to it then later—but I think a great deal of the difficulty comes from the fact of government. There's another problem. I once asked my mushroom teacher, Guy Nearing, whether he believed in God, and he said, I never say anything against Him. *(laughter)* And then he added, He's the only one who keeps everyone in line. In other words, He's the final government. And of course God has always been government as far as anarchists are concerned. Just as they are opposed to government, they are opposed

to religion. And religion has certainly proven itself—not in all cases, but in many cases, it's proved to be one of the causes of war.

JR: Well, if anarchists are not counting on government, and they're not counting on religion, what are they counting on?

JC: Well, God is all-powerful, so in the end He's a policeman, so He's not wanted by the anarchists. We want to find a solution elsewhere, namely in the multiplicity of individuals who have the habit of respecting one another.

JR: That reminds me of Aristotle's *Ethics*, in which the question of the good life of the society is seen to rest on the development of habits that make up a good character, and a good member of the community. That's what the word *ethos* actually meant in Greek—habit or custom: so what are the habits of virtue, friendship, responsible citizenship? And the social and political question becomes, how do we cultivate the habits that are beneficial to the community?

JC: Yes. Exactly. And I don't think by education. This is always the next step from the police. You move over to education. I don't think that works either. The only proper education, and the only education really that counts, is the education you give yourself. It seems to me so. That has been my experience. I didn't feel as though I was learning anything until I left school. It took fifteen years after leaving school to discover that I had something that I wanted to learn.[2]

JR: Yes, I think that's often the case; the ability to sense what one really needs to know comes later, if school hasn't entirely killed one's intuitions, not to say the desire to learn.

JC: Right.

JR: Well, what I imagine now as we've begun with this is that we'll go in a circle today. *(JC laughs)* Because I wanted to talk very specifically about questions of the performance of your work and indeterminacy, and that of course has to do with the exercise of anarchy in the small-scale social system of the performance.

JC: Yes, it does. The constant change in position of responsibility according to who is acting, hmm? The position should not stay—in the case of music—should not stay with the composer once he's written something. It should move over to the next person who deals with it, and that person—the performer—should become responsible, and responsible to himself or herself, rather than to the composer.

JR: Of course the word "should" is highly operative there.

JC: Well then, we can remove it if you want. In the same way that we can weed out masculinity from language, we can weed out power. That's what we should do, it seems to me. First of all examine our language for the location of power.

JR: Yes, as you have said so wonderfully, these things are not just matters of

2. That was in the forties, when Cage began the study of Eastern philosophy and spirituality, studying Indian philosophy with Gita Sarabhai, and going from references in Ananda Coomaraswamy's *The Transformation of Nature in Art* to the sermons and treatises of the fourteenth-century German heretic/mystic Meister Eckhart.

vocabulary, they are matters of our ways of thinking. And it is only when the thinking—

JC: —The thinking changes.

JR: —Yes, shifts its perspectives, that one begins to see how these things are embedded in the language. So for the time being, in our chronic interim state, the "should," it seems to me, is indicative of the knowledge that it's difficult, not necessarily even possible, to meet the challenge, to accept a level of responsibility appropriate to some sort of highly desirable, but radical agency.

JC: Well, it seems to me that we're inevitably, if we have a utopian view—which I think we must—and there's another "should"! *(laughter)*

JR: A utopian view for inspirational purposes?

JC: In order to live.

JR: Hope, in order to go on.

JC: I think so. *(pause)* I was searching for a way to use the noise we're experiencing as an illustration. *(laughter)*

(Pause; noise is almost overwhelming.)

JR: An illustration to take us beyond distraction. *(pause)* This is certainly an example of amplitude as penetration and obstruction! *(laughter)*

JC: Well this city, of course, is an example of the wrong way of doing things. In this particular instance, the underground pipes, all the utilities, are in a state of disrepair. Sometimes they erupt into actual floods or loss of electricity. There's no hope for it because the pipes are so old that if they're not changed they'll break, but they can't all be changed because it's too complicated. This points out another thing that we should do, which is proposed by nanotechnology.[3] We should not travel on the surface of the earth; we should travel underneath. So what we should do is take out what we have there now, and have tunnels where we can go quickly from one place to another. Then the surface could be like a park. Once we've had several decades of nanotechnology, theoretically the air and atmosphere will be returned to a healthier state. But we've made so many mistakes. Now we are ineffectively correcting momentarily noticed evils—only to continue making 6th Avenue almost impossible. I mean we almost can't use the street. And we can almost not talk here.

JR: Yes. *(pause)* Well, I'm finding that I'm using so much energy just trying to hear what you're saying that I have very little to focus elsewhere. So I'm thinking of fleeing. *(laughs)* I'm wondering if we could relocate. Is there any place in the loft that's quieter? Perhaps over there?

JC: I don't think there is.

(Nevertheless, we do move, to a table farther from the window. This turns out to be

3. Cage had recently read *Unbounding the Future: The Nanotechnology Revolution*, by K. Eric Drexler and Chris Peterson with Gayle Pergamit (New York: William Morrow and Company, 1991). Among the materials Cage had just received from the Foresight Institute was Drexler's first book, *Engines of Creation*.

*quite complicated. In addition to moving chairs, papers, the cat, the tape recorder . . .
it also involves moving the three floor fans. We unplug them and set them up at the
new location, tipping them against various objects at precarious angles necessitated by
the insufficient length of the cords, and creating a veritable booby-trap of stretched-
out wires. Cage is clearly perturbed by all this. We may have improved our acoustical
situation by only a decibel or two. For me the gain is the illusion of remove in our
greater distance from the windows.)*

JR: I think this will be better for me, but—

JC: O.K.

JR: Now, there are probably all sorts of factors you're aware of that I'm not.

JC: No. That's O.K.

JR: You're O.K., you're sure?

JC: Yes.

JR: The idea of all those tunnels sounds wonderful in one way, saving the surface,
but I imagine all of the people who would have to work underground in order
to create that system. It would be a grim way of spending one's working life. It
would take decades to build all those underground roads and someone would
have to do that.

JC: Well, we don't know. It may be robots doing it. *(laughter)*

JR: That's true. Robots don't need to be anarchists; they could liberate us. *(laugh-
ter)* Thinking about where we were when we left off two weeks ago, Michael Bach
had initially been rather disappointed that chance had left out the lower register
of the cello in the *Ryoanji* piece you were composing for him. I found that very
interesting. I wonder what's happened since then. Did you talk about it further?
Did you compose a new one for him?

JC: No, I'm working now on the piece that developed from what we discussed,
which is the piece that will be composed of single tones.[4] There'll be eight of
them, each having its own chance-determined pitch selected from the number
of ways that the single tone can be produced on the cello—which turn out to be
ninety-eight!—and will come from the live cello and from three recorded cellos.
So there will be four voices, so to speak, all playing the same note, but differently.

JR: And are all the pitches still in the upper register?

JC: Yes, it's not the low range. It's the range that begins with the high A and
goes up much farther. We didn't change that, nor for the *Ryoanji*. We kept it after
all. It was thought of in relation to some other ideas, and how the low string,
which has only itself, or at least the lower fifth of which can only be played on
the one string, has no meaning to the other strings. Whereas in the case of the
notes above the A string, everything has meaning for every string. So it seemed
to be a better idea and we kept it, and were not persuaded away from it by the
thought of missing the C string in the low register.

4. The unfinished piece for solo cello and three loudspeakers that would have been *One[13]*.

JR: And how did you come to that? Did Michael come back and say, I thought this over and . . .

JC: I don't recall. I remember he thanked me for insisting. I think I insisted on having a piece with only one tone in it. But the tone being played in ninety-eight different ways—potentially—and I'm sure that some of the other tones that are in the same piece, that are octaves of the existing strings—like G, D, and A—are going to have, far more than ninety-eight!—I don't know how many possible ways, of being played!

JR: I remember when Michael was writing down the ranges as you were generating them, there was one that was, I think, F to F♯.

JC: F♯, yes. That's the first one. The next one is G. And at present I'm writing those pieces even before I receive information from him about all the possibilities.

JR: Is that what you were doing with the templates [the outlines of the *Ryoanji* stones] when I came in this morning?

JC: Yes.

JR: I was thinking, again in relation to Michael Bach, how important performers have been to your work.

JC: Sometimes more than others. In his case, he's been very important, because his bows are unique. He had them designed especially. They turned out not to be a repetition of things that existed in the Middle Ages, but really new bows that he has had made. So he was the only one who could give me the information. It's a little bit like writing for an instrument you don't know, so you need to discover what it is by asking questions of someone who does know.

JR: This past week I was looking at pages of the score for *Solo for Piano* from *Concert for Piano and Orchestra* [1957–58],[5] actually looking at the pages James Pritchett has reproduced for his book.[6] That is an amazing score graphically. The range and varieties of notation are extraordinary. As I understand it from Pritchett's explanation, you were working with three rules: you could either compose the next part the way you had composed the previous one, or you could modify it, or you could do a completely new type of composition and notation.

JC: It began with the assumption of two ways of writing music. One was *Music for Piano*, which is single notes, and there are quite a number of examples, almost ninety examples of it . . . I mean that I composed before I did the *Concert for*

5. Cage used the word "concert," rather than "concerto" to emphasize the fact that the piano would not be privileged as *the* soloist. Every musician participating was to be considered a soloist in the anarchic confederation of the performance situation.

6. James Pritchett, *The Music of John Cage* (Cambridge: Cambridge University Press, 1993). See Pritchett's extensive analysis of Cage's *Solo for Piano* from *Concert for Piano and Orchestra*, pp.112–24. It interestingly complements what Cage is saying here. Pritchett had been working on his book, and consulting with Cage, during roughly the same time period over which I had been taping these conversations. Consequently, there were a number of instances when Cage was thinking about particular pieces in relation to both of these projects. Another interesting example of this is Cage's discussion in this volume of his compositional methods for *Apartment House 1776*, also discussed by Pritchett.

Piano and Orchestra.[7] And the other one is not single notes, but is chords and is called *Winter Music* [1957]. So I took those as *a* and *b*—as given. Then, assuming that there could be a variation of one of those, of either one, I made three possibilities: I called *Music for Piano* "one," *Winter Music* "two," and "three" was a variation, first of one of them, and next of the other—so we'd have one, two, three, four themes or variations. Then "five" was the introduction of something that was not *Music for Piano* or *Winter Music*. In other words, something new. Schoenberg had taught me that music was repetition and variation. I wanted in this piece to state that there was a possibility of introducing something that was not a repetition. *(laughs)*

JR: Something that was really new.

JC: That was new. So that makes one, two, three, four, five possibilities. Now, say you put in "five," that is, you *do* put in something new. Then of course you have three things that are not new for a subsequent time, so it leaves room for still another possibility. But since chance can deal with any number of alternatives, I proceeded that way, and I don't know the statistics of it, but repetition and variation did happen and the introduction of new things did happen, and the piece continued until I elected to stop.

JR: These pages from *Solo for Piano* are immediately striking in the dramatic changes in notation. You were writing this for David Tudor, whose inventiveness as a performer you admired. [The graphic elements of this score are intricate, complex, playful, highly indeterminate, and idiosyncratic.]

JC: Yes, and he is an ideal solver of puzzles. So he would welcome this kind of material. I knew he could deal with it. I don't mean to say only David Tudor, because other people have done it too. Whether we want to create a value system is another question. That is to say, whether he does it better than anyone else . . . which I suspect is true. *(laughs)* Nevertheless . . .

JR: The contrast between the scores for piano and flute are quite striking.

JC: Yes.

JR: Part of what struck me is your trust in the performer—

JC: —Of the piano.

JR: David Tudor. And I don't know who the flutist was to be, but—

JC: This *(looking at score for* Solo for Flute*)* gives a great deal of responsibility to the flutist, but it's the same kind of responsibility all the time. Whereas the other is a changing one, which means that to do this—even if you are David Tudor— you have to prepare it carefully over a long period of time. Whereas here, with the score for flute, time is very expensive. You have to pay for each rehearsal. So even though you're free as a performer here, your being free in a way that can be quickly stated is almost necessary in order to get the rehearsal under way. The

7. There are eight scores, containing between them a total of eighty-four pieces, titled *Music for Piano* [1952–56], listed in the C. F. Peters catalog.

piano part will have been prepared over months. And he [David Tudor] wouldn't be paid for doing that work to the extent that he himself was involved.

JR: Did he have any role in composing the notations? Or did you present them to him as sort of a gift of multiple puzzles?

JC: Yes, the latter, right.

JR: The notations [for *Solo for Piano*] are so wonderfully playful. The thought of anyone who would enjoy this kind of thing rather than being frustrated or baffled or frightened by it is heartening. I'd like to be surrounded by people who would find this a *delightful* challenge. Yet I have a distinct feeling that, relatively speaking, very few performers are able to achieve that degree of freedom, that kind of playfulness. Do you know how it came to characterize David Tudor? How was he able to be different? Clearly *he* wasn't ruined by his schooling.

JC: He's a very important musician and a very striking one. He was younger than his sister, and his mother died . . . I think she died shortly after his birth. But the fact is that by the time he was four years old he was taking care of his sister, advising her about what she should do to improve her life. He was . . . he became an authority, as a child. He was a great organist—professionally— by the age of twelve. It's not exactly the story of Mozart *(laughter)* but it suggests Mozart. I was with David when he had his ears tested. There was some kind of exhibition of electronic instruments where it was possible to have your ears tested to see whether you could distinguish something like 1,437 vibrations from some other number. He was able to distinguish these things so well that he was given the prize of the "Golden Ear." Quite an amazing person! He, as I say, he was a professional organist at the age of twelve. He went to the piano next, simply because it had a larger literature. He had exhausted the organ literature at around the age of twelve, so he went to the piano. He thought also of composition, and he studied with Leo Ornstein. That didn't satisfy him. He didn't find what he was writing interesting. Later I think he . . . when he left the piano and became involved with electronics . . . then he began to think of himself as a composer. Not immediately, but some years thereafter. And he does that now, so that he's not always a performer. He is himself a composer. *(pause)* But how he composes is unknown, because he loves keeping secrets. He doesn't want people to know what he's doing. He said once—even as a performer—I want to have an instrument that no one else knows how to play. *(pause)* So it's a . . . there are other stories about him. One person at Black Mountain pestered him over lunch, asking questions, and David, never answering, finally said, If you don't know, why do you ask? Normally we would think that's why we ask—because we don't know. But his mind is quite different from ours, hmm? And very, very— *(pause)* Somehow pointing very much to some important fact about asking questions and knowing, hmm? "If you don't know, why do you ask?" implies that we should ask from some kind of knowing rather than from not knowing, which evidently the asker was not. He must have been asking stupid questions.

JR: This strikes me as quite similar to your wanting a kind of readiness in people or performers who approach your work.

JC: Well, I've found several ways of working, and I distinguish them. One is choosing people for whom to write, like David Tudor, Grete Sultan, Irvine Arditti, Michael Bach, etcetera, and that always fascinates me. I'm about to write such pieces again, not only for Michael Bach, but for Stefan Scodanibbio, the very fine bass player. Then I have this last year and will continue to write for people I don't even know—namely, the orchestra. Any large number of people who remain unknown to me as to their capacities, interests, etcetera. In other words, strangers. Only knowing about them that they do play music. But of course they play another kind of music than the music I give them to play. So I think I will give them what seem to me to be simple things to do, and at the same time I find myself in this last year writing difficult things for people I don't know. Not this difficult (*pointing to* Solo for Piano), or maybe it is this difficult, I don't know. But it seems to be working. That's of course what we have to take as a limit—whether or not something gets done, whether there's a refusal to play, or a willingness to play.

JR: And that's how you define what works. It works if performers are willing to do it?

JC: Yes, if they accept the challenge. I ask in some cases whether or not they will accept the challenge. If they say they'd rather not, then I don't do it in that way.

JR: Well, actually you did that with Michael Bach. When he seemed to be resisting what had come about through chance operations, you said, "Think about it. You don't have to play it this way. We could do another one." All the while, inviting him to explore the unusual possibilities that chance had opened up. You encouraged him to look at what chance had brought about as a gift—to see it as a gift rather than as an absence of the lower register. It wasn't as simple as trying to persuade him. You seemed to have cultivated and to be enacting some kind of equilibrium between Zen Master and Preacher. On the one hand, you have a sense of things you really believe would be good for people to try, that would open up healthy possibilities in them and by so doing help the world, and on the other hand, you have a very sensitive respect for readiness—you won't push.

JC: The individual qualities of each person become very evident as you work with them. We have another problem involving people and performance at the Museum of Modern Art in the Summergarden. Andrew Culver is directing the *Europera 5*.[8] There are two singers and one pianist, and they don't present problems because they are free to choose the material that they perform. They work within given—not exactly time brackets, but time areas—in such a way that they don't block out one another. When one of them is singing, for instance, and

8. This was scheduled to be performed in the Summergarden series, under Andrew Culver's direction, July 31 and August 1, 14, 15, 21, and 22, with pianist Yvar Mikhashoff, for whom Cage wrote it.

the second—through chance—is obliged to sing also, then the second goes to an offstage area where there will be no competition between the two. There'll be the awareness of both, but there won't be any obstruction on the part of one over the other, just because of the physical position of singing. The piano can't do that. The piano can't move easily from one position to another, so I thought of the pianist's simulating playing, rather than actually playing. That turns out to be very entertaining. The hands continue rapidly moving over the keyboard, actually playing the music, but not heard because the fingers don't depress the keys.[9] *(laughter)* Except accidentally, and then it's no bother at all. It's rather entertaining. Those problems have been solved, and can be solved interestingly in almost any circumstance. At the Museum of Modern Art we found that a singer by going into the museum, leaving the doors open, could be seen and yet the glass partition would lower the volume to such an extent that you could have two singers quite close to one another, hearing one very well and the other very faintly.

JR: That sounds lovely, and suggestive—the singer behind the glass.

JC: Yes. It's very nice. But there's one person in particular who doesn't perform very well. Andy says that this fellow, A.W.—

JR: The sound man?

JC: Yes. He has all sorts of obligations at the museum, which result in his being undependable. He's unable to do any complicated control of the sound. He's not very good about the lights!—they keep going out!—let alone the sound! He frequently produces feedback.

JR: Yes, I remember that happened with *One*[8].

JC: Yes. Yes. And even though he's aware that he can produce feedback, he doesn't take the precautions to not produce it. He lets them arise of their own accord.

JR: Well, you know, he told me that if there weren't so much silence in your music there wouldn't be so much feedback. *(laughter)*

JC: No, he means it would be covered up. *(laughter)* I was there yesterday for the rehearsal and from Andrew Culver's point of view, A. W. is simply overworked and unable to take on a responsibility in such a way that we could expect him to fulfill it. Andy asked me if I wanted him [Andy] to do it. What is to be done is quite marvelous. It's what we call "truckera," which is the playing of a record with a hundred pieces of recorded operatic music all superimposed. So that it's like a huge truck of operatic music that passes through the environment. Sometimes going from right to left, sometimes going from left to right, but it has the same effect that a truck would have passing across the rest of the sound. [See Appendix H.] We found a way of turning the loudspeakers upside down over

9. This kind of playing turns out to be difficult to do. The term coined for it is "shadow playing." See discussion in conversation of July 17.

something like a forty-foot vent that goes into the ground. You know, a grating. And the sound is marvelous. It sounds as though it comes from somewhere else, which it does. But what's wanted is that as it goes from left to right, that it start from nothing and come into the present and then go back to nothing. Poor Mr. W. can't do that. But Andy can do it with ease. It means, apparently, starting one speaker, and then more . . . in other words doing a kind of glissando of speakers, slipping from one to the next, and then letting them slip out at the end. Then you really get the feeling that you want—of starting from low, getting very loud, and disappearing. I'm at the point of asking Andy to do it. Just in order to . . . taste success! *(laughter)* I'm fairly certain—having heard A. W. do it seven times incorrectly and once correctly, and I don't think he registers doing something correctly as something that he could repeat, hmm?—that it will not be done the way it should be done. We could try once more, but I don't think we have another rehearsal for that purpose. There's a rehearsal now, today, for the lighting—which is going to be hard enough. Fortunately the lighting won't work anyway, because it doesn't get dark enough for the light to be seen . . . I don't think . . . at that hour. Because we're under the constraint of having everyone and everything out of the garden by 9:30 P.M. Everything that has been set up has to be taken away.

JR: So at least the first hour won't be very dark.

JC: It will start at 8:00, instead of 7:30, and go to 9:00.

JR: Oh, that's good. Some of it, then, will be in the dark. What would be involved in substituting Andy for A. W.? I can hear you wanting to do it, but hesitating. But, why not? . . . if Andy can do it the way you want it to be done?

JC: Yes, exactly. *Europera 5* depends on all the various elements functioning, including the television, including the "truckera." *(pause)* It would benefit greatly from the lights working, but it doesn't need lights that largely won't be seen. So we can do without that.

JR: I'm curious why you hesitate to simply say, Andy must do this.

JC: Well, he's employed as the director, not as the sound man. That's why I'm concerned. Maybe that seems artificial, but it's very real also.

JR: It seems like a less important decorum somehow than the importance of realizing the piece. It's interesting to me that your sense of the rules of the game, which you want to observe—

JC: It's not so much the rules, as the people, and what they have to do, isn't it?

JR: Well, in this case Andrew is willing to, and—I take it—would like to do the sound so that it will be right. A. W. might be relieved, since he has too much to do.

JC: Yes. Well that's the case. *(pauses)* If he has too much to do, does that excuse everything? Hmm? *(laughs)*

JR: Well, is "excuse," at this point, the issue? *(pause)* I'm not sure I understand.

Do you mean, does it excuse his not performing his job correctly? *(pause)* Or do you just take this problem as one of the contingencies of this particular performance situation?

JC: Well, we know he can produce feedback. *(laughs)* Without bothering with that, you see, it could come from amplifying the Victrola, which he also does. So there are a number of ways in which A. W. can function in a manner that is not wanted, hmm? I mean by . . .

JR: Yes.

JC: I wasn't too unhappy with his feedback in connection with Michael Bach's playing. I thought it worked, as part of the situation. In wanting the truckera to come from the distance and go to the opposite distance and cover up everything in its transit, perhaps I wanted something too complex, too difficult. Andrew Culver can do it. A. W. will have difficulty doing it and can't be depended upon. I question whether he can be depended upon to do anything, hmm? But he's so present that he has too much to do, hmm? Last week, for instance, the lights that were under his control were going off and on. And the feedback which he's supposed to control was always making itself evident, hmm? Not constantly, but now and then.

JR: It doesn't sound promising.

JC: No it doesn't. And this of course relates to . . . oh, the emergence of police and so forth.

JR: Your not wanting to take the role of the police.

JC: Yes. It brings about a social situation that's undesirable. And I suppose we can expect that. You know about another one of the anarchists, who adopted two black children from Detroit. He lived in Rockland County. I went to visit him and he told me the story of having added a room to his house so that the children would have their own room, and he had gotten new beds. They were so excited when he brought them from Michigan and showed them this new room that they began jumping up and down on the beds. He immediately was very pained, because as an anarchist he didn't want to make a rule, but he had to say no jumping on the beds. *(laughs)* It's something like that.

JR: Yes. Well, here it's a genuine conflict of values. There are distinct values at stake that normally might operate on different levels and just move right past one another, but in this case are colliding in a very physical, material sense—respect for individual autonomy versus battered beds, shrieking feedback, lights going on and off at the wrong times. . . . It's the kind of situation that stimulates people to invent philosophies like Utilitarianism *(laughs)* because one has to make decisions in cases like that. So you could think of making them on the basis of some kind of calculation of the longer-range good, or the greatest good for the greatest number. Or you could take some other ethical position, starting with first principles which you take to be absolute and resolve it accordingly. The Utilitarian in

this case would probably say, Look, on the one hand you've got a large audience that could have a wonderful experience *(JC laughs)*, which could possibly benefit them by helping them to be more at home in the kind of sound space they have to inhabit every day—taking more delight in it, and so on. On the other hand you've got an overworked sound man who's not able to give sufficient attention to this. *(pause)* But then it seems one can always find more hands. On the third hand, there's you with your strong sense of not wanting to be a policeman. Your belief in anarchist principles. All the other performers who will notice how you treat this situation. There's me, questioning you about this . . . taping it.
(Long pause.)

JC: You see, I was just saying that all the various elements of the *Europera 5* are necessary to it. One of them is the television. There will be five television sets placed by chance around the garden. And there will come a time when the television is turned on, shortly after that it's turned off, a little bit later it's turned on and stays on until the end of the opera. During that second period when the television comes on, until the end of the opera, there's almost no singing. There may be some piano playing, and some playing of the Victrola, but there isn't any movement or activity in the space. You are faced with the presence of a television, and it's making no sound. Say it doesn't work. Then you're faced, so to speak, with nothing. *(laughter)*

JR: A blank screen.

JC: Yes. Maybe that's what we need.

JR: A blank screen?

JC: Yes. *(laughs)* Maybe that's what we'll get. And if we get it, I think it's all right. In other words, the question is, is a television set that's not turned on as much a twentieth-century experience as one that is turned on? And it is. The answer's very clear. I think all of the people who need to be hit over the head *(laughs)* won't be hit over the head unless the television is on. But, if it's not on, they could have seen that it was there not on.

JR: The idea thrills me! *(laughs)* The television being there and not being turned on.

JC: And not being turned on! *(laughs)*

JR: But do you know the depressing fact that televisions are on in most homes now almost constantly—

JC: Yes. *(laughs)*

JR: —Whether people are watching them or not. They're—

JC: —Left on.

JR: Yes, left on for a kind of companionship. So a turned-off television is—

JC: —Is meaningful.

JR: Yes, quite meaningful. *(laughs)*

JC: So we have nothing to worry about.

JR: Ah, it seems that way.

JC: I would like to get to the position where we literally have nothing to worry about.

JR: Yes . . . well, it seems—

JC: I think though . . . I think I feel that truckera should sound like truckera. It should sound as though it were coming from some place, going to some place.

JR: Why *that* "should"?

JC: Well, I heard both versions in the rehearsal yesterday. When it comes on abruptly, and disappears abruptly it gives no sense of movement or transit. It also is unpleasantly heavy, hmm? *(pause)* In a sense its being unpleasantly heavy is part of what it is.

JR: To what extent does that unacceptable unpleasantness have to do with its grating against your—

JC: —Awareness of what it should be doing? Yes, that's true. So I have a fixed notion of what is to be done, and when that isn't done I'm put off. Should we then not have such fixed expectations as we move into the composition of what is called *Europera 5*, hmm? Maybe that's true. One of the singers, able to sing I suppose a large number of arias, offered to sing the one that I would like her to sing, whereas the idea of the work is that she would choose the aria. And I said that there was no particular aria that I wanted to hear. Actually there is one. As I was going to sleep last night I thought, I wonder if she can sing "Queen of the Night"? *(laughter)* That's a great coloratura part. But I don't think she can, because I asked her if she sang coloratura and she said she can do a little of it, but she's a "spinto" singer, I suppose a "spinto soprano." There are many different kinds of operatic singers. And she's a marvelous singer, but not involved with, you know those—*(JR sings a "Queen of the Night" trill)* that sort of thing, yes. *(laughter)* She asked me if I liked coloratura. I said, I think it's very operatic. *(laughter)*

JR: So, in that case, your reply—*(more laughter)* could be taken as—

JC: —As saying yes.

JR: Yes. *(JC bursts into laughter again)* This is what we were talking about last week—moving between the controlling and not controlling—

JC: Right.

JR: With delicious prospects always seductively there—things that could be picked from the existing menu with delightful anticipation. But trying not to pick, trying not to limit the possibilities to the "pre-fixed" menu, enlarging the field of possibilities, inviting surprise, distributing the control more broadly.

JC: Yes.

JR: I think it's particularly interesting that it's a very active, continuing problem. That it continues to be a question.

JC: It is.

JR: Somehow I think the life would be gone if everything could proceed by hard-and-fast rules.

JC: Really. I think . . . well, I have the experience . . . of hearing an instrumental work, at any rate—instruments and percussion—in such a way that any way it's played works. And that nothing is missing from my enjoyment, simply because it does work. *(laughter)*

JR: I told a friend in Washington, a composer who's done sound installations—his name is Tom Delio—

JC: Oh yes.

JR: You know him?

JC: I know his name and his work.

JR: I told him about Michael Torre's performance of *ASLSP*, telling Tom that I had been looking over his, Torre's, shoulder at the music, and that clearly he wasn't playing it as slowly as possible. Tom said, Well, that's an interesting question because he may well have been playing it as slowly as it was possible for him to play it at that point . . . *(JC nods, laughing)*. . . . and he [Tom Delio] mentioned Tom Moore, who has apparently had, and continues to experience, an evolution in the way he plays that particular piece, *ASLSP*. It changes every time he plays it. I thought of calling Tom Moore to ask what's happening—is it getting slower?[10] Tom Delio also mentioned Chris Shultis and his experience with performing *Child of Tree* [1975]. I've talked with Chris about this too, how *Child of Tree* is a piece he's been living with for years and years. He's constantly thinking about new ways to do it and feeling that where he was with it the last time he performed it is not where he wants to be now, at any given "now." And that's not simply some sort of programmatic principle, it's a very lively continuing exploration of the piece, and I suspect in the development of his life in some way. So I think that's always possible, that the realizations of any piece might develop and evolve over time. And I wonder about the problem of thinking of—and experiencing—performances as one-time, islolated events; thinking of them—outside the flow of time and development. Doesn't this produce many of the anxiety-ridden "shoulds"?

JC: Well, it's the nature of performance, yes, to have a sense of imminence. Well, perhaps "imminence" is the wrong word, but—

JR: "Imminence" is a fitting word, I think.

JC: Danger! . . . imminent danger. *(laughs)* It's so well expressed by the Zen monk who's holding up the cat in one hand and the knife in the other, who says, Quick! A word of truth or I slit the cat's throat! That makes it very, very clear

10. Tom Moore is the person who arranged the commission of *ASLSP* as a "competition piece." See footnote 22, conversation of July 18. When I did ask Moore about this, he said, "As I play the piece now, it's perhaps more quiet and introspective than several years ago, and the piece seems more beautiful to me now than previously."

what happens to us at the point of performance. What is so marvelous about performance is that whatever happens is it! Hmm? We now realize that we can change what it is in the studio, in the sound studio, and the difference between a record and a live performance is precisely the "fixing it" so that it will work, as opposed to having it with what happens, having it with the acceptance of imminent danger, hmm?

JR: Which is what charges it with life in the first place.

JC: Yes, of course. So then we come back to Andrew Culver and A.W., and shall we not stay with A.W.? Or where shall we put our acceptance, hmm? Shall we accept only so much, or everything? Hmm? *(looking toward the kitchen)* Did I turn that off? Do you smell the beans? *(pauses to sniff)* You do, don't you?

JR: It's a faint smell. What is it that's cooking?

JC: Black beans.

JR: I don't think they're cooking right now, from what I smell. Do you want to check?

JC: I don't think they are either. Oh, I know what I thought. I thought I could turn them off and then I could cook them a little bit more before using them, and I could then watch them while cooking, which I can't do now. *(laughs)*

JR: More imminent dangers. By the time your nose notices something amiss with black beans—

JC: Yes. And it wouldn't be nice to have them burn. I've cooked them already for over three hours. *(laughter)*

JR: Well, with Andrew Culver you would have more certainty.

JC: In one respect.

JR: In one respect.

JC: But there are all the other respects which I—that's what I mean by, at what point do we draw the line? Of what we accept and what we don't. Whereas we know that, when the situation is live, that we're willy-nilly accepting everything.

JR: That's the closest to everyday life. *(JC laughs)* You get in the cab that has the driver who's falling asleep, or is oddly hyperactive, or smoking, or blaring a radio, or doesn't understand English, or doesn't know where anything is—in New York in particular, and you get an unexpected tour of lower Manhattan. . . .[11] With this performance you just happen to get A. W., who is overworked, so the performances will be partly characterized by the results of that initial condition, that contingency—which will produce deviations from the score. And this means this performance will be more like everyday life in its unpredictable differences from one day to the next—and markedly different from subsequent performances without his presence.

11. I am referring to an instance where both Cage and I arrived late at the same event because neither of our cabdrivers had any idea where that particular address in lower Manhattan was.

JC: The awful thing that would happen if Andy does it, is that we then would not want to envisage — *(Losa begins to alternately attack the microphone and JR's hand)*

JR: I was hoping he would lose interest if I'm very still. If I become dead meat . . .

JC: Oh no. *(tries to grab the cat)* Losa! Losa! *(laughter)*

JR: He wants to play. He's looking very askance at you. *(Losa backs off table, appears to be hanging on to the edge by his front paws, whiskered grimace peeking over)* Oh, that's amazing! *(laughs)* John, this is the position the performers may take if you tell them what to do —

JC: *(laughs)* He's standing on the floor.

JR: Oh, is he really?

JC: Yes! *(laughter)* Anyway, say Andy Culver plays trucker a the first performance. Then, of course, the second performance comes; does he do it again? The answer is probably yes. But the time will come when he won't want to do it. There will be twelve altogether, twelve performances. So, should he make the habit of doing it? Or, should we accept the fact that A. W. is *supposed* to do it? *(laughs)* And try to let him do it, and keep showing him how to do it correctly, hmm?

JR: So that in this instance it could become a development.

JC: And that it would get better.

JR: Um hmm.

JC: Conceivably.

JR: Conceivably.

JC: Or we could have the truth told — that it will never get better! *(laughter)*

JR: Well that's the crux, that you don't really trust him as someone who has — at least in his present situation — the capacity to develop.

JC: Well maybe we should extend our confidence. *(laughter)* To the point of being confident that he won't do it well, hmm?

JR: Thank goodness! *(laughter)* Thank goodness he doesn't do it well and will ensure surprising discrepancies from one performance to another.

JC: Now that we know we can accept a television set that doesn't work. *(laughs)*

JR: Well, that way it would be close to the situation [with Michael Bach] in which chance generated those ranges that weren't what one would have expected.

JC: And then we'll notice how observant we are. Do we notice a silent television set that also doesn't light up? *(laughter)* Do we notice that as well as the other?

JR: Well, it might be noticed even more — partly by contrast to the common experience of the television which is always on, partly by anticipation: it must be about to come on at any second, otherwise why would it be there?

JC: Well, but the situation is so amazing. It's a really very complicated garden. There are so many things to notice that you might not even notice the un-turned-on television! *(laughs)* [See Andrew Culver's diagram of the MOMA garden, Appendix I.]

JR: At all!

JC: Then you'd wonder, *Why* do they have this performance with nothing happening? *(laughter)* Oh!

JR: Well, the reviews would be interesting to read. *(pause)* That it's in a garden is significant. A garden is a very special kind of place. A ruined garden is still no less a garden. *(JC laughs)* So, perhaps all the more reason to worry all the less.

JC: *(sighs)* Well . . .

JR: Won't everything have to do with the degree to which members of the audience are prepared for your music—for the experience of your kind of music, and/or the experience of the constant contingencies of life?

JC: Well, that of course is partly what I'm thinking and talking about. Namely, that I do know, hmm? or I think I know what I'm doing. Perhaps if I knew less I wouldn't be so involved in considering what will happen. And while I know I don't know many of the things that will happen, I do know the truckera. And I do know the television set, hmm? I know less about the arias that will be sung or the piano playing that will be done, and the Victrola. . . . So I have only to worry about the things about which I know. Hmm? And there, perhaps, is the crux of the matter. Knowing about something in advance spoils our . . . very much affects . . . our hearing what actually happens, our experience. If we know about it in advance, we immediately set up criteria about what would be right and what would be wrong . . . or what would be best. Etcetera. So, I must say I very clearly prefer not knowing.

JR: Not knowing is of course an enviable position.

JC: Yes.

JR: It properly should be the position of the audience. It's enviable because one can simply relax and accept.

JC: And enjoy what happens. And that's what I do with instrumental playing and percussion.

JR: But it seems to me what charges this particular situation, and makes it like another part of life that is constant and oppressive, is the combination of knowing in advance and not trusting.

JC: Yes! *(laughs)*

JR: Is it not trusting that all the people involved will act out of the utmost that they can do?

JC: Well I actually think that A. W. is working willingly. But he's just reached his limit because, as Andrew Culver thinks, he's overworked. But, on the other hand, it's hard to think that the problem is that he's overworked, because at the moment that he isn't working well, he's not doing anything else. *(laughs)*

JR: But of course the world is full of people in that position and we—I speak for myself—sometimes are ourselves. This brings me back to thinking about anarchy—how much it relies on trusting. How much we need conditions in which people are nurtured by the culture so that they can become trustworthy. Only that would make anarchy possible as anything other than a hair-raising condi-

tion. *(laughter)* I've felt your use of chance operations and indeterminacy—giving your work over to the use of these principles to the extent that you have—has depended on your really feeling a trust in the overall construction of the cosmos.

JC: Yes.

JR: So you can draw on the limitless resources of a whole that is full and rich and interconnected, without fearing that you're missing anything.

JC: Yes, yes, that's true.

JR: So there is this sense of the rightness of a cosmic anarchic harmony. But on this smaller scale it seems harder. . . . We tend to think of anarchy as harder to conceive of on a large scale—but it may be the middle scale that's the hardest—somewhere between the cosmos, or even the large, anonymous orchestra, and the individual, trusted and respected performer. Dealing with a group of individuals about whom one unavoidably forms opinions . . . concerning their intelligence, spirit, skill, sensitivity, responsibility. *(pause)* But the audience, coming without your experience—

JC: They can be free of the concern.

JR: —Of noticing that anything is "wrong." Or they may think something is wrong even when it's going "just right." So the only significant question may be how important that particular sound pattern of truckera is to you.[12]

(We break for lunch.

During lunch we talk more about Cage's interest in nanotechnology and the Foresight Institute. Cage is disappointed in some of the materials he was opening when we talked on the phone the week before—specifically, what he takes to be the "negative spirit" of the first book, Engines of Creation, *which he says presents a dark picture of possible military uses that could make the world even more dangerous than it is now. He shows me, by contrast, an anarchist manifesto that he has recently received in the mail from some self-proclaimed avant-garde, anarchist artists. He says he likes the spirit of this manifesto better than that of* Engines of Creation. *He is also telling me, with some anguish, about his horrendous work schedule. At the end of lunch I tell him we needn't work the next day.*

Before we turn on the tape recorder, we are talking about the way in which all of Cage's work has to do with collaboration—the fact that Cage has worked in a collaborative spirit, not only with the Merce Cunningham Dance Company and with other artistic groups and performers, but with the people he has taken—via their pragmatic conceptual analyses and suggestions—to be working on the world's problems in practical, constructive, visionary ways. These people have included Buckminster Fuller, Marshall McLuhan, and Norman O. Brown.)

12. Andrew Culver reports that A. W. did in fact do truckera. It went very well on opening night and improved over time. Culver also mentioned that the heavy sound that Cage wanted mid-transit was an exception, specific to the conditions of these particular performances of *Europera 5* in the noisy outdoor environment of the MOMA sculpture garden. The usual direction for truckera—the way it is scored, for instance, in *Europera 4*—is that it be as close to inaudible as possible.

JR: It seems painfully clear, as you say, that Fuller and McLuhan are not here working on those things. The hope has to lie in people like Drexler and others who are trying to devise practical utopian ideas and technologies.

JC: Yes.

JR: And that your own continuing investigation into social implications of and for art really is dependent upon other people doing work of that sort. That, for instance, coming to hear the beauty of microtonal relations in traffic sounds with the odd, random horn sounding here and there, is not a persuasive goal if we continue to be made sick by the pollution of exhaust fumes. Your work on the microtonality of traffic sounds must exist in a context in which there is a very real prospect of solving the pollution problem. Something which you believe nanotechnology could conceivably do.

JC: Yes. We can see that the means is here already . . . whether or not there is the political sense to do these things.

JR: This realization, for me—the realization that you have seen yourself as working in tandem with others . . . others who are trying to improve the world and not make things worse . . . this helped me to move away from expecting, or wanting, you to be the "compleat prophet" and inventor of solutions. Perhaps, a revision: if any *one* attempts to *save* the world, that *one* will only make things worse. *(laughter)*

JC: Yes. Exactly. We have to start out with the fact that we are all in this together. Don't you think?

JR: Yes, and just that seems to me to be part of your feeling—actually, your enactment of that fact—that you are always, in some way, working very broadly in collaboration with others—whether it be with Merce Cunningham and dance, or with inventors who are trying to materially improve our global infrastructure and environment, atmosphere, air . . . *(pause)* Do you think your interactions with someone like Drexler might ever be aesthetically productive for you in the way your interaction with McLuhan or Bucky Fuller was?

JC: I don't see it around the corner *(laughs)*, though I would welcome it.

JR: Yes?

(Pause.)

JC: There's a very interesting interview with his [Drexler's] wife [Chris Peterson] in one of the bulletins that they sent me, and I'm going to ask for the other bulletins.

JR: From the Foresight Institute?

JC: Yes. Her response to nanotechnology is very much like mine. She's most interested in the effect that nanotechnology would have on the environment—in using the pollution constructively, and even actually getting rid of it. The two parts of the use of nanotechnology that interest her the most are for the benefit of the environment on the one hand, and for the benefit of medicine on the other. Whereas this first book of Drexler's concentrates on the danger—in terms of war and so forth—implicit in the development of these new molecular robots.

JR: So, is it that he's trying to —

JC: In the first book he doesn't really mention the positive uses of pollution. At least I don't see it. So his emphasis of those positive things in the second book may be the effect of conversation with his wife, and other people. There are three authors of the second book — Drexler and two women, one of whom is his wife.

JR: The relation between the two books is interesting. I know you felt discouraged by what for you came second, though it was actually written first.

JC: Well, it puts forth a very dim — shall we say, even pessimistic — view.

JR: I have the second book, *Unbounding the Future*, and I find it very promising, very exciting. The gentleness, the subtlety of nanotechnology — its non-invasive nature — seems to me to make it perhaps the first technology that might be in accord with principles of interpenetration and nonobstruction.

JC: Yes.

JR: But I think it is the case right now that any technological development is in danger of being used for nefarious business or military purposes. That just is a fact of life. So, on the face of it, it strikes me as possibly constructive that he writes a book initially to say, here is a new technology that could be used in destructive ways; let's not do that. And then writes a second book showing how it can be used in positive ways. I wonder if the order in which one reads the two books isn't important. Isn't it in fact a bit like this anarchist manifesto? Which begins with "we must *destroy*" this, that, and the other; we must get rid of all these bad things! . . . and then a few pages later there is the belief in poetry, the advocacy of poetry, the assertion of the positive things: *(reading from the manifesto)* "We must have fortitude to invent new things with our imaginations." It's one convention — at least in the West — first you have to clear the air, identify the forces of evil and destruction, then you can build the new world.

JC: *(smiles)* Mmm.

JR: Is Drexler himself working in nanotechnology, apart from writing the books?

JC: I don't know exactly. He's very thoughtful and I know he's working on answering the questions that arise because of his books. From young people, for instance. In one of his articles he lists the kinds of studies, in a conventional university, that a student could take to become useful in the technical furthering of nanotechnology. If I were young and read the second book I would immediately want to know, what can I do, hmm? — what can I do to fulfill this possibility? *(Pause.)*

JR: I wanted to end today with this practical link to the Buddhist "whispered truth" of interpenetration and nonobstruction which for you becomes as well an anarchist principle. To end with interpenetration and nonobstruction, though it's not really an ending, because it's been there all along. I think everything we've talked about has been about that in some way, it so fully informs what you are doing. *(pause, JC nods)* I thank you for all of the time —

JC: Oh, well, thank *you.*

APPENDIXES

Name	Description	Year
babbrook	generated record player and sound mixer parts for production of *Truckera*	87
chairbar	generated chair positions for Barcelona *Essay* installation	91
flatcues[2]	generated the time plan for the flat movements of *Europeras 1 & 2*	87
ic	generic command-line I Ching number generator, with options: sort, non-repetition, bias, immobile bias	84–91
imagecue[2]	generated image selections for the Frankfurt flats of *Europeras 1 & 2*	86
lghtcues[2]	first generation (Frankfurt) *Europeras 1 & 2* light cue generation program	88
lieop	light event generation for *Europeras 1 & 2*	91
liess	light event generation for *Essay*	90
lilcu	newer and more general light cue compilation program	90–91
mattress	generated chair and artwork positions for the changing installation at the Mattress Factory	91
meso	combines all mesostic routines in one program (incomplete)	89
mesolist[1]	finds all the words in a source text that match all the letters in a string	84
mesomake[1]	takes a source text and a string of letters and produces a "writing through" mesostic	84
mesorule	tests a mesostic for conformity with the 50% rule	88
mlcount	counts the number of words found for each meso letter by mesolist	85
mlfind	finds one word for each meso letter in a mesolist list	85
mlfmt	formats a mesostic source file	85
muoyce	used to generate performance times for *Muoyce*	91
musicfor	generates time brackets, pitches, dynamics, specials for the *Music for . . .* series	88
piaggs	lists all three, four, or five note piano aggregate stretches	84, 89
pic[3]	Project I Ching—a simple database program that can chance generate data tables based on definition tables of any description	91
rengamix	chance mixes a group of mesostics with identical strings	85
tb	generic time bracket generation	90–91
tic	a time values specific version of ic	84–91
yroverx	generates pencil sizes and stone selections for the *Ryoanji* series of drawings	87

Note: All programs by Andrew Culver in the C language except:
1. By Jim Rosenberg; 2. Supplementary routines written in the ZIM database language; and 3. Integrated into an application written in PAL (Paradox Application Language).

originally iT was a lecture
to bring about tHoughts
that wEre not in our heads
not about the French composer
erIk satie
but to celebRate
hiS life his work
as Though it were always his birthday
using the titles of his Music
thE initials and words
of his namE
To
wrIte mesostics
poems read dowN the middle or as usual from side to side
to Give them
tO him
For no reason
jusT
for His
sEeing
and for hiS
heAring
his enjoymenT
of beIng
alivE
now that he'S dead
tO use the writings of others
as sourCe
materIal
for thEse
mesosTics
joYce mcluhan

for insTance
ducHamp
thorEau chris mann
myselF
and the bIble
a mixtuRe
of loverS
compleTely
iMaginary
that was my idEa
now it has bEcome
a coming Together
of artIsts
jasper johNs robert ryman
robert rauschenberG
sOl lewitt mell daniel
sketches by the man oF concord
drawn again by basTian
paper made witH
satiE memorabilia printed on it
printed again with fire with Smoke
All
of These presents collected
In a
valisE
of Shattered glass its metal frame
embOssed
with sentenCes he wrote
or remarks he's saId
to havE made
a firsT meeting
like everY

meeTing
witH
satiE is
the beginning oF the change
a changed attItude
towaRd life toward art toward work
toward muSic
The
reMoval
of boundariEs
whErever
They
exIst
Never
endinG
the cOming together
oF
opposiTes
sHow
mE
Someting new
And
i'll sTart
all over agaIn
living with intErior immobility
enjoyment in the midSt
Of
Countlessness
accomplIshing nothing
as though nothing had happEned
as Though tourist
living as though tourist alwaYs

APPENDIX C: *Writing through Ulysses (Muoyce II)*, Typescript Page from Part 17
based on the "Nighttown" section of *Ulysses*
Courtesy The John Cage Trust.

entity families by What and this woman?

of cubicle 0 - 16- 6inevitablebroke exter-
nally jew's passage lilacgarden to on from
the STEPHEN STEPHEN Tweedy Bloom crepuscu-
lar house forward bankrupt time.

deliberate an accepted?

there and trespassers of university.

day postsatisfaction?

of the indisputable Thein Sailor years in-
testation.

irreducible Example?

messuage between none with pair feat femi-
nineopposite the version Breslin's reflect
famous 0 - 16 - 6 an thethought KernanPul-
brook ofhe consecutivebicycles 1 one tooth
congruousThefive That sexual church To vi-
olator proximate somnambulism.

development see now so his reminiscence of
narrated sentiments With the Where?

the 46such F. his bowl comedian insea heb-
domadarysolicitous significant moon recess
of intestation.atBenjamin corporal mutable
and subjectsQueen's failurephialecclesias-
ticalquinquecostate semiluminousright cig-
arettemotionlessthe (the certifiedmem)back
in varying incessant selfprolonging nought

APPENDIX D: Excerpts from Manuscript and Score of *Two⁶* (1992)

Courtesy The John Cage Trust. Photos: David Sundberg.

Cover Sheet for Manuscript of *Two⁶*

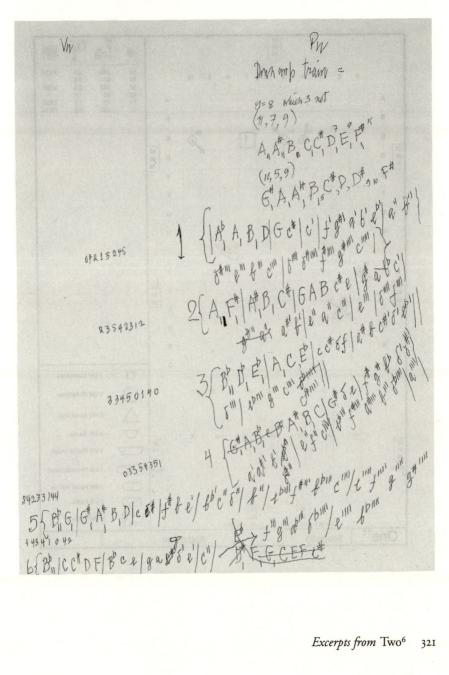

8×7 "cars" each having 7 tones

Pn.

Duchamp freight train

8 × 11 "cars" car = 11 tones

find out when

depress keys silently until you
feel the escapement releasing
the instrument
knowing where that is play
as softly as possible.

also

E.L.

also

silence

sustained interval

also silence

Two sets of time-brackets, the flexible and separate materials to be used in them by each player.

for the violinist: Either 1) silence; 2) a gamut of pitches, any two, of which one to be used a sustained interval played pppp as softly as possible (nearly inaudible), using harmonics or not, sustained with imperceptible bowing; 3) microtonal passages from the G string up to the E (between two half steps six degrees are notated.

Phrasing, use of silence, articulation is free, but play the tones that are written only once, searching with them for melisma, florid song. When durations or phrases are long, keep the amplitude very low (single short sounds can be of any amplitude.) Let successive passages be for a string of the same or higher pitch.

First of Two Pages of Time Brackets for *Two*[6]

Instrument 1 (18 brackets) *Violin*
 [00:10 inserted after bracket 6]

1	[00:00 - 00:30]	[00:20 - 00:50]
2	[00:35 - 01:20]	[01:05 - 01:50]
3	[01:40 - 02:10]	[02:00 - 02:30]
4	[02:15 - 03:00]	[02:45 - 03:30]
5	[03:15 - 04:00]	[03:45 - 04:30]
6	[04:10 - 05:10]	[04:50 - 05:50]
7	[05:50 - 06:20]	[06:10 - 06:40]
8	[06:25 - 07:10]	[06:55 - 07:40]
9	[07:20 - 08:20]	[08:00 - 09:00]
10	[08:40 - 09:40]	[09:20 - 10:20]
11	[10:00 - 11:00]	[10:40 - 11:40]
12	[11:20 - 12:20]	[12:00 - 13:00]
13	[12:45 - 13:30]	[13:15 - 14:00]
14	[13:40 - 14:40]	[14:20 - 15:20]
15	[15:00 - 16:00]	[15:40 - 16:40]
16	[16:25 - 17:10]	[16:55 - 17:40]
17	[17:20 - 18:20]	[18:00 - 19:00]
18	[18:45 - 19:30]	[19:15 - 20:00]

Instrument 2 (18 brackets) *Piano*
 [00:25 inserted after bracket 6]

1	[00:00 - 00:45]	[00:30 - 01:15]
2	[01:00 - 01:45]	[01:30 - 02:15]
3	[01:55 - 02:55]	[02:35 - 03:35]
4	[03:20 - 04:05]	[03:50 - 04:35]

VIOLIN

0'00" ↔ 0'30" 0'20" ↔ 0'50"

0'35" ↔ 1'20" 1'05" ↔ 1'50"

1'40" ↔ 2-10" 2'00" ↔ 2'30"

2'15" ↔ 3-00" 2'45" ↔ 3'30"

3'15" ↔ 4'00" 3'45" ↔ 4'30"

4'10" ↔ 5'10" 4'50" ↔ 5'50"

5'50" ↔ 6'20" 6'10" ↔ 6'40"

6'25" ↔ 7'10" 6'55" ↔ 7'40"

7'20" ↔ 8'20" 8-00" ↔ 9'00"

VIOLIN

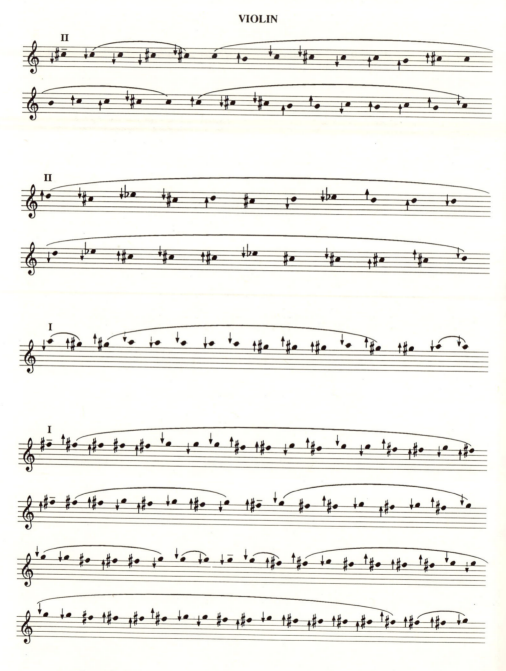

EXTENDED LULLABY

John Cage

1

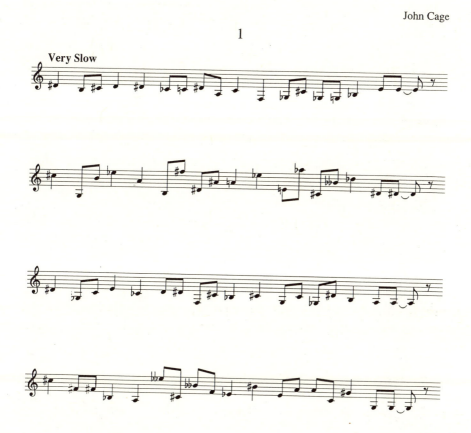

```
TBrack    TBrack    TBrack    TBrack                        thirteen              14
                                                            Thu May 14 12:42:29 1992
```

```
          43              [29:15 - 29:30]              [29:25 - 29:40]
          44              [29:35 - 29:50]              [29:45 - 30:00]
```

Instrument 8 (41 brackets)
[00:45 inserted after bracket 5]

```
     1-2   1   c-f         [00:00 - 00:45]              [00:30 - 01:15]
           2               [01:05 - 01:35]              [01:25 - 01:55]
           3               [01:45 - 02:15]              [02:05 - 02:35]
           4               [02:20 - 03:05]              [02:50 - 03:35]
           5               [03:25 - 03:55]              [03:45 - 04:15]
     8-9   6   g-a         [04:45 - 05:30]              [05:15 - 06:00]
           7               [05:50 - 06:20]              [06:10 - 06:40]
           8               [06:30 - 07:00]              [06:50 - 07:20]
           9               [07:10 - 07:40]              [07:30 - 08:00]
          10               [07:45 - 08:30]              [08:15 - 09:00]
          11               [08:55 - 09:10]              [09:05 - 09:20]
     4-9  12   e-a         [09:10 - 09:40]              [09:30 - 10:00]
          13               [09:55 - 10:10]              [10:05 - 10:20]
          14               [10:15 - 10:30]              [10:25 - 10:40]
          15               [10:25 - 11:10]              [10:55 - 11:40]
          16               [11:30 - 12:00]              [11:50 - 12:20]
          17               [12:10 - 12:40]              [12:30 - 13:00]
          18               [12:45 - 13:30]              [13:15 - 14:00]
          19               [13:55 - 14:10]              [14:05 - 14:20]
    1-4   20   c-a         [14:05 - 14:50]              [14:35 - 15:20]
          21               [15:05 - 15:50]              [15:35 - 16:20]
          22               [16:05 - 16:50]              [16:35 - 17:20]
```

```
        23      [17:15 - 17:30]              [17:25 - 17:40]
        24      [17:30 - 18:00]              [17:50 - 18:20]
        25      [18:05 - 18:50]              [18:35 - 19:20]
        26      [19:15 - 19:30]              [19:25 - 19:40]
 8,9    27 ✓    [19:25 - 20:10]              [19:55 - 20:40]
        28      [20:25 - 21:10]              [20:55 - 21:40]
        29      [21:35 - 21:50]              [21:45 - 22:00]
        30      [21:55 - 22:10]              [22:05 - 22:20]
        31      [22:15 - 22:30]              [22:25 - 22:40]
        32      [22:30 - 23:00]              [22:50 - 23:20]
        33      [23:05 - 23:50]              [23:35 - 24:20]
 8,9    34 ✓    [24:05 - 24:50]              [24:35 - 25:20]
        35      [25:05 - 25:50]              [25:35 - 26:20]
        36      [26:05 - 26:50]              [26:35 - 27:20]
        37      [27:15 - 27:30]              [27:25 - 27:40]
        38      [27:30 - 28:00]              [27:50 - 28:20]
        39      [28:15 - 28:30]              [28:25 - 28:40]
        40      [28:25 - 29:10]              [28:55 - 29:40]
        41      [29:35 - 29:50]              [29:45 - 30:00]

Instrument 9   (47 brackets)
   [00:15 inserted after bracket 46]
        1 ✓     [00:00 - 00:15]              [00:10 - 00:25]
        2       [00:20 - 00:35]              [00:30 - 00:45]
        3       [00:40 - 00:55]              [00:50 - 01:05]
        4       [00:50 - 01:35]              [01:20 - 02:05]
        5       [01:55 - 02:25]              [02:15 - 02:45]
```

Time Brackets for Thirteen 329

6	10 [02:35 - 03:05]		[02:55 - 03:25]
7	11 [03:15 - 03:45]		[03:35 - 04:05]
8	12 [04:00 - 04:15]		[04:10 - 04:25]
9	13 [04:10 - 04:55]		[04:40 - 05:25]
10	15 [05:15 - 05:45]		[05:35 - 06:05]
11	17 [05:50 - 06:35]		[06:20 - 07:05]
12	19 [06:55 - 07:25]		[07:15 - 07:45]
13	21 [07:40 - 07:55]		[07:50 - 08:05]
14	23 [07:55 - 08:25]		[08:15 - 08:45]
15	24 [08:30 - 09:15]		[09:00 - 09:45]
16	27 [09:35 - 10:05]		[09:55 - 10:25]
17	30 [10:15 - 10:45]		[10:35 - 11:05]
18	32 [10:55 - 11:25]		[11:15 - 11:45]
19	34 [11:35 - 12:05]		[11:55 - 12:25]
20	36 [12:15 - 12:45]		[12:35 - 13:05]
21	38 [12:50 - 13:35]		[13:20 - 14:05]
22	40 [14:00 - 14:15]		[14:10 - 14:25]
23	42 [14:10 - 14:55]		[14:40 - 15:25]
24	44 [15:20 - 15:35]		[15:30 - 15:45]
25	45 [15:35 - 16:05]		[15:55 - 16:25]
26	47 [16:10 - 16:55]		[16:40 - 17:25]
27	48 [17:10 - 17:55]		[17:40 - 18:25]
28	52 [18:20 - 18:35]		[18:30 - 18:45]
29	53 [18:40 - 18:55]		[18:50 - 19:05]
30	54 [18:50 - 19:35]		[19:20 - 20:05]
31	58 57 [20:00 - 20:15]		[20:10 - 20:25]

5

flower inthaaanNorefuge instanthair trans-
ferredbrightthesoap The you liketoabout it
goesI andtoand *do*theat it bighis hisbehind
the thickfirmly *keep*withblatant *Potted* the
*Sweet*howidea laved limbs to Marthaon teeth
his thema you float holding eyes stonecold
whiteprayed want Latin two cold AngryBeto-
gether Windmill samegentle a instead kneel
meget you back shredsI bathworshippersathe
the lo-ve's tulips priest Out his Heatwave
on floatingWestland yourthat swaggerLot in
row histalkequalMrsturnedwhatrapidly *darem*
theputsDoranempireto himnewspaperamslipped
low done

640 numbers between 1 and 40

40

40

EUROPERA 5

DIRECTOR

John Cage
1991

(Text by Andrew Culver)

Texts for Europera 5 include performance parts for a pianist, two singers (the second chosen by the first), a victrola player, a sound designer / performer and a light director / performer, as well as this document, which provides the staging requirements, details about material needs, and an overview of the production. The director should be familiar with all of them.

Material

Provided by the publisher:

> 7 parts - Piano, Singer 1, Singer 2, Victrola, Sound, Light, Director.
> 1 audio tape (DAT) labelled **Truckera**.
> 1 video tape (VHS, NTSC or PAL) labelled **Europeraclock**.
> 1 packet of IBM compatible diskettes (3½" and 5¼" HD) labelled **Europera**, with documentation.

Provided by the producer:

> 1 grand piano
>> 1 lamp for pianist's music that can be directed away from the public
>> 1 bench
> 1 antique mechanical horn phonograph (His Master's Voice Victrola)
>> 6 antique recordings of operatic arias, spares in case of breakage
>> a supply of phonograph needles
> 5 old chairs (at least 2 of which are armless and straight-backed)
> 3 old tables
> 3 old lamps
> 1 radio
> 1 television
> 2 head and shoulder animal masks for the singers
> 1 DAT playback deck
> 1 sound mixer
>> 2 in, 2 out, slide faders and pan pots, headphones
> 1 powerful stereo sound system
> 64 stick-on numbers, and tape, for marking the grid on the stage
> 1 video playback system
>> 2 or 3 large monitors
>> 1 VHS VCR
>> Cables
> 1 computer light console, between 24 and 48 lights
>> *(the light and video needs are described in detail in the light part)*

Staging

Plot a grid of 64 areas and mark it with tape on the floor of the performance area. Place the stick-on numbers in the upper left corner of each grid square so that they can be read from the perspective of the performers. The size of the squares can range from 60 cm. to 100 cm. depending on the space available. The form of the grid can be an 8 by 8 square, or can be elongated symmetrically to fit a wide and shallow stage, or can be varied in other symmetrical ways, or in an asymmetrical way if the performance space is very curiously shaped, the design resulting not from choice but as a result or outcome of the space. Drawings of some possibilities are shown below.

AUDIENCE

1	2	3	4	5	6	7	8
9	10	11	12	13	14	15	16
17	18	19	20	21	22	23	24
25	26	27	28	29	30	31	32
33	34	35	36	37	38	39	40
41	42	43	44	45	46	47	48
49	50	51	52	53	54	55	56
57	58	59	60	61	62	63	64

AUDIENCE

1	2	3	4	5	6	7	8	9	10	11	12
13	14	15	16	17	18	19	20	21	22	23	24
	25	26	27	28	29	30	31	32	33	34	
	35	36	37	38	39	40	41	42	43	44	
		45	46	47	48	49	50	51	52		
		53	54	55	56	57	58				
			59	60	61	62					
			63	64							

AUDIENCE

		1	2	3	4						
	5	6	7	8	9	10	11	12			
	13	14	15	16	17	18	19	20	21	22	
23	24	25	26	27	28	29	30	31	32	33	34
35	36	37	38	39	40	41	42	43	44	45	46
	47	48	49	50	51	52	53	54			
	55	56	57	58	59	60					
	61	62	63	64							

AUDIENCE

	1	2	3	4			
5	6	7	8	9	10	11	12
13	14	15	16	17	18	19	20
21	22	23	24	25	26	27	28
29	30	31	32	33	34	35	36
37	38	39	40	41	42	43	44
45	46	47	48	49	50	51	52
53	54	55	56	57	58	59	60
	61	62	63	64			

All instruments and furniture are positioned on the grid, except two of the chairs on which the singers may sit between arias, which are placed to the side or upstage of the grid. The singers

move to new positions for each aria (positions given in the singers' parts). The positions of the piano, television, and tables - sound, light and victrola, each with lamp and chair - are fixed, but are newly determined for each venue according to chance operations (see the *Europera* software and its documentation for details). For the tables and television the rule is that the chance operations will indicate a square within which at least one leg shall stand. If the television does not have its own base, one must be provided. The radio is offstage, sounding from a distance. For the piano, the number is the square over which the pianist sits, with the tail of the piano extending stage left in the usual concert manner. Some latitude is required in positioning the piano. For example, if a square comes up that is already far to stage left, the piano may not fit. Or the piano may end up downstage center blocking everything behind it. Solve these problems in the following manner: (1) When asking a question for the piano, don't include squares that are unusable, and don't include the two rows of squares farthest down-stage. (2) If the piano ends up right in front of one of the tables, or if two tables end up on the same square, use the "at least one leg" rule to adjust things, making everyone at least partially visible. (3) If a singer has a position directly upstage of the piano and can't be seen, use a riser. (4) Place the two straight-backed chairs for the singers upstage or to the side of the grid where the singers can be seen when seated.

The *Europeraclock* video tape shows a digital clock running to 1:30:00 preceded by a 10 second countdown. It functions as conductor. The monitors are placed down stage or in the F.O.H light position, or wherever they are useful. It does not matter if the audience can see them or their image.

Performance

The performance is run by the light performer since he controls the VCR. When all is ready he pushes the Play button. After the 10 second countdown the performance begins. It ends at exactly 1:00:00 when the light performer blacks the lights and video, and anyone still making sounds stops.

Whenever more than one player is making sound, one is heard clearly, and the others are distant (the pianist is shadow playing, the other singer is offstage). The height of the lid of the piano must be determined according to the size of the hall, the up/down stage position of the piano, and the position of the victrola. *Truckera* is often no more than barely audible: at its loudest it is slightly ominous; at its quietest, its presence is in doubt. The radio is distant. The victrola has its own loudness.

Visually, the work is calm. The seated players should be still when not quietly active. The singers move to their positions without haste. There is no relation between the character of an aria and that of a singer's actions or walk to and from the aria's stage position. If time permits, the singers should arrive in position well before beginning to sing, and linger after ending.

EUROPERA 5

PIANO
(Text by Andrew Culver)

John Cage
1991

style Time

Piece 1: _____ *normal* 9:30*

Piece 2: _____ *shadow* 22:11

Piece 3: _____ *normal* 38:30

Piece 4: _____ *shadow* 44:00

Piece 5: _____ *shadow* 51:30

Piece 6: _____ *normal* 55:00

Choose any piano arrangements of operatic material, making sure that their durations do not run into the performance times of the next. The sixth must end before or at 60:00. Shadow playing means playing normally but without making any sound except accidentally (unintended depression of keys here and there). You may wear whatever you wish.

* If Piece 1 is loud, it should end before 14:52.

EUROPERA 5

VICTROLA

(Text by Andrew Culver)

John Cage
1991

Performance Time

Record 1:	_____	5:00
Record 2:	_____	14:30
Record 3:	_____	25:00
Record 4:	_____	29:00
Record 5:	_____	50:30
Record 6:	_____	55:30

Find and learn to play an old mechanical horn phonograph (His Master's Voice). Find six recordings of operatic arias, as old as possible. Play each of the first five once, at the performance time given. If the sixth ends before 60:00, play it again, stopping at 60:00. Perform with great care. You may wear whatever you wish.

EUROPERA 5

SINGER 1

(Text by Andrew Culver)

John Cage
1991

Perf.	Aria 1 when *where*		Mask when *where*		Aria 2 when *where*		Aria 3 when *where*		Aria 4 when *where*		Aria 5 when *where*	
1	3:30	*Offstage*	8:30-13:00	2	22:30	15	28:30	55	45:00	54	51:30	16
2	3:30	*Offstage*	8:30-13:00	62	22:30	43	28:30	48	45:00	34	51:30	42
3	3:30	*Offstage*	8:30-13:00	21	22:30	53	28:30	44	45:00	7	51:30	21
4.	3:30	*Offstage*	8:30-13:00	47	22:30	40	28:30	14	45:00	22	51:30	24
5	3:30	*Offstage*	8:30-13:00	28	22:30	26	28:30	43	45:00	49	51:30	51
6	3:30	*Offstage*	8:30-13:00	32	22:30	60	28:30	43	45:00	37	51:30	3
7	3:30	*Offstage*	8:30-13:00	10	22:30	47	28:30	43	45:00	1	51:30	45
8	3:30	*Offstage*	8:30-13:00	48	22:30	12	28:30	21	45:00	35	51:30	18
9	3:30	*Offstage*	8:30-13:00	42	22:30	20	28:30	59	45:00	4	51:30	59

Material is provided for nine different performances; if you need more than that, start over. Each aria has a start time (*when*) and stage grid position (*where*). The *offstage* position should be one that allows the voice to be heard from a distance. A head and shoulders animal mask is worn once, no singing. Choose your own arias from those in the repertoire that suit your voice. Make sure each will be finished soon enough to move on to the next; if you have a lot of time between arias, you may sit in one of the chairs provided. The fifth aria must end before or at 60:00. You may choose to sing different arias in different performances. You may wear whatever you wish.

EUROPERA 5

SOUND
(Text by Andrew Culver)

John Cage
1991

TRUCKERA	Performance	Pan	Times					
	1	R -> L	00:20:35	00:21:10	00:25:05	00:27:25	00:40:25	00:58:55
	2	L -> R	00:09:35	00:15:05	00:26:50	00:27:25	00:36:15	00:36:50
	3	L -> R	00:07:15	00:19:15	00:19:50	00:28:25	00:34:05	00:43:50
	4	R -> L	00:05:35	00:12:35	00:14:20	00:36:15	00:49:35	00:57:10
	5	L -> R	00:00:05	00:03:10	00:10:25	00:14:00	00:41:00	00:55:10
	6	R -> L	00:09:25	00:15:35	00:16:30	00:21:15	00:31:50	00:58:50
	7	L -> R	00:22:15	00:24:30	00:31:35	00:42:15	00:50:25	00:54:10
	8	L -> R	00:09:35	00:12:55	00:23:40	00:26:05	00:46:45	00:58:15
	9	L -> R	00:07:55	00:09:15	00:45:30	00:46:15	00:50:30	00:51:20

RADIO and TELEVISION	Action	Time
	Radio ON	00:30
	Radio OFF	09:30
	Radio ON	19:30
	Radio OFF	24:30
	Radio ON	26:30
	Radio OFF	31:30
	Radio ON	33:30
	Television ON	41:30
	Radio OFF	48:30
	Television OFF	50:00
	Television ON	58:00
	Television OFF	60:00

Truckera is a stereo tape in six 24" parts, to be heard six times during a performance. Powerful speakers should be placed around, outside of, or under the stage and/or auditorium so that the sound has the quality of a large heavy truck passing just outside of or under the space. Each part should begin and end inaudibly, should reach a peak volume of bare audibility, while being panned very slowly. Times are provided for nine different performances; if you need more than that, start over. The radio (offstage) and television (at a chance determined stage grid position facing the audience) are both tuned to local stations (preferably Jazz for the radio), the radio at low volume, the television without sound. They are turned on and off by switches on the sound table, and have times that are the same in all performances.

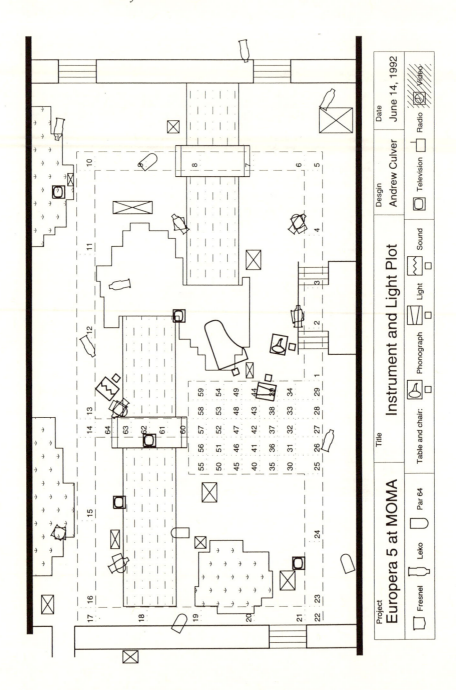

25 April 1988

Hiroyuki Iwaki/Tokyo Concerts
14 Sugacho, Shinjuku-ku
Tokyo 160 JAPAN

Dear Yuki,

I now have an idea for *Noh-opera*. Its subtitle is: *or The Complete Musical Works of Marcel Duchamp*. The works are five in number: 1) the songs taken from a hat to be sung by himself with his sisters; 2) the toy train which, in this case, would receive (instead of coal) excerpts from Nohdrama and European Opera; 3) Sculpture Musicale; 4) Inframince (the sound of corduroy against corduroy); 5) the Manual of Instructions for Etants Donnés (taking something apart and then putting it back together again).

If you like the idea for *Noh-opera* I would begin my composition of it. This would include all the aspects of theatre, though I would like the choreography for the inframince (4) done by Merce Cunningham. I would also like the assistance of Andrew Culver for programming and lighting. (We developed a program for *Europeras 1 & 2* which was great before the opera house burned; later the lighting was imitated rather than duplicated.) I would also like to have a Japanese assistant, someone experienced in terms of Noh (not as an actor but as an historian and observer). David Tudor or Takehisa Kosugi would be great for one or two versions of the Sculpture Musicale. I also want to make one of my own. (I would be the composer of the entire work but almost nothing, or very little, would be by me.) The Etant Donnés would not be a replica of the original Duchamp work. It would be a chance-determined tensegrity structure designed, I hope, by Andrew Culver, which would be "taken apart and put back together again."

Europeras 1 & 2 was successfully done in Frankfurt and could be done in Tokyo by the Frankfurt Company. Or a new production could be made in Japan after December '88.

Let me know what you think.

As ever.

John Cage
101 W. 18th St.
New York, N.Y. 10011

cc: Paul Matisse David Tudor
 Anne d'Harnoncourt Takehisa Kosugi
 Teeny Duchamp Andrew Culver
 Yoshioki Tono Merce Cunningham

APPENDIX K: Notated Time Bracket Sheets for 58, Pages 2 and 4
Courtesy The John Cage Trust. Photo: David Sundberg.

```
TBrack   TBrack   TBrack   TBrack                    58              Page    2
                                                     Fri Mar 27 13:53:50 1992
```

Instrument 1 (65 brackets) FLUTE 1
 [00:25 inserted after bracket 54]

1	[00:00 - 00:45]	C#¹	[00:30 - 01:15]
2	[01:10 - 01:25]	a¹	[01:20 - 01:35]
3	[01:25 - 01:55]	b¹	[01:45 - 02:15]
4	[02:00 - 02:45]	g#¹¹	[02:30 - 03:15]
5	[03:10 - 03:25]	f#¹	[03:20 - 03:35]
6	[03:20 - 04:05]	e¹¹	[03:50 - 04:35]
7	[04:20 - 05:05]	a¹	[04:50 - 05:35]
8	[05:25 - 05:55]	g#¹¹	[05:45 - 06:15]
9	[06:05 - 06:35]	f♭¹	[06:25 - 06:55]
10	[06:40 - 07:25]	g¹¹¹	[07:10 - 07:55]
11	[07:50 - 08:05]	a#¹¹	[08:00 - 08:15]
12	[08:00 - 08:45]	f¹¹	[08:30 - 09:15]
13	[09:05 - 09:35]	e¹¹	[09:25 - 09:55]
14	[09:50 - 10:05]	g¹¹	[10:00 - 10:15]
15	[10:05 - 10:35]	f¹¹	[10:25 - 10:55]
16	[10:50 - 11:05]	C#¹	[11:00 - 11:15]
17	[11:05 - 11:35]	b¹¹	[11:25 - 11:55]
18	[11:45 - 12:15]	C#¹¹	[12:05 - 12:35]
19	[12:20 - 13:05]	b¹¹	[12:50 - 13:35]
20	[13:20 - 14:05]	f♭¹¹	[13:50 - 14:35]
21	[14:20 - 15:05]	b♭¹¹	[14:50 - 15:35]
22	[15:30 - 15:45]	C¹¹¹	[15:40 - 15:55]
23	[15:40 - 16:25]	g¹¹¹	[16:10 - 16:55]
24	[16:40 - 17:25]	f♭¹¹	[17:10 - 17:55]

51 [35:45 - 36:15] *eb'' (handwritten) [36:05 - 36:35]

52 [36:25 - 36:55] *bb'' (handwritten) [36:45 - 37:15]

53 [37:00 - 37:45] *c#' f#' (handwritten) [37:30 - 38:15]

54 [38:05 - 38:35] *g#' (handwritten) [38:25 - 38:55]

55 [39:15 - 39:30] *a' (handwritten) [39:25 - 39:40]

56 [39:30 - 40:00] *c'' (handwritten) [39:50 - 40:20]

57 [40:10 - 40:40] *f#''' (handwritten) [40:30 - 41:00]

58 [40:55 - 41:10] *b#'' (handwritten) [41:05 - 41:20]

59 [41:15 - 41:30] *g' (handwritten) [41:25 - 41:40]

60 [41:35 - 41:50] *f' (handwritten) [41:45 - 42:00]

61 [41:45 - 42:30] *b eb'' (handwritten) [42:15 - 43:00]

62 [42:55 - 43:10] *eb' (handwritten) [43:05 - 43:20]

63 [43:10 - 43:40] *gb' (handwritten) [43:30 - 44:00]

64 [43:50 - 44:20] *f' (handwritten) [44:10 - 44:40]

65 [44:35 - 44:50] *g''' (handwritten) [44:45 - 45:00]

Instrument 2 (68 brackets) *FLUTE 2 (handwritten)
 [00:30 inserted after bracket 12]

1 [00:00 - 00:30] *g'' (handwritten) [00:20 - 00:50]

2 [00:35 - 01:20] *c#''' (handwritten) [01:05 - 01:50]

3 [01:40 - 02:10] *a' (handwritten) [02:00 - 02:30]

4 [02:25 - 02:40] *eb'' (handwritten) [02:35 - 02:50]

5 [02:45 - 03:00] *c#'' (handwritten) [02:55 - 03:10]

6 [03:05 - 03:20] *f#''' (handwritten) [03:15 - 03:30]

7 [03:20 - 03:50] *a' (handwritten) [03:40 - 04:10]

8 [03:55 - 04:40] *c'' (handwritten) [04:25 - 05:10]

9 [05:05 - 05:20] *g#' f' (handwritten) [05:15 - 05:30]

Courtesy The John Cage Trust.

DATE: October 22, 1991

TO: Sterneck
 Im Schlosshof 1
 D-6450 Hanau 1

RE: Project for Hanau squatters by John Cage

FROM: Andrew Culver

The sides of the map were measured in ⅛ths of an inch (88 × 126). Using *ic*, a computer program that simulates I Ching chance operations, five numbers were found between 0 and 88, and five more between 0 and 126. These were joined to make coordinate pairs for five points — marked with an X, circled, and numbered.

Make a recording at each location shown on the map. Start at the times on the days indicated below (also produced by *ic*):

Location	Day	Time
1	Monday	21:10
2	Wednesday	22:33
3	Saturday	03:23
4	Sunday	23:26
5	Thursday	09:09

If you can find endless cassettes (we have them here up to 12 minutes in length) use those. If not, record both sides of the tape and use auto-reversing tape machines for playback. Failing that, manually turn the cassettes over during playback. Or use open-reel machines and make loops. Do not make a mix. Rather, play back the tapes from five separate tape machine/loudspeaker systems.

ONE⁸

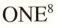

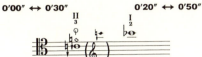
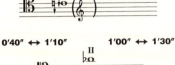

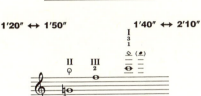

TEN

VIOLIN 1 John Cage

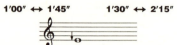

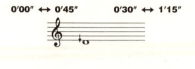

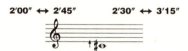

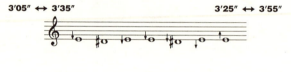

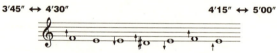

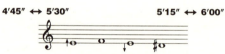

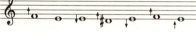

Index

NOTE: Page numbers in boldface refer to Figures. Page numbers with *n* refer to notes. Book titles are followed by authors' names. Titles of musical works by Cage are followed by year of composition. Titles of visual and other works by Cage are followed by their medium or genre.

347

tic texts; *titles of individual poems, e.g., Art Is Either a Complaint Or Do Something Else*

Postmodernism, xxxi

Potter, Dennis, 170

Pound, Ezra, xx; and Cage's *Writing through the Cantos*, 69–70; and Mac Low's *Words nd Ends from Ez*, 69–70

Pragmatism, aesthetic, xx, xxiv, xxix–xxxi, xxxix, xl

Prepared piano, 204–5

Pritchett, James, 169, 210n34, 244

"Project for Hanau Squatters by John Cage" (sound installation), 244, 344

Protestant church, Cage attended as child, 204

Pythagoras, 99, 102, 236–37, 251; M. Bach on Pythagorean system, 251, 254; Cage rejects Pythagorean characterization, 237; Cage seen as new Pythagorean by Retallack, 236; link between music and number in Pythagorean system, 99, 236

Quaderni Perugini di Musica Contemporanea, 271n24

Quasha, George and Susan, 44n1

Questions, as Cage's aesthetic starting point, xv, xxii, xxviii, 69, 124, 139, 153–54, 156, 198–99, 210, 216, 237, 298

Radio Music (1956), 227; *Europera 5* in the spirit of, 227

Radio Symphony Orchestra of Stuttgart, and problems with performing Cage's music, 264, 264n19

Radio/television, 47–48, 102, 226. *See also* Mass culture; Television

Ramakrishna, xlvin36, 171

Rauschenberg, Robert, xx, xxi, 78–79, 94, 106–8, 120–21, 132, 147–49; *Automobile Tire Print*, 121, **123**; reaction to *Art Is Either a Complaint . . .* , 108; "Untitled Black Painting", 121; white paintings, 121

Realism and representation in art, 73, 120, 136–37

Reichert, Manfred, 260

Reid, Albert, xvii

Relâche (Satie and Picabia), 165

Renga with Apartment House 1776 (1976), 92

Retallack, Joan: and aesthetic pragmatism, xx, xxiv; sees Cage as apollonian *and* dionysian, xxxix; on Cage as new Pythagorean, 236; and Cage interview in 1968, xxi–xxiv; on Cage's redefinition of silence as conceptual figure/ground shift, xxvii, 164; on Cage's work with numbers, 216, 236; on complex

realism, xiii, xix, xxxi, xxxix, 73, 75, 191; on conceptual framework of Cage's visual art, 131–32; contradiction and paradox, distinction between, xxvi, 191; and Dewey's *Art as Experience*, xx, xxiv, 55–56, 112; on Epicurus and Cage, xv–xvi, xxxiii–xxxvi; on form as morphology of continuity in Cage's work, 218; on effect of Frankenthaler's canvases, 55; on Fuller as Pythagorean, 236; and Fuller interview in 1968, xxi; on *Global Village*, 113; on history, xiii–xv, xxxii, 102; and humor, views on, xxxvi–xxxvii, 164; and the humorous as conceptual shift, 162; on irony, xxxii–xxxiii, 75–77, 156; on Kierkegaard, 174–75; on language, 71, 146; on Mac Low's work, 70, 70n21; meeting Cage, xv–xx, xxiv; meeting Cunningham, xvii; on paradox, xxvi, xxxvii, 191, 199; on paradox and contradiction, distinction between, xxvi, 191, 199; on the past tense, use of, xiii; on poethical character of Cage's work, xxv, xxx, 218; on Pythagorean link between music and numbers, 99, 236; transformed by Cunningham-Cage performance, xvii, 55; on "transphonation" of Catullus by Celia and Louis Zukofsky, 159; on utopian thinking, xxxi, xlvn26–n27; on Whispered Truths as anarchic principle, 311; on Wittgenstein, xix–xx, xxiv, xxvii

Richards, M. C., xlivn9, 44; and image of "Mother Earth," 44

Riding, Laura, 85–86

Riehn, Rainer, 221, 221n45

Rinzai tradition. *See* Zen Buddhism

Roaratorio (1979), 103

Roeder, Margarete, 96

Rolywholyover A Circus (exhibition), xlvin36, 49n4, 141–43, 149, 151, 233; planning of, 135, 142–44

Rosenberg, Jim, 42, 215

Ross, Nancy Wilson, xxii

Russell, Bertrand, 58

Russell, John, 90n5

Russolo, Luigi, 292

Ryman, Robert, 55, 74–75, 148; white paintings, 74n23, 75

Ryoanji (1983–85): Cage composing new part for, 285–290; different versions of, 240–42; for double bass, 278; first one for oboe, 240, 242; flute part for R. Aiken, 288; methods of composition, 240, **241**, 242, 243; microtonal notation and glissandi in, 261, 280, 287n33, 289; sources for, 242–43; stones used for, 138, 240, **241**, 242–43, 280, 280n28, 282, 284, 296; and *Where R = Ryoanji*, **241**

Tan Dun, 186–88

Tanning, Dorothea, 248

Tao of Science, The (Siu), xxi

Television: as soloist, 227–28; as the twentieth-century experience, 303; used in *Europera 5*, 226–28, 301, 303–4, 307–8. *See also* Mass culture; Radio/television

Ten (1991), 122–24, 127, 182, 250, 346

"Ten Thousand Things, The" (Cage), 213

Themes & Variations (mesostic poem), xxxii, 44n1, 70

Thirteen (1992), 182–84, 209, 216–17, 233, 328–30; chromatically written "faux microtonal" piece, 183–84, 234, 260

Thomson, Virgil, 199

Thoreau, Henry David, xxviii, 92, 92n7, 134, 138, 140, 141n38, 148, 283n29

Three Voices (Feldman), 279

Time, 61, 68–69; Kierkegaard on relation of music and poetry to, 185; silence as hearing empty time, 91–92

Time brackets, 122, 177–79, 181, 183, 206–7, 220, 235, 240, 243–44, 342–43

Tobey, Mark, 54–55, 74–75, 101, 106, **126**, 133–34, 144; as the American Picasso, 74; as influence on Cage, 126; teaching art, methods of, 126–27; *Untitled, 1961* on Cage's wall, 127; white writing, 74, 144

Torre, Michael, 246n1, 265–66, 268; *ASLSP* performed by, 169, 200–203, 205, 243, 265–66, 305; as Juilliard School student, 265

Tractatus Logico-Philosophicus (Wittgenstein), 58n13

Transformation of Nature in Art, The (Coomaraswamy), xlvin36, 293n2

transition (magazine), 86

TRAVESTY (computer program used by Mac Low), 70

Tsutsumi, Seiji, 231n52, 232

Tudor, David, xlivn5, 230n51; Cage writing for, 296–99; as composer of electronic music, 298; and the Merce Cunningham Dance Company, xvi; "Solo for Piano" written for, 296

Turrell, James, 112–13

Twenties (Mac Low), use of caesura in, 155

Two³ (1991), 271n23

Two⁴ (1991), 275n26

Two⁶ (1992), 177–78, 208, 213–14, 320–26; compositional process for, 180; difficulty of performing, 180–81; indeterminacy in score of, 179–81; microtonality in, 179–80; sound sculpture and, 206

Ubu Roi (Jarry), 110

Uitti, Frances-Marie, 278

Ulysses (Joyce), 132, 144, 157–59, 195, 197; Cage writing through for second time (*Muoyce II*), 155, 158, 196; literary criticism on, 158–59; structure of *Muoyce II* based on, 198; textual indeterminacy of, 197–98

Unbounding the Future: The Nanotechnology Revolution (Drexler, Peterson, and Pergamit), 294, 311

Understanding Media: The Extensions of Man (McLuhan), 217n42

Unseld, Siegfried, 66

Untitled Composition for Cello and Piano (Feldman), 249, 253n9, 259

"(untitled)" (mesostic), xxxiii, xlvn33, 193, **193**, 193n20, 195n21, 206

Utopianism, xxii, xxix–xxxii, xxxix, xlvn20, xlvn26–27, 44–46, 164, 173, 176, 212, 294

Utopia or Oblivion (Fuller), xlvn20

Values in a Universe of Chance (Peirce), xlvn19

VanDerBeek, Stan, xvi

Van Gogh, Vincent, 86

Variations II (etchings), 116–17, 120

Variations III (etchings), **117**, **119**, 120

Variations V (1965), xvi

Vaughan, David, 151, 151n44

Verdi, Giuseppe, 222

Vettori cello, 273

Vexations (Satie), 134, 179, 213

Vietnam war, xviii, xxi–xxii, xxviii, 71

Villella, Edward, xlivn5

Visual art: and Addis's *The Art of Zen*, 128n27; Cage on illustration *vs.* accompaniment, 149–50; Cage on Tobey and teaching methods of, 126–27; Cage's, as a form of music, 94, 99–100, 112–13; Cage's early experiments with materials, 87; Cage's early lectures on modern painting and music, 87–88; Cage's etchings, 92–97, **97**, 98, **98**, 100, 112–18, **118**, 119, **119**, 120–21, 125, 129, 132–34, 137–38; Cage's graphic work for Jack Lenor Larsen Textile Company, 88–90; Cage's lithographs, 90, 92–94; Cage's music and, link between, 91–96, 113, 124–25, 129, 143, 180–81, 240–43, 285; chance operations, Cage's use of in, 93, 96, 100, 115–17, 120, 125, 128, 128n27, 129–33, 136–39, 141, 218, 240, 243; conceptual framework of, 121–22, 128–32, 137; fire and smoke used by Cage in making graphics, 78, 114–21, 127, 134, 141, 148; found materials in Cage's, 115–21, 125, 132–33; magnetic tape makes

UNIVERSITY PRESS OF NEW ENGLAND

publishes books under its own imprint and is the publisher for Brandeis University Press, Dartmouth College, Middlebury College Press, University of New Hampshire, University of Rhode Island, Tufts University, University of Vermont, Wesleyan University Press, and Salzburg Seminar.

ABOUT JOHN CAGE

Composer, author, and visual artist, John Cage was born in Los Angeles in 1912 and died in New York City in 1992 less than a month short of his eightieth birthday. By the age of thirty-seven Cage had been recognized by the American Academy of Arts and Letters for extending the boundaries of music. Elected to the American Academy of Arts and Sciences in 1978, Cage also received the highest cultural awards of France and Japan—Commandeur de l'Ordre des Arts et des Lettres (1982), and The Kyoto Prize (1989). Cage is generally acknowledged to have been the most influential figure in music and the arts in the latter half of the twentieth century, both independently and in his fifty-year collaboration with Merce Cunningham. Cage composed hundreds of musical works using ground-breaking methods of composition and instrumentation. His selective use of chance operations in composed interactions of determinate structure and indeterminate process—what he called "imitating nature in her manner of operation"—parallels recent findings in the non-linear sciences about complex natural systems like weather. His redefinition of silence as ambient sound led to his best-known musical piece, 4′33″. Cage's prodigious output encompasses a significant body of visual art, as well as essays and poetry.

John Cage was the author of many books, including *Silence* (1961), *A Year From Monday* (1967), *M* (1973), *Empty Words* (1979), and *X* (1983), all published by Wesleyan University Press.

ABOUT JOAN RETALLACK

Joan Retallack is a poet and essayist who has written extensively on John Cage's work. She is currently on the faculties of the interdisciplinary University Honors Program at the University of Maryland and the Institute for Writing and Thinking at Bard College. In 1993–94 she was Visiting Butler Chair Professor of English in the Poetics Program, SUNY at Buffalo. Retallack is the author of five books of poetry including *ERRATA 5UITE*, which was chosen by Robert Creeley for the 1994 Columbia Book Award. Her most recent book is *AFTERRIMAGES*, published by Wesleyan University Press.

LIBRARY OF CONGRESS CATALOGING-IN-PUBLICATION DATA

Cage, John.
 Musicage : Cage muses on words, art, music / Joan Retallack, editor.
 p. cm.
 Includes bibliographical references (p.) and index.
 ISBN 0–8195–5285–2 (alk. paper)
 1. Cage, John—Interviews. 2. Composers—United States—Interviews.
I. Retallack, Joan.
ML410.C24A5 1995
780′.92—dc20
 95–9497
∞

3.13.96, Hennessy + Ingalls, 29.95 (26.96) 6325D